NEW YORK
FROM THE AIR

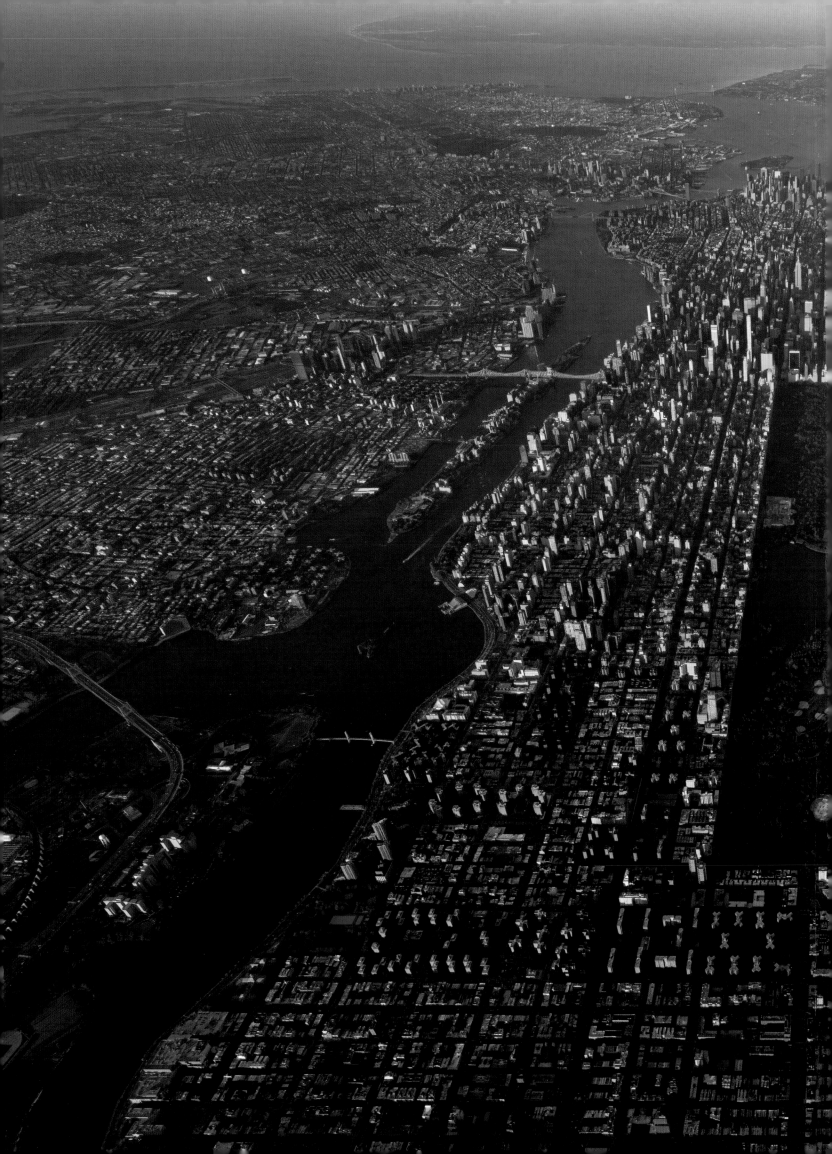

NEW YORK
FROM THE AIR

Aerial Photography
by Paul Seibert

RIZZOLI
NEW YORK

New York · Paris · London · Milan

FlyNYON was founded by aviation experts with a combined 101 years of flight experience in the helicopter industry. We make professional aerial photography services accessible to everyone by providing a crowdsourced aerial experience. Since its inception in 2012, FlyNYON has flown over 250,000 passengers. FlyNYON's CEO and founder Patrick K. Day, a third-generation military veteran and aviator, has combined his industry expertise with an innovative way of thinking. For more information, please visit www.flynyon.com, @FlyNYON, or facebook.com FlyNYON/.

First published in the United States of America in 2022 by
Rizzoli International Publications, Inc.
300 Park Avenue South
New York, NY 10010
www.rizzoliusa.com

Pages 6–7: Image from "All the Buildings in Manhattan" courtesy of Taylor Baldwin. https://tbaldw.in/nyc-buildings

Publisher: Charles Miers
Associate Publisher: James Muschett
Managing Editor: Lynn Scrabis
Editor: Candice Fehrman
Design: YummyColours
yummycolours.com

Printed in China

2022 2023 2024 2025 / 10 9 8 7 6 5 4 3 2 1

ISBN: 978-0-7893-3977-5

Library of Congress Control Number: 2021946749

Visit us online:
Facebook.com/RizzoliNewYork
Twitter: @Rizzoli_Books
Instagram.com/RizzoliBooks
Pinterest.com/RizzoliBooks
Youtube.com/user/RizzoliNY
Issuu.com/Rizzoli

To God, the creator of all things,
To my wife, Leiani,
To my parents and my sister,
To my entire family,
To my friends,
To my creative community,

Thank you.

I am the sum of all of you, your love,
your support, and your advice.

This book is a representation of all of me,
and I would be nothing without all of you.

Thank you.

INDEX

HUDSON YARDS
AND VESSEL
Pages 51, 114–115,
117, 149, 158

NEW YORK CITY
Pages 36–37, 62–63, 95, 146–147, 180, 185

WASHINGTON
SQUARE PARK
Pages 65, 88

AVENUE OF THE AMERICAS
Pages 34–35

MANHATTANHENGE
Page 126

9/11 TRIBUTE IN LIGHT
Pages 153, 176, 177, 178–179

ONE WORLD TRADE CENTER
Pages 25, 32, 42, 92, 93, 107,
132, 144, 148, 152

WEST SIDE HIGHWAY AND
FINANCIAL DISTRICT
Pages 112, 165

THE OCULUS
Pages 142–143

STATEN ISLAND FERRY,
NEW YORK HARBOR
Page 133

MANHATTAN BRIDGE
Page 21

BROOKLYN BRIDGE
Pages 20, 82, 138, 163

EAST RIVER
Pages 38–39

LOWER MANHATTAN
Pages 10–11, 18–19, 30–31,
99, 108, 160–161, 184–185,
186–187

MUNICIPAL BUILDING
Page 140

STATUE OF LIBERTY
Pages 56–57, 89, 100–101, 106, 122–123, 128

COVERNORS ISLAND
Pages 44–45, 66–67

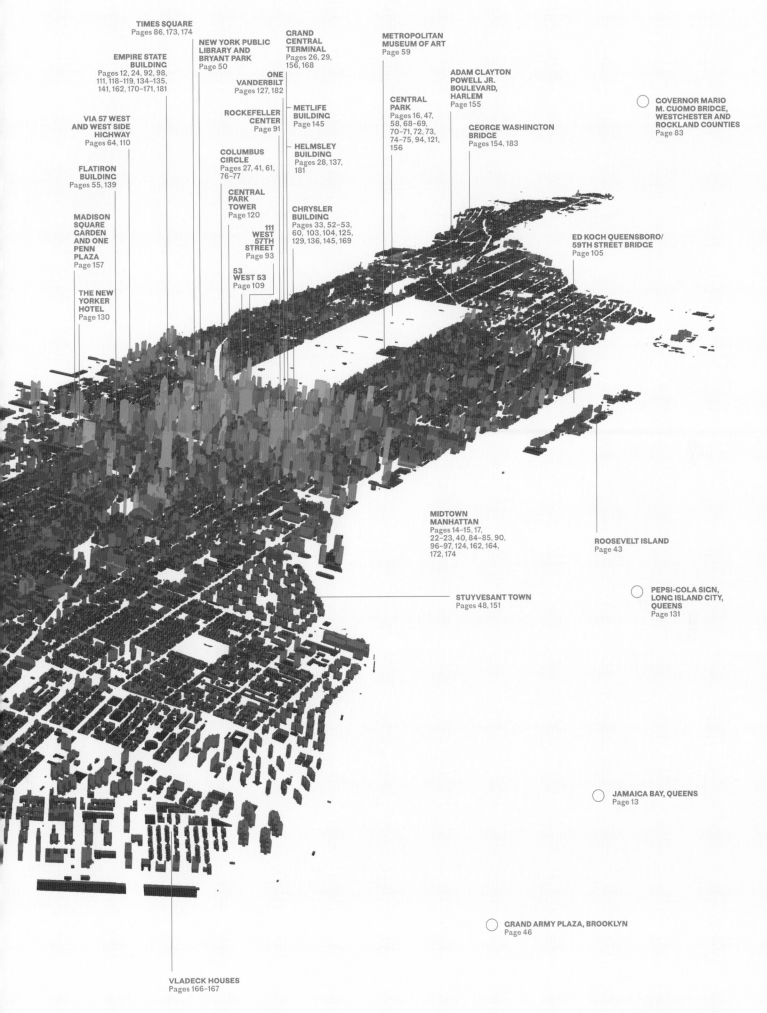

Pages 86, 173, 174

NEW YORK PUBLIC
LIBRARY AND
BRYANT PARK
Page 50

GRAND
CENTRAL
TERMINAL
Pages 26, 29,
156, 168

METROPOLITAN
MUSEUM OF ART
Page 59

EMPIRE STATE
BUILDING
Pages 12, 24, 92, 98,
111, 118–119, 134–135,
141, 162, 170–171, 181

ONE
VANDERBILT
Pages 127, 182

ADAM CLAYTON
POWELL JR.
BOULEVARD,
HARLEM
Page 155

GOVERNOR MARIO
M. CUOMO BRIDGE,
WESTCHESTER AND
ROCKLAND COUNTIES
Page 83

VIA 57 WEST
AND WEST SIDE
HIGHWAY
Pages 64, 110

ROCKEFELLER
CENTER
Page 91

METLIFE
BUILDING
Page 145

CENTRAL
PARK
Pages 16, 47,
58, 68–69,
70–71, 72, 73,
74–75, 94, 121,
156

GEORGE WASHINGTON
BRIDGE
Pages 154, 183

FLATIRON
BUILDING
Pages 55, 139

COLUMBUS
CIRCLE
Pages 27, 41, 61,
76–77

HELMSLEY
BUILDING
Pages 28, 137,
181

ED KOCH QUEENSBORO/
59TH STREET BRIDGE
Page 105

MADISON
SQUARE
GARDEN
AND ONE
PENN
PLAZA
Page 157

CENTRAL
PARK
TOWER
Page 120

CHRYSLER
BUILDING
Pages 33, 52–53,
60, 103, 104, 125,
129, 136, 145, 169

111
WEST
57TH
STREET
Page 93

THE NEW
YORKER
HOTEL
Page 130

53
WEST 53
Page 109

MIDTOWN
MANHATTAN
Pages 14–15, 17,
22–23, 40, 84–85, 90,
96–97, 124, 162, 164,
172, 174

ROOSEVELT ISLAND
Page 43

STUYVESANT TOWN
Pages 48, 151

PEPSI-COLA SIGN,
LONG ISLAND CITY,
QUEENS
Page 131

JAMAICA BAY, QUEENS
Page 13

GRAND ARMY PLAZA, BROOKLYN
Page 46

VLADECK HOUSES
Pages 166–167

CONEY ISLAND, BROOKLYN
Pages 78–79, 80–81

FRO THE AI

Paul Seibert

When opportunity and passion collide, there is often an end result that can far exceed one's imagination. This book, a labor of love, is the end result of my passion meeting opportunity. In 2015, I was asked by my friend David LaCombe if I'd be interested in participating in a dual-helicopter photo flight; we call that an "air-to-air" flight. Having been intrigued by aerial images I had seen other photographers posting on social media, I jumped at the chance. This was the opportunity that started it all.

Upon landing, I immediately knew that I had to have that experience again as quickly as possible. I set out posting my images and tagging the company that I flew with over and over again. A few months later, FlyNYON offered me a role as a contributing photographer. For the next two years, I flew over New York City and its iconic landmarks honing my craft. In the years since, my passion only grew stronger. I pushed myself to find new compositions, and was afforded ample opportunity to understand where the light would be to create dramatic and engaging images. I learned to love the juxtaposition between the geographical formations and how humans have found a way to use every last inch to populate this area. I also strove to highlight the architectural features that can't be seen or appreciated at street level.

As the years progressed, I was repeatedly asked the inevitable questions regarding heights, such as "Why?" and "Have you always been this way?" In time, I came to the realization that I have always been this way. Six months out of the year, I live in the Northeast under a lush green canopy of deciduous trees, which makes the sky seem small. Because of this, I have distinct memories of wanting to find the perfect perch. That has driven me to seize any opportunity I can to see the edge of all things.

With this book, my desire is to provide readers with breathtaking views of New York above the noise. So often, when people speak of New York, they mention the speed, the sound, and the intensity of everyday life. This book gave me the chance to show a different New York. I wanted to highlight the fact that this is a city of islands (mostly, sorry to the Bronx), and that alone provides unique opportunities to create images that combine landscape with the city's skyline. New York is also known for its unapologetic attitude and brashness. However, over the years I have seen architectural details that suggest there is a fineness and delicacy to these creations. Finding and sharing these lesser-seen details has become somewhat of an obsession for me.

These last six years I have witnessed so much change—change in the city, change in how we navigate life together, and change in myself and my craft. I am so incredibly humbled and honored to present to you the culmination of that time, here, in the physical form, beyond the digital realm. My hope is that you can feel my love for this city through my images.

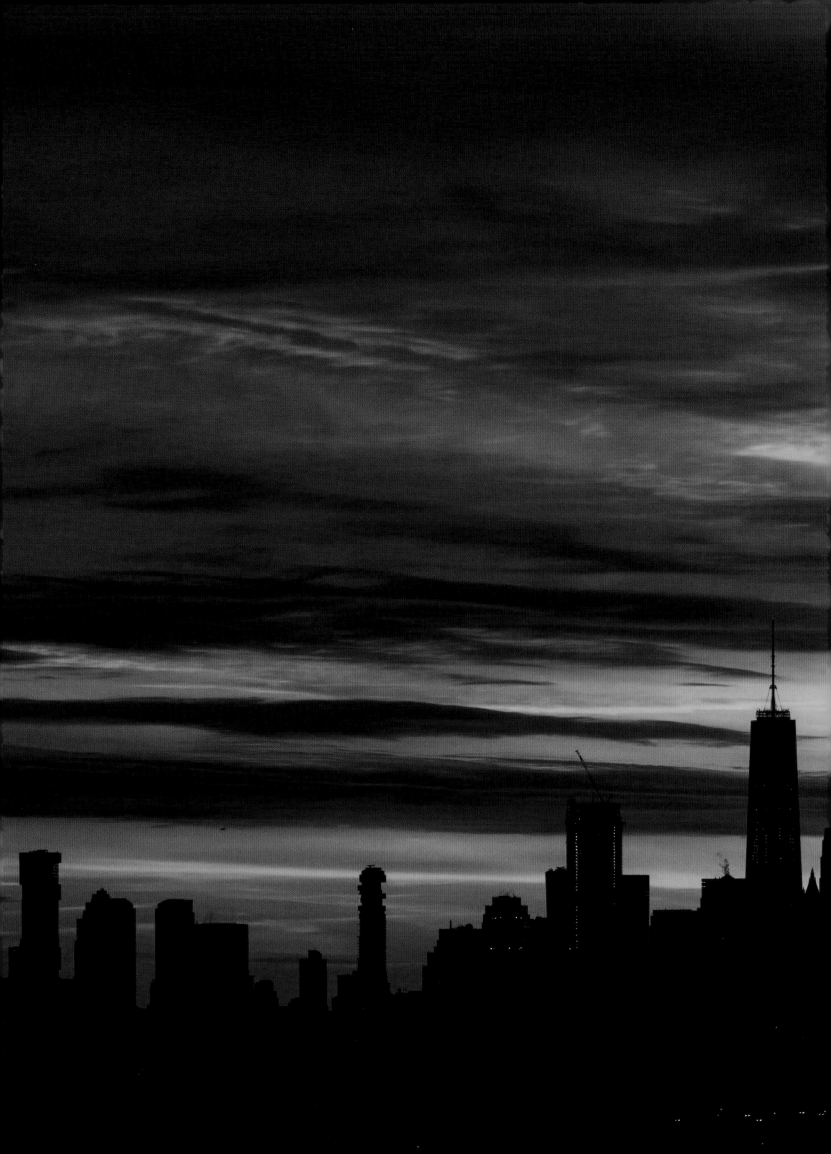

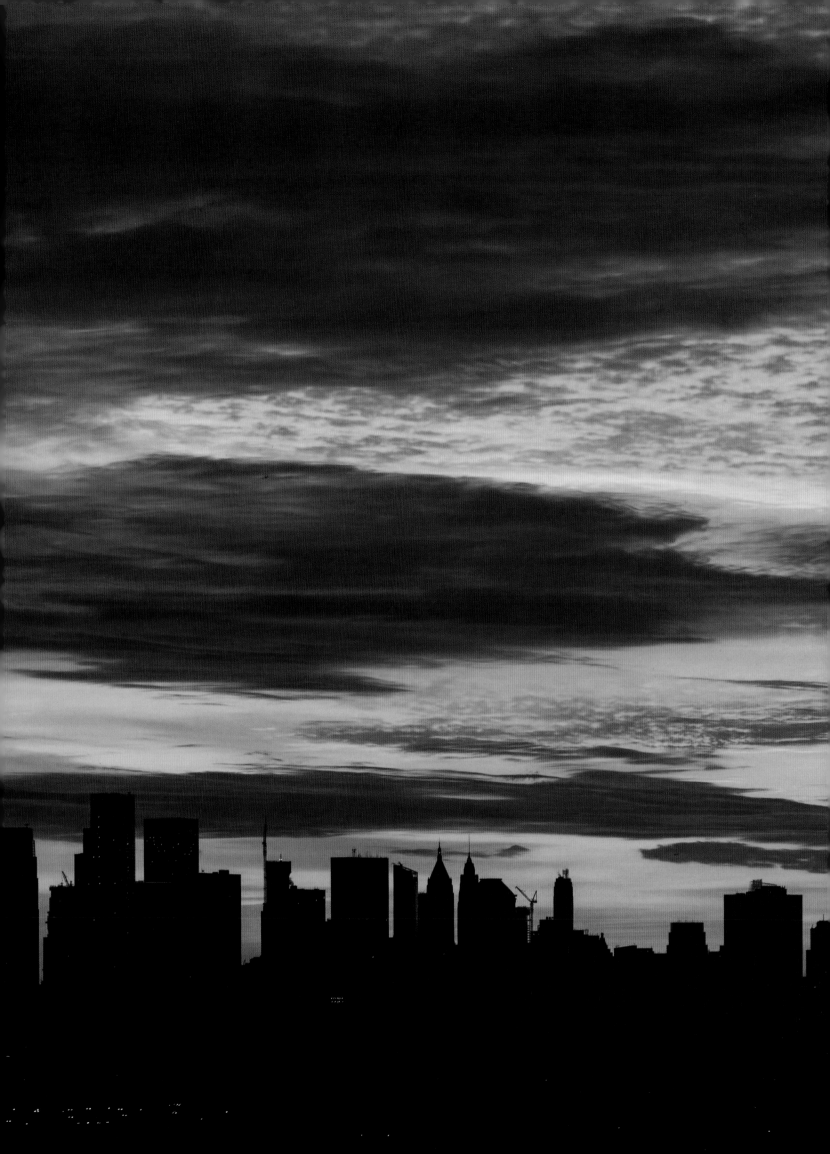

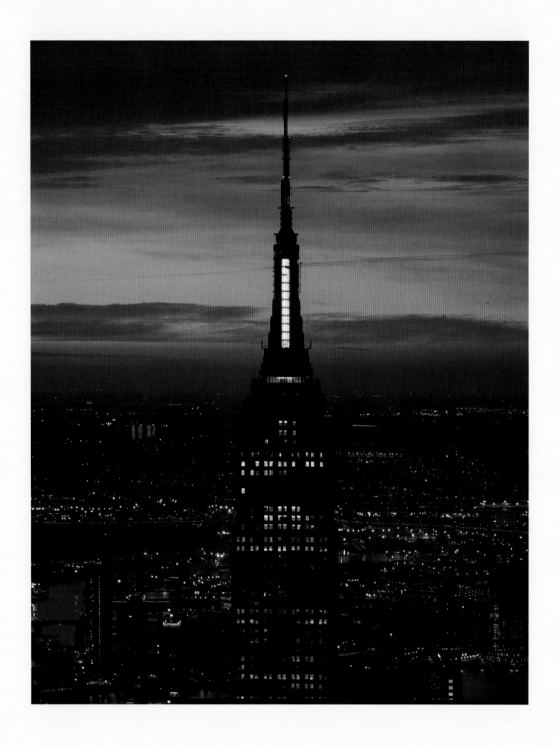

Pages 10-11
Lower Manhattan, as seen
from Kearny, New Jersey
1 min. and 14 sec. before sunrise
Altitude 1,000 feet

Above
Empire State Building,
as seen from Edge NYC
17 min. and 30 sec. before sunrise
Altitude 1,131 feet

Page 13
Jamaica Bay, Queens
1 min. and 55 sec. after sunrise
Altitude 2,000 feet

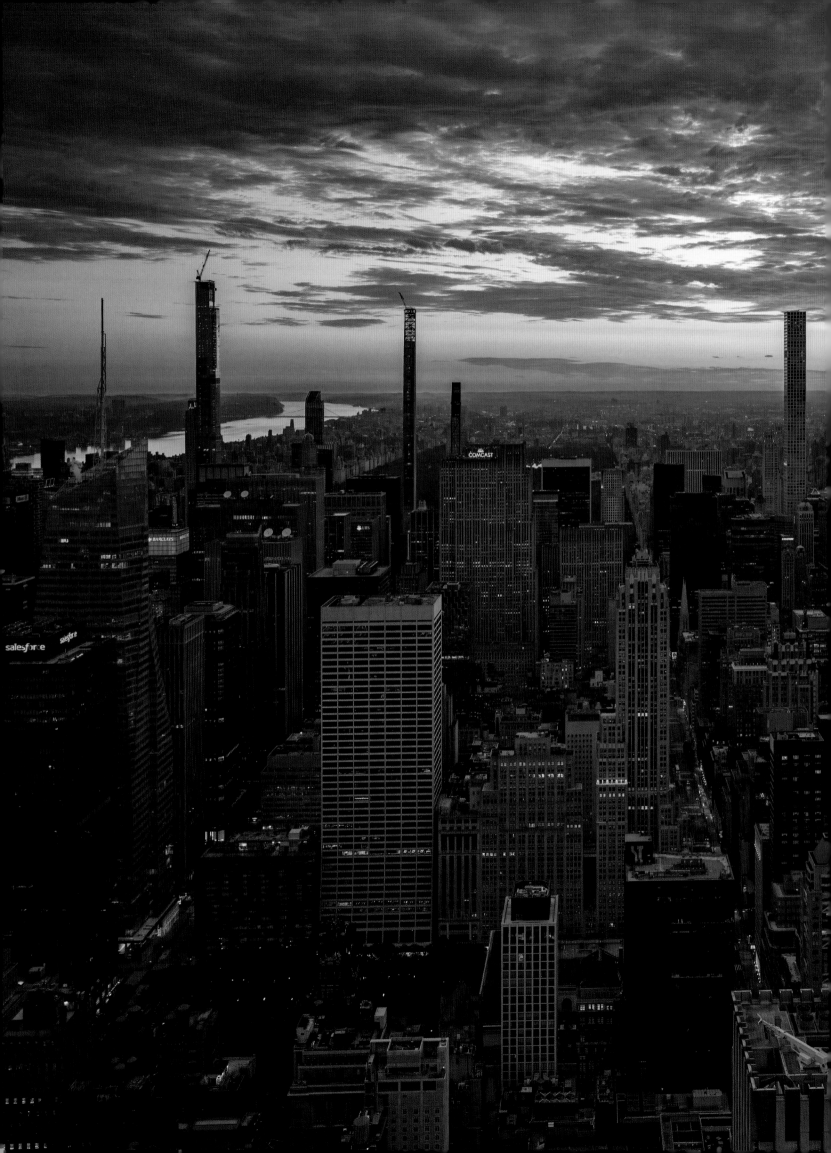

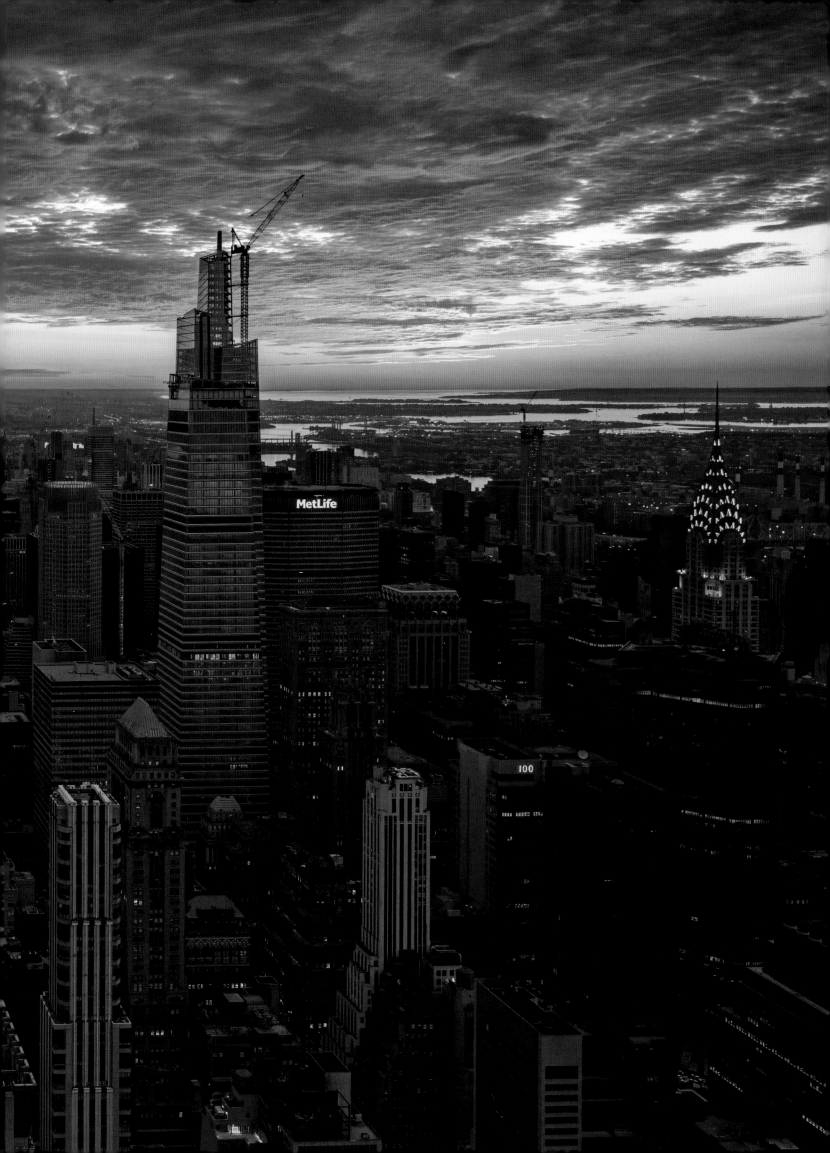

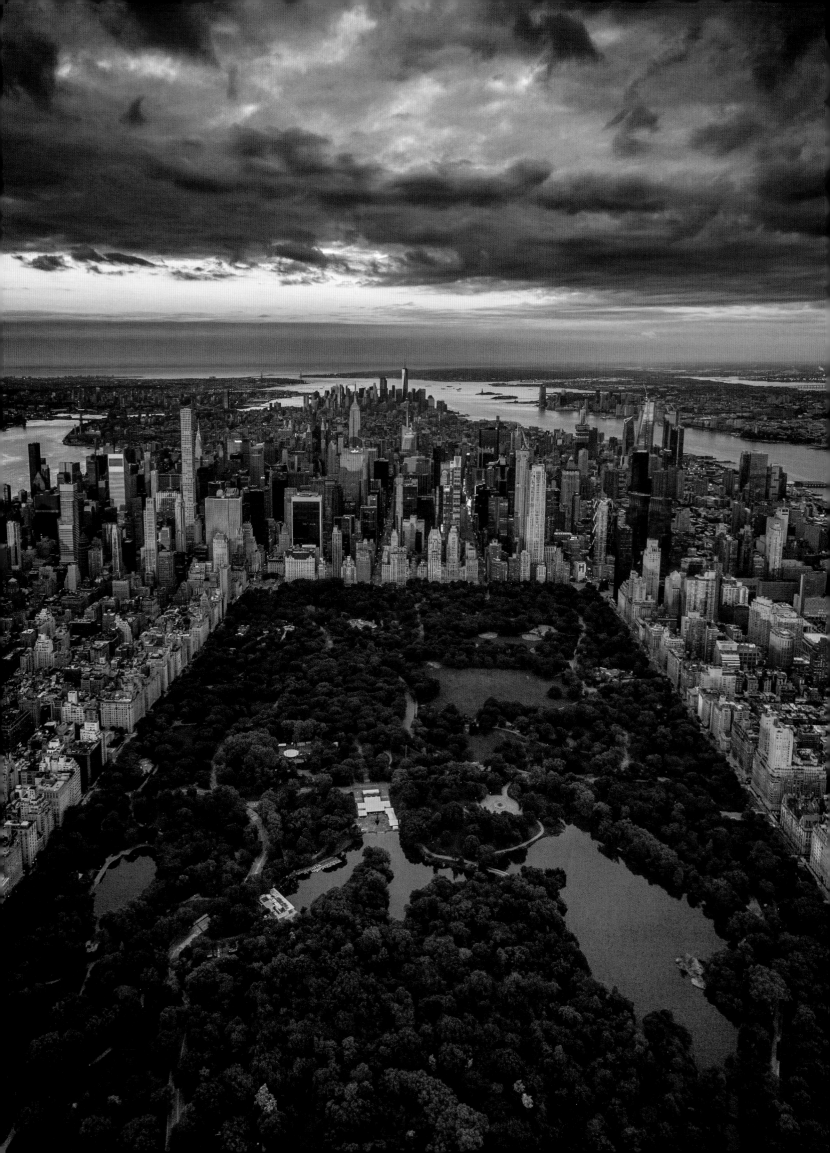

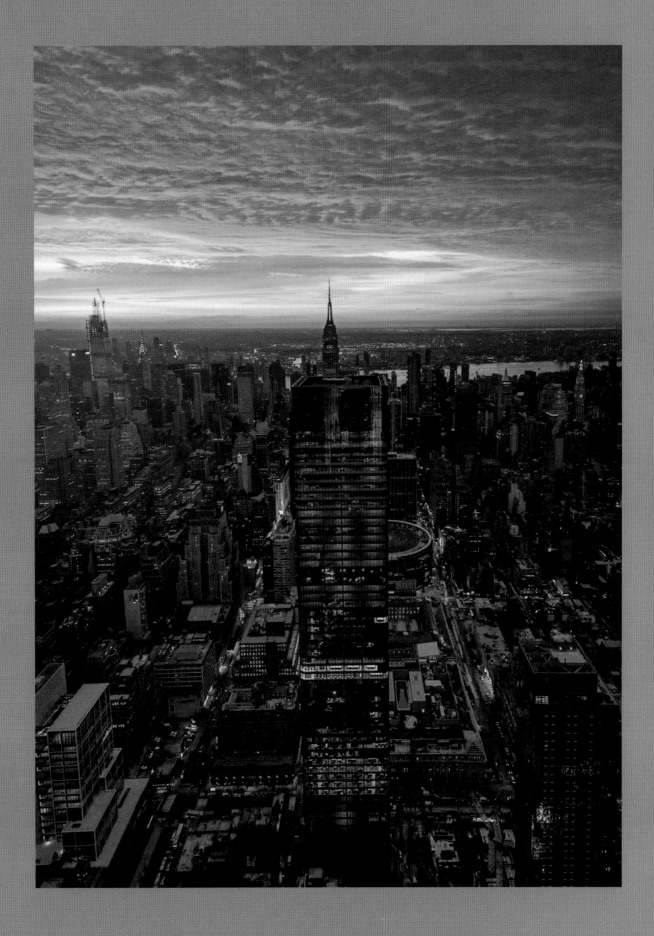

Pages 14-15
Midtown Manhattan, as seen from Empire State Building 86th floor observation deck
13 min. and 13 sec. before sunrise
Altitude 1,050 feet

Page 16
Central Park, looking south
4 min. and 17 sec. after sunrise
Altitude 1,700 feet

Above
34th Street and 33rd Street, looking east from Edge NYC
10 min. and 32 sec. before sunrise
Altitude 1,131 feet

Pages 18-19
"The Money Shot,"
Lower Manhattan, looking north
14 min. and 16 sec. after sunrise
Altitude 1,450 feet

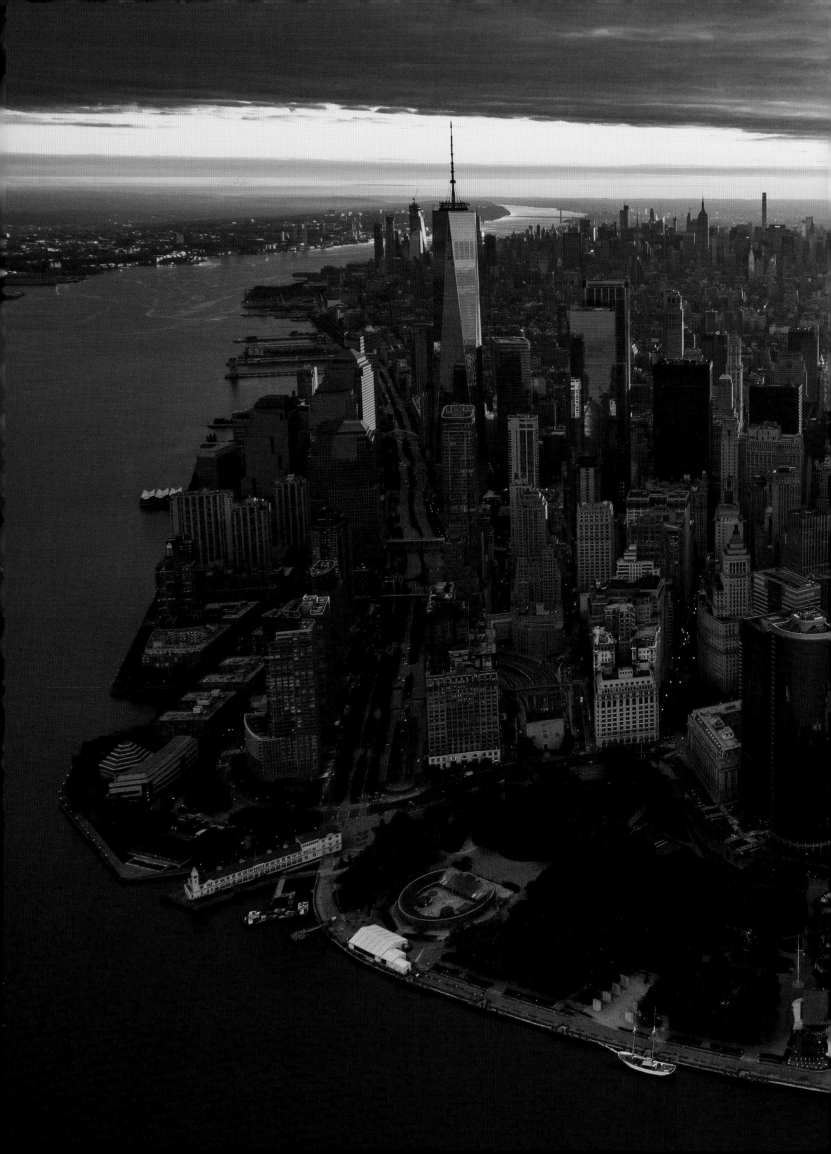

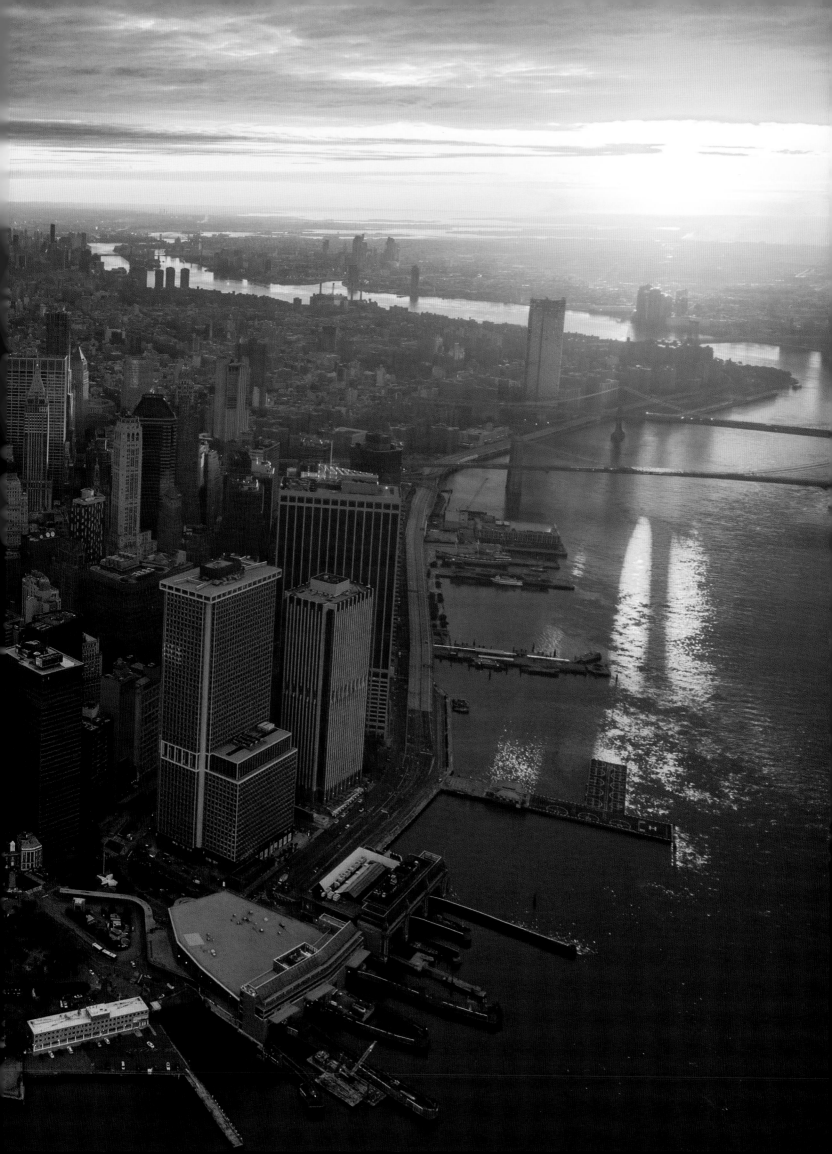

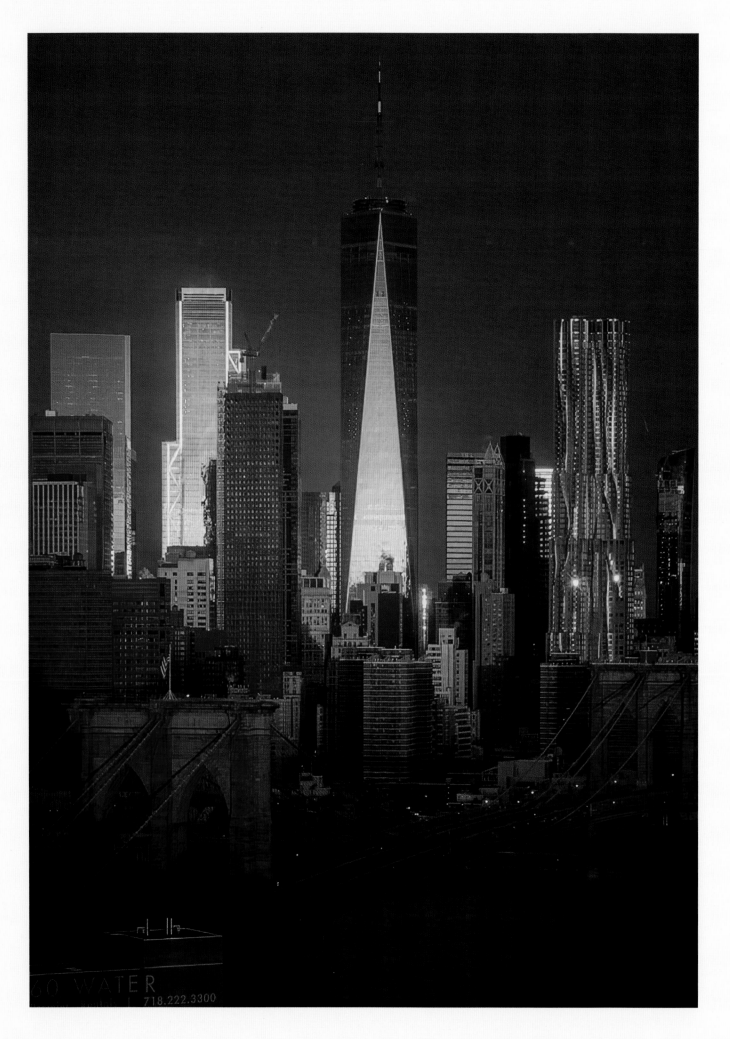

Brooklyn Bridge and Lower Manhattan,
as seen from Dumbo, Brooklyn
7 min. and 39 sec. after sunrise
Altitude 325 feet

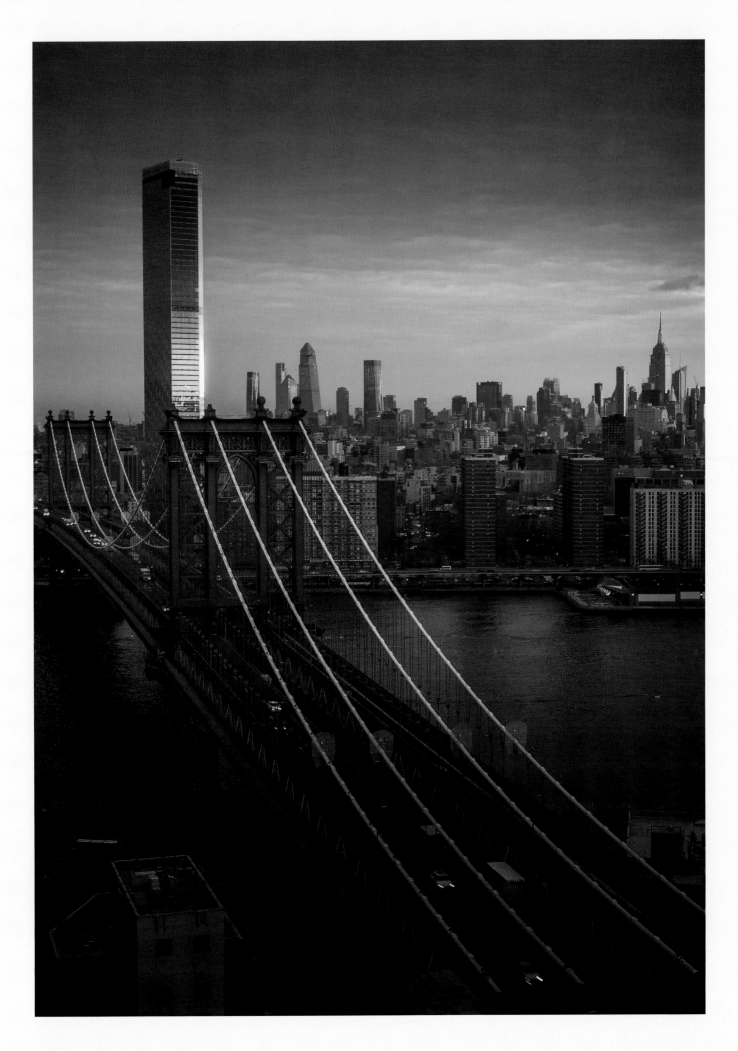

Manhattan Bridge and Midtown Manhattan,
looking west from Dumbo, Brooklyn

4 min. and 57 sec. after sunrise

Altitude 325 feet

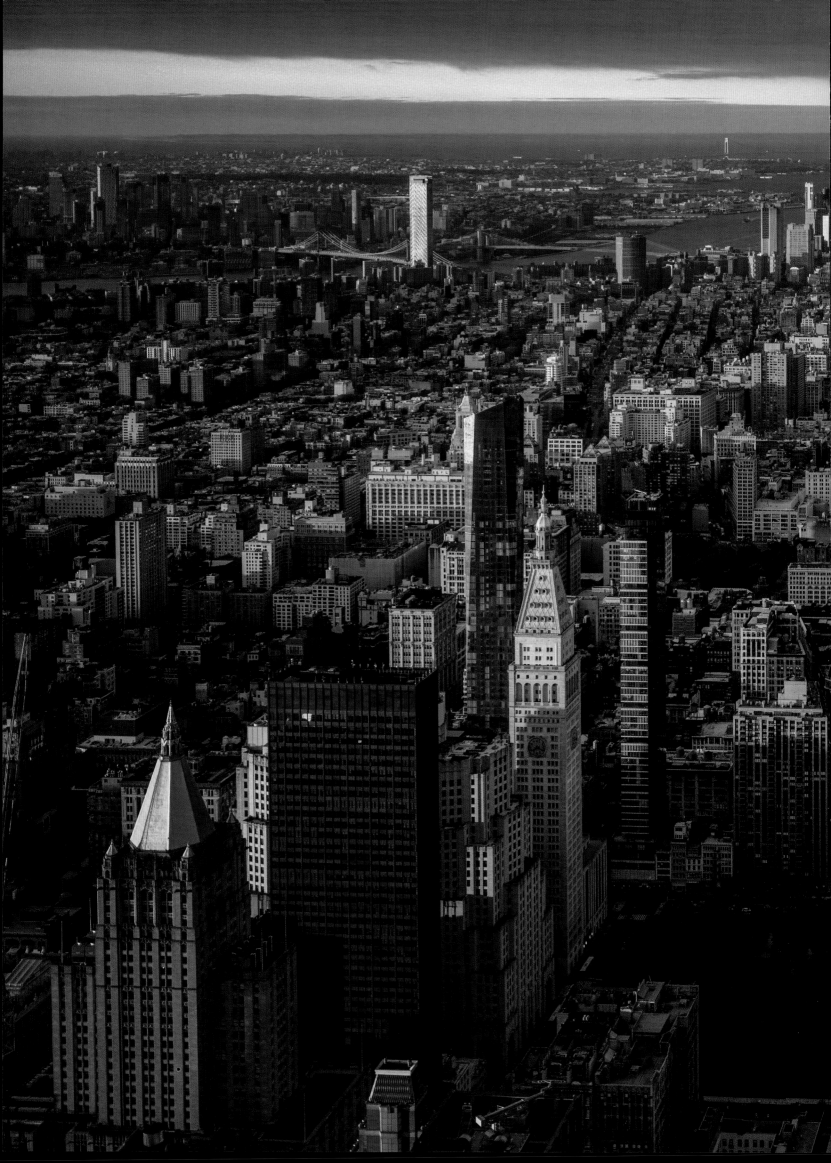

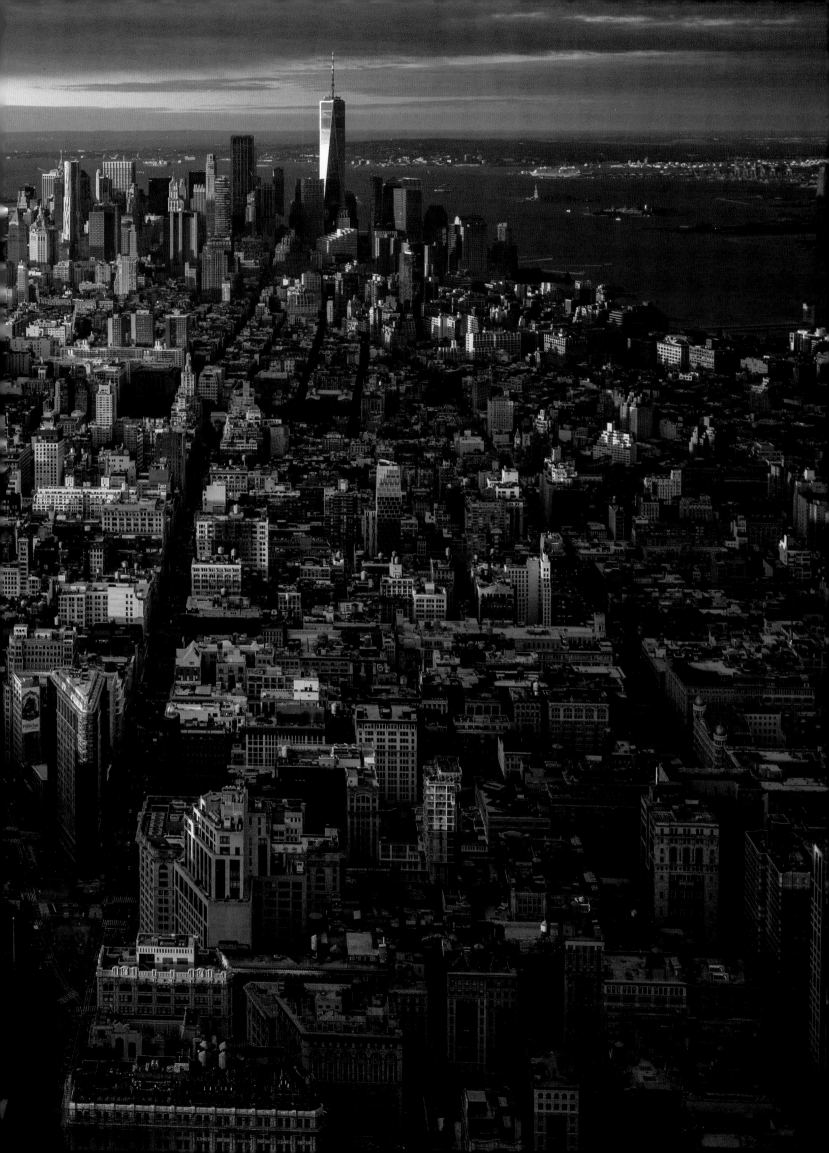

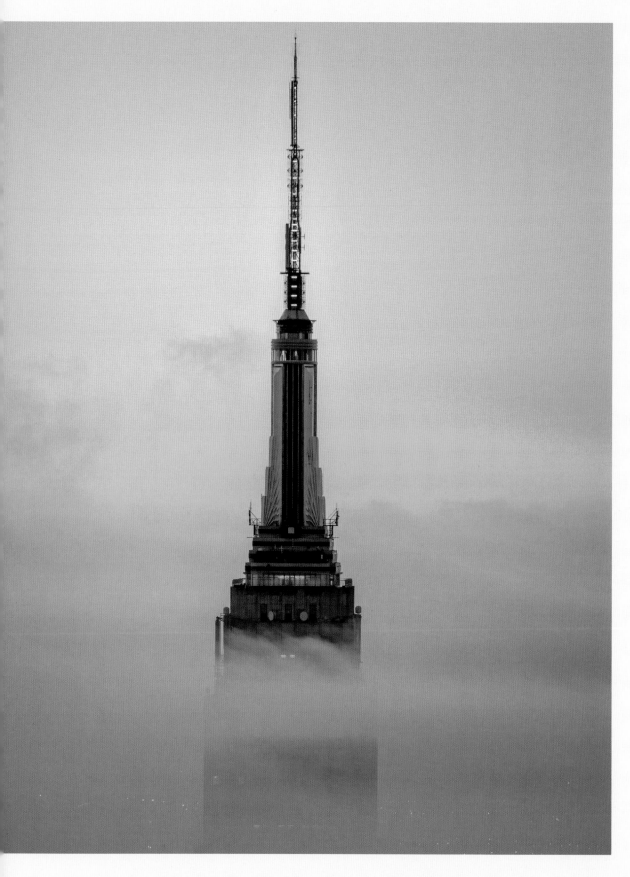

Pages 22-23

Midtown and Lower Manhattan,
as seen from Empire State Building
102nd floor observation deck

16 min. and 28 sec. after sunrise

Altitude 1,250 feet

Above

Empire State Building, looking east

13 min. and 16 sec. before sunrise

Altitude 1,150 feet

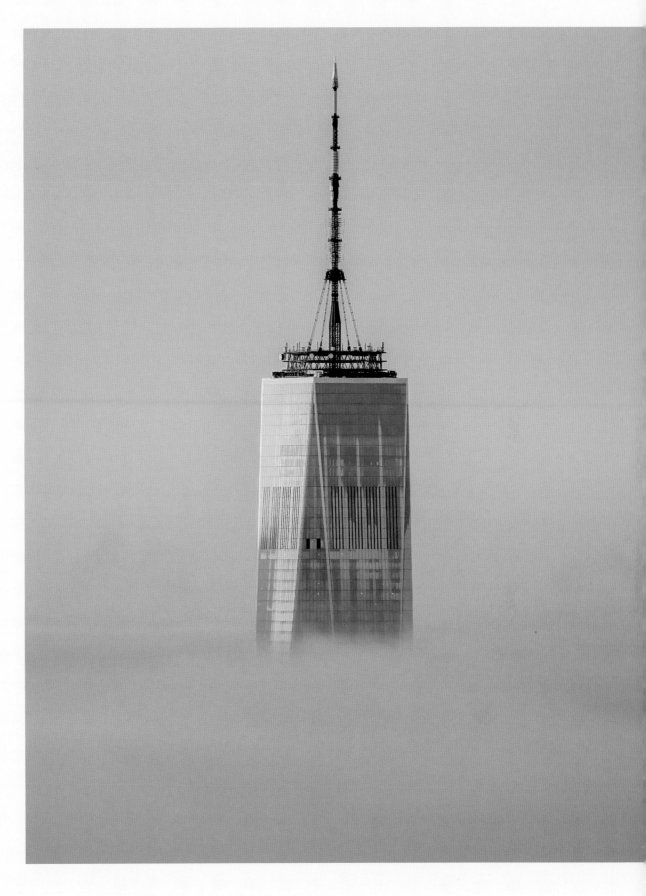

Above
One World Trade Center
7 min. and 54 sec. after sunrise
Altitude 1,150 feet

Page 26
Grand Central Terminal
1 hr., 38 min., and 25 sec. after sunrise
Altitude 155 feet

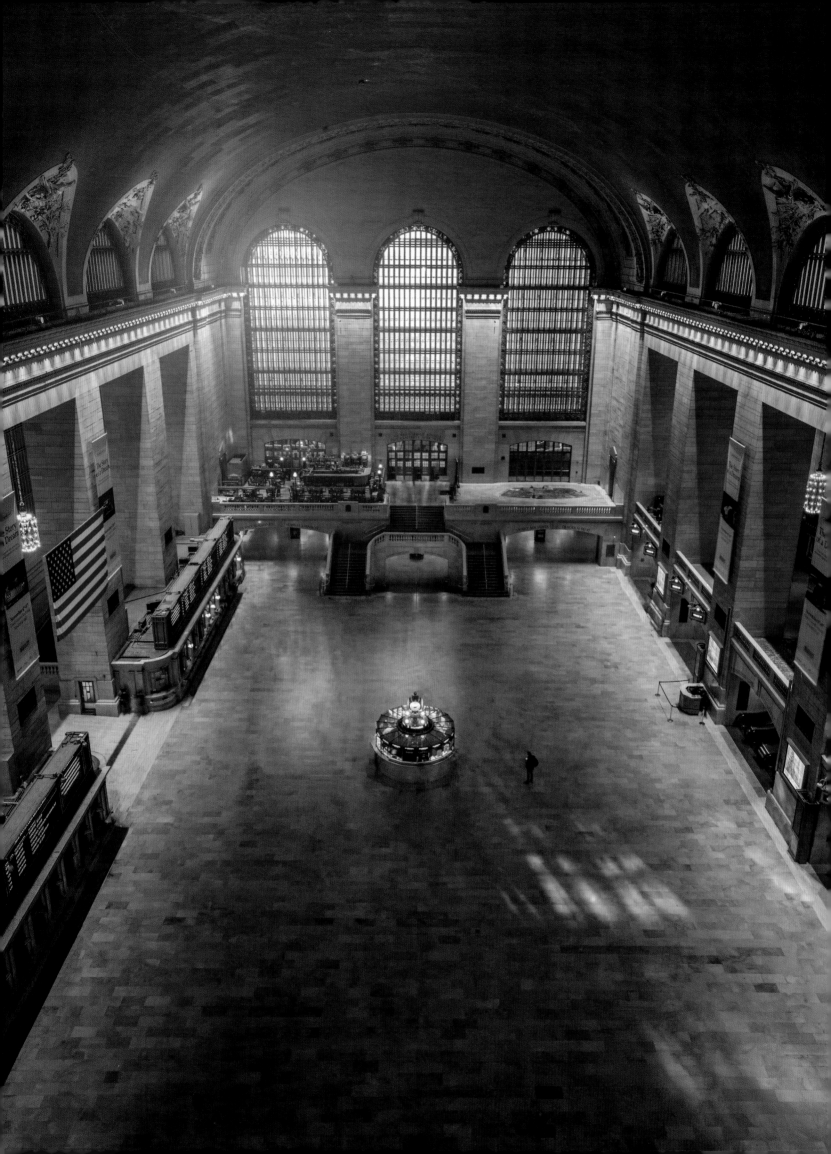

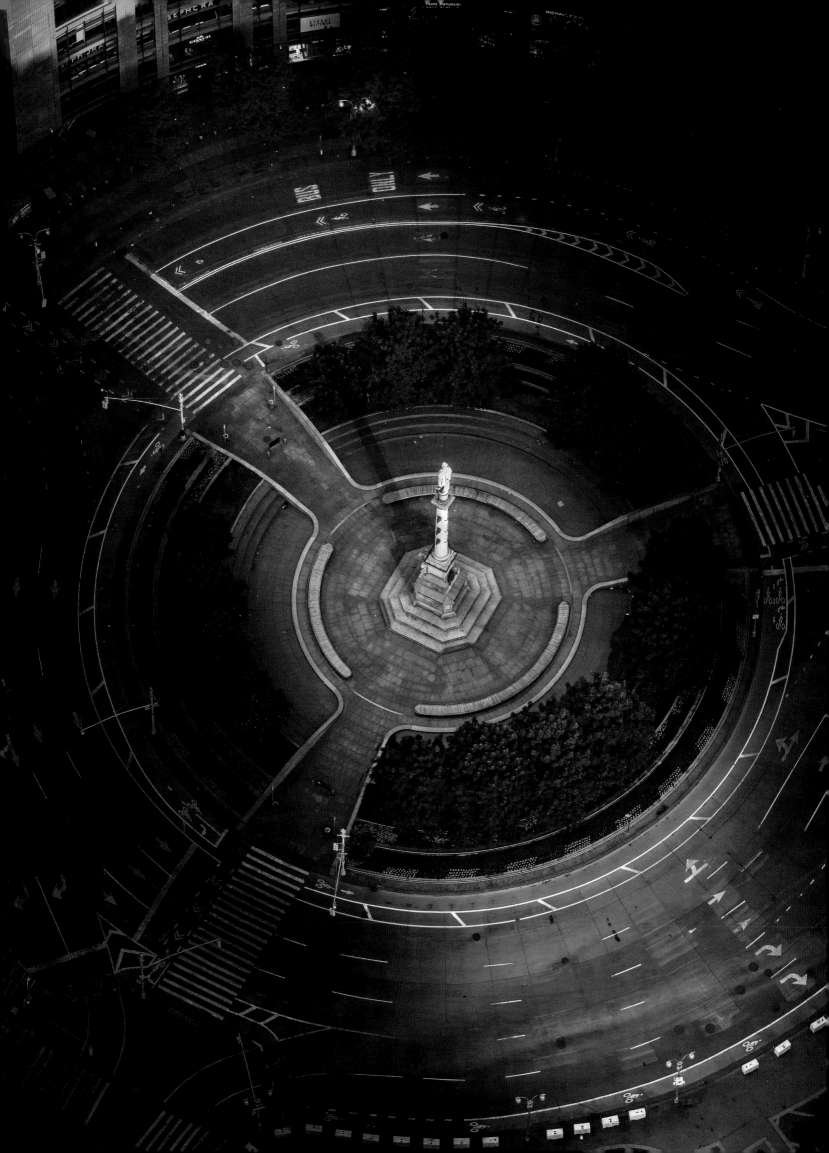

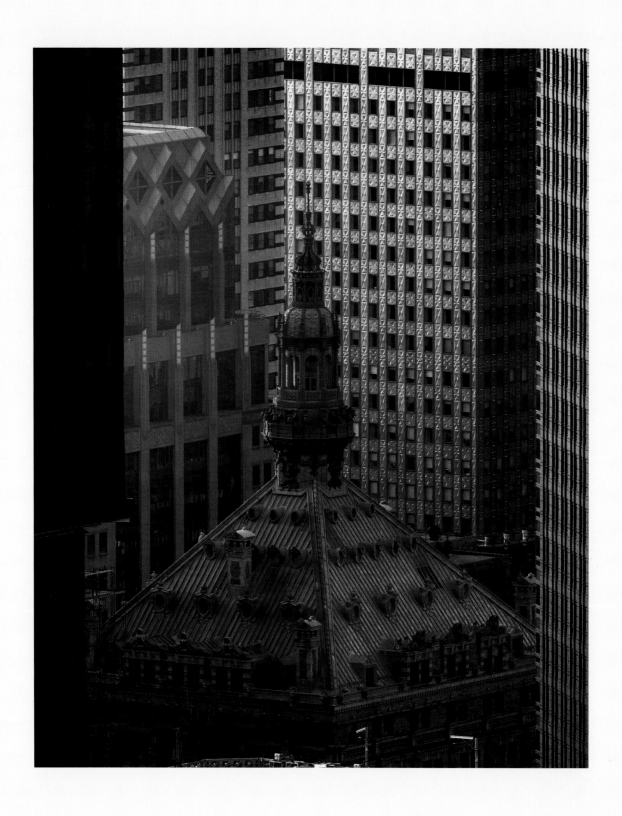

Page 27
Columbus Circle
21 min. and 7 sec. after sunrise
Altitude 2,000 feet

Above
Helmsley Building
10 min. and 45 sec. after sunrise
Altitude 950 feet

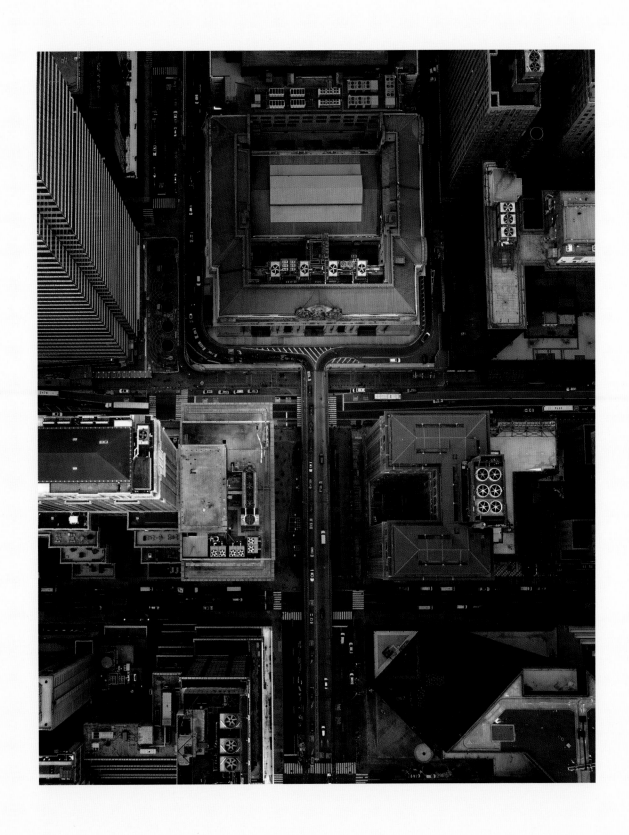

Above
Grand Central Terminal and
Park Avenue Viaduct
35 min. and 35 sec. before sunset
Altitude 1,830 feet

Pages 30-31
Lower Manhattan and Brooklyn
7 hr. and 20 min. after sunrise
Altitude 10,000 feet

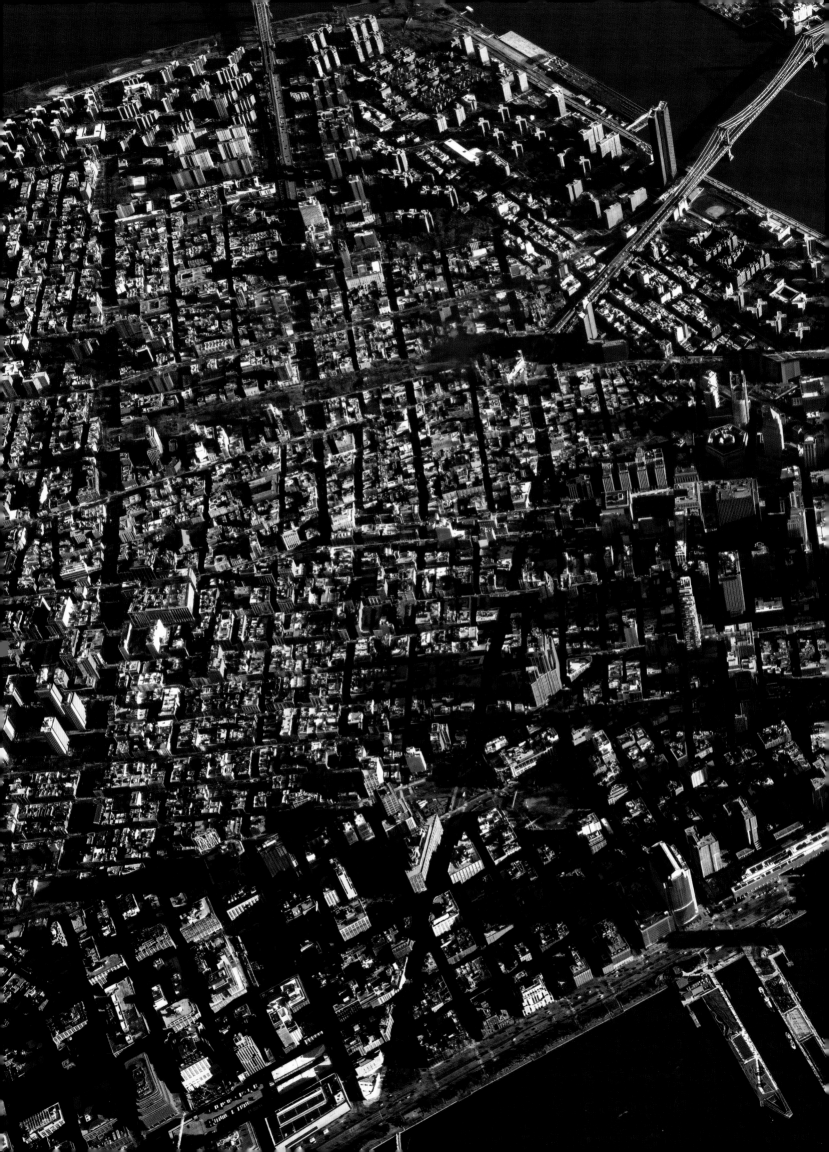

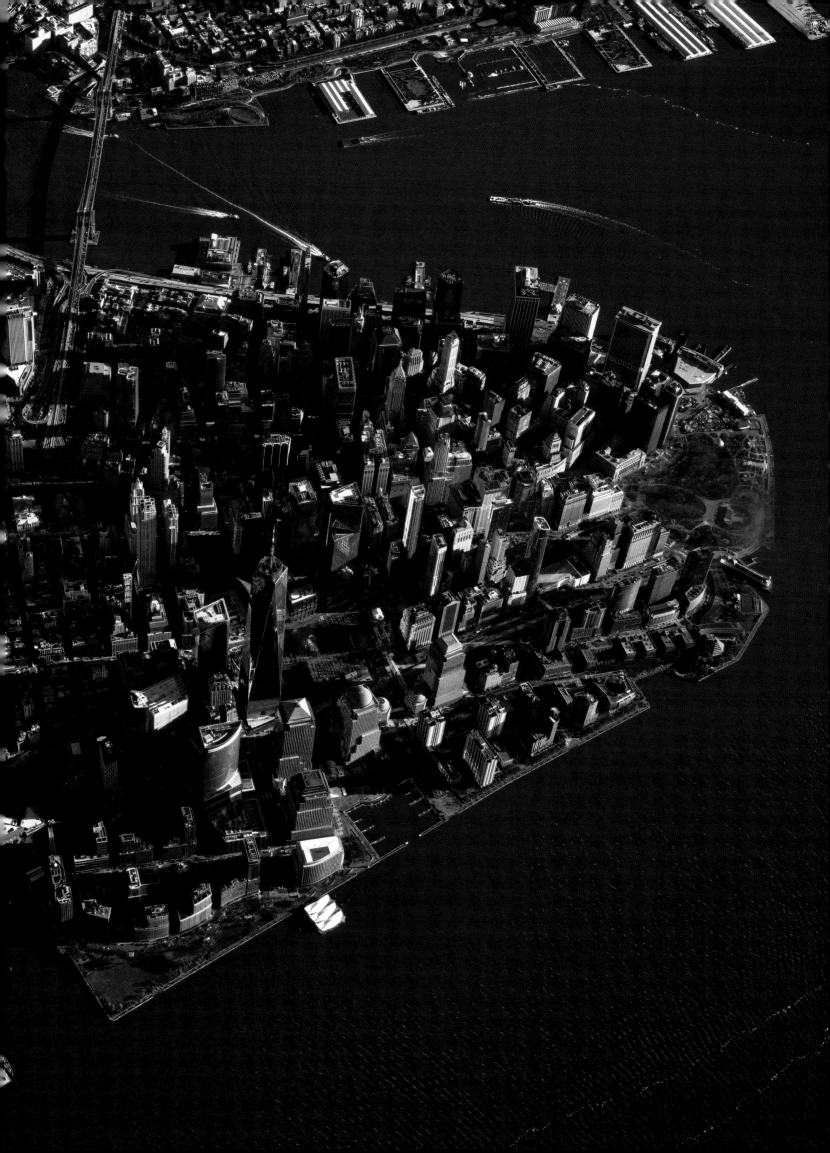

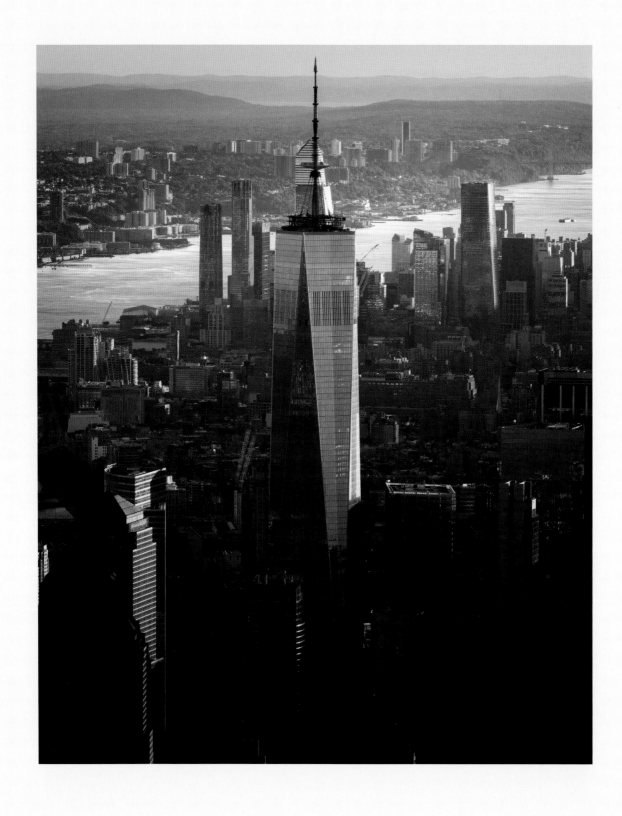

Above

One World Trade Center
and Hudson Yards

44 min. and 8 sec. after sunrise

Altitude 1,700 feet

Page 33

Chrysler Building crown and taxicab

3 hr. and 42 min. after sunrise

Altitude 1,450 feet

Pages 34-35

Avenue of the Americas

37 min. and 33 sec. after sunrise

Altitude 1,050 feet

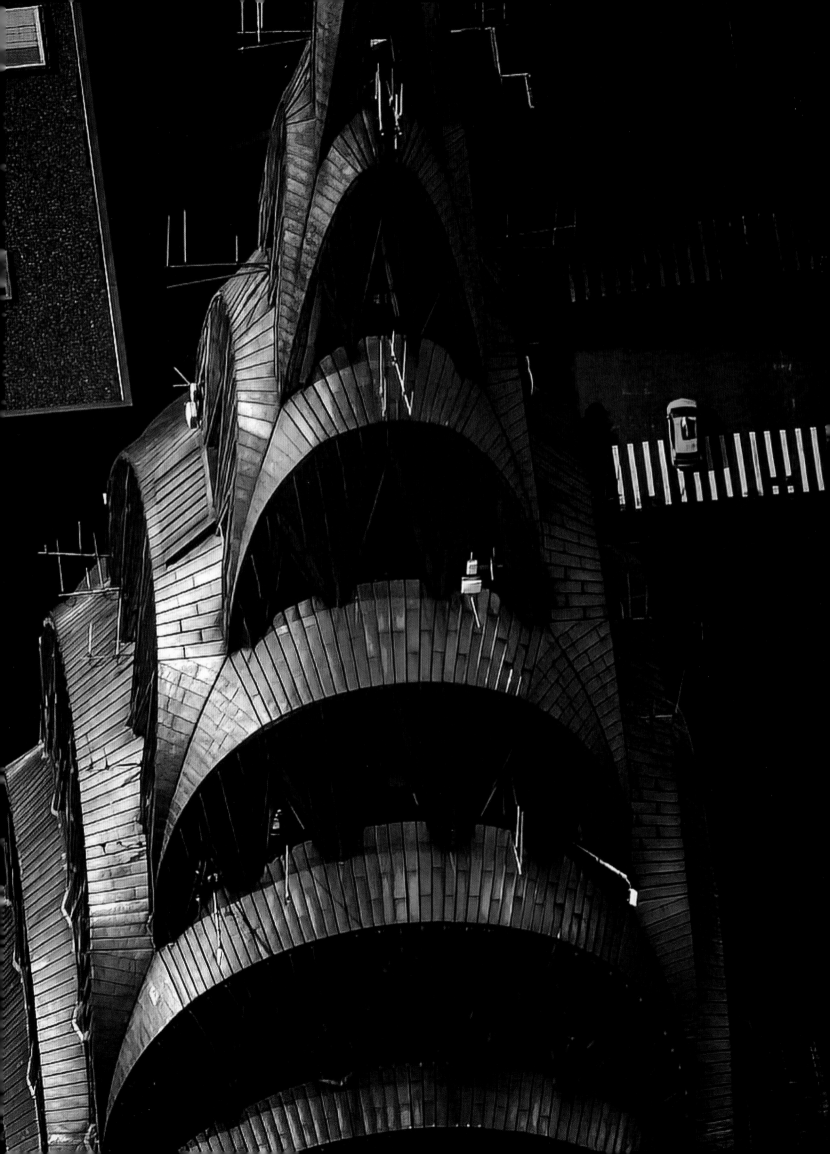

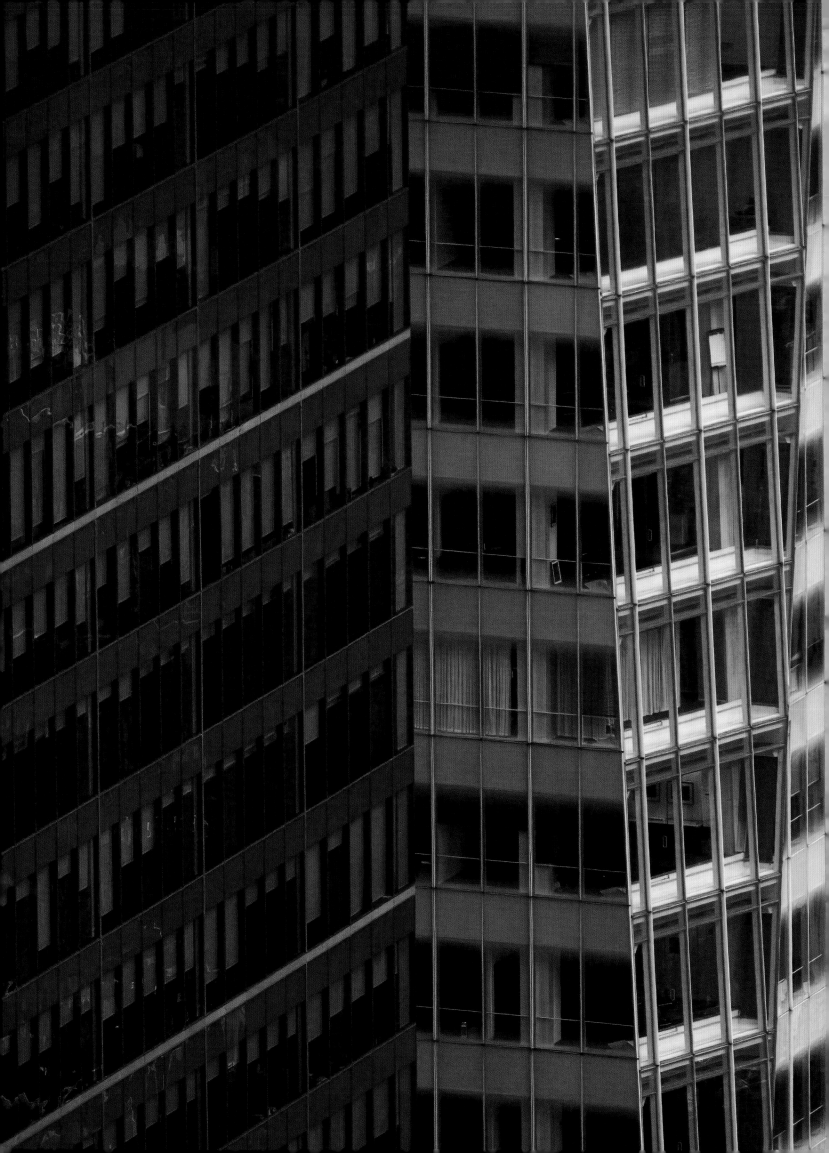

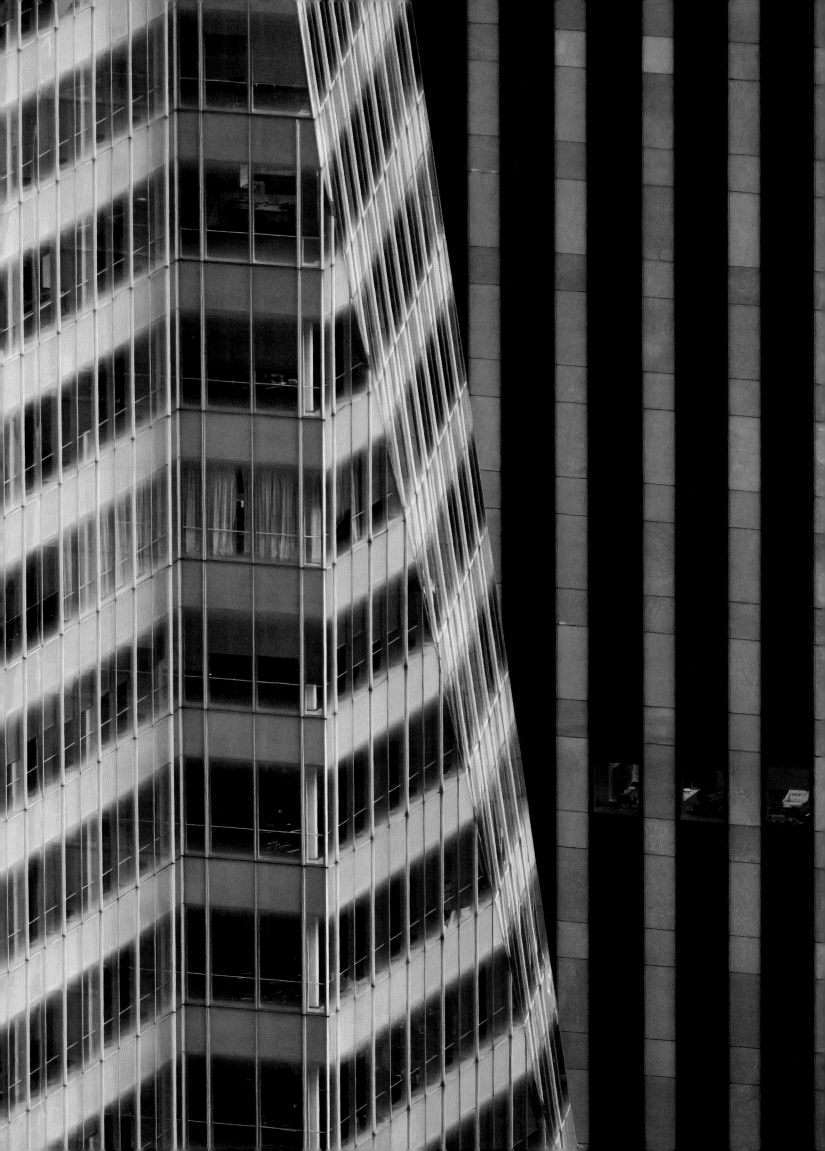

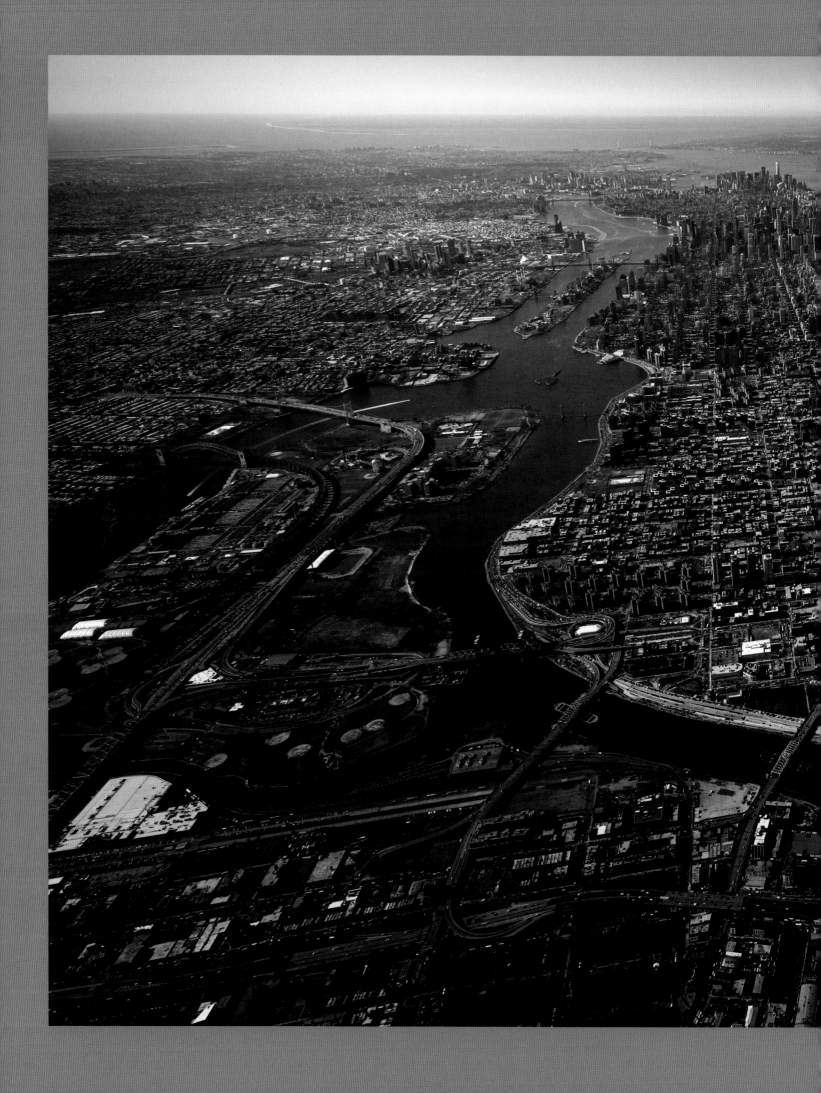

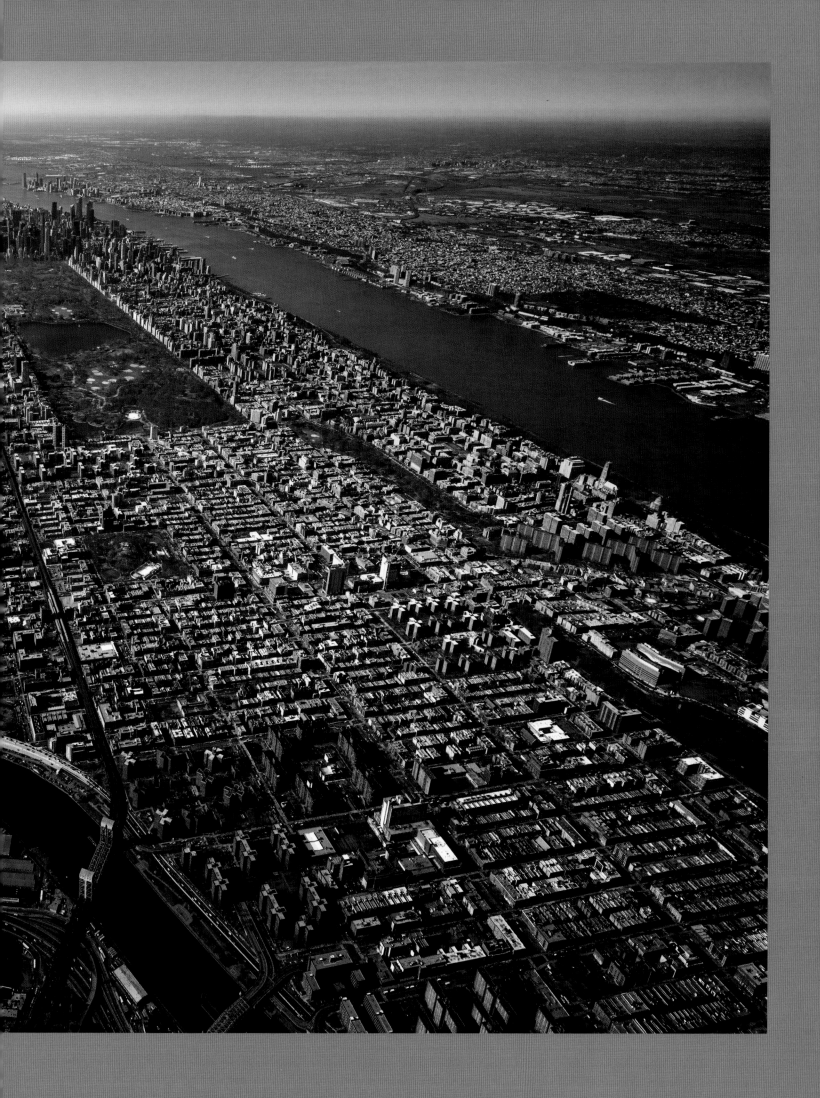

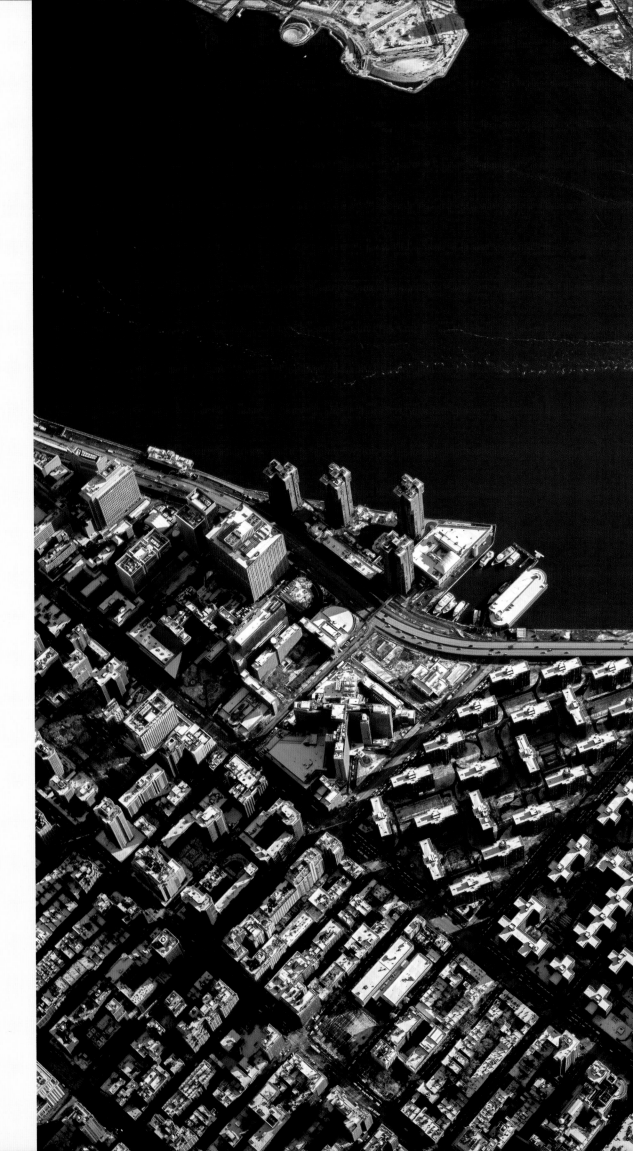

Pages 36-37
Five boroughs and two states
2 hr. and 2 min. after sunrise
Altitude 7,000 feet

Right
East River and Lower East Side
3 hr. and 30 min. after sunrise
Altitude 7,500 feet

Page 40
Fifth Avenue Divider
2 hr. and 36 min. after sunrise
Altitude 5,500 feet

Page 41
Columbus Circle
and Central Park
2 hr. and 40 min. after sunrise
Altitude 5,500 feet

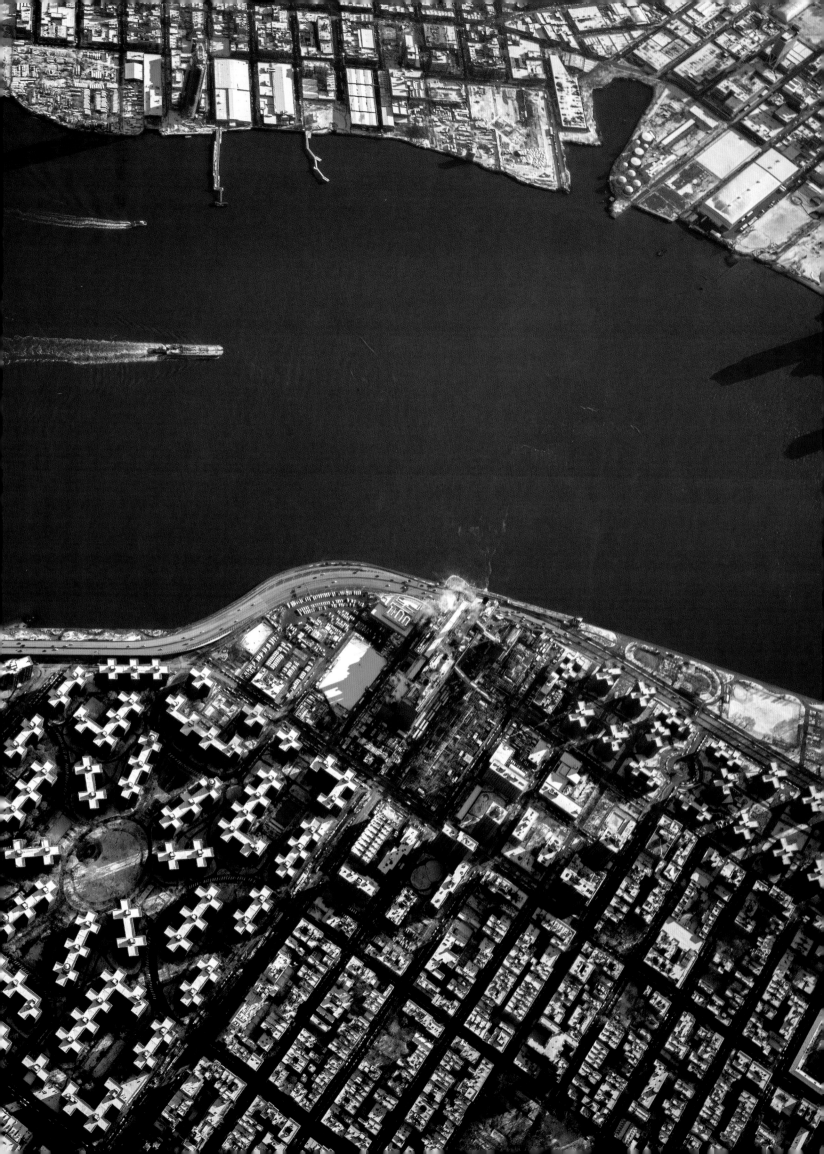

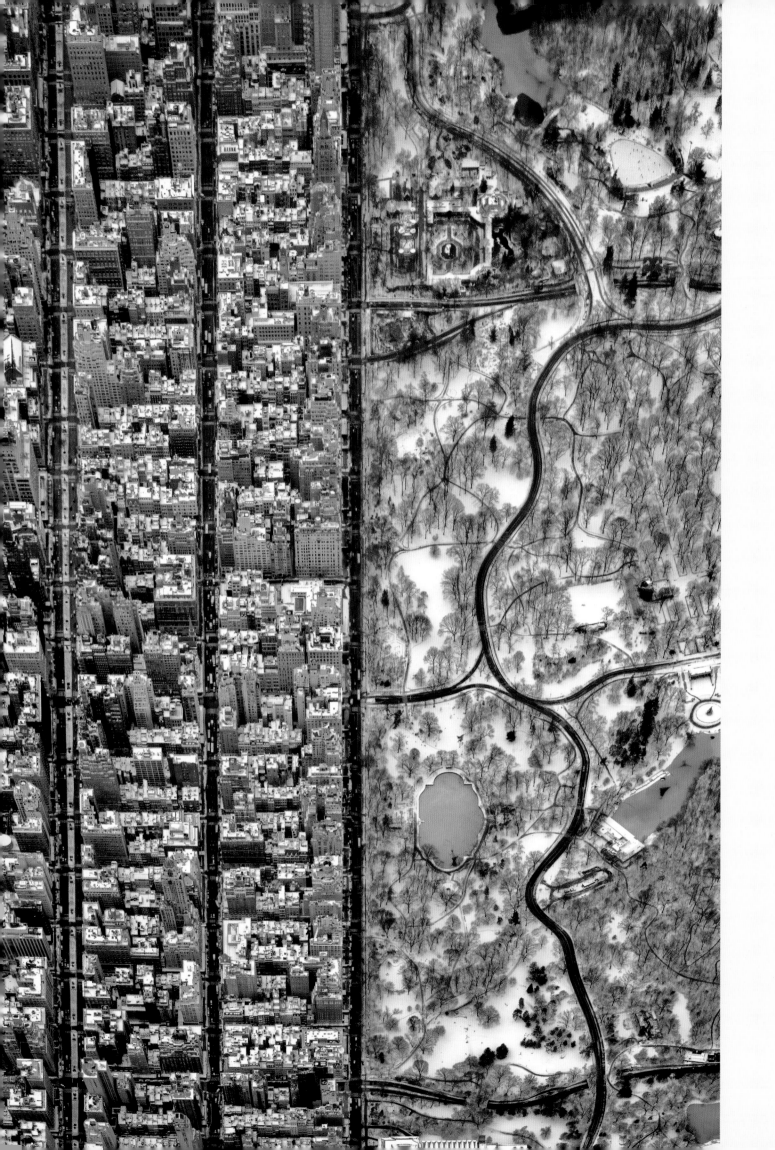

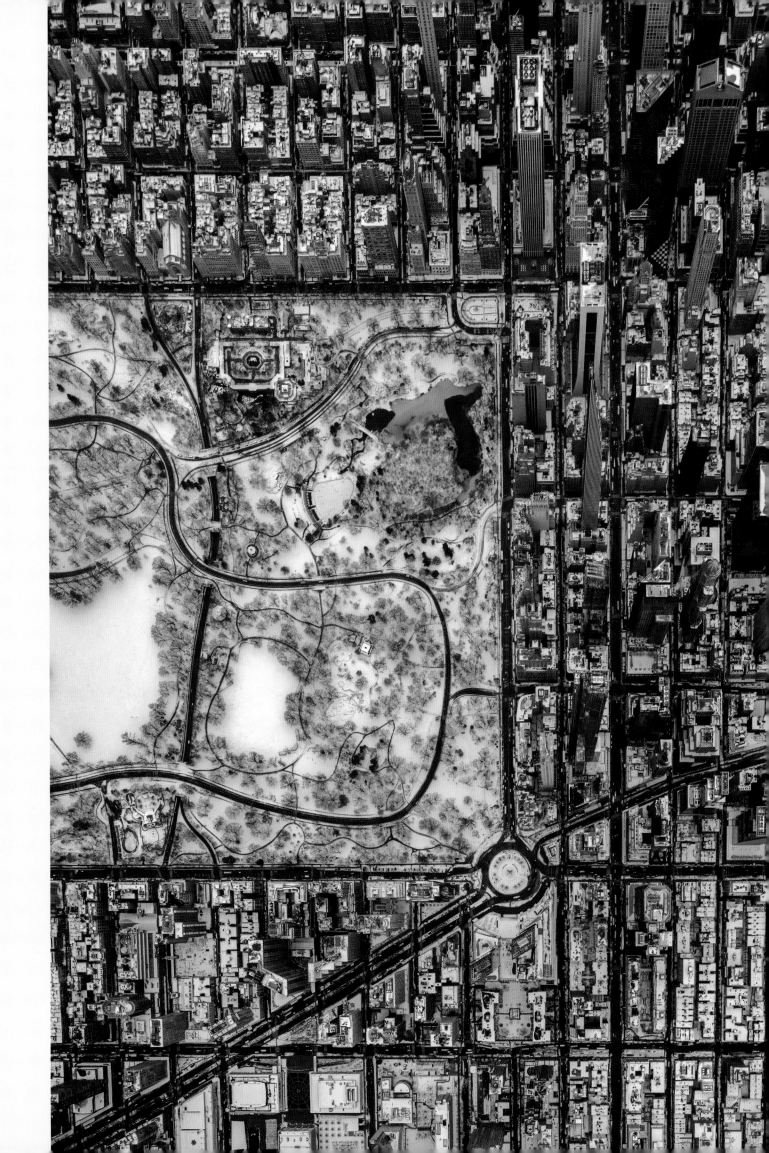

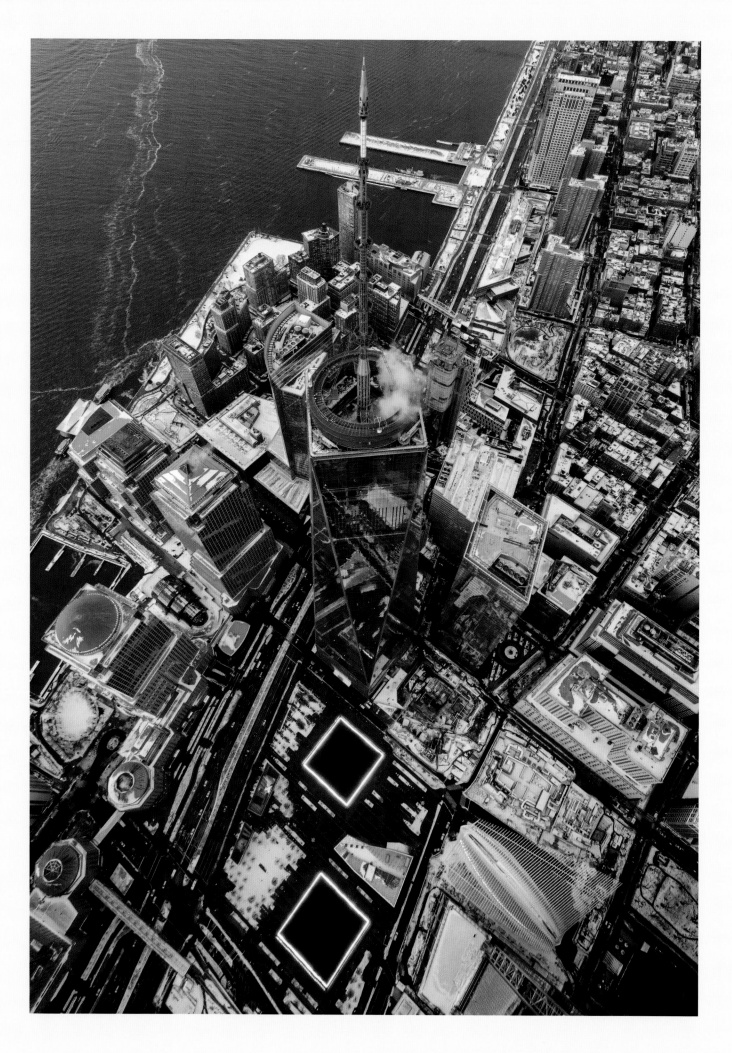

One World Trade Center and Ground Zero
49 min. and 10 sec. after sunset
Altitude 2,100 feet

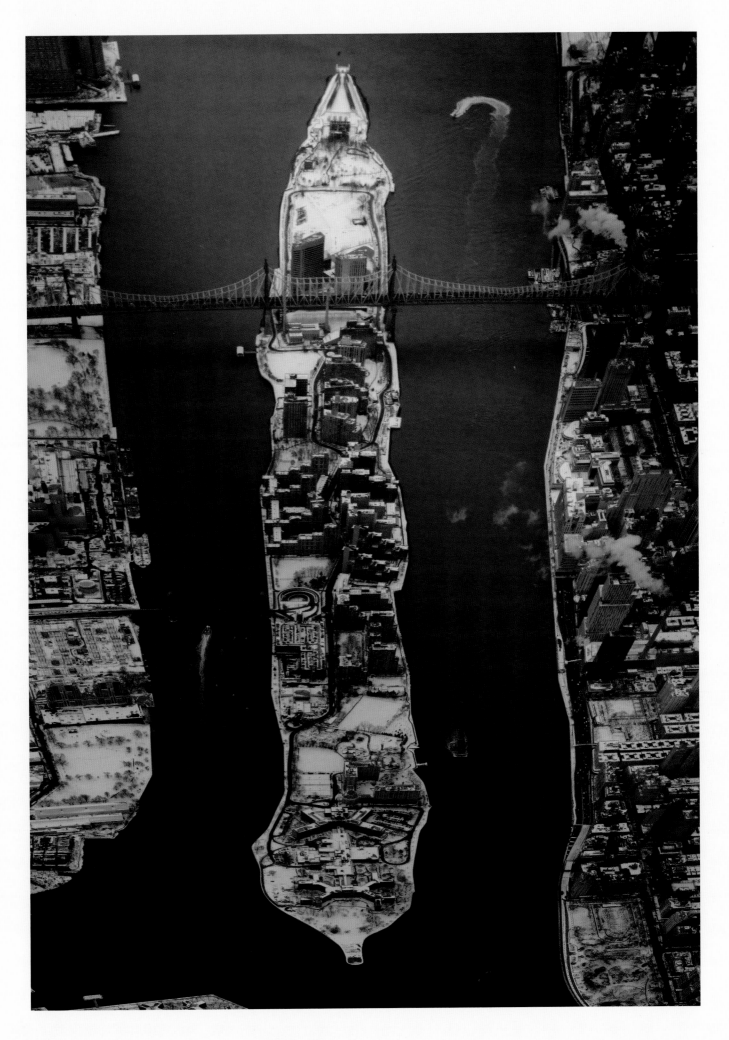

Above
Roosevelt Island
2 hr. and 25 min. after sunrise
Altitude 5,200 feet

Pages 44-45
Governors Island
3 hr. and 22 min. after sunrise
Altitude 3,000 feet

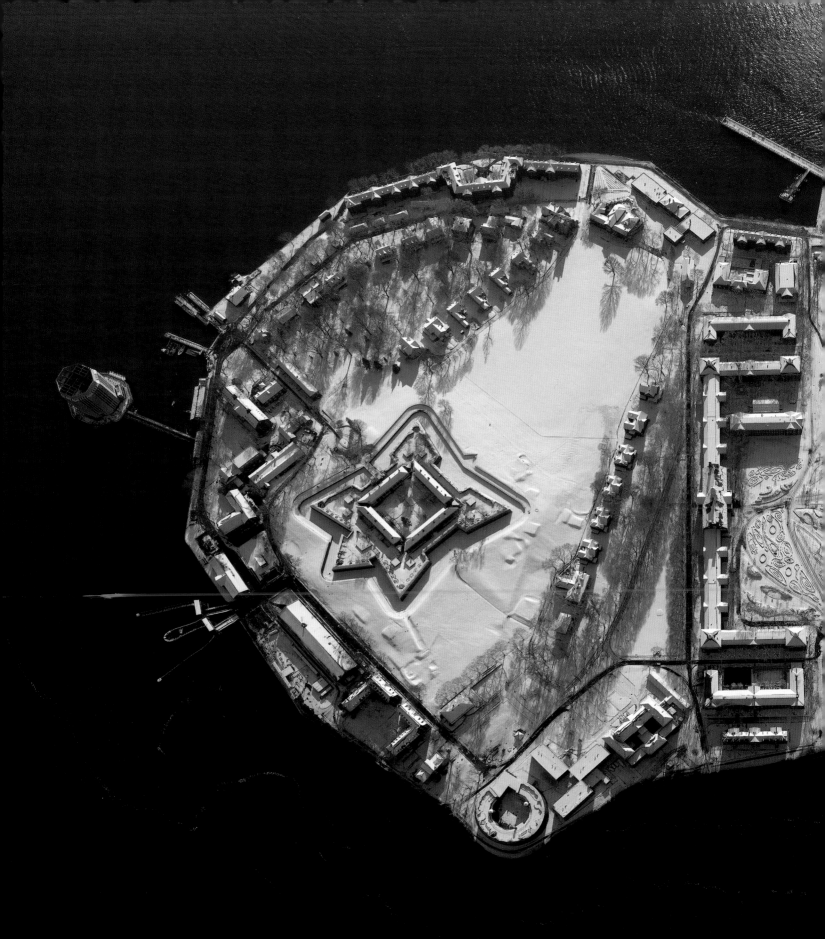

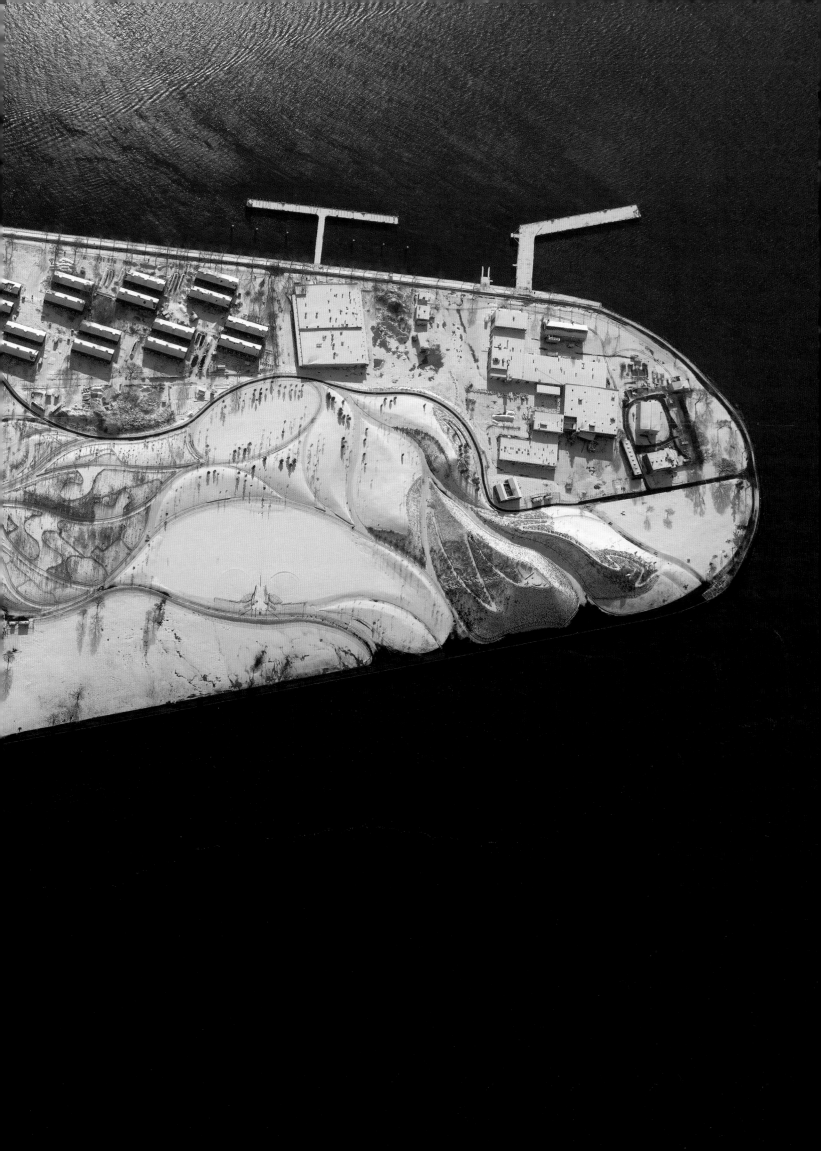

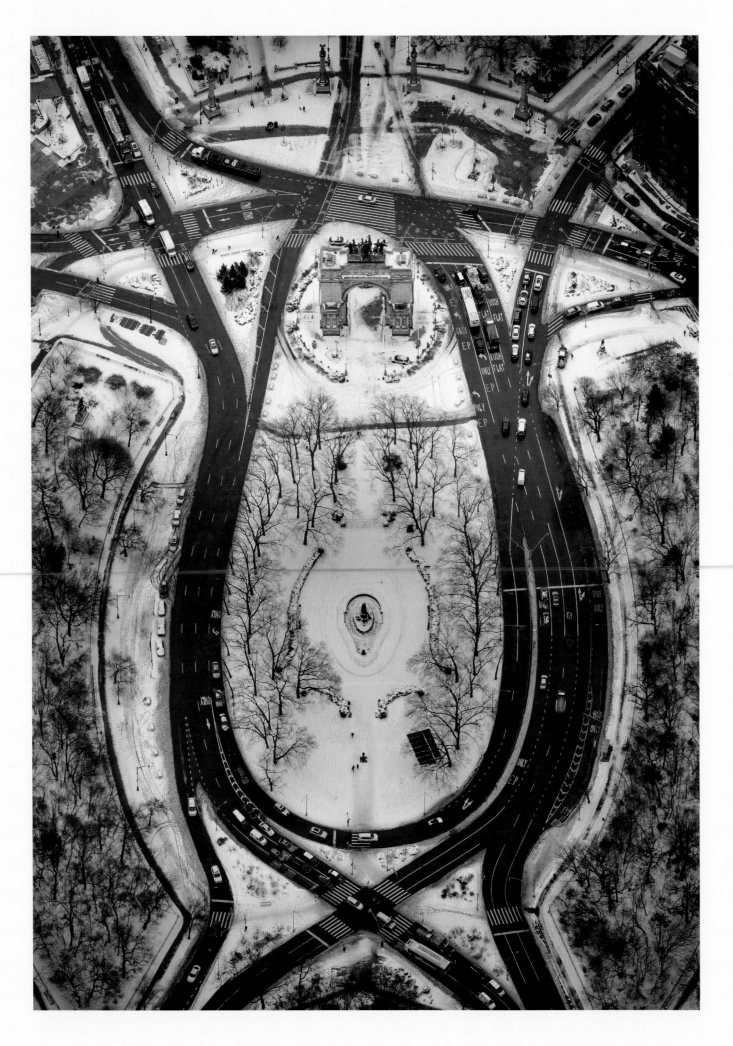

Grand Army Plaza, Brooklyn
2 hr. and 23 min. after sunrise
Altitude 5,100 feet

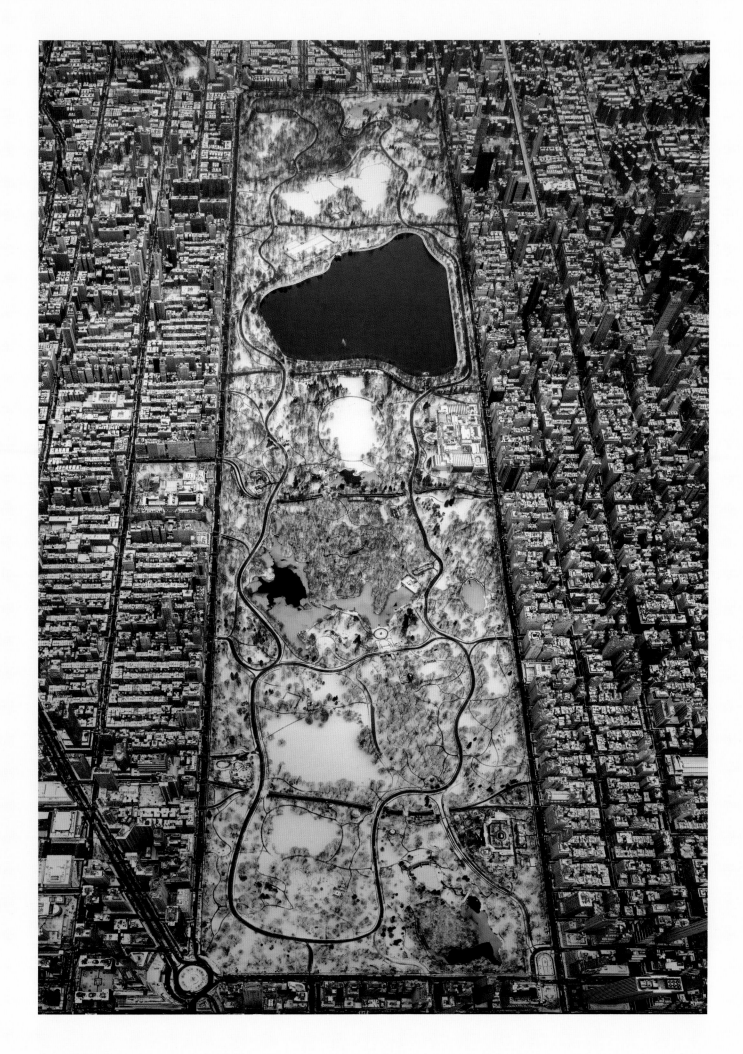

Central Park
2 hr. and 44 min. after sunrise
Altitude 5,400 feet

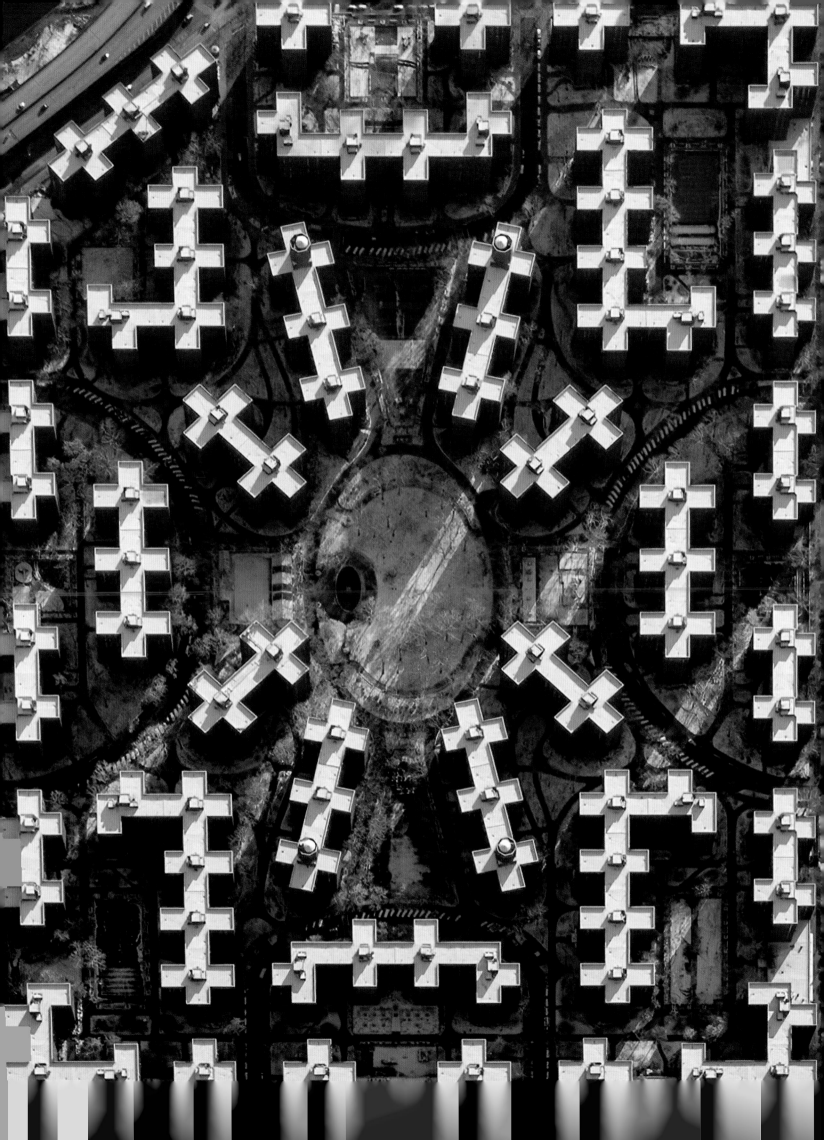

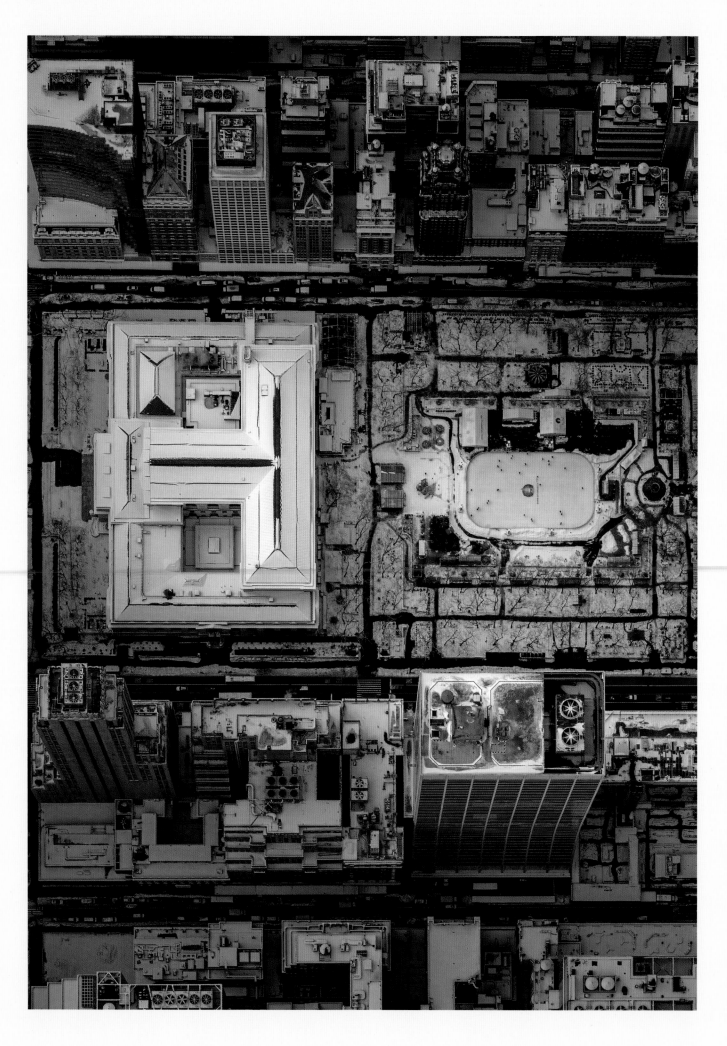

New York Public Library and Bryant Park
2 hr. and 54 min. after sunrise
Altitude 5,000 feet

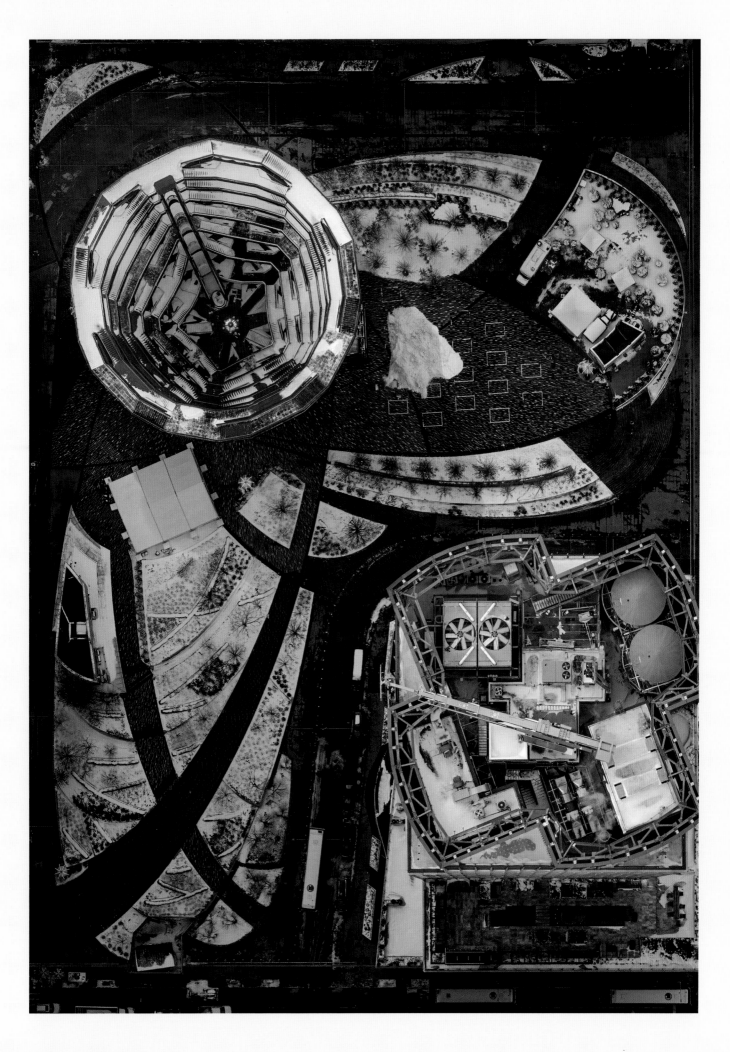

Hudson Yards and Vessel
3 hr. and 2 min. after sunrise
Altitude 4,000 feet

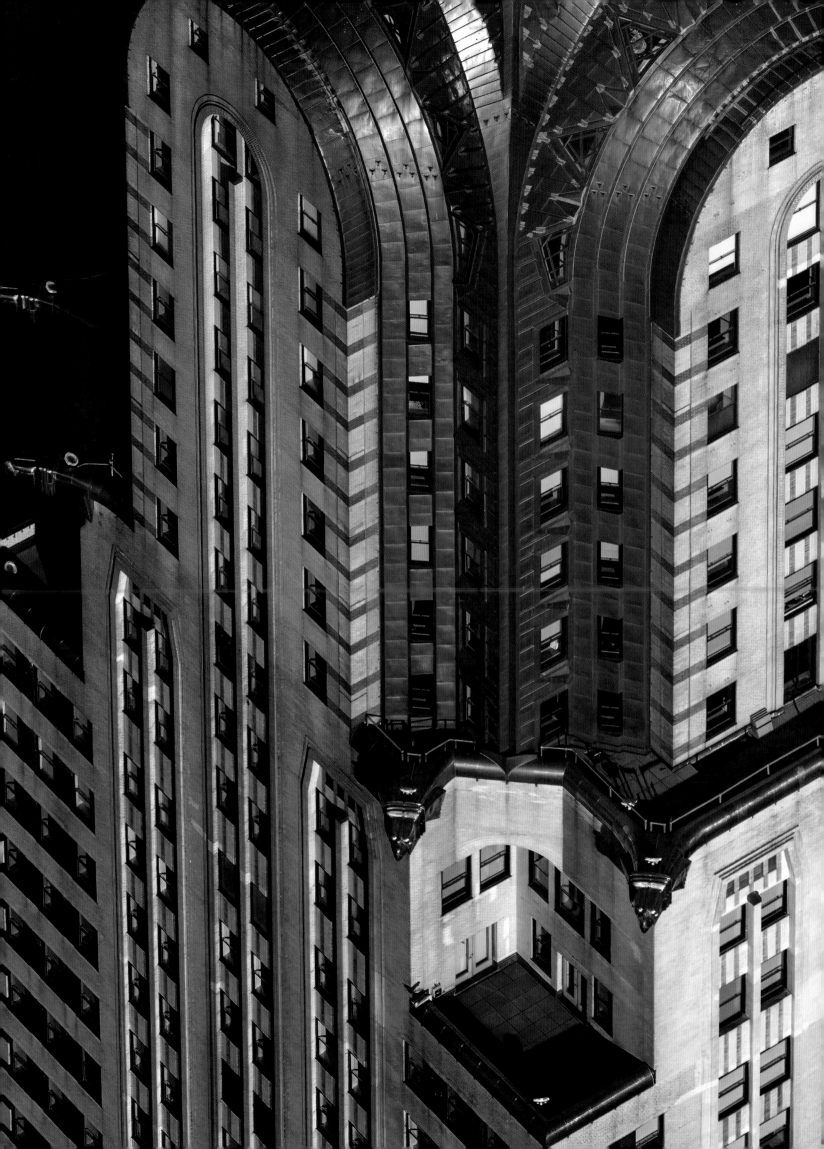

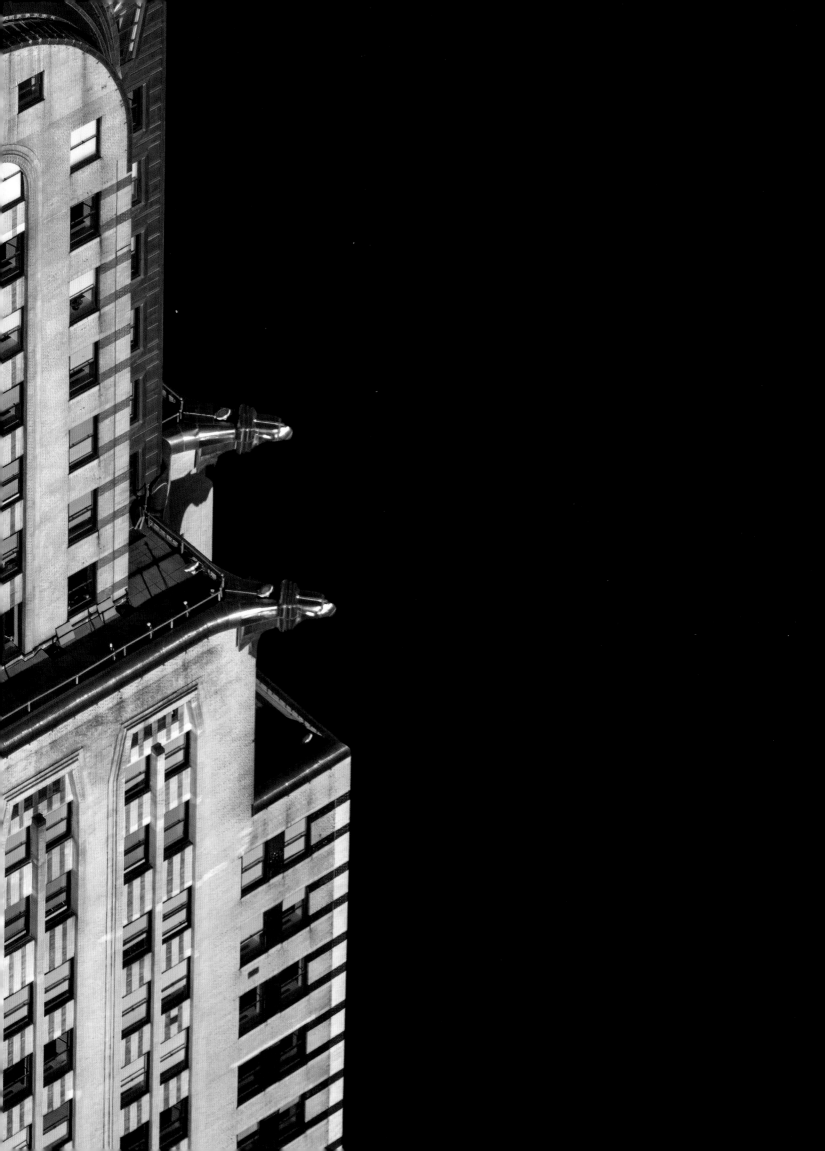

⌐⌐⌐⌐⌐ SPECIAL FLIGHT RULES AREA (SFRA)

EXAMPLES OF CLASS B ALTITUDES

$\frac{70}{30}$ — — — Ceiling in hundreds of feet MSL

— — — Floor in hundreds of feet MSL

(Floors extending "upward from above" a certain altitude are preceded by
a (+). Operations at and below these altitudes are outside of Class B Airspace.)

> HELICOPTER ROUTES DEPICTED ALONG RIVER
> SHORELINES ARE INTENDED TO BE FLOWN OVER
> WATER, NOT PIERS, BULKHEADS, OR LAND.

REGULATIONS REGARDING FLIGHTS OVER CHARTED NATIONAL PARK SERVICE
AREAS, U.S. FISH AND WILDLIFE SERVICE AREAS, AND U.S. FOREST SERVICE AREAS

The landing of aircraft is prohibited on lands or waters administered by the National Park Service, U.S. Fish and
Wildlife Service or U.S. Forest Service without authorization from the respective agency. Exceptions include:
1) when forced to land due to an emergency beyond the control of the operator, 2) at officially designated landing
sites, or 3) on approved official business of the Federal Government.
All aircraft are requested to maintain a minimum altitude of 2,000 feet above the surface of the following:
National Parks, Monuments, Seashores, Lakeshores, Recreation Areas and Scenic Riverways administered by the
National Park Service; National Wildlife Refuges, Big Game Refuges, Game Ranges and Wildlife Ranges administered
by the U.S. Fish and Wildlife Service; and Wilderness and Primitive areas administered by the U.S. Forest
Service. FAA Advisory Circular (AC) 91-36, "Visual Flight Rules (VFR) Flight Near Noise-Sensitive Areas," defines
the surface as: the highest terrain within 2,000 feet laterally of the route of flight, or the upper-most rim of a canyon
or valley.
Federal regulations also prohibit airdrops by parachute or other means of persons, cargo, or objects from aircraft
on lands administered by the three agencies without authorization from the respective agency. Exceptions include:
1) emergencies involving the safety of human life, or 2) threat of serious property loss.

. Boundary of National Park Service areas, U.S. Fish and Wildlife Service
areas, and U.S. Forest Service Wilderness and Primitive areas.

Pages 52-53

Iron eagles of the Chrysler Building

1 hr. and 39 min. before sunset

Altitude 1,900 feet

Page 55

Flatiron Building

2 hr. and 43 min. after sunrise

Altitude 200 feet

Pages 56-57

Statue of Liberty

2 hr. and 32 min. after sunrise

Altitude 275 feet

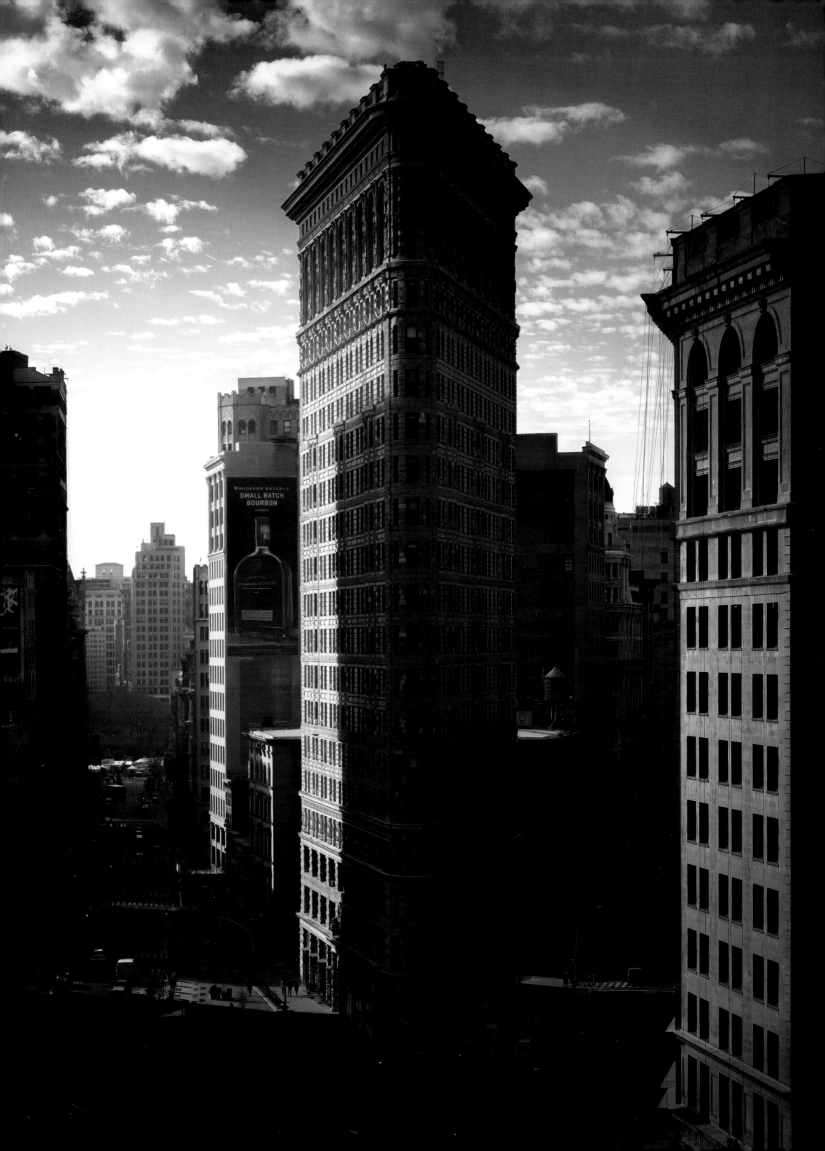

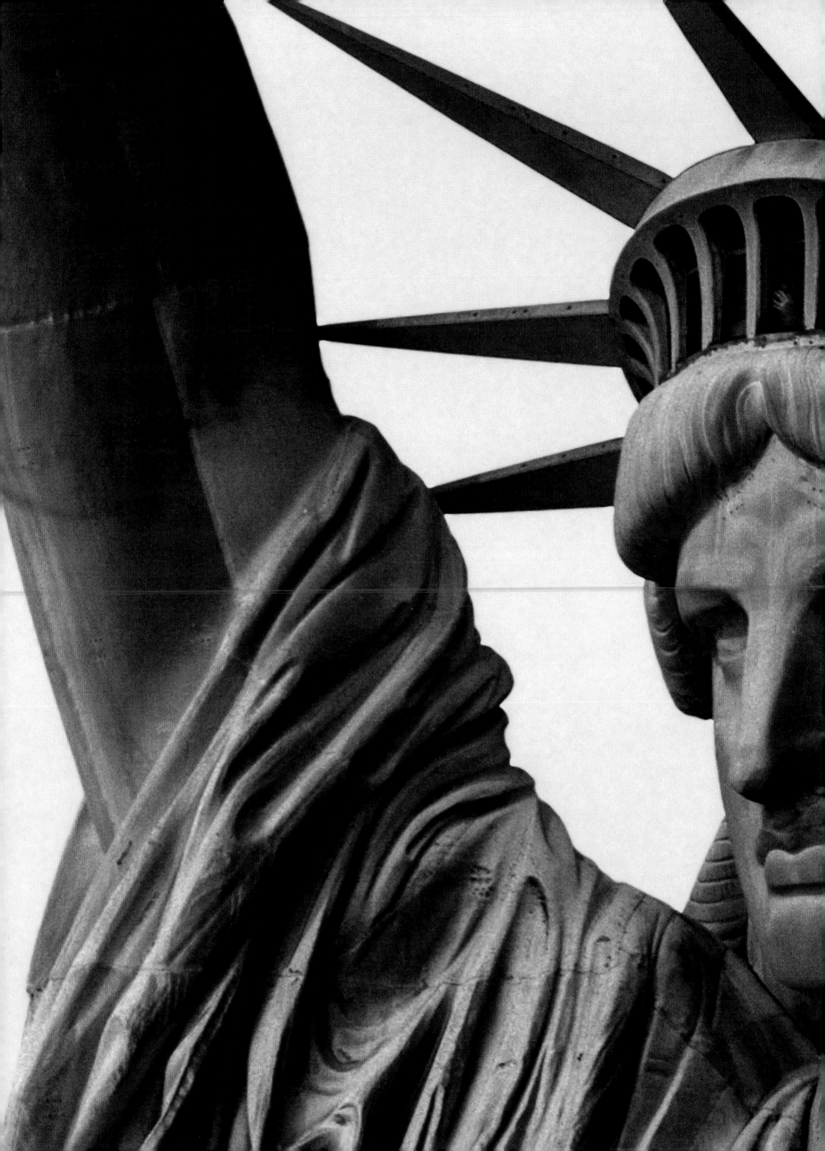

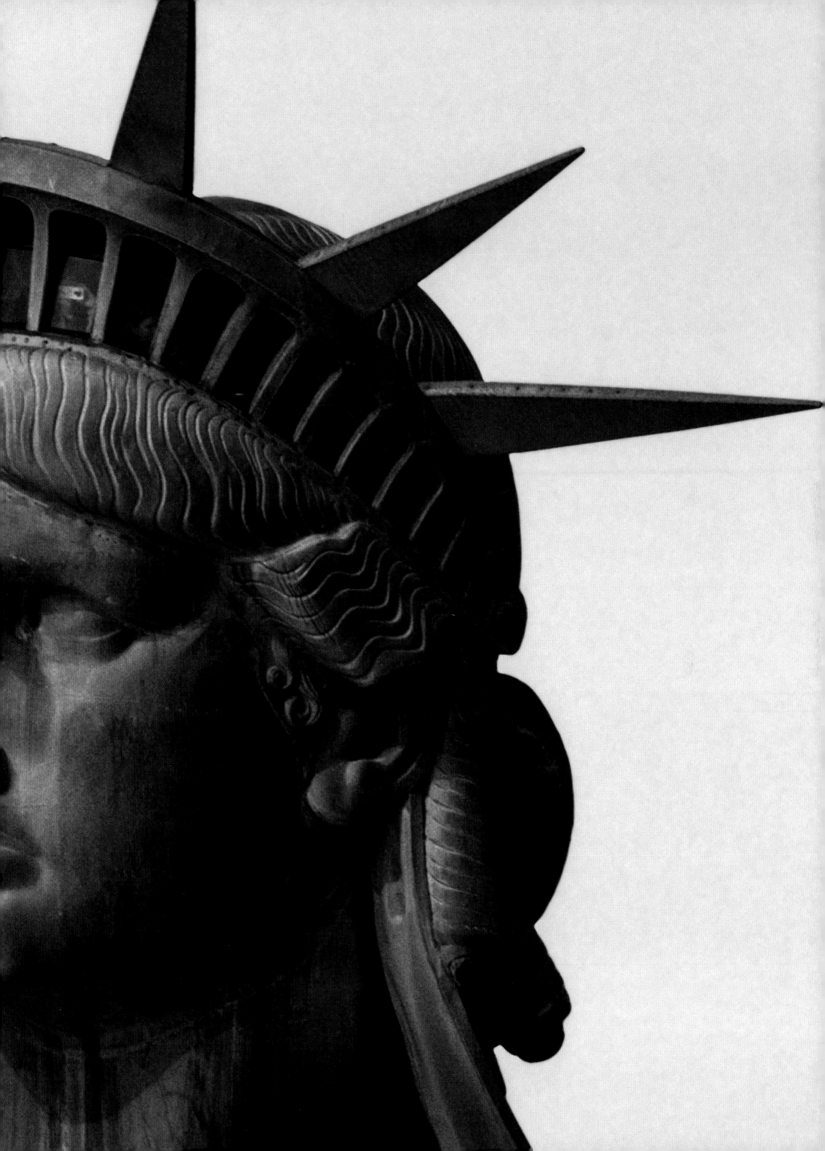

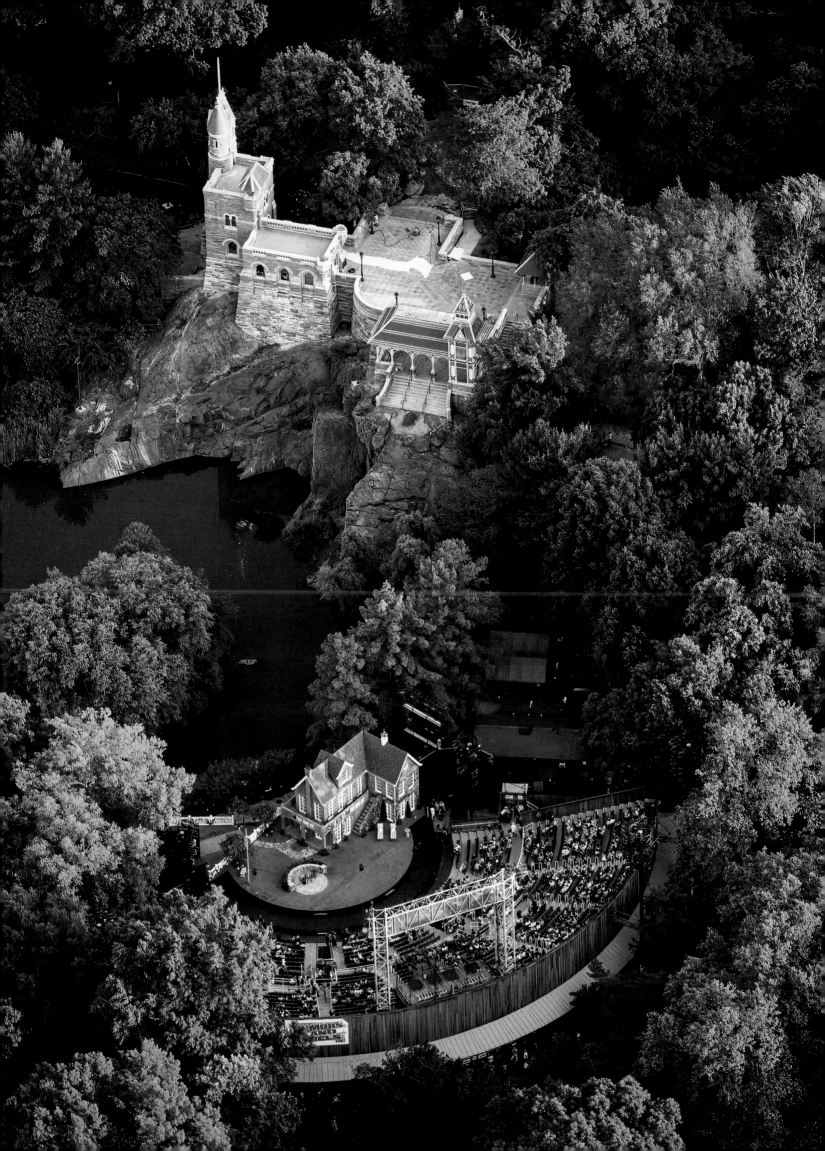

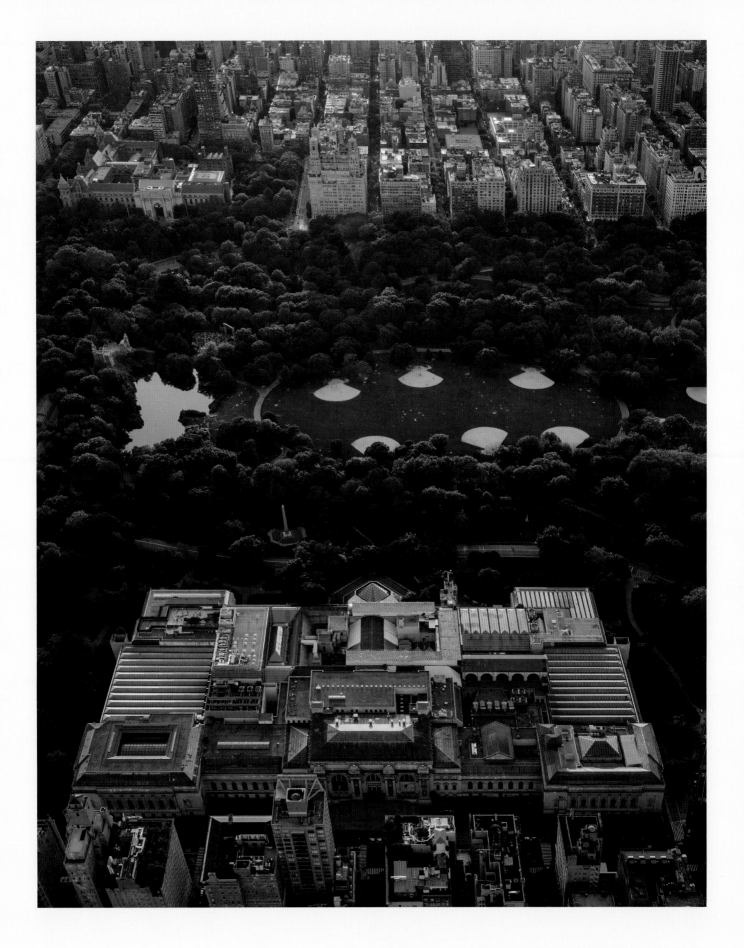

Page 58

Shakespeare in the Park and
Belvedere Castle, Central Park

1 hr. and 37 min. before sunset

Altitude 1,000 feet

Above

Metropolitan Museum of Art,
Great Lawn, and Central Park West

1 hr. and 36 min. before sunset

Altitude 900 feet

59

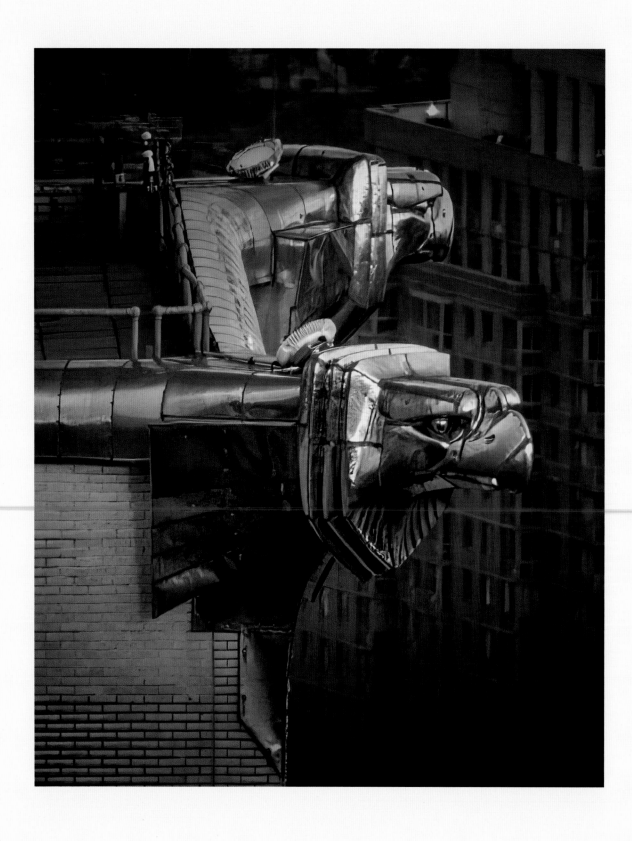

Above
Chrysler Building eagles
1 hr. and 11 min. before sunset
Altitude 780 feet

Page 61
Columbus Circle, Central Park West,
and Central Park South
49 min. and 26 sec. after sunrise
Altitude 1,550 feet

Pages 62-63
New York City
1 hr. and 1 min. before sunset
Altitude 10,500 feet

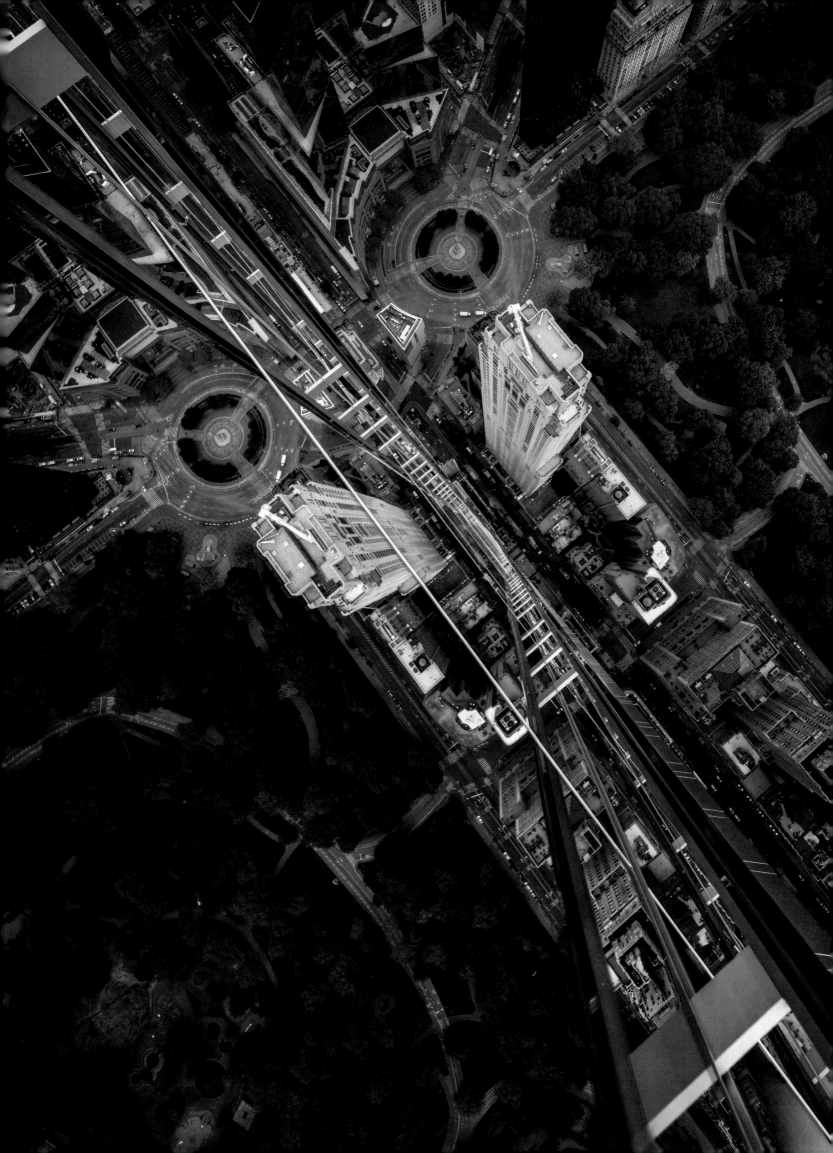

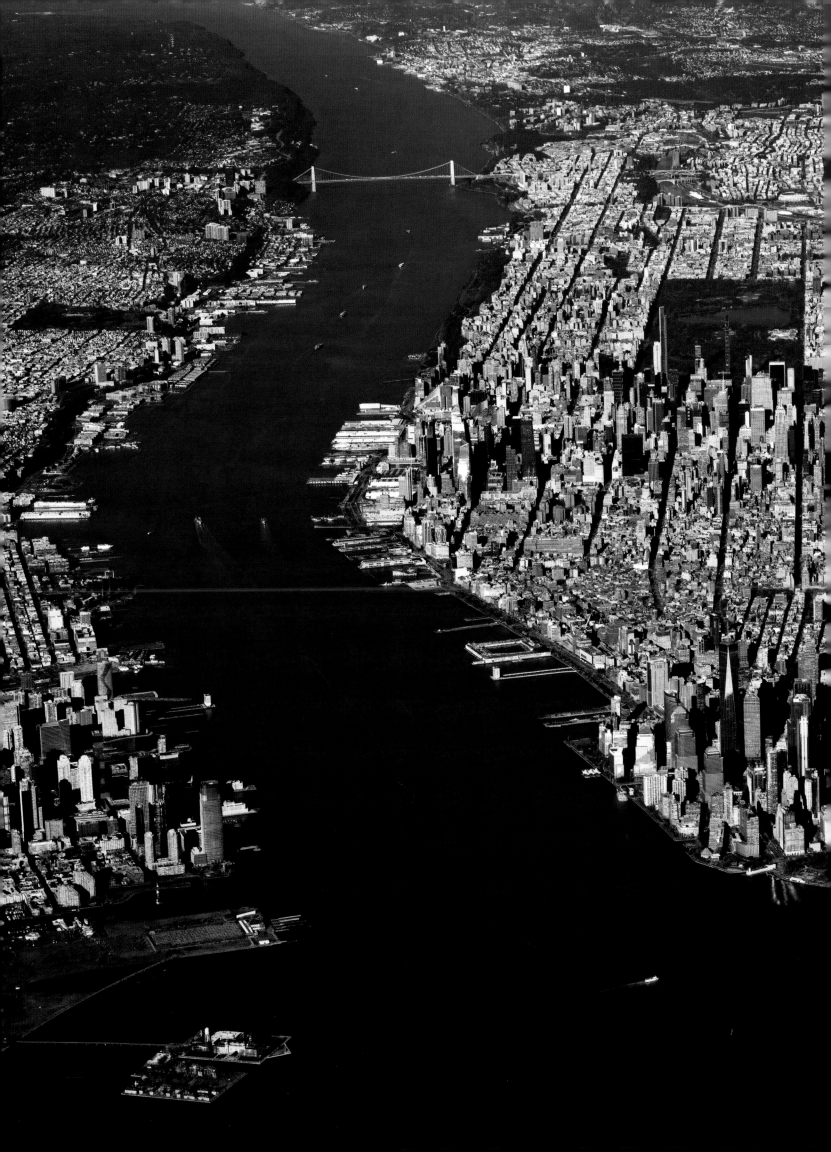

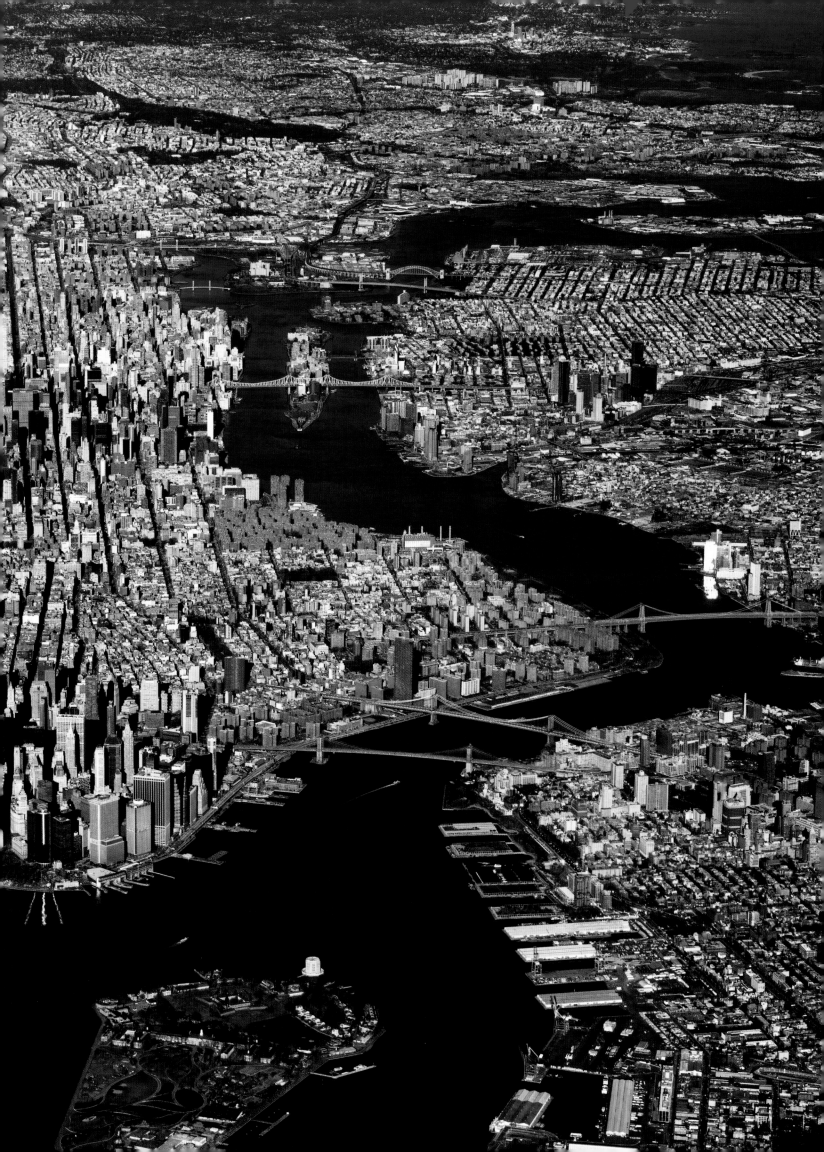

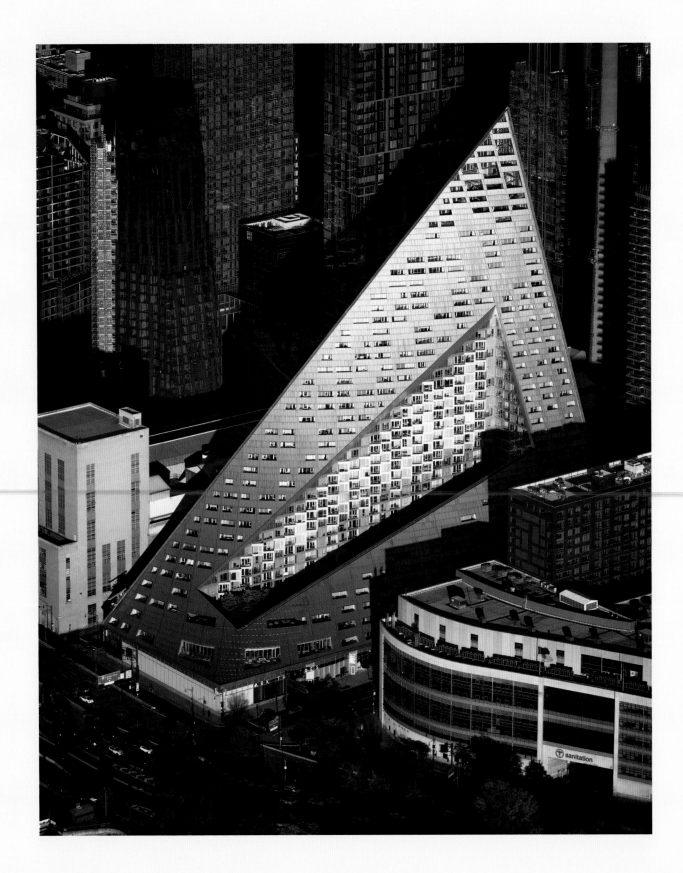

Above
Via 57 West and West Side Highway
47 min. before sunset
Altitude 1,075 feet

Page 65
Washington Square Park
1 hr. and 11 min. before sunset
Altitude 1,350 feet

Pages 66-67
Fort Jay, Governors Island
1 hr. and 13 min. before sunset
Altitude 900 feet

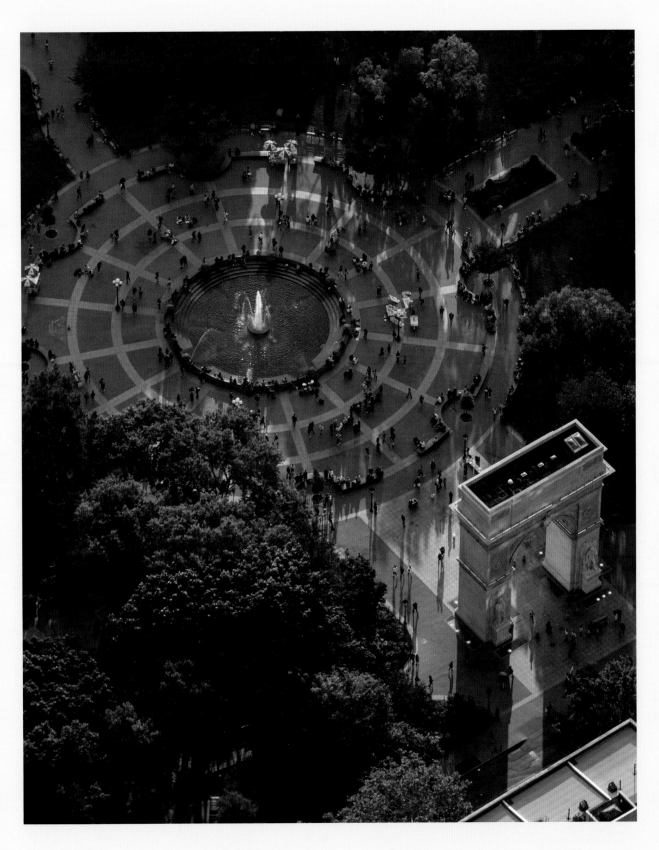

Pages 68-69

The San Remo and the Lake,
Central Park

1 hr. and 2 min. before sunset

Altitude 1,600 feet

Pages 70-71

Central Park West

23 min. and 35 sec. after sunrise

Altitude 1,200 feet

Page 72

Bethesda Terrace and Fountain,
Central Park

44 min. and 49 sec. before sunset

Altitude 1,475 feet

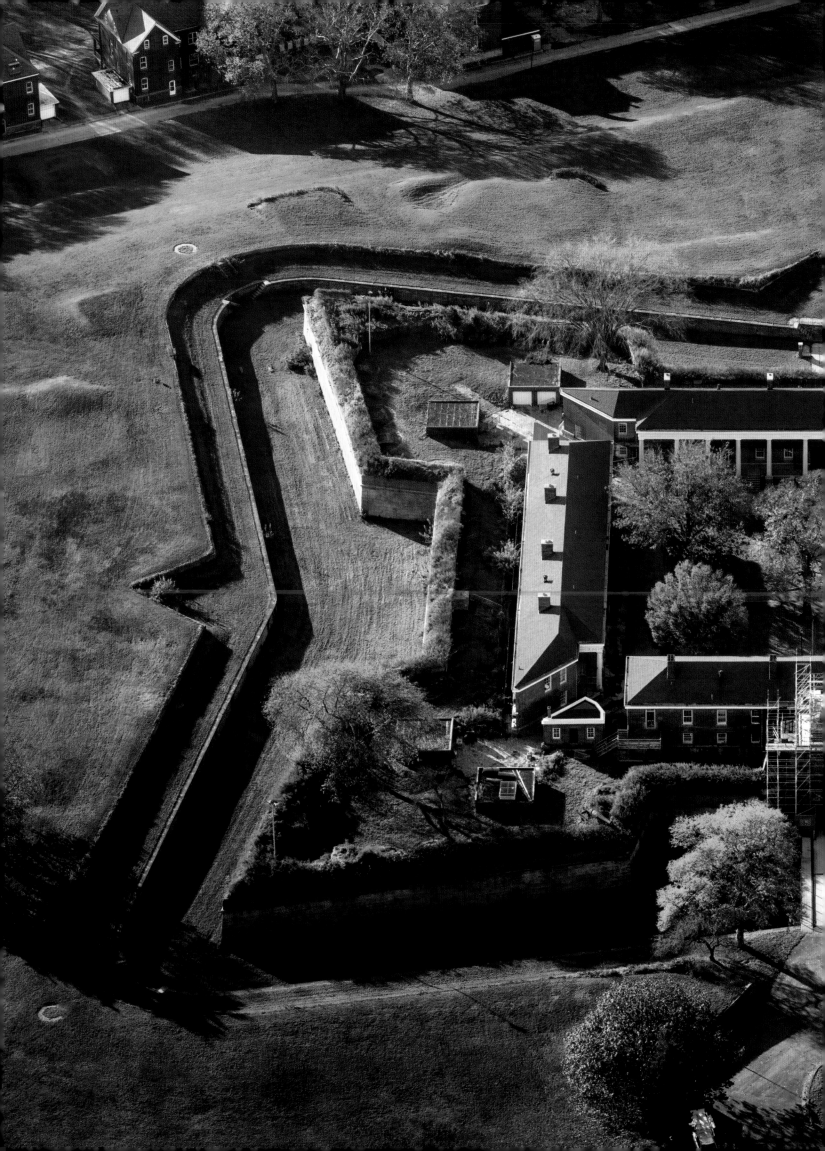

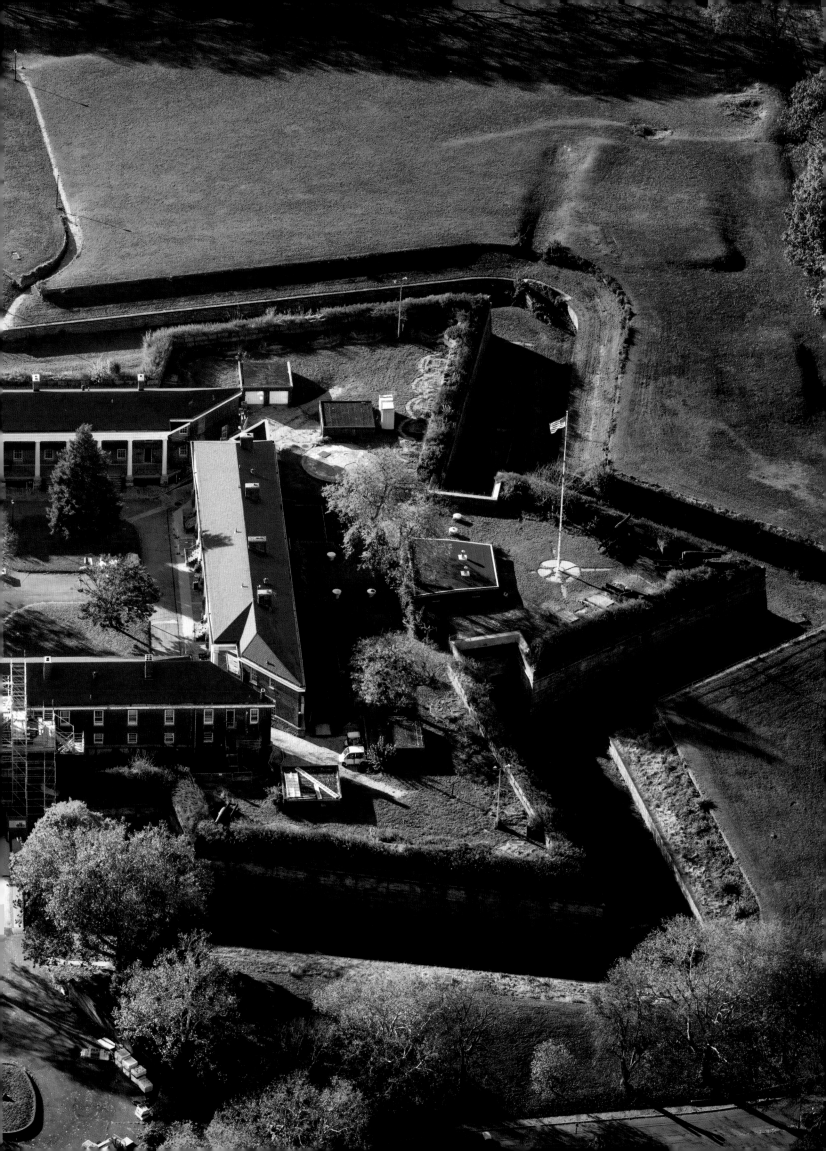

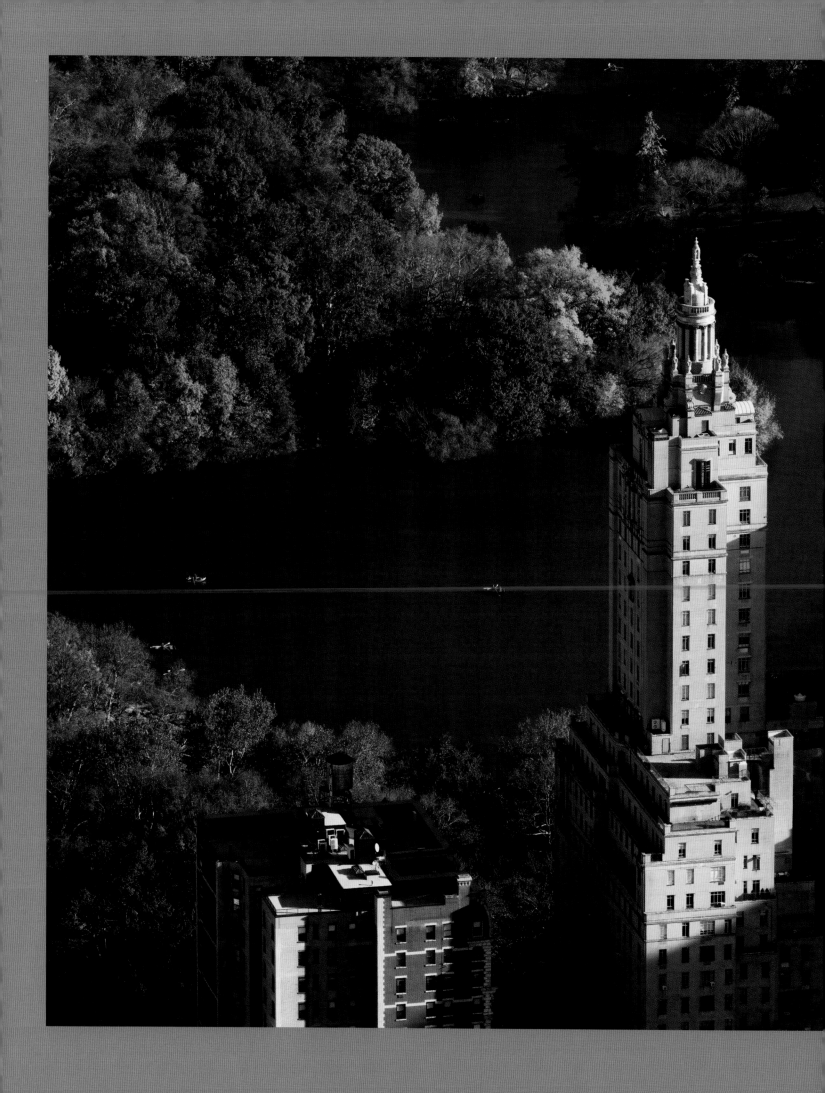

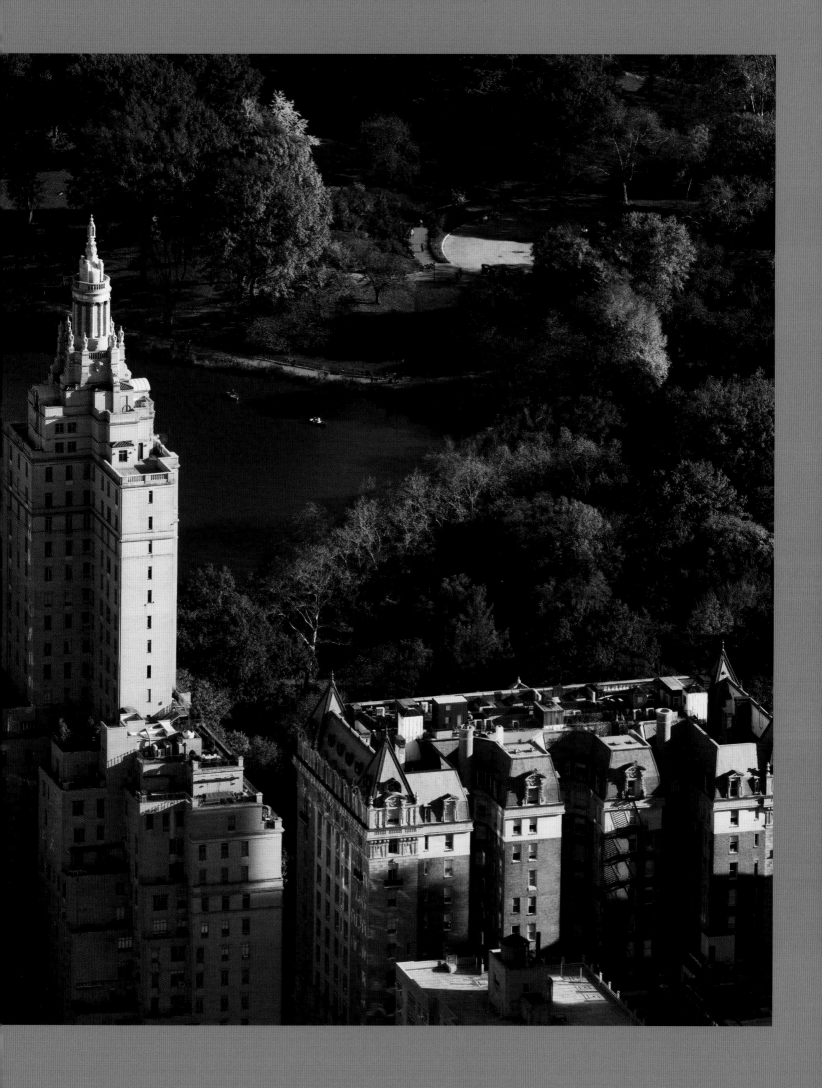

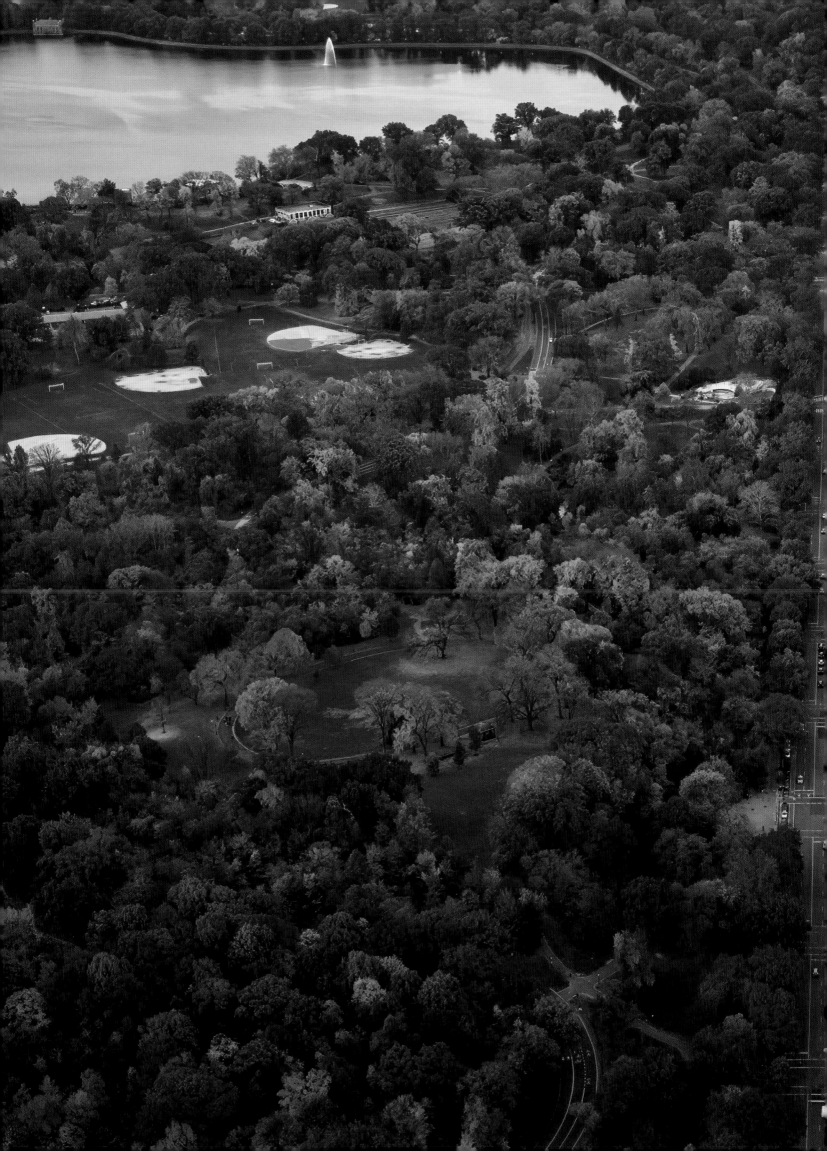

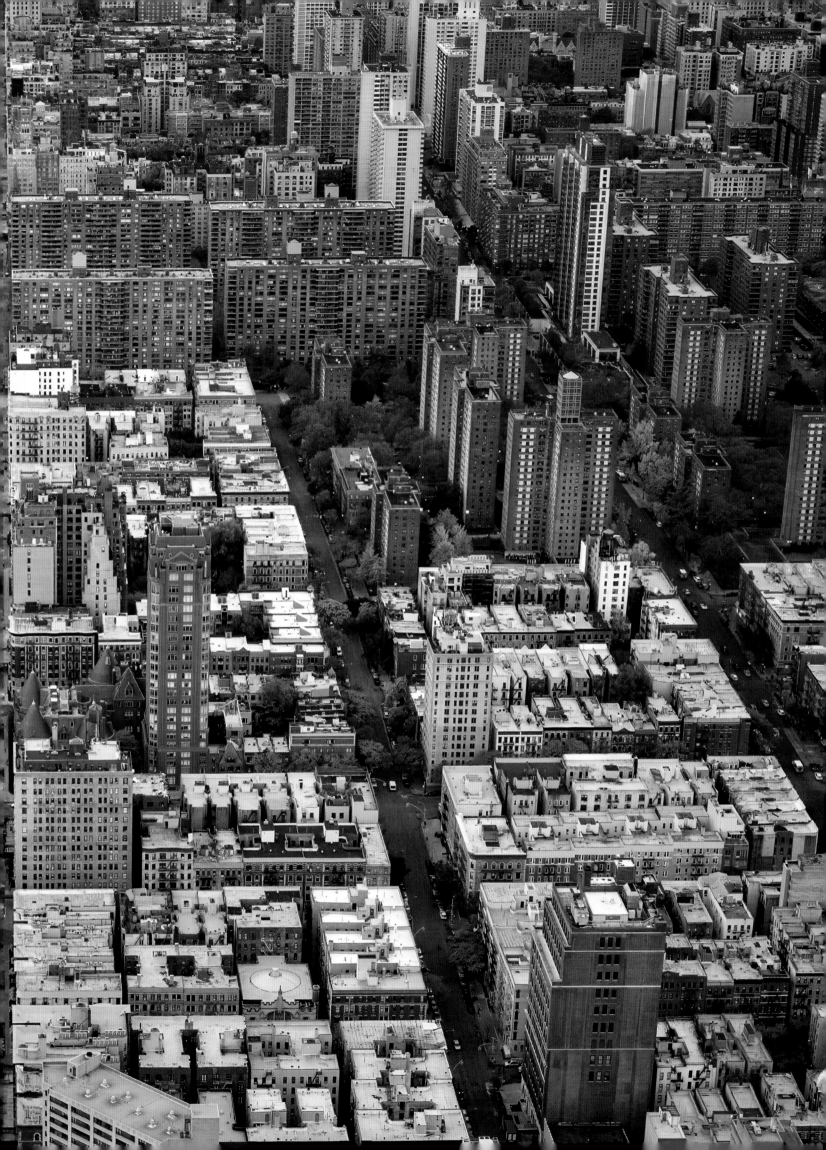

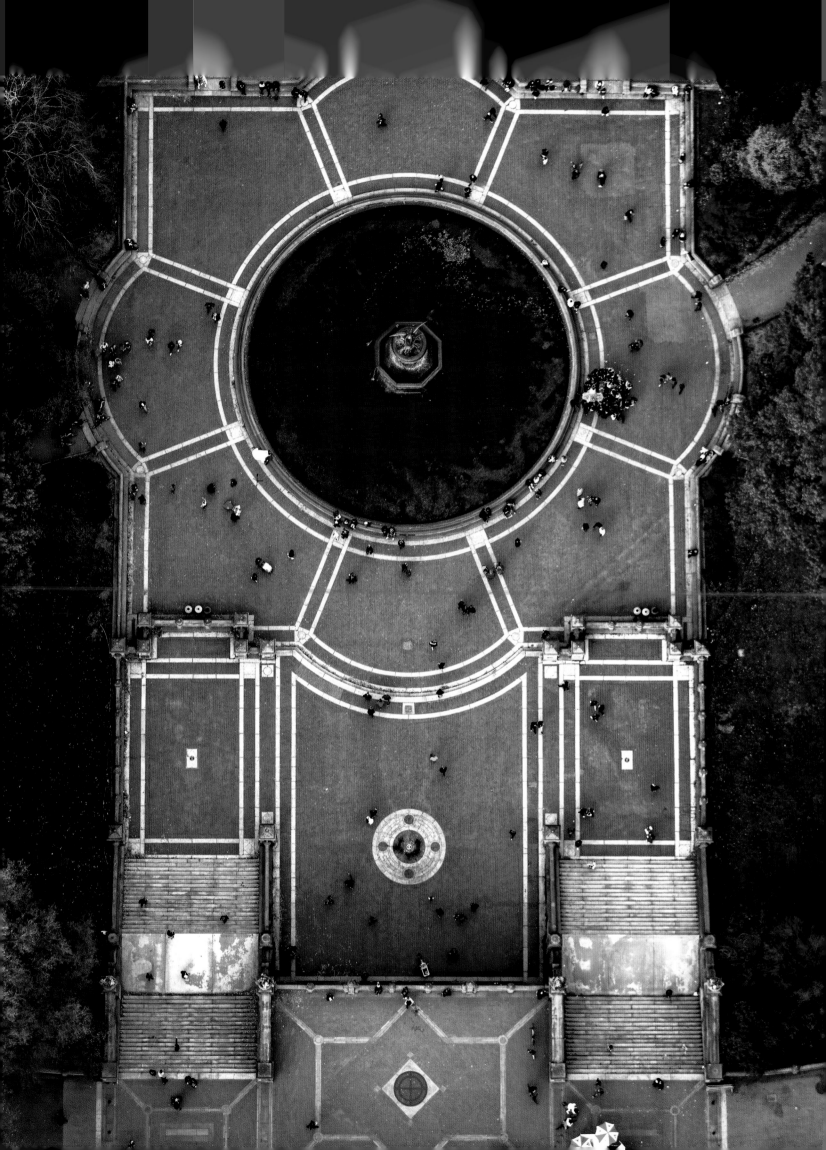

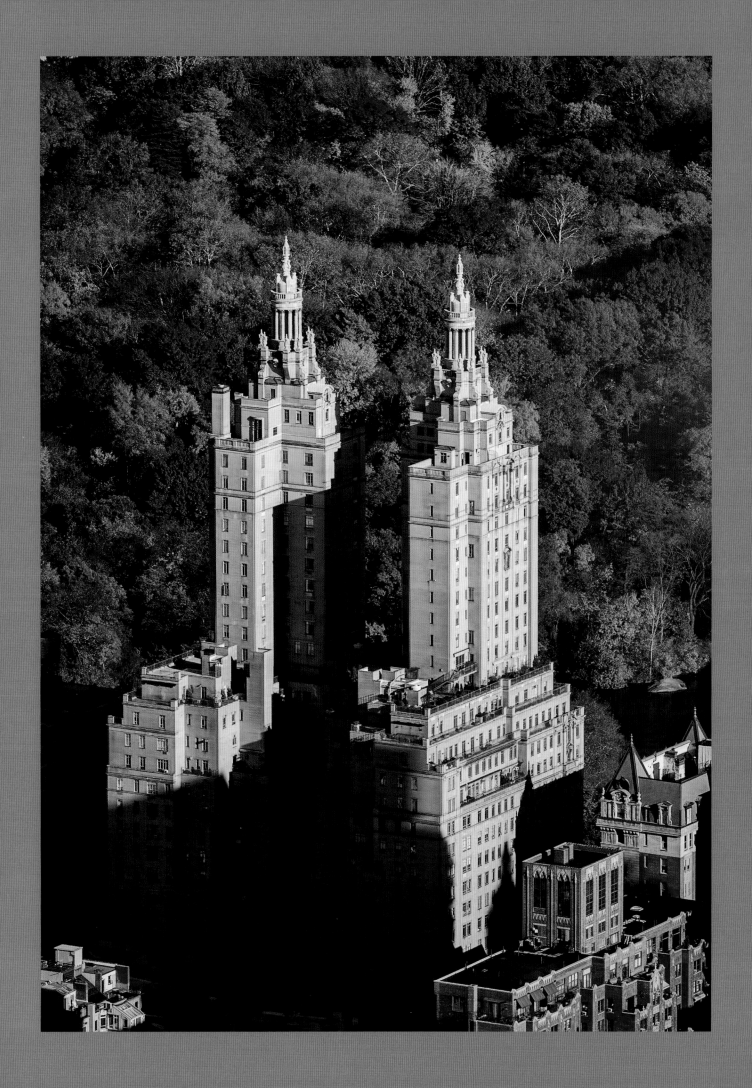

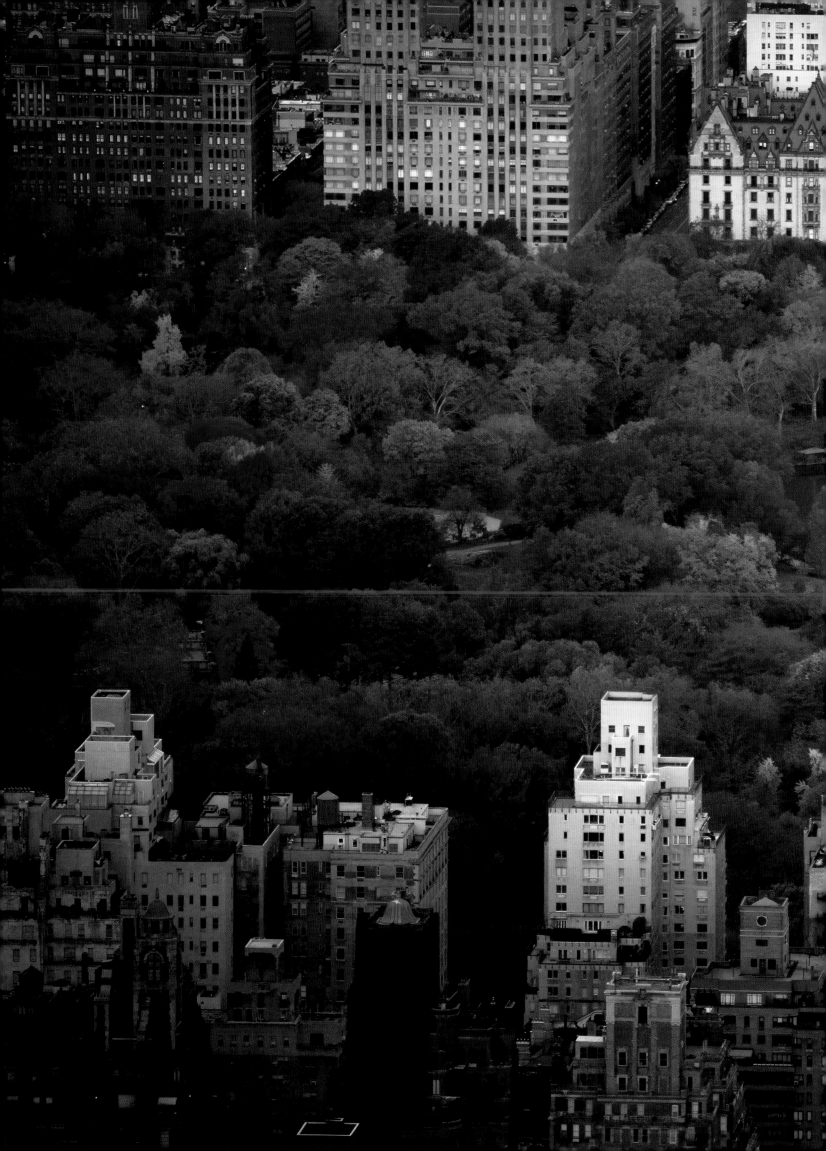

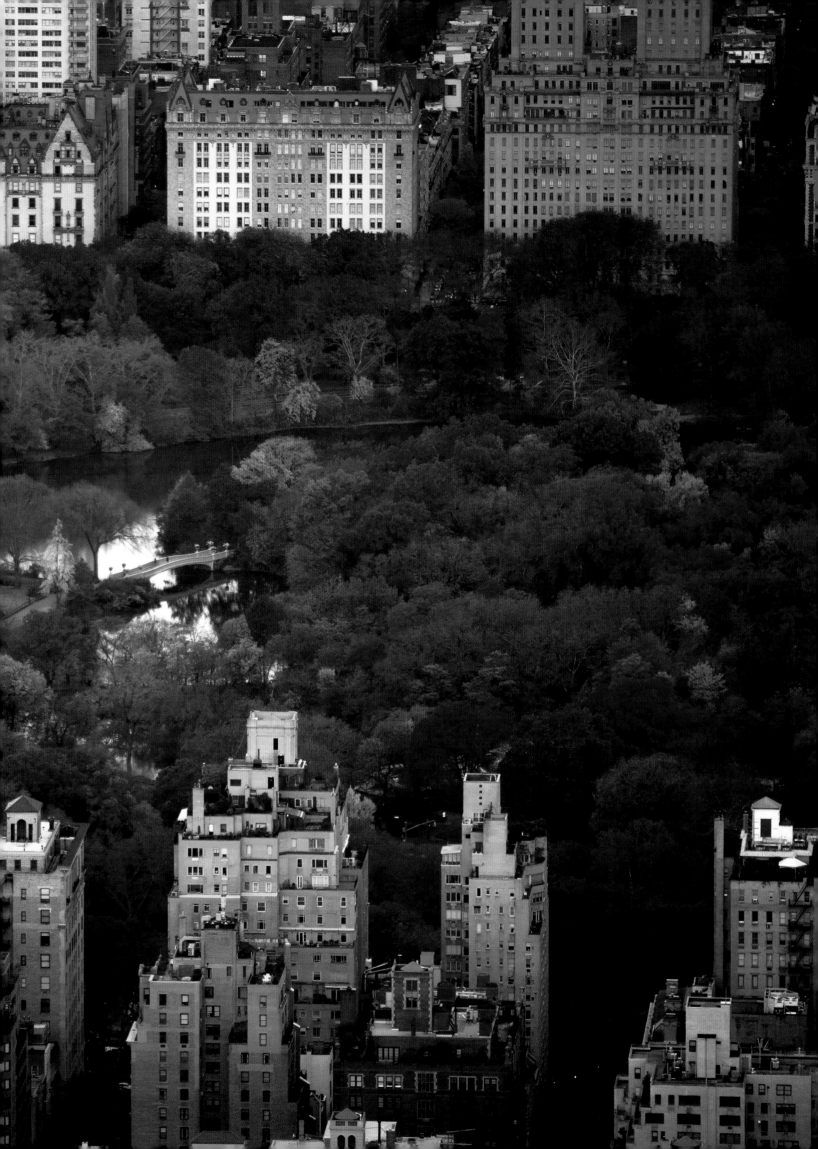

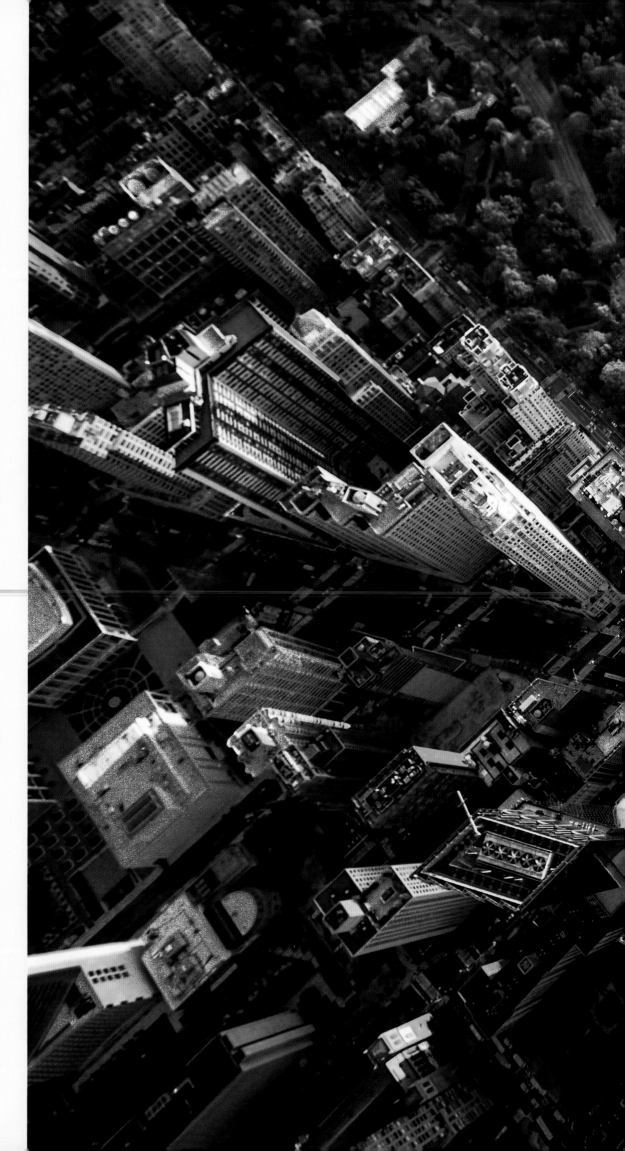

Page 73
The San Remo
1 hr. and 3 min. before sunset
Altitude 1,600 feet

Pages 74-75
Bow Bridge, Central Park
23 min. and 23 sec. after sunrise
Altitude 1,550 feet

Right
Columbus Circle and
Maine Monument
34 min. and 16 sec. after sunrise
Altitude 1,900 feet

Pages 78-79
Wonder Wheel,
Coney Island, Brooklyn
51 min. and 24 sec. before sunset
Altitude 1,150 feet

Pages 80-81
The Cyclone and Wonder Wheel,
Coney Island, Brooklyn
25 min. and 58 sec. before sunset
Altitude 1,200 feet

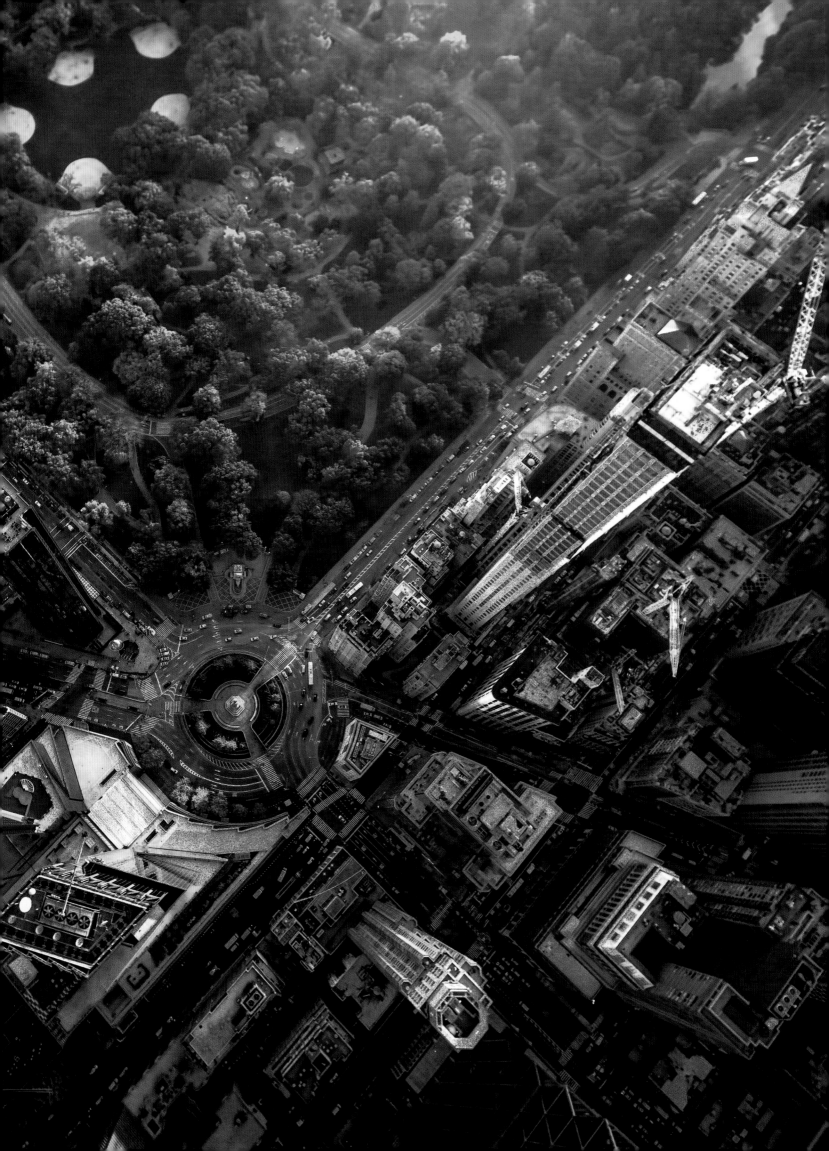

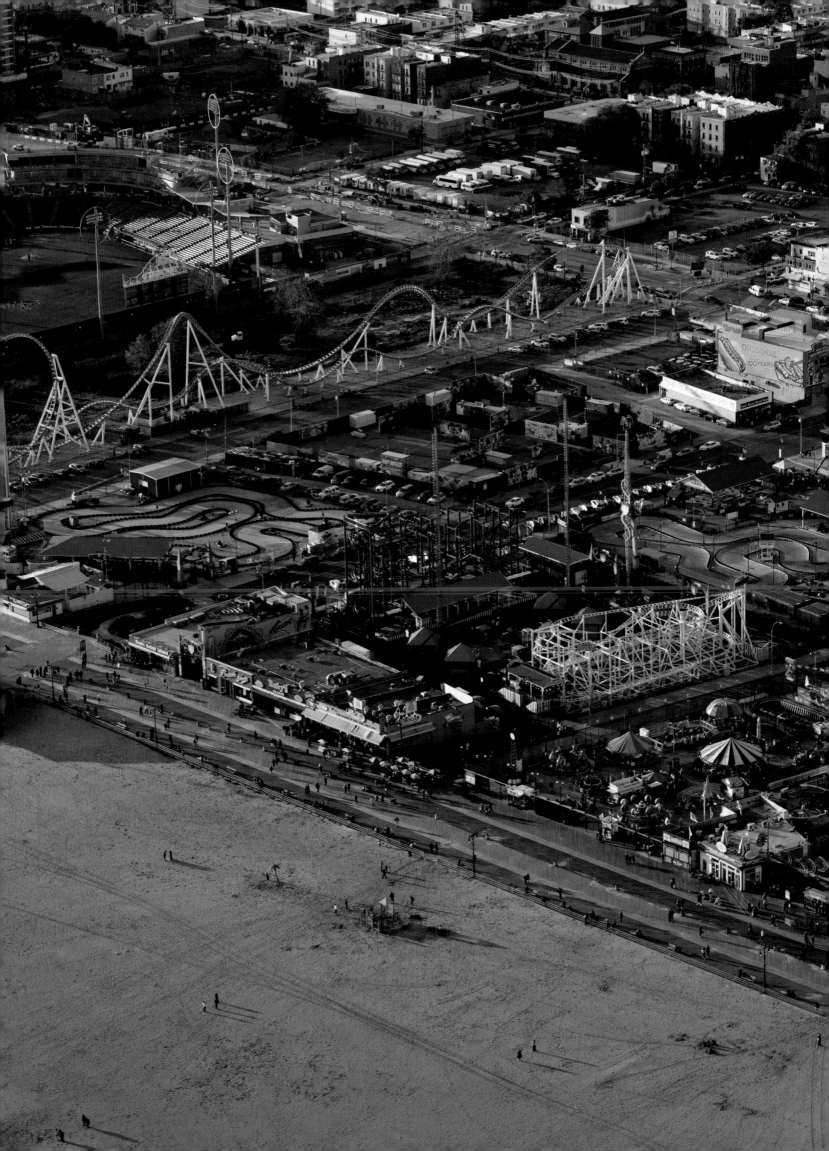

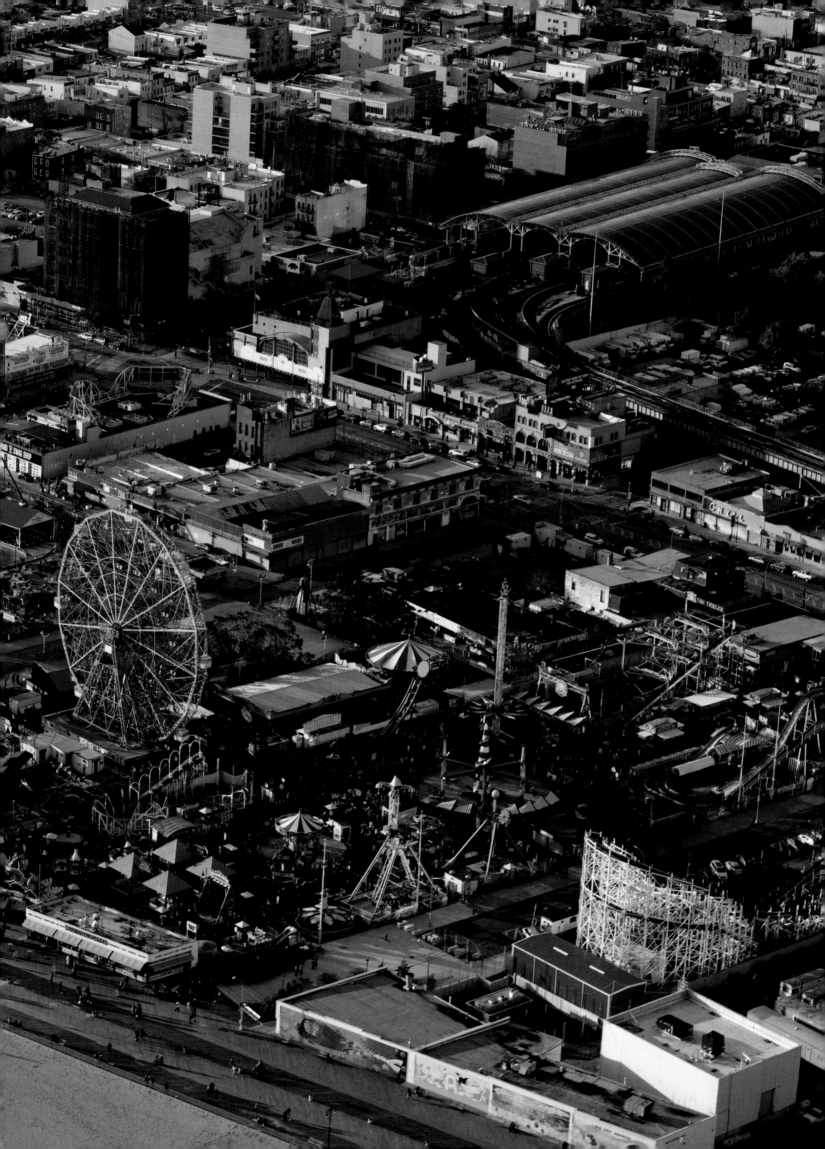

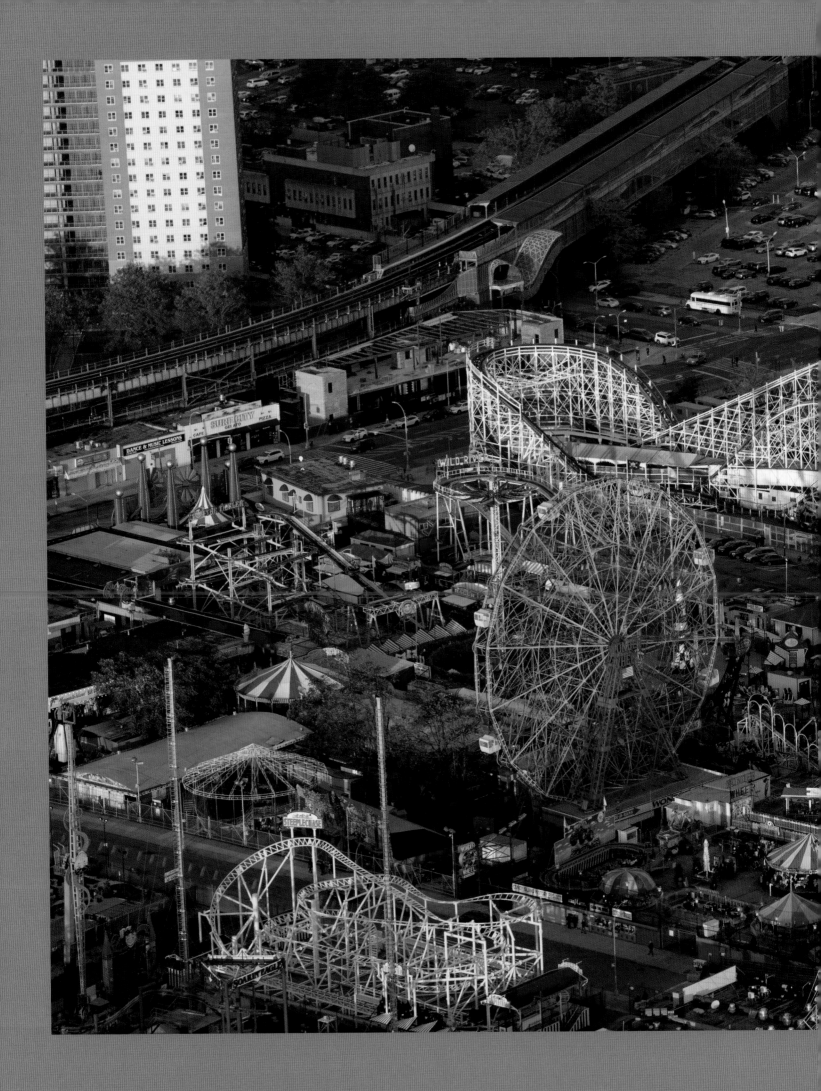

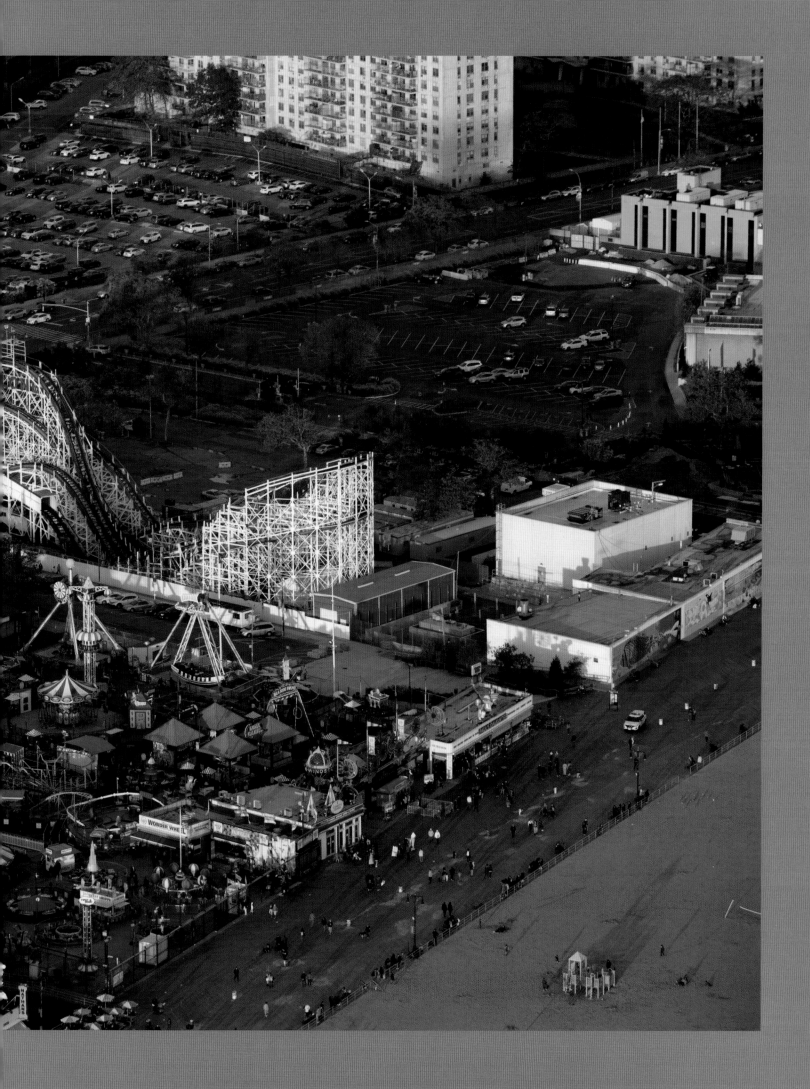

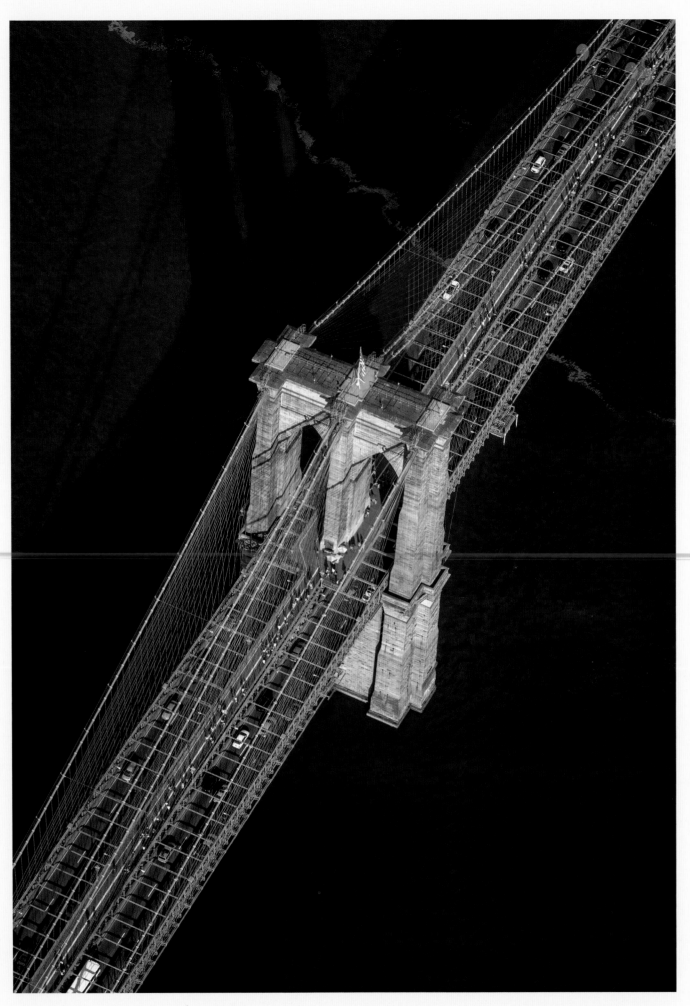

Above
Brooklyn Bridge
2 hr. and 7 min. before sunset
Altitude 1,225 feet

Page 83
Governor Mario M. Cuomo Bridge,
Westchester and Rockland counties
1 hr. and 29 min. before sunset
Altitude 3,750 feet

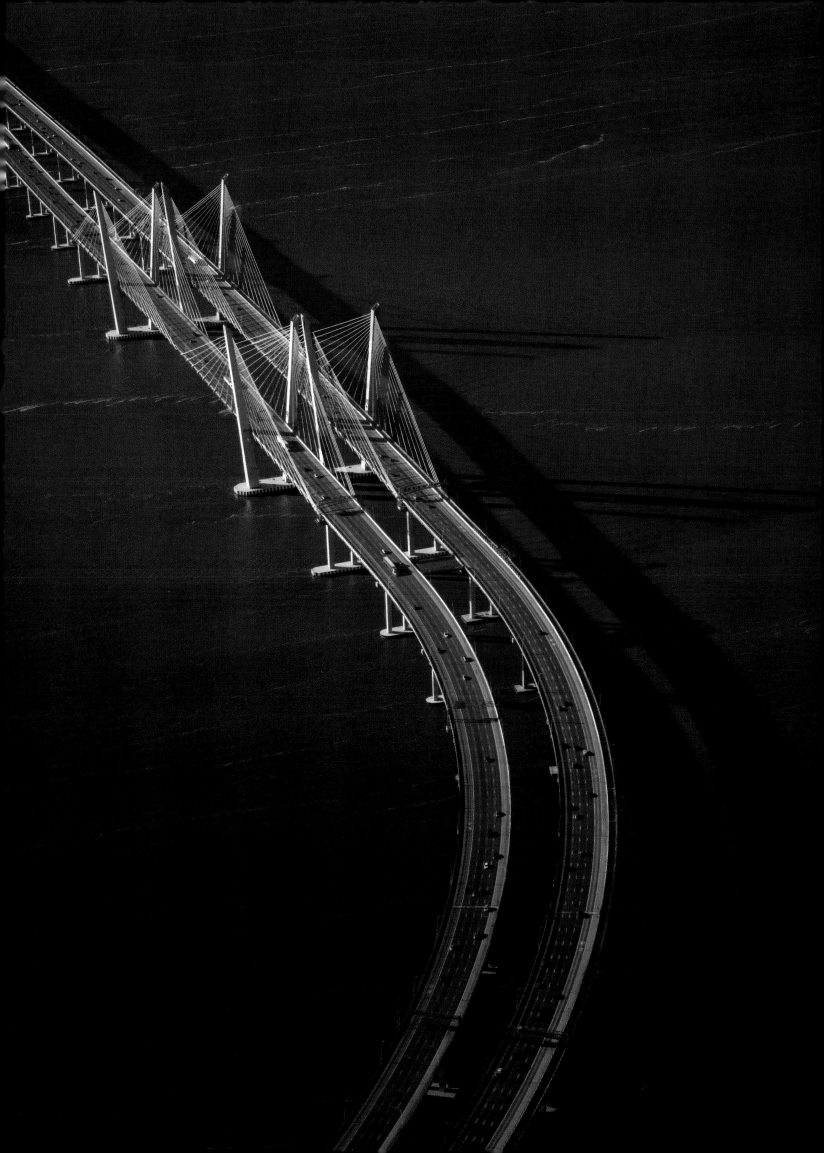

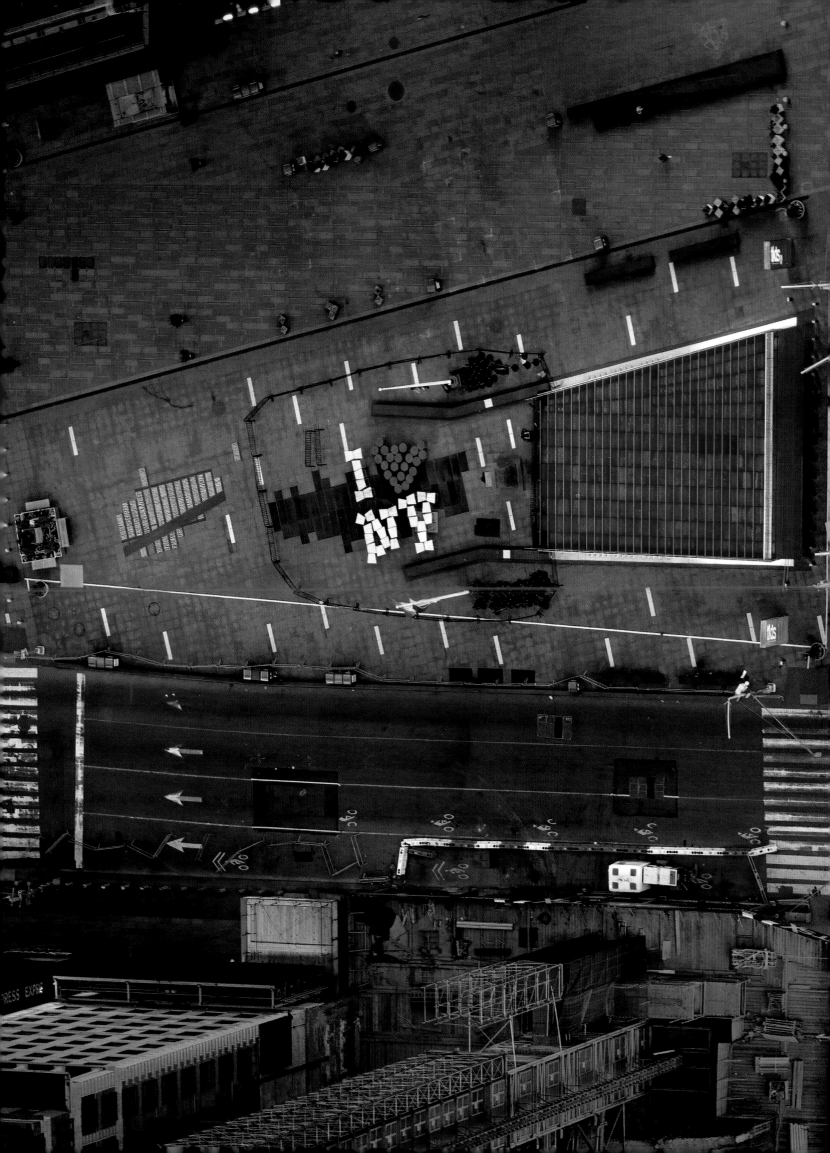

Pages 84-85
Midtown mosaic
29 min. after sunrise
Altitude 1,050 feet

Page 86
Pandemic Times Square
17 min. and 44 sec. after sunrise
Altitude 1,480 feet

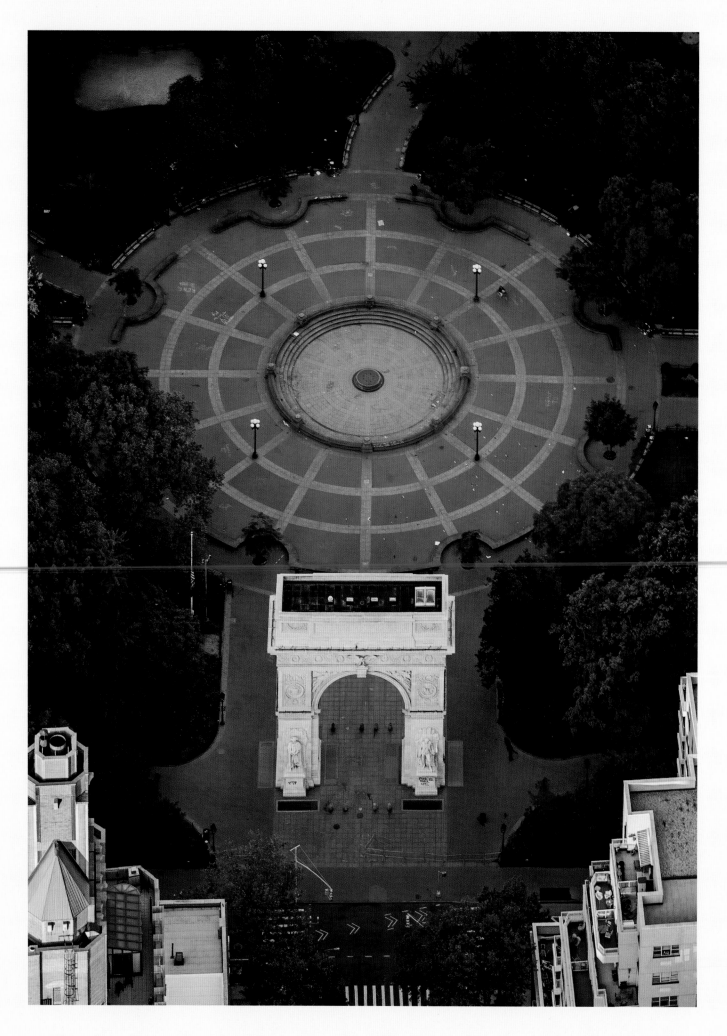

Above
Pandemic Washington Square Park
29 min. and 58 sec. after sunrise
Altitude 1,560 feet

Page 89
Pandemic Statue of Liberty
47 min. and 38 sec. after sunrise
Altitude 700 feet

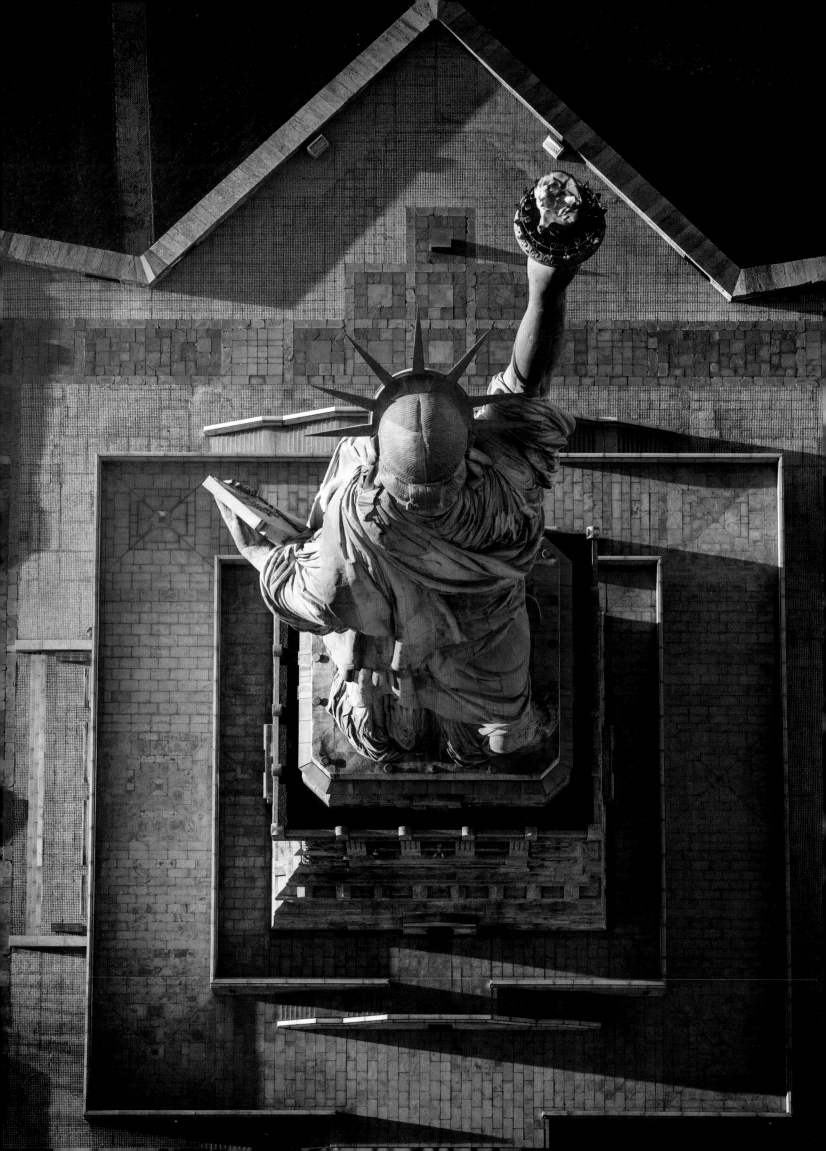

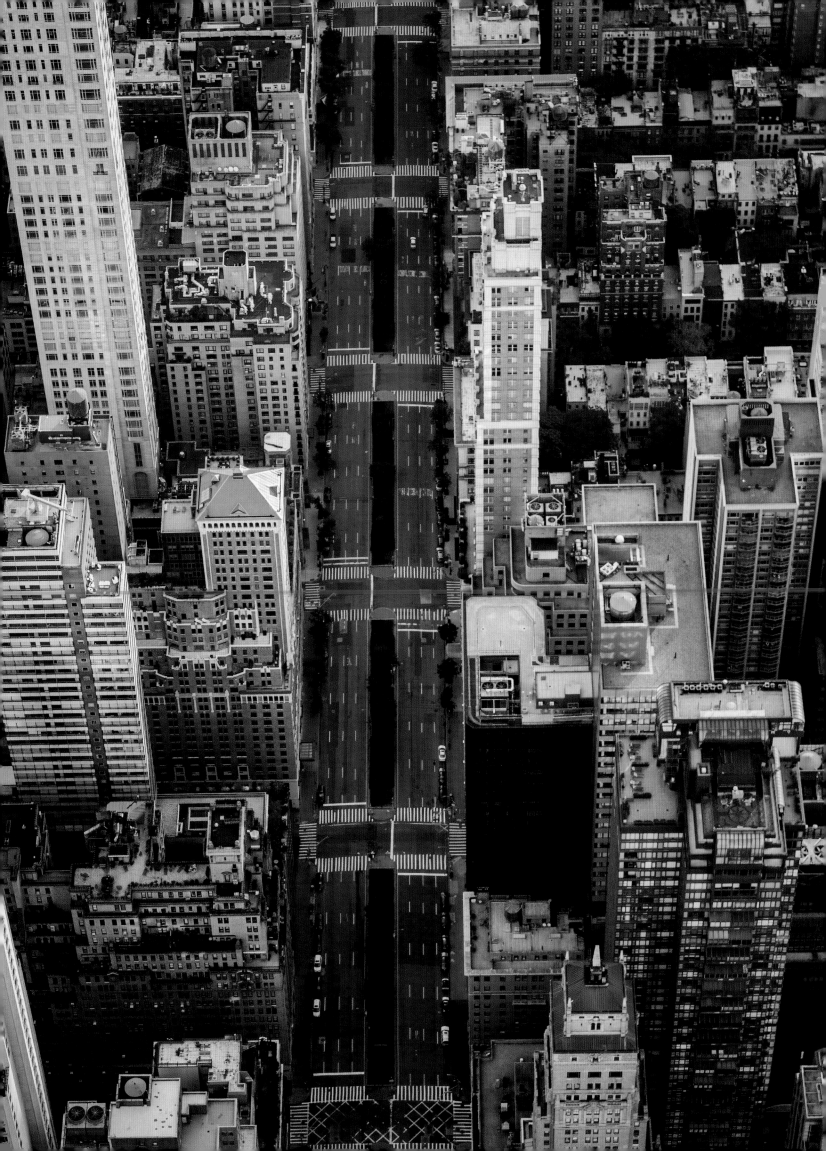

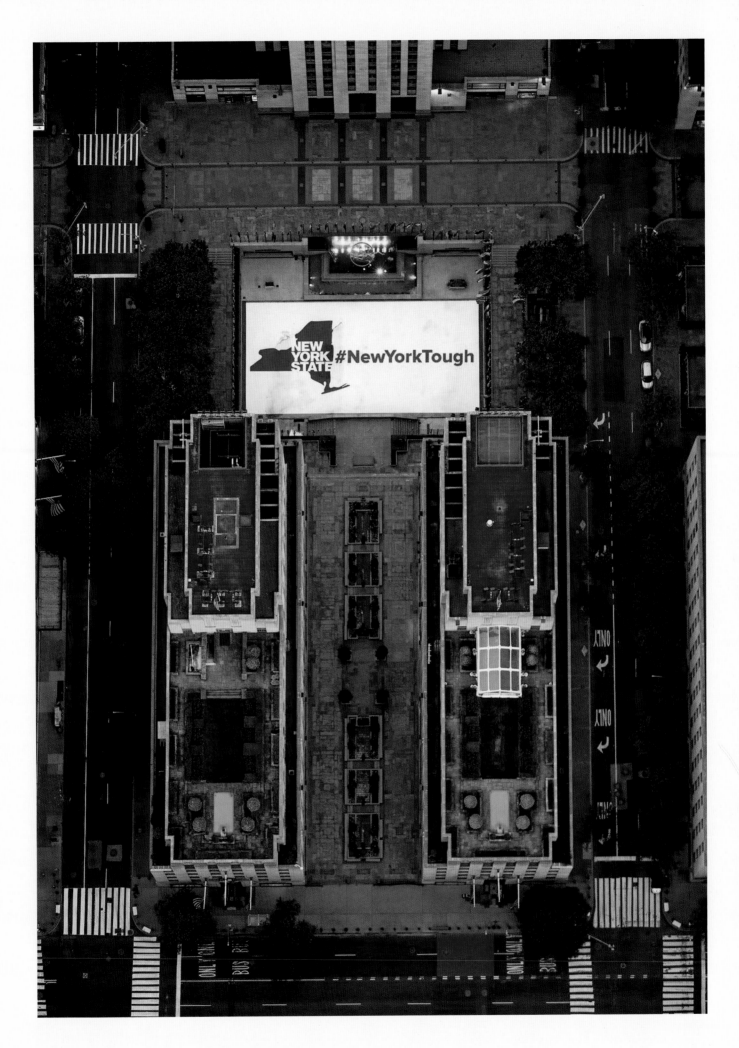

Page 90
Pandemic Park Avenue
34 min. and 5 sec. after sunrise
Altitude 1,600 feet

Above
Pandemic Rockefeller Center Rink
25 min. and 6 sec. after sunrise
Altitude 1,550 feet

Below

Spire of Empire State Building and
One World Trade Center

14 min. and 53 sec. before sunset

Altitude 1,350 feet

Page 93

111 West 57th Street trussing and
One World Trade Center

27 min. and 53 sec. before sunset

Altitude 1,420 feet

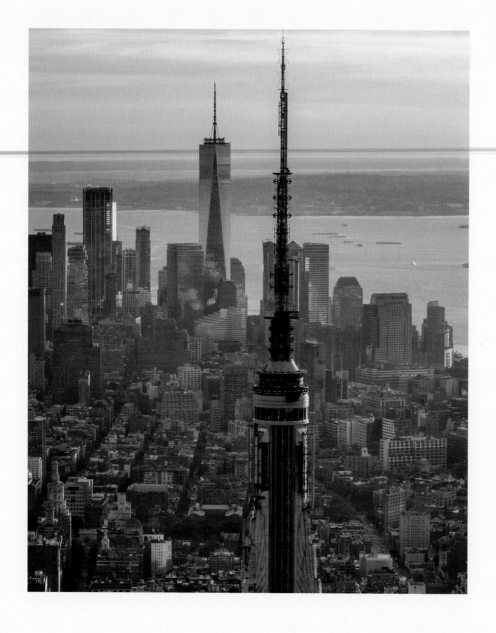

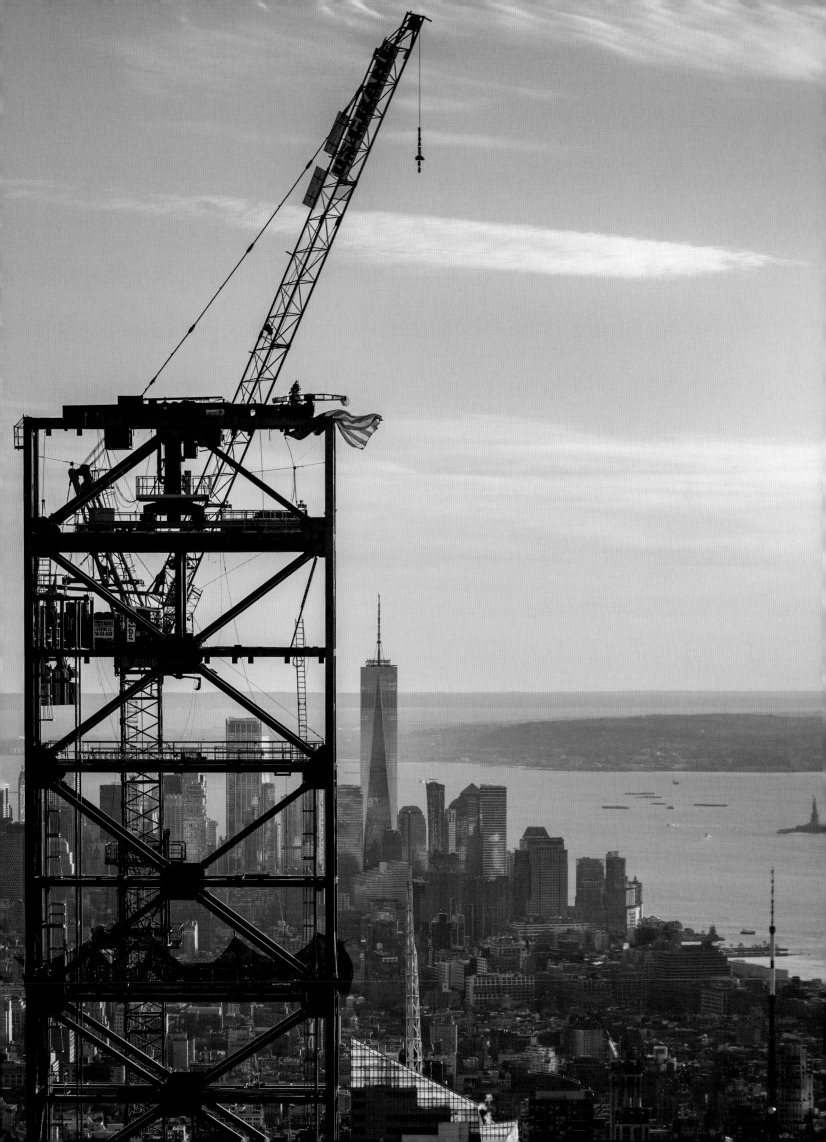

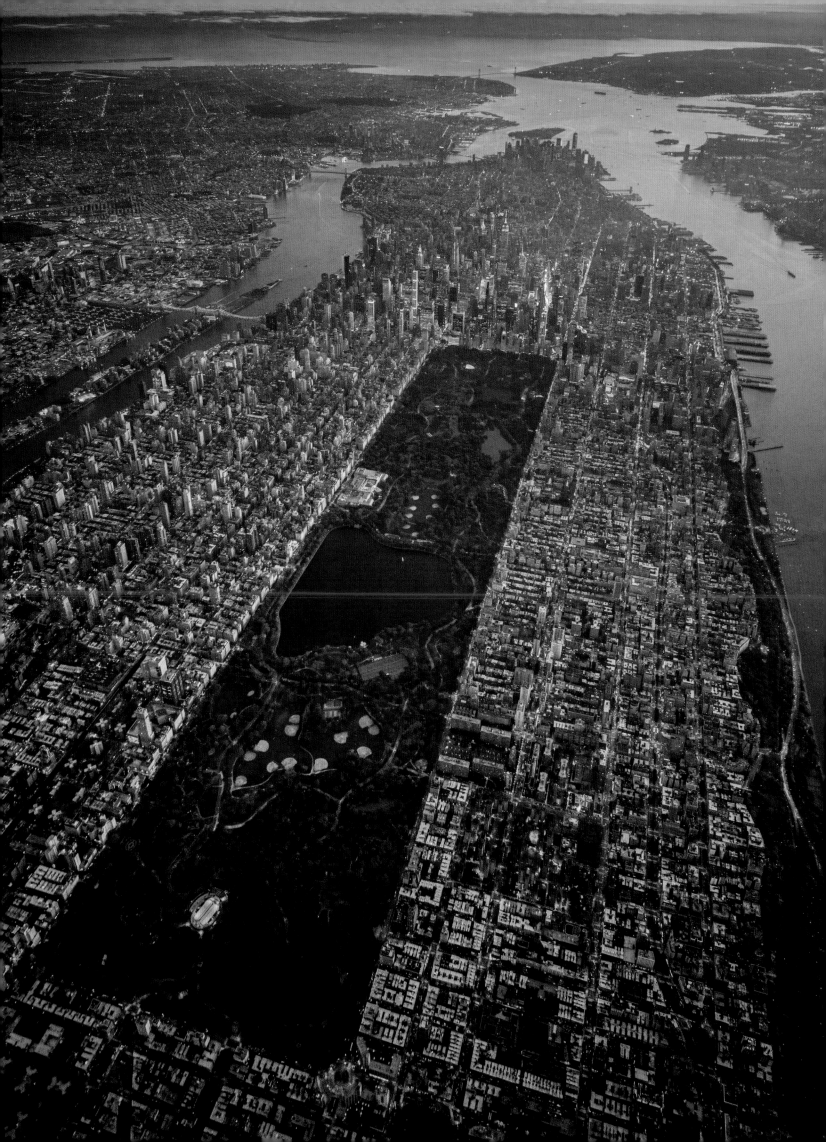

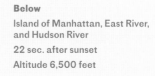

Page 94
Central Park, looking south
18 min. and 34 sec. after sunset
Altitude 7,500 feet

Below
Island of Manhattan, East River,
and Hudson River
22 sec. after sunset
Altitude 6,500 feet

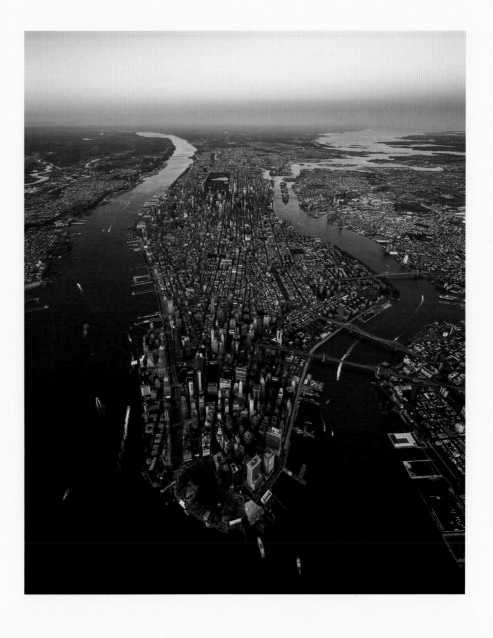

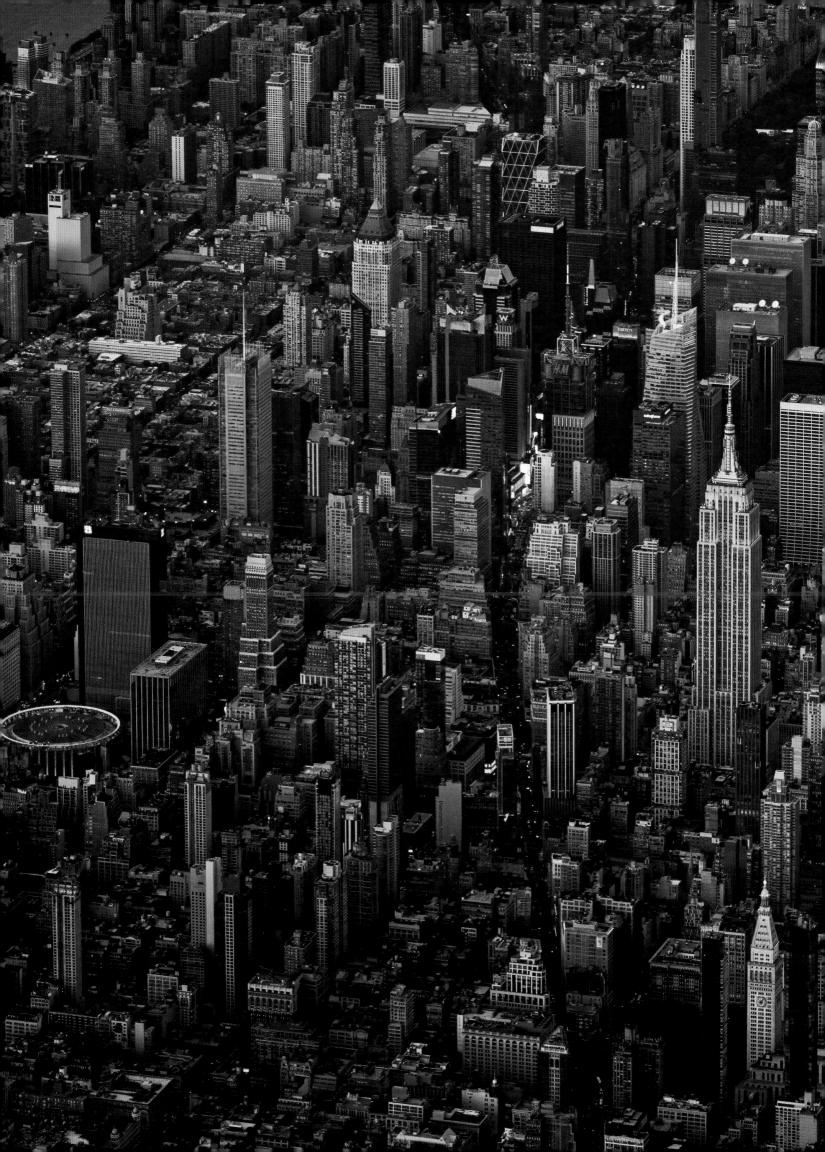

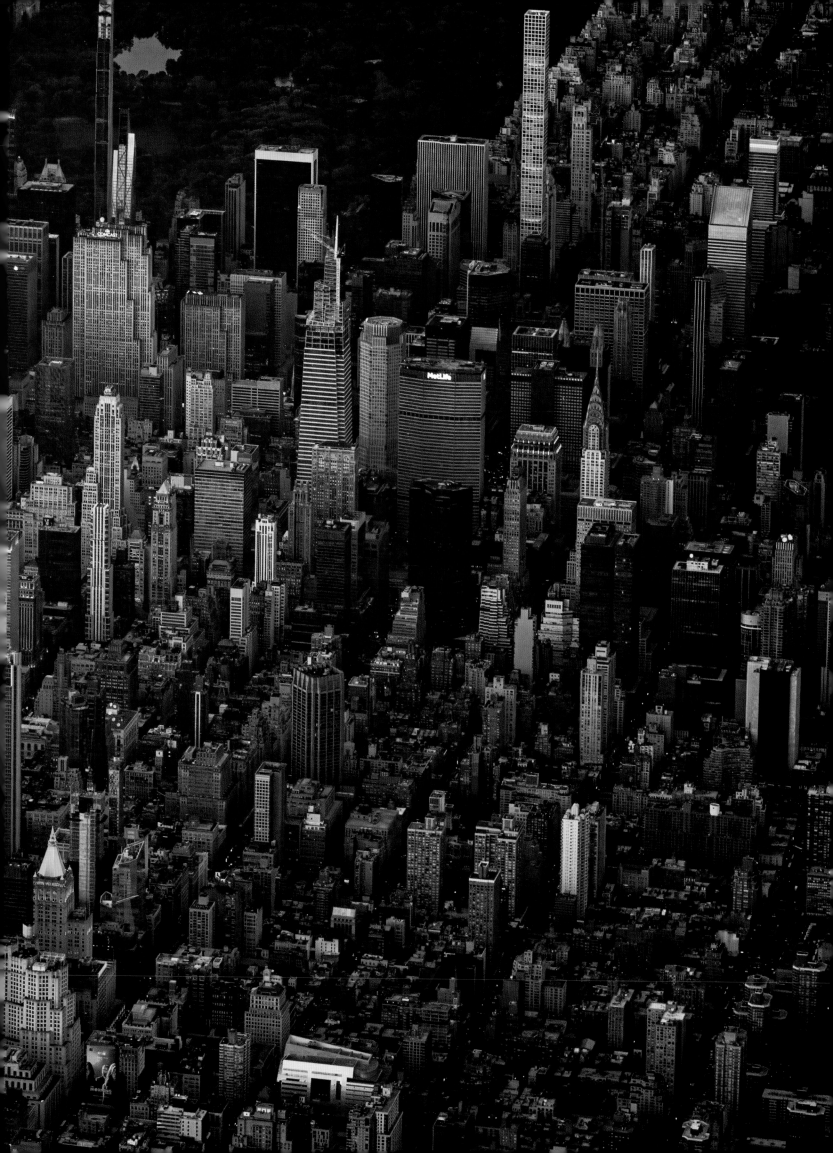

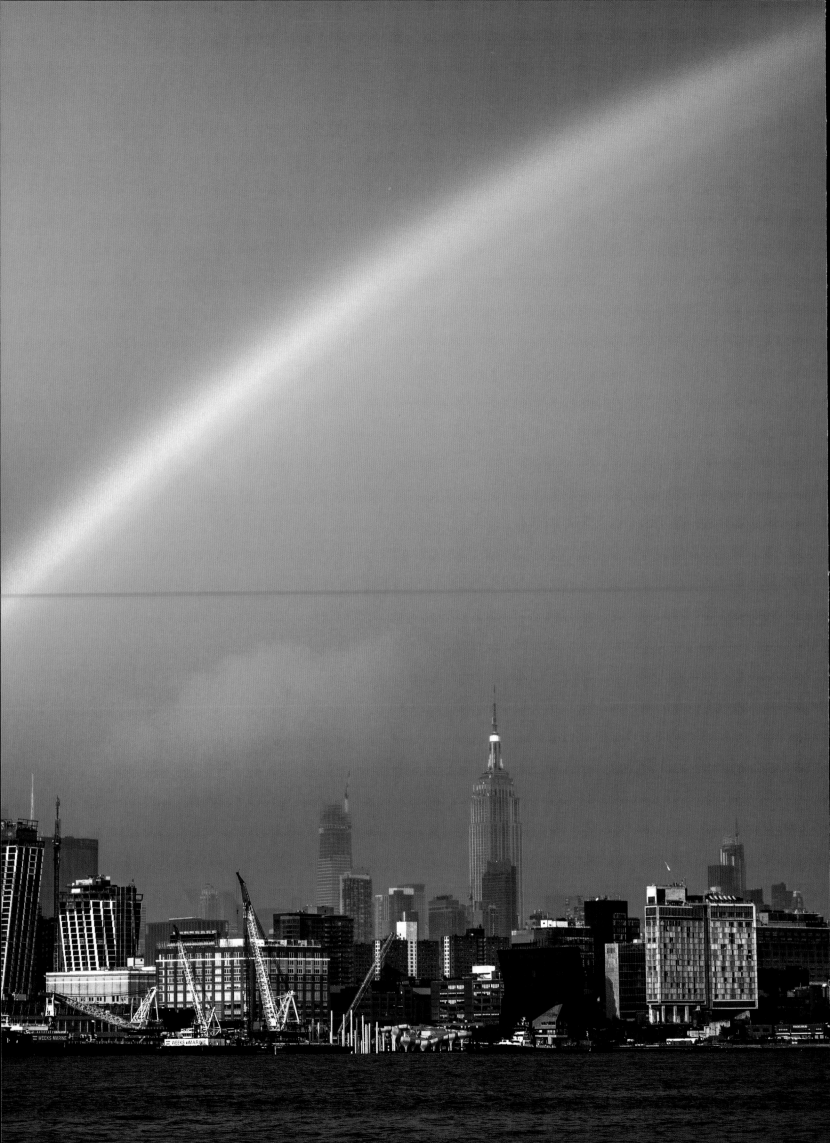

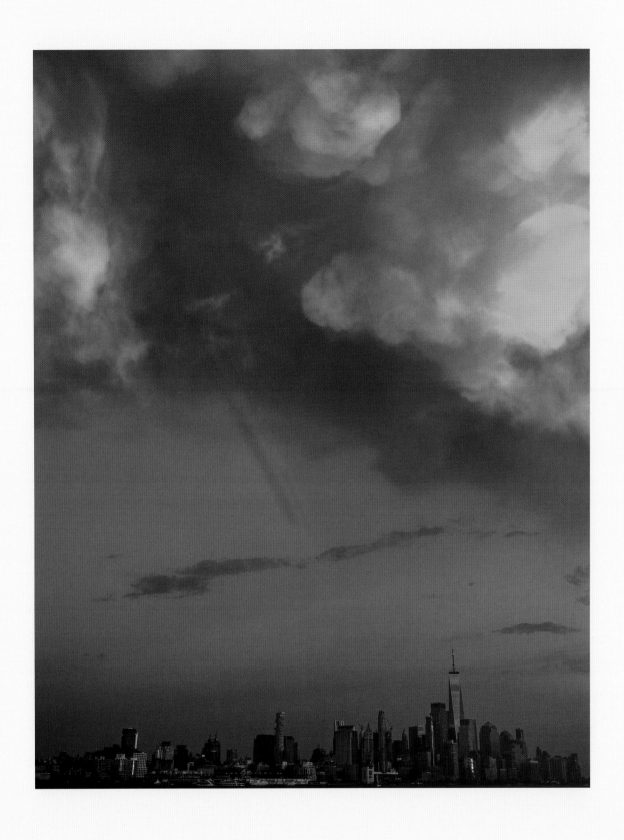

Pages 96-97
Midtown Manhattan
3 min. and 10 sec. after sunset
Altitude 7,100 feet

Page 98
Rainbow over Empire State Building
1 hr. and 43 min. before sunset
Altitude 7 feet

Above
Mammatus clouds and
rainbow over Lower Manhattan
5 min. and 33 sec. before sunset
Altitude 8 feet

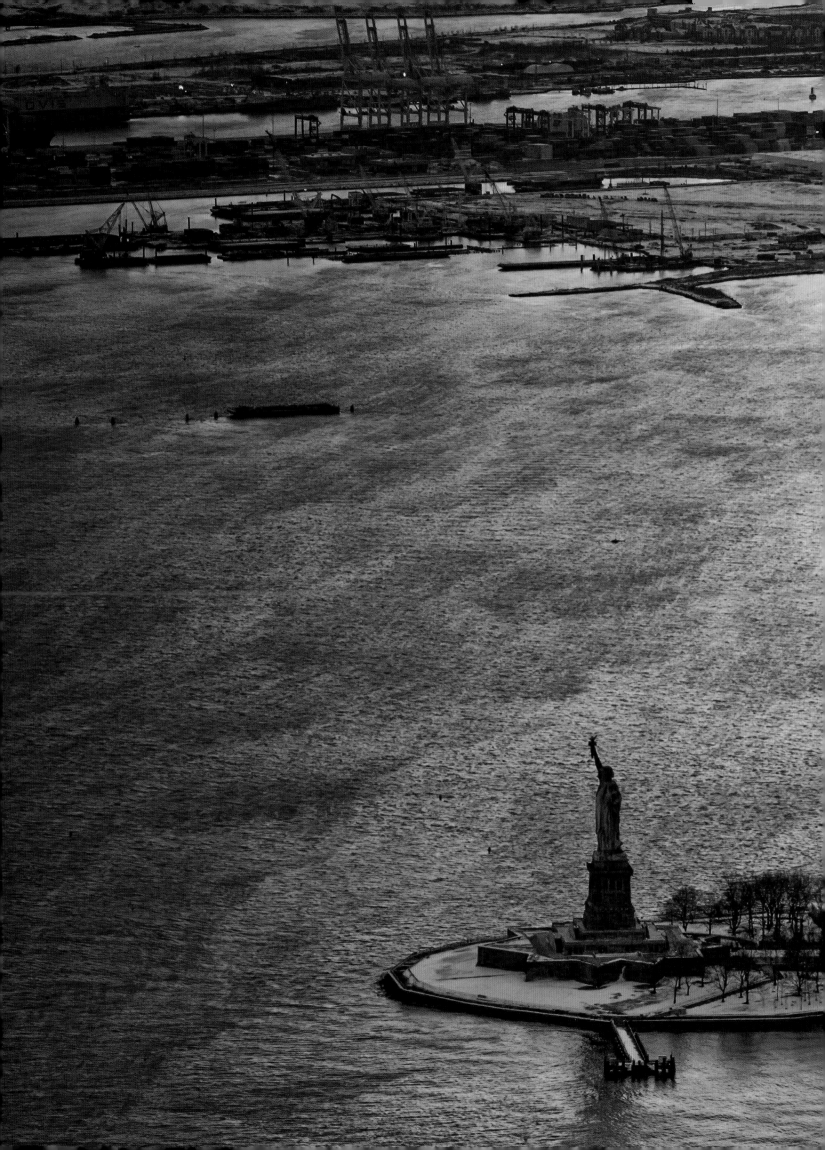

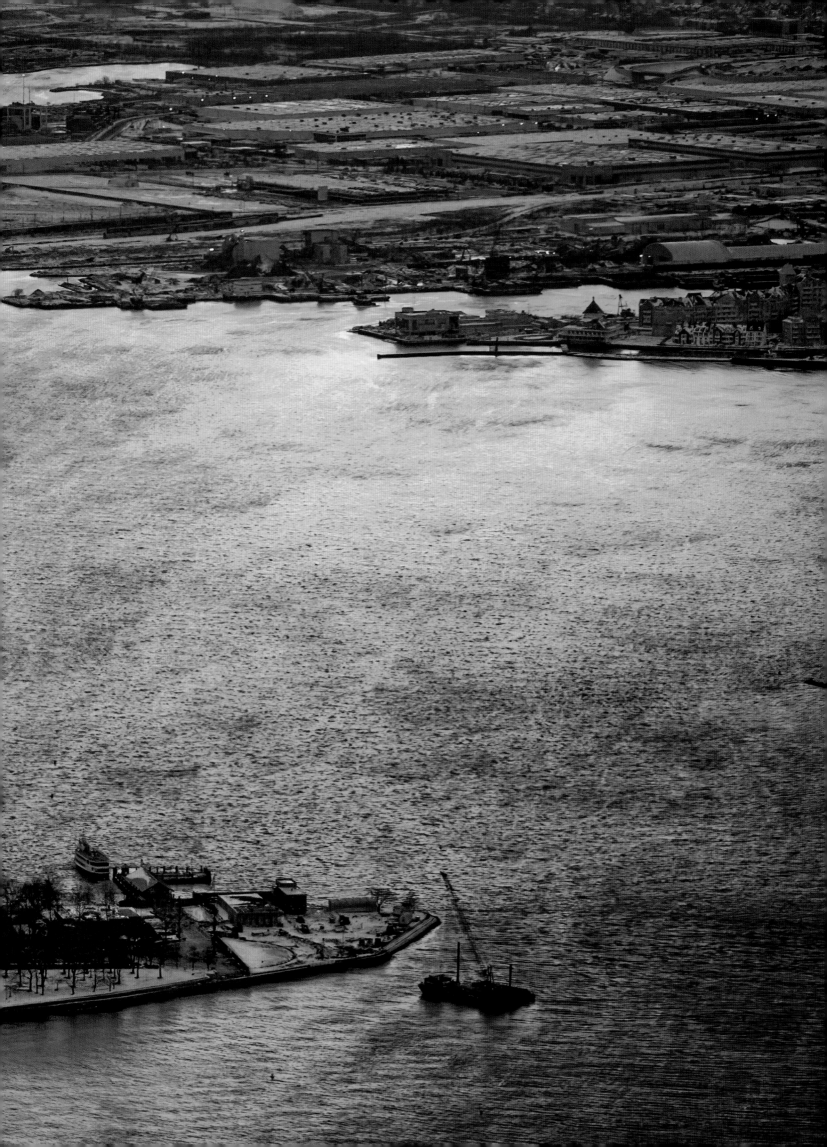

Pages 100-101
Snow-covered Statue of Liberty
13 min. and 19 sec. before sunset
Altitude 1,750 feet

Page 103
Chrysler Building
54 min. and 54 sec. before sunset
Altitude 1,490 feet

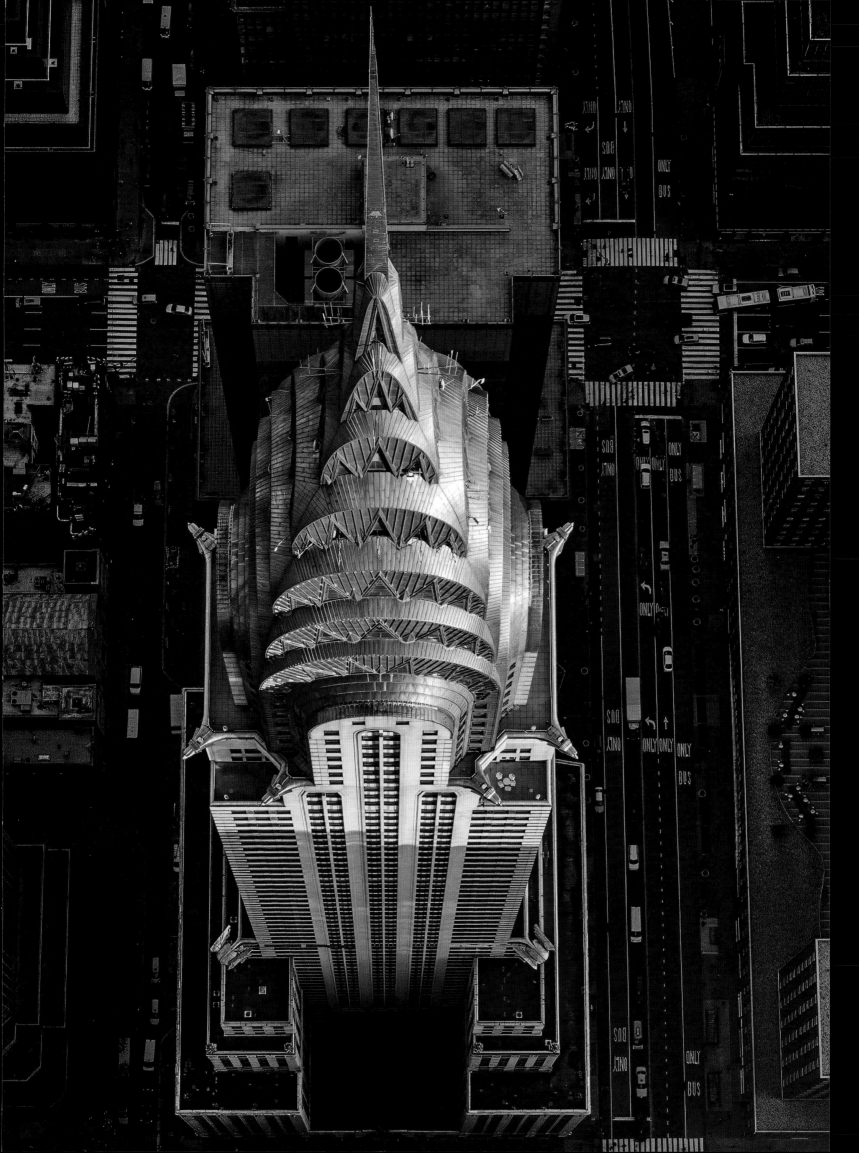

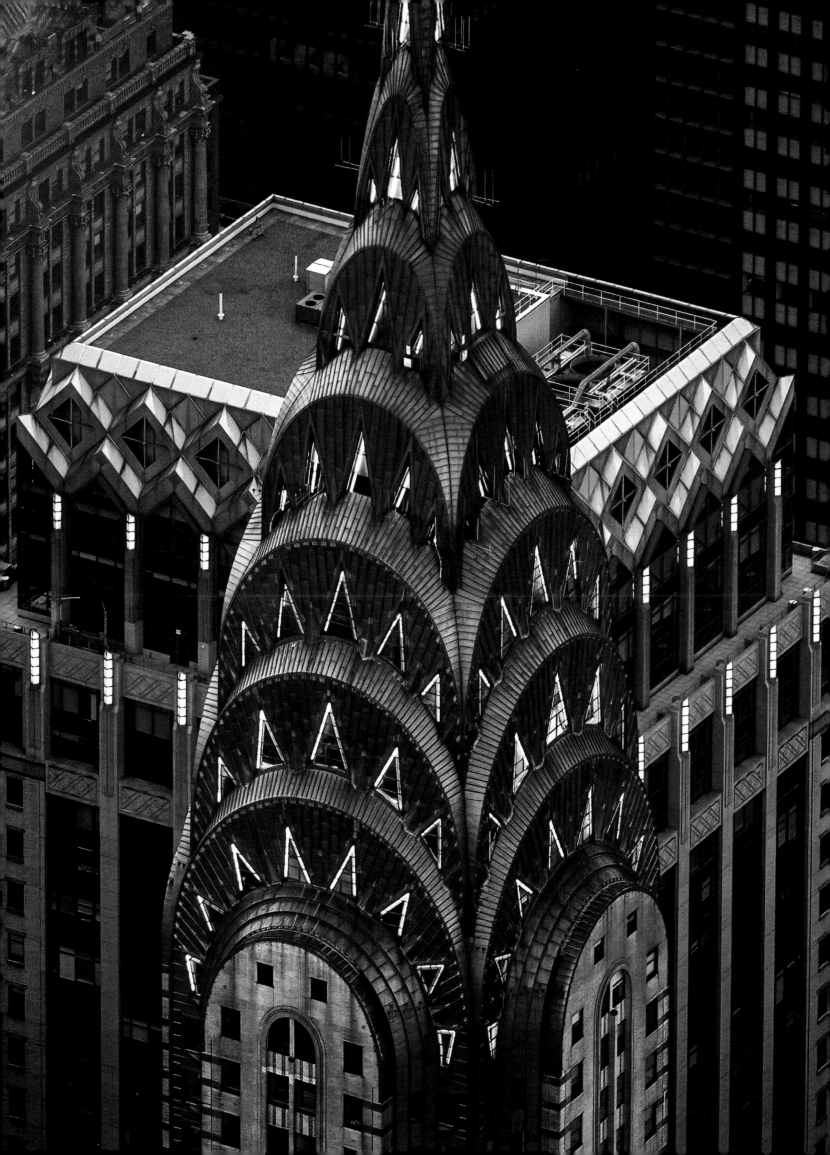

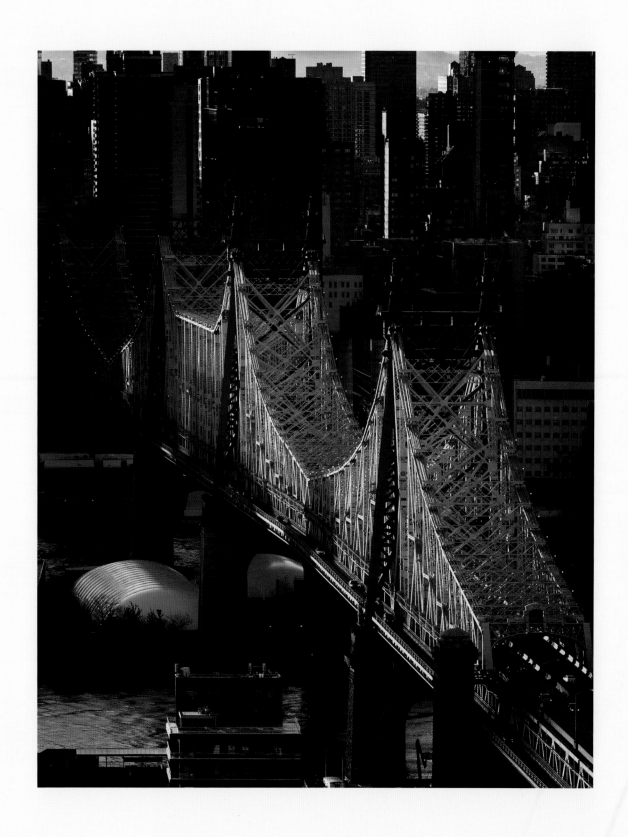

Page 104
Chrysler Building
10 min. and 35 sec. before sunset
Altitude 1,600 feet

Above
Ed Koch Queensboro/
59th Street Bridge
35 min. and 57 sec. before sunset
Altitude 580 feet

105

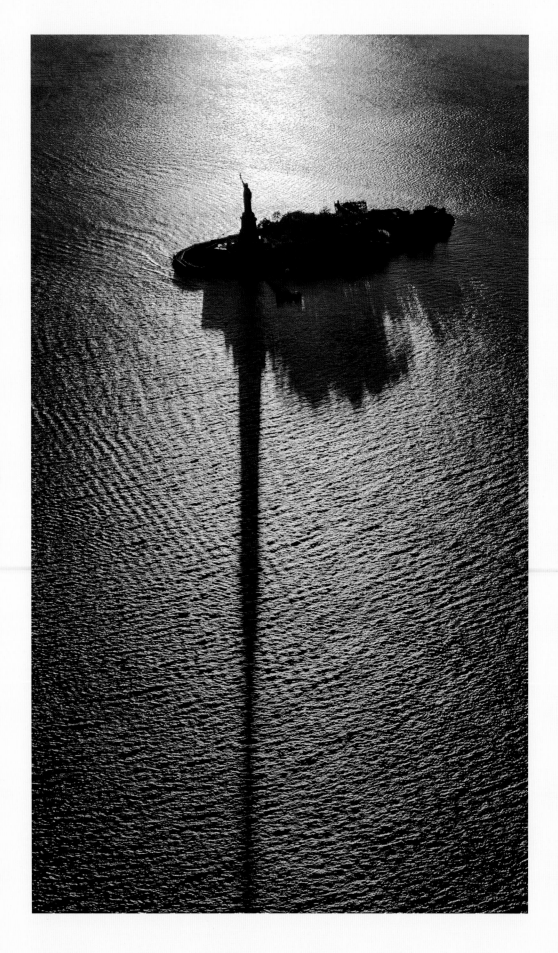

Above
Statue of Liberty shadow
13 min. and 8 sec. before sunset
Altitude 1,900 feet

Page 107
One World Trade Center
37 min. and 17 sec. before sunset
Altitude 1,100 feet

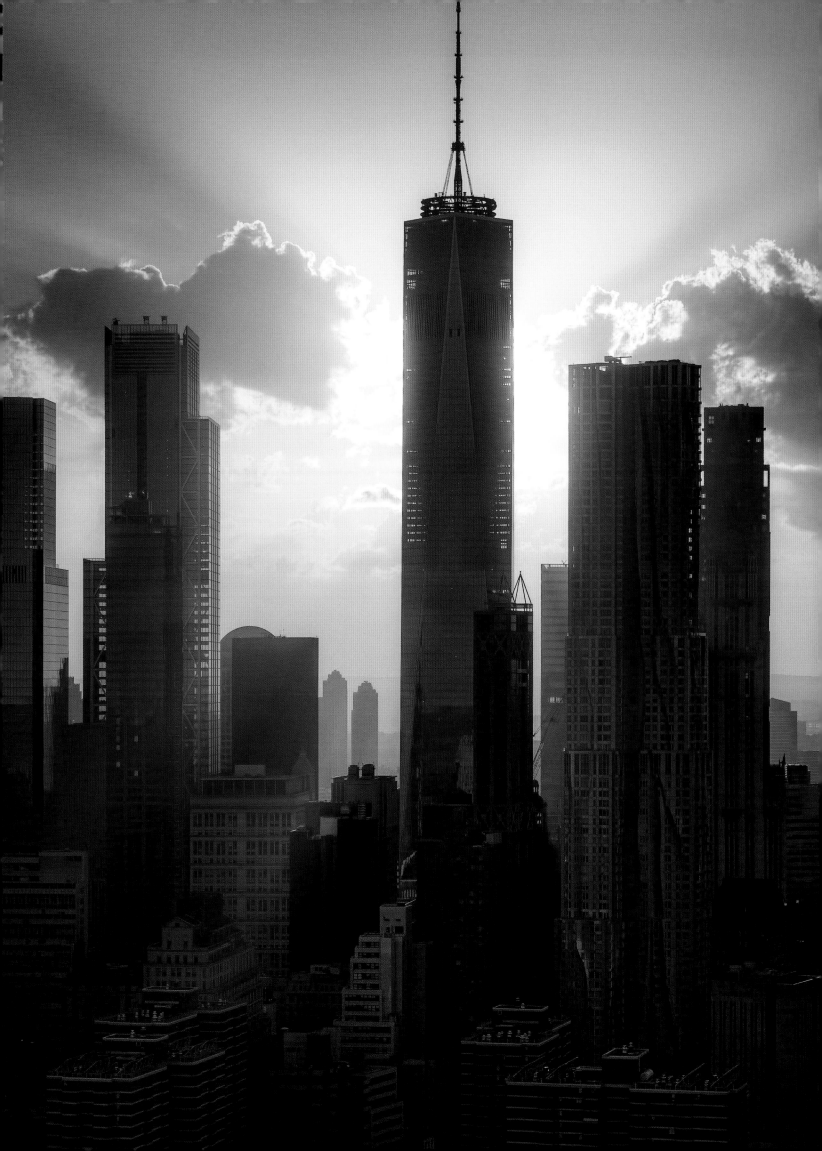

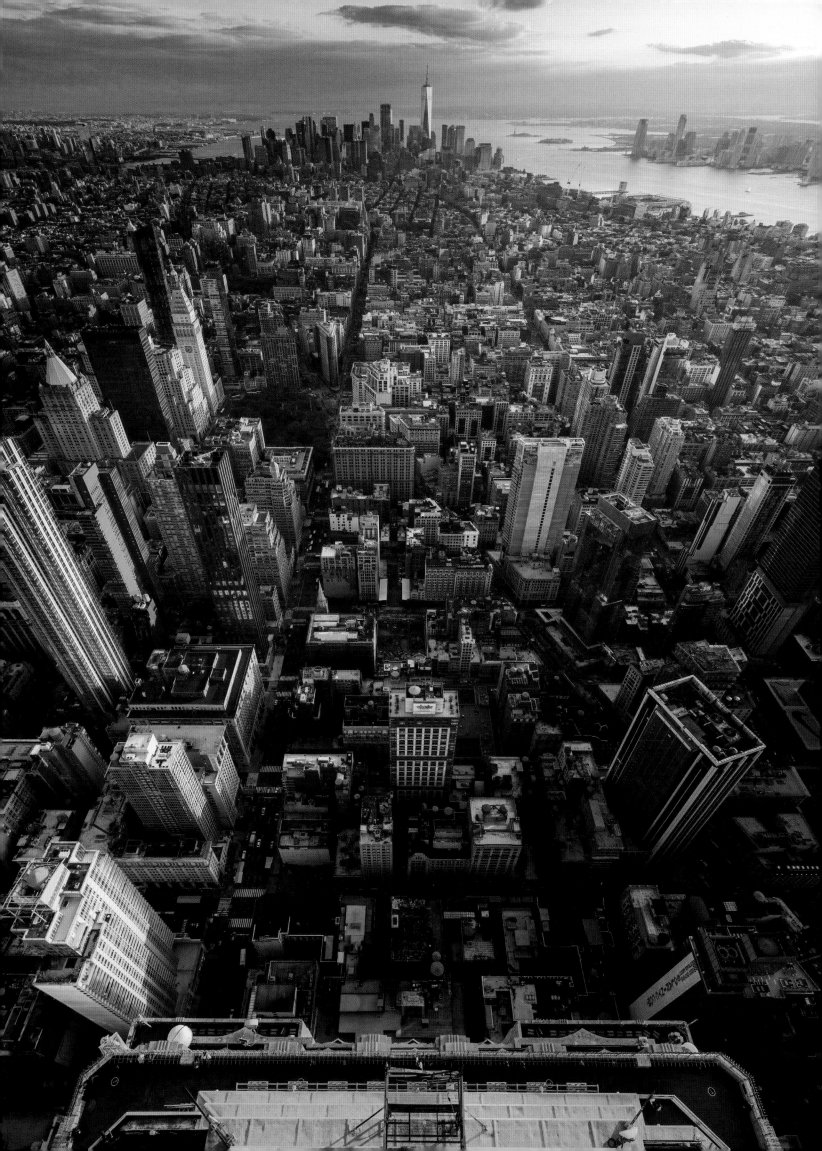

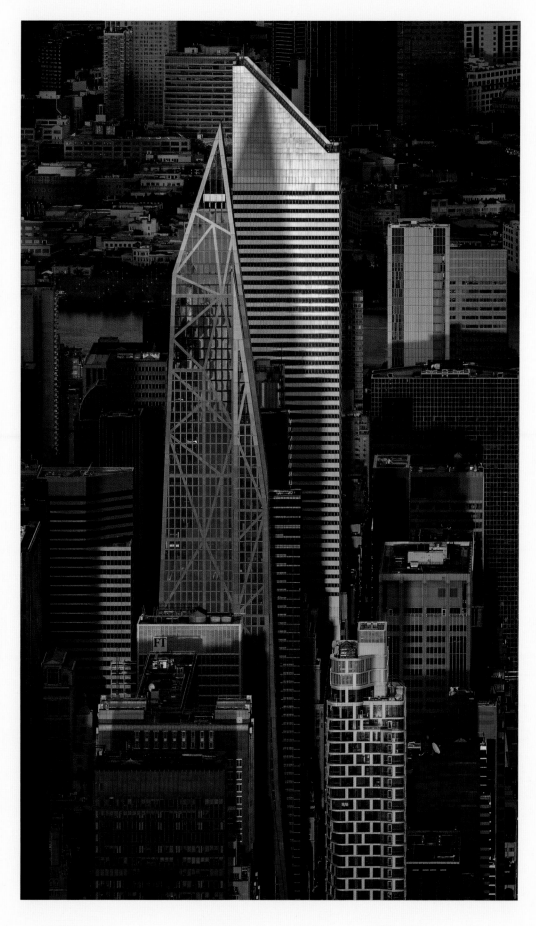

Page 108
Lower Manhattan, as seen from
Empire State Building 103rd floor
32 min. and 1 sec. before sunset
Altitude 1,250 feet

Above
53 West 53
1 hr. and 24 min. before sunset
Altitude 1,750 feet

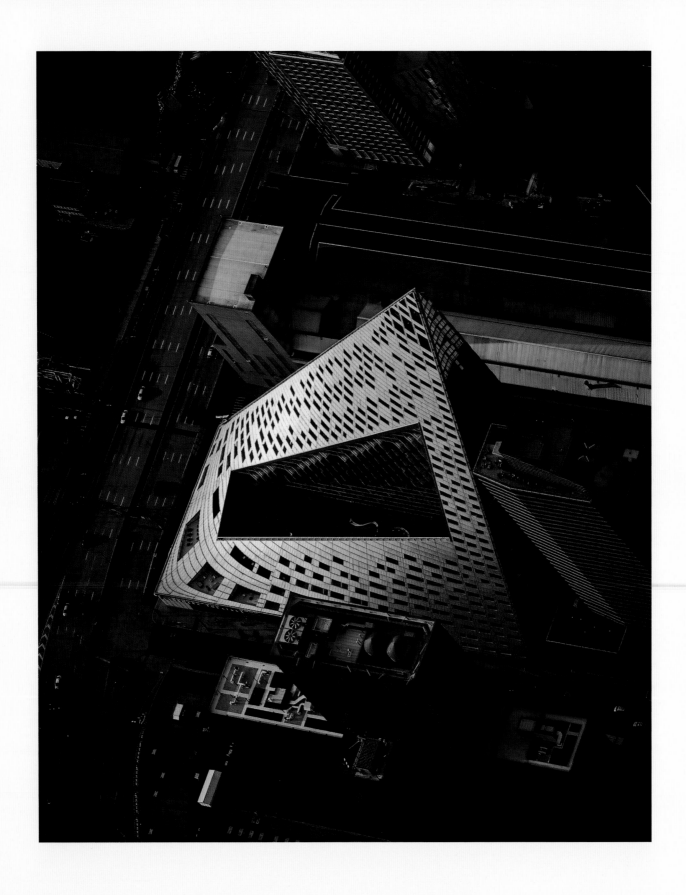

Above
Via 57 West
55 min. and 36 sec. before sunset
Altitude 6,500 feet

Page 111
Empire State Building
19 min. and 54 sec. before sunset
Altitude 1,800 feet

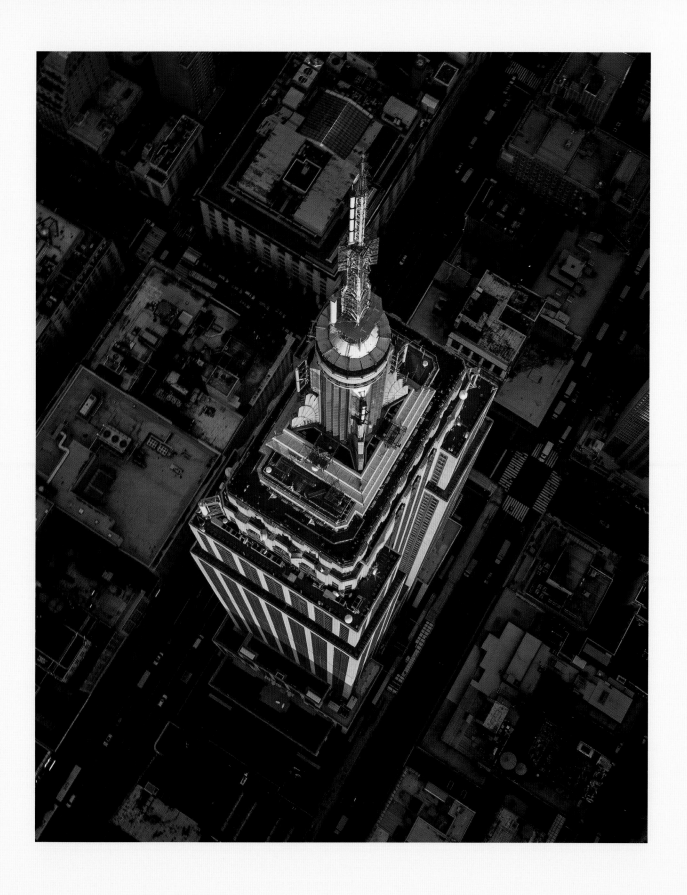

Page 112
Financial District
13 min. and 52 sec. after sunset
Altitude 1,675 feet

Pages 114-115
Vessel
8 min. and 44 sec. before sunset
Altitude 110 feet

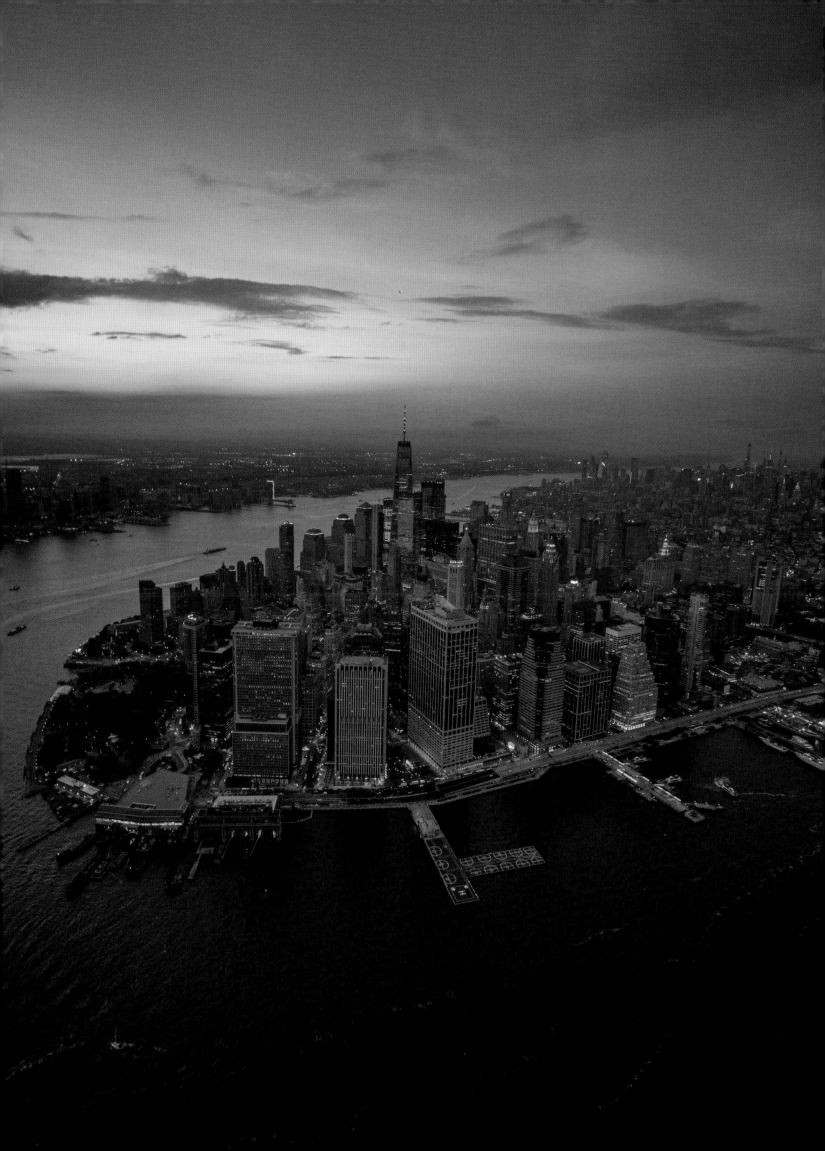

DOWNTOWN
MANHATTAN
STATUE OF LIBERTY/
ELLIS ISLAND
EASTERN LONG ISLAND

NEW YORK

HELICOPTER ROUTE CHART
NEW YORK
LEGEND

Consult Chart Supplement for details involving airport lighting, navigation aids and services.
All times are local. For additional symbol information refer to the Chart User's Guide.

AIRPORTS

Hard-surfaced runways 1500 ft. or greater

Open dot within hard-surfaced runway configuration indicates approximate VOR, VOR-DME, DME or VORTAC location.

All recognizable hard-surfaced runways, including those closed, are shown for visual identification.

Other than hard-surfaced public use (R) Private use

HELIPORTS OTHER

(H) Heliports - public and private (F) Ultralight Flight Park Selected

(+) Hospital Helipads ⚓ Seaplane Base

(+) Trauma Center

(H) Helipads located at major airports

☆ Rotating airport beacon in operation Sunset to Sunrise

OBJECTIONABLE - Airport may adversely affect airspace use.

AIRPORT DATA

FSS FAR 91
NO SVFR Location Identifier
Box indicates FAR 93 Special Air Traffic Rules & Airport Traffic Patterns
[NAME] (NAM) (PNAM) ICAO Location Indicator shown outside contiguous U.S.
CT - 118.3 ★ (C) ATIS 123.8
285 L 122.95
Unverified Heliport — (Unverified) UNICOM
Airport of Entry — AOE

FSS - Flight Service Station
NO SVFR - Fixed-wing special VFR flight is prohibited.
CT - 118.3 - Control Tower (CT) - primary frequency
★ - Star indicates operation part-time. See tower frequencies tabulation for hours of operation.
(C) - Follows the Common Traffic Advisory Frequency (CTAF)
ATIS 123.8 - Automatic Terminal Information Service
ASOS/AWOS 135.42 - Automated Surface Weather Observing Systems (shown where full-time ATIS not available). Some ASOS/AWOS facilities may not be located at airports.
UNICOM - Aeronautical advisory station
285 - Elevation in feet
L - Lighting in operation Sunset to Sunrise
*L - Lighting limitations exist; refer to Supplement.
When information is lacking, the respective character is replaced by a dash. Lighting codes refer to runway edge lights.

RADIO AIDS TO NAVIGATION AND COMMUNICATION BOXES

⊙ VHF OMNI RANGE (VOR)
⬡ VORTAC
⬡ VOR-DME ☐ DME
⊙ Other facilities, i.e., FSS Outlet, RCO, etc.

◎ Non-Directional Radio Beacon (NDB)

◉ NDB - DME

122.1R 122.6 123.6
OAKDALE (H)
362 ★ 116.4 OAK ▭

Underline indicates no voice on frequency.
///// - Crosshatch indicates Shutdown status.
★ - Operates less than continuous or On-Request.
(A) - ASOS/AWOS
(H) - HIWAS

122.1R
FSS radio providing voice communication MIAMI

122.6
CHICAGO CHI

Heavy line box indicates Flight Service Station (FSS). Frequencies 121.5, 122.2, 243.0 and 255.4 are available at many FSSs and are not shown above boxes. All other frequencies are shown.

R - Receive only

Frequencies above thin line box are remoted to NAVAID site. Other FSS frequencies providing voice communication may be available as determined by altitude and terrain. Consult Supplement for complete information.

AIRPORT TRAFFIC SERVICE AND AIRSPACE INFORMATION

Only the controlled and reserved airspace effective below 18,000 ft. MSL are shown.

HELICOPTER ROUTES

Compulsory Non - Compulsory

PRIMARY [MARRIOTT] [118.3] ⇨ ▲ △

SECONDARY OR MILITARY

TRANSITION ➡ ⬅ ➡ ⬅ ➡ ⬅ ➡

POLICE ZONES • • • • • • • • • • •

Route Name Tower Frequency Arrow indicates One-way Route Altitude Changeover Point Reporting or Holding Points

ZONE 1 / 500 Maximum Altitude

Recommended Route Altitude
500 Minimum 500 Maximum 500 Recommended

Class B Airspace
Class C Airspace (Mode C - see FAR 91.215/AIM.)

Class B/Class C Airspace Surface Area

MODE C (See FAR 91.215/AIM.)

- - - Class D Airspace
Ceiling of Class D Airspace in hundreds of feet (A minus ceiling value indicates surface up to but not including that value.)

[40]

- - - Class E (sfc) Airspace

← IR211 MTR - Military Training Route

||||||| Prohibited, Restricted, and Warning Areas
||||||| *Alert Area and Military Operations Area (MOA)
*Alert Areas do not extend into Class A, B, C and D airspace, or Class E airport surface areas.

//// Special Airport Traffic Area (See FAR 93 for details.)
:::::: ADIZ - Air Defense Identification Zone

OBSTRUCTIONS

1000 ft and higher AGL

Above 299 ft & below 1000 ft AGL

Group Obstruction Wind Turbine Wind Turbine Farm

Obstruction with high-intensity lights; may operate part-time

(2894' UC)

Elevation of the top above mean sea level → 2049
Height above ground → (1149)
Under construction or reported: position and elevation unverified → UC
NOTICE: Guy wires may extend outward from structures.

TOPOGRAPHIC INFORMATION

Power Transmission Line
■- - - - -■ Aerial Cable
(O) Lookout Tower
618 (Elevation Base of Tower)

STATUE
OF
LIBERTY

Pictorial Symbol

MISCELLANEOUS

(A)
A - Aerobatic Practice Area (See Supplement.)
G - Glider Operations
H - Hang Glider Activity
U - Ultralight Activity
UA - Unmanned Aircraft Activity
▽ Parachute Jumping Area (See Supplement.)

Space Launch Activity Area (See Supplement.)

VPXYZ ◆ VFR Waypoints (See chart tabulation for latitude/longitude.)

◆ STADIUM
Intermittent TFR site (within 3 NM, up to & incl 3000' AGL)

NAME (VPXYZ)

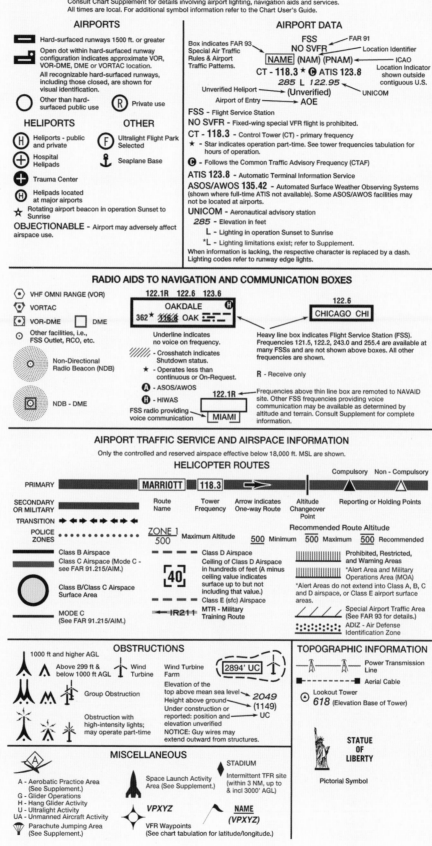

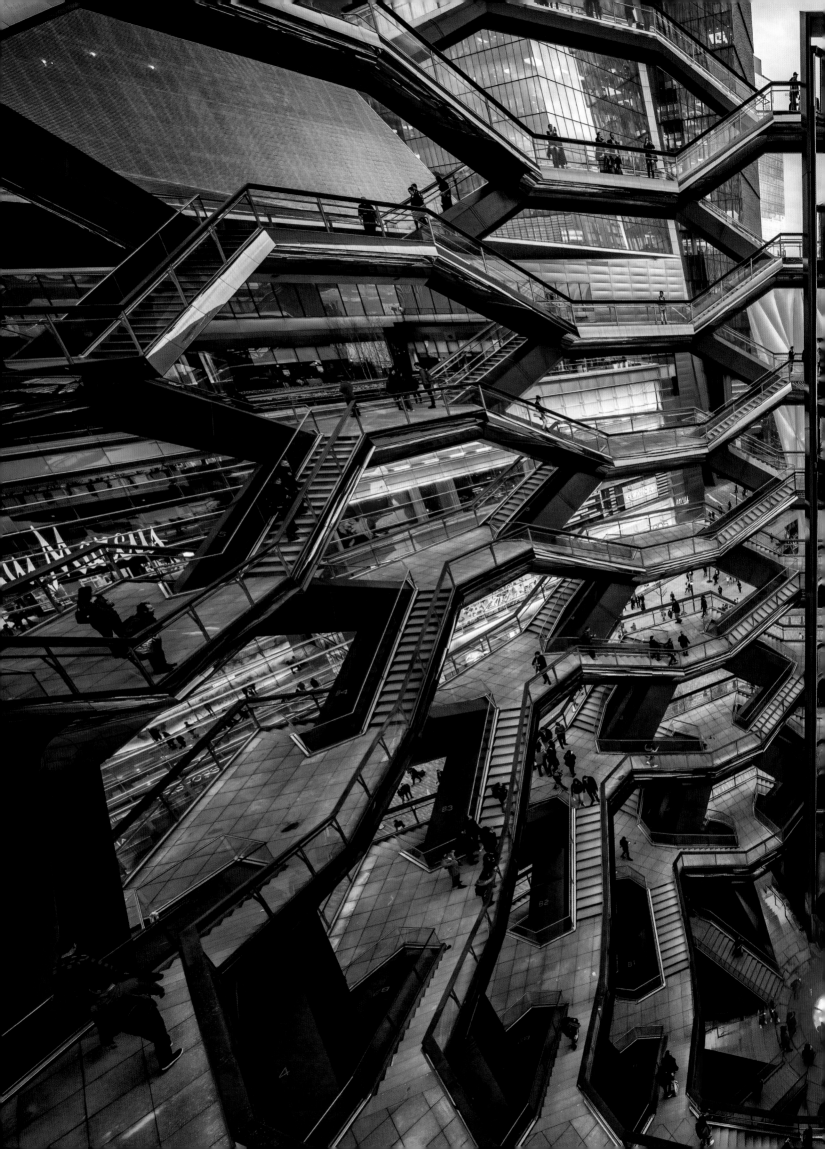

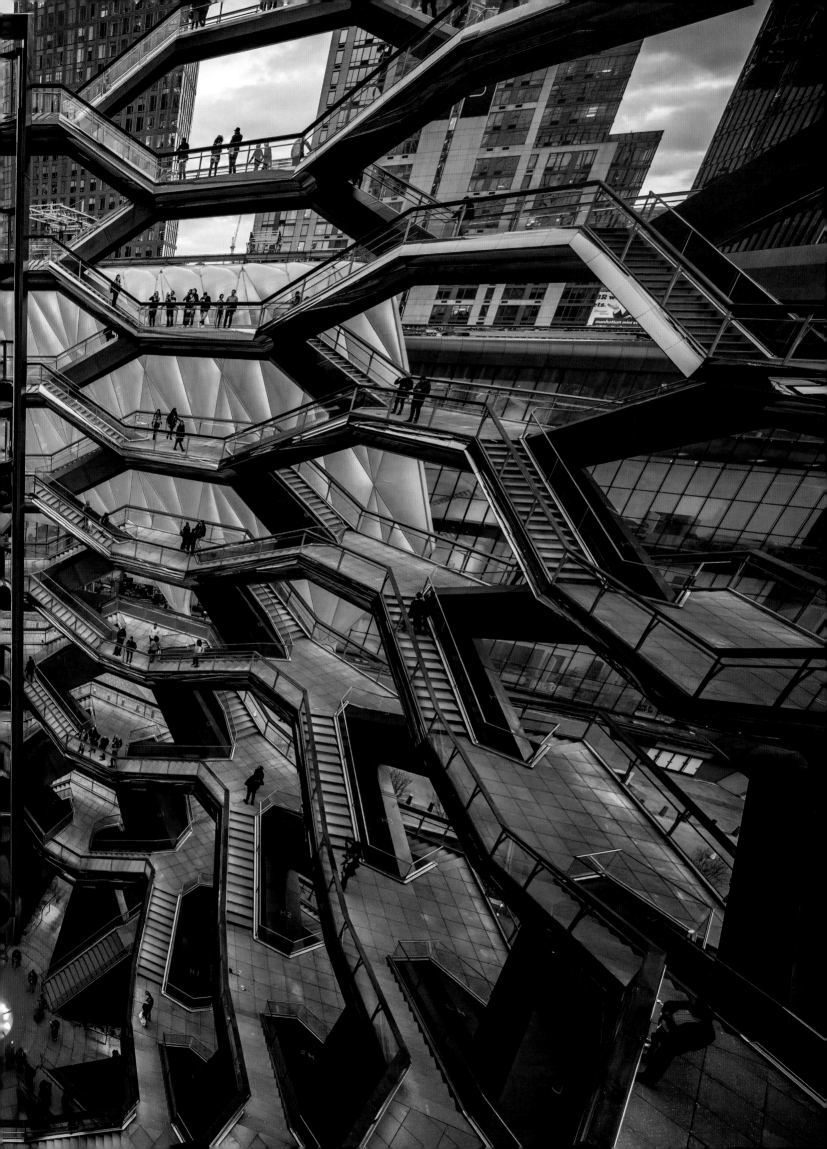

Page 117

Hudson Yards

9 min. and 7 sec. after sunset

Altitude 400 feet

Pages 118-119

Empire State Building 86th floor
observation deck

3 min. and 4 sec. after sunset

Altitude 1,050 feet

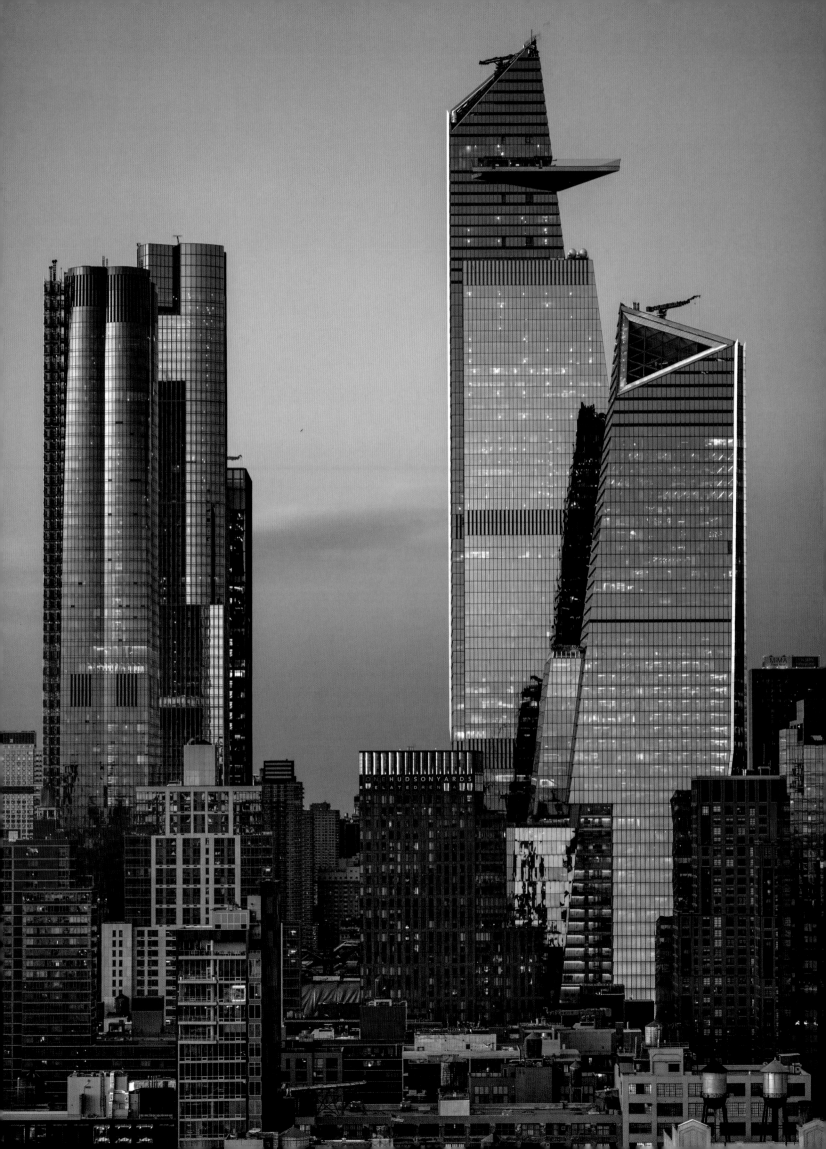

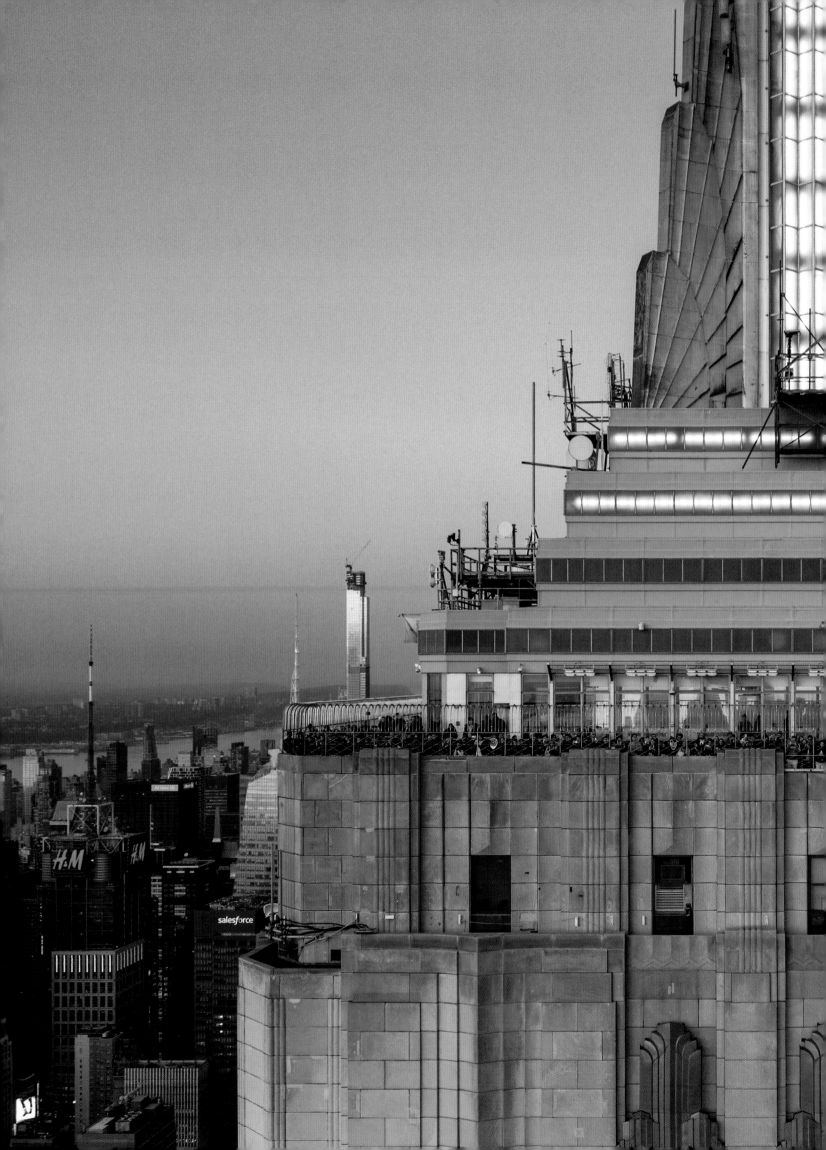

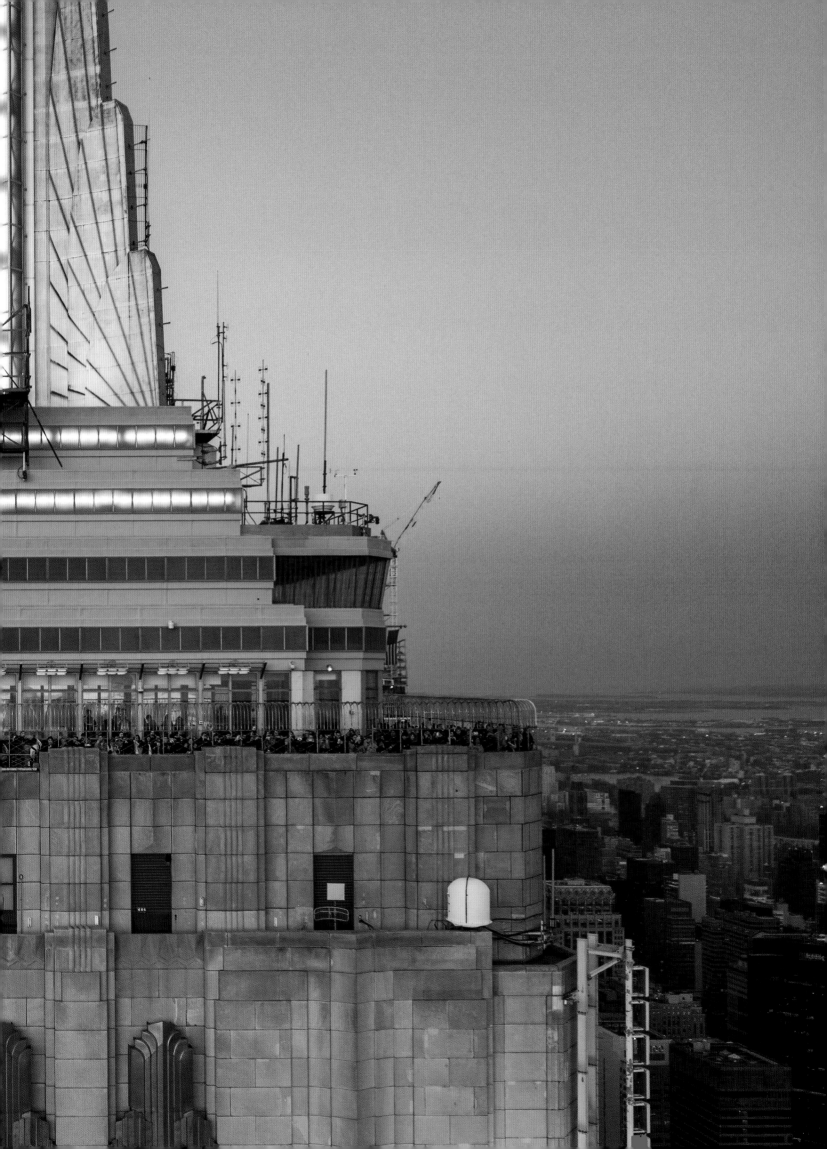

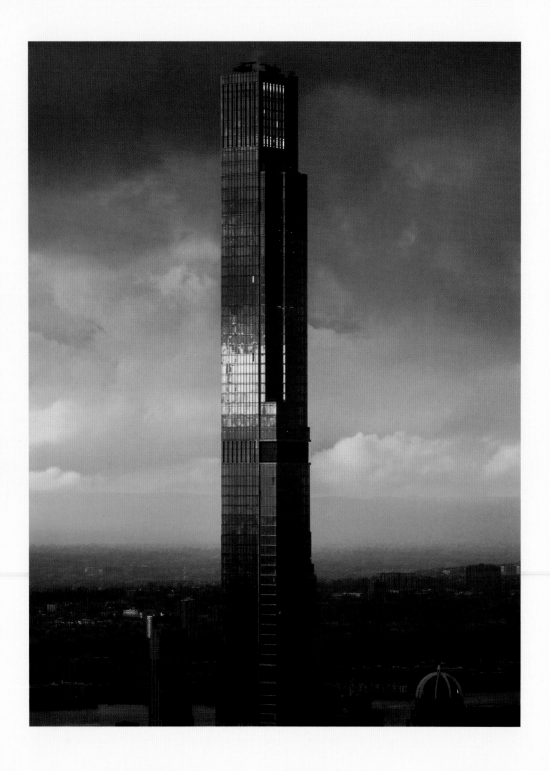

Above

Central Park Tower, as seen from
One Vanderbilt

17 min. and 14 sec. before sunset

Altitude 1,020 feet

Page 121

Central Park, as seen from Central
Park Tower

14 min. and 45 sec. after sunrise

Altitude 1,550 feet

Pages 122-123

Statue of Liberty and Midtown
Manhattan, as seen from Bayonne,
New Jersey

46 min. and 29 sec. before sunset

Altitude 13 feet

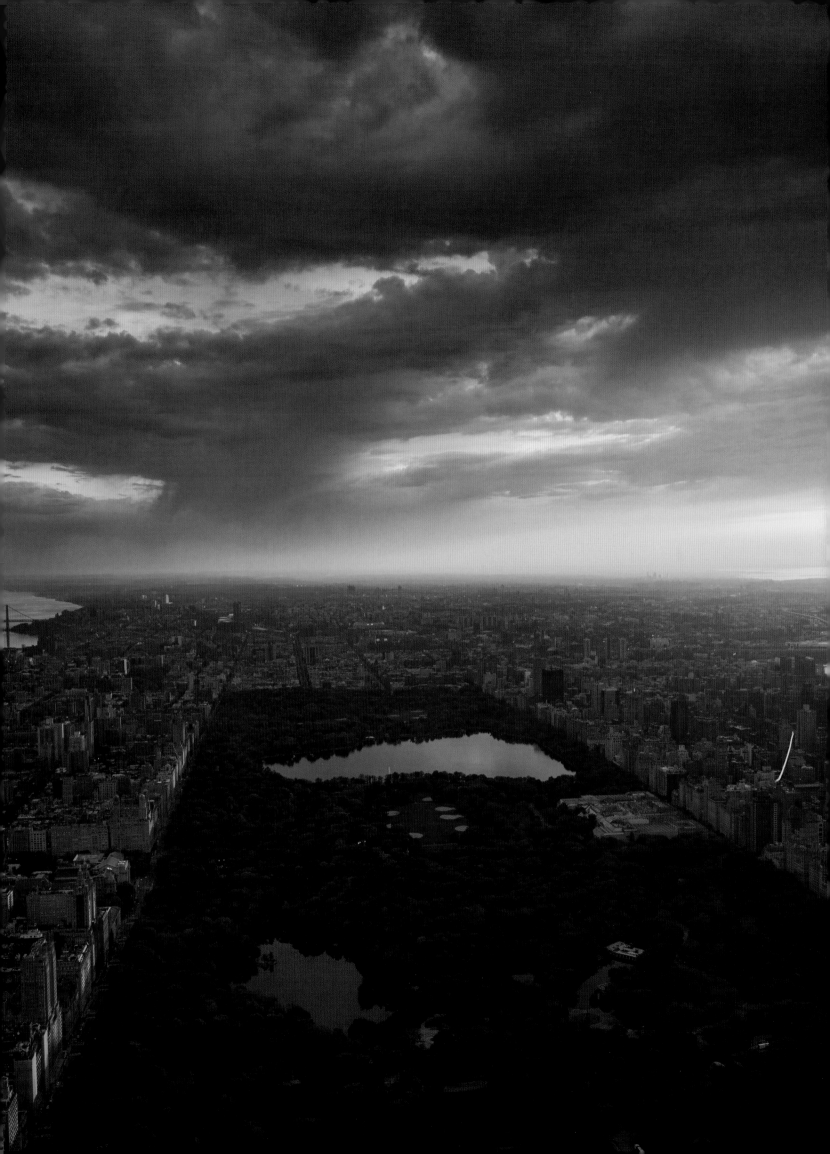

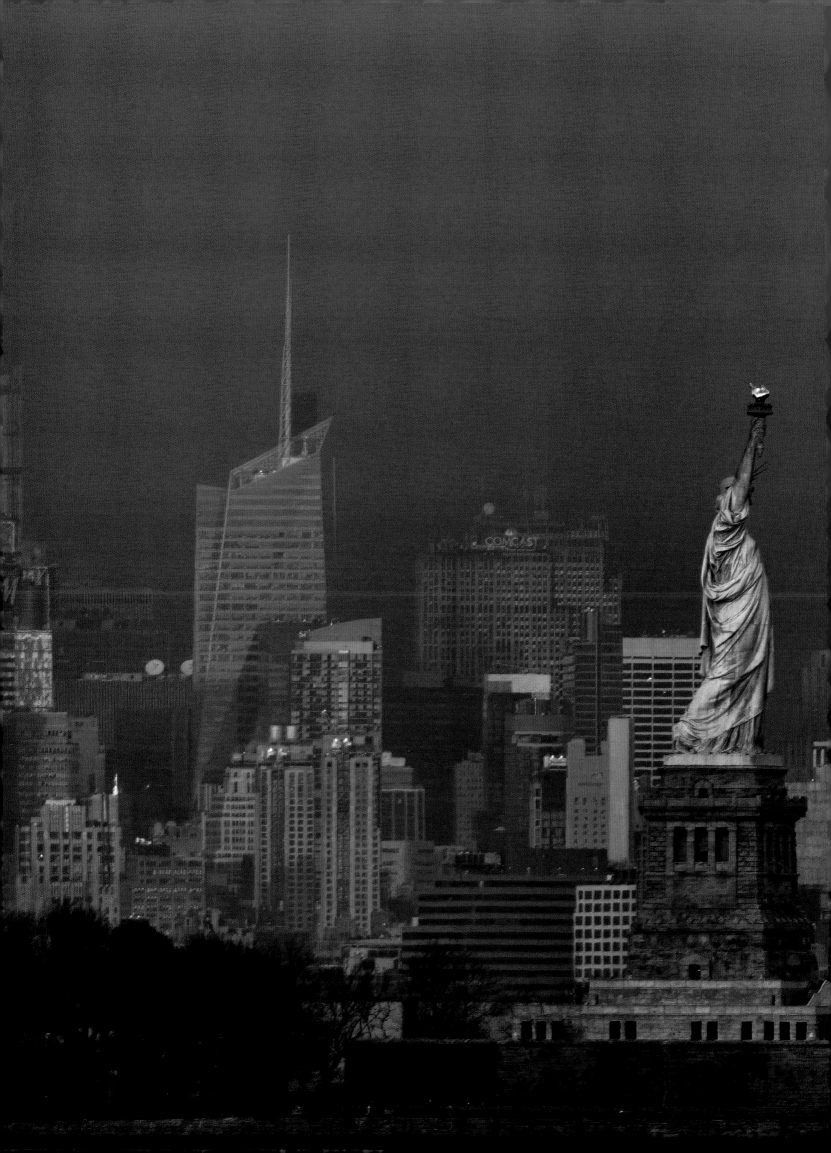

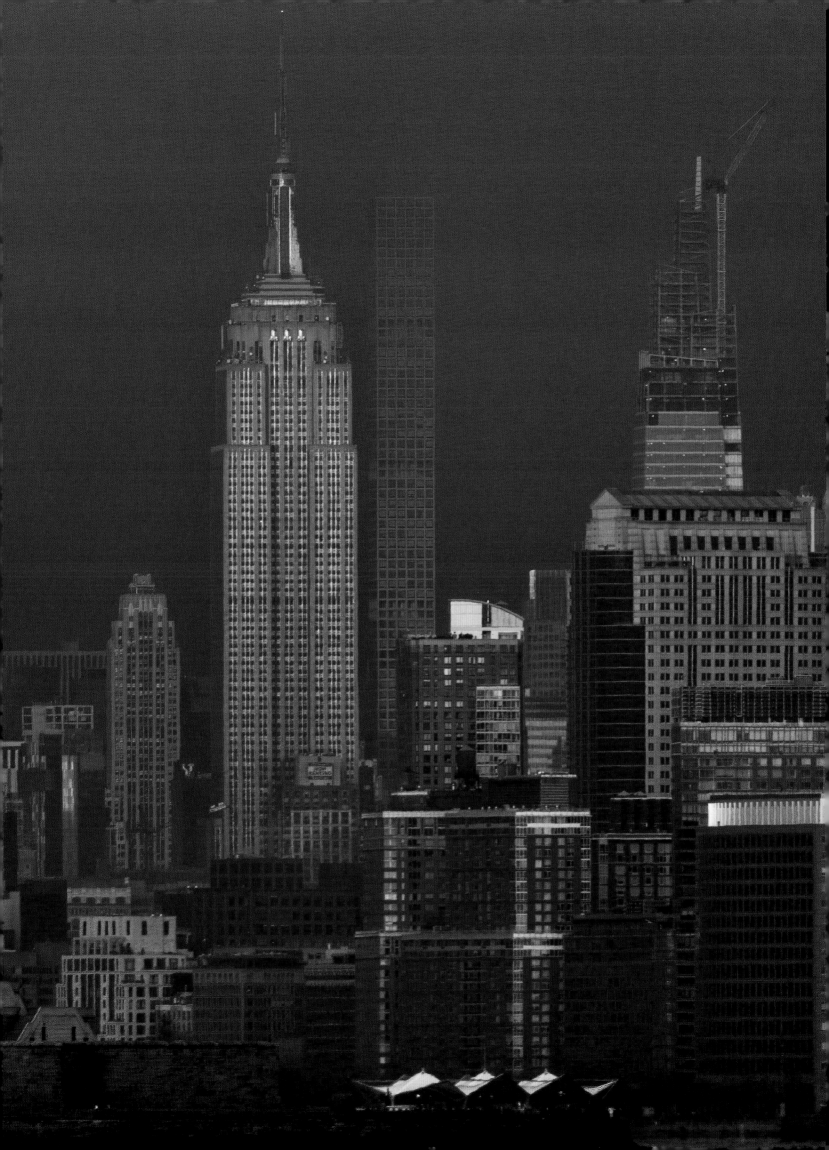

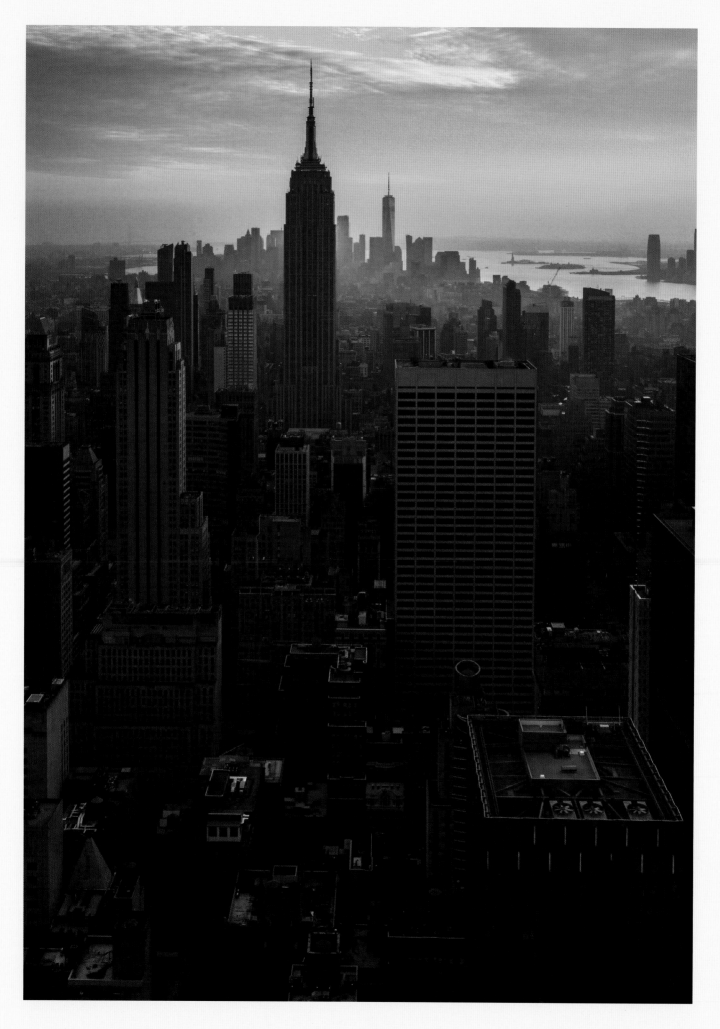

Above
Midtown Manhattan, looking south
23 min. and 47 sec. before sunset
Altitude 850 feet

Page 125
Chrysler Building crown close-up
12 min. and 59 sec. before sunset
Altitude 250 feet

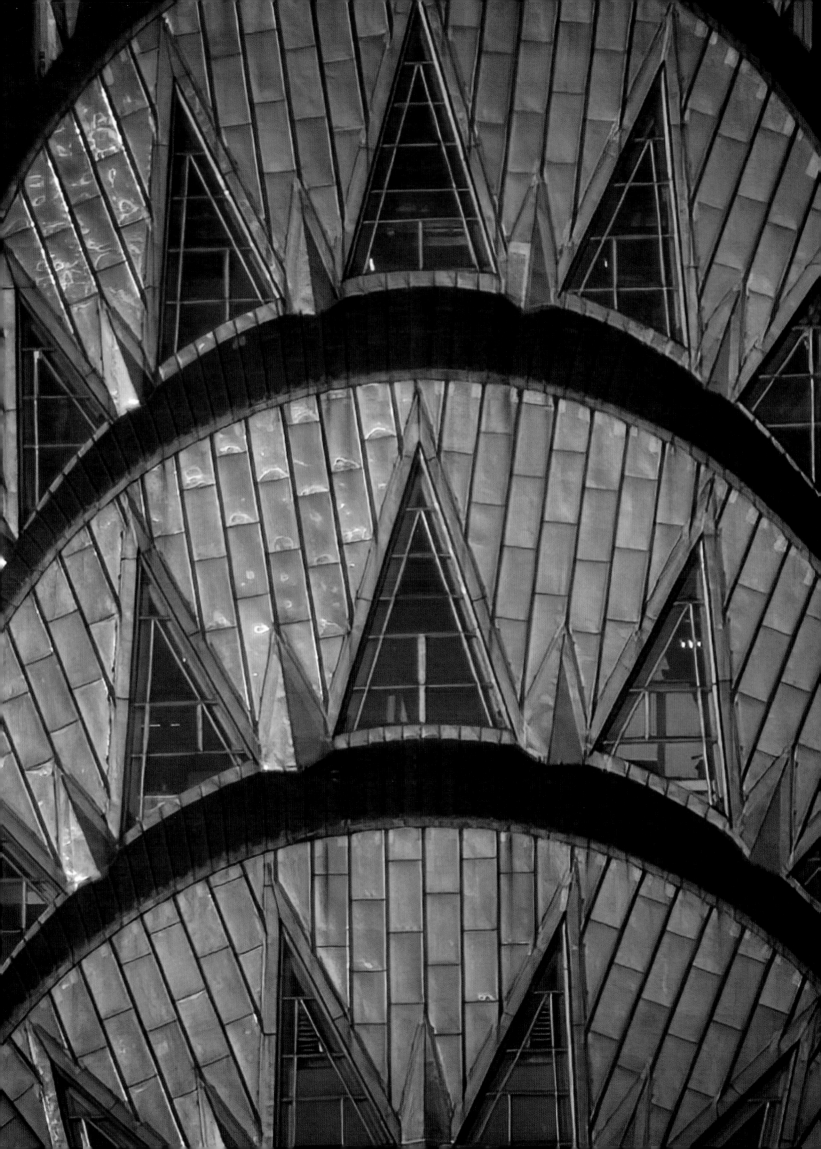

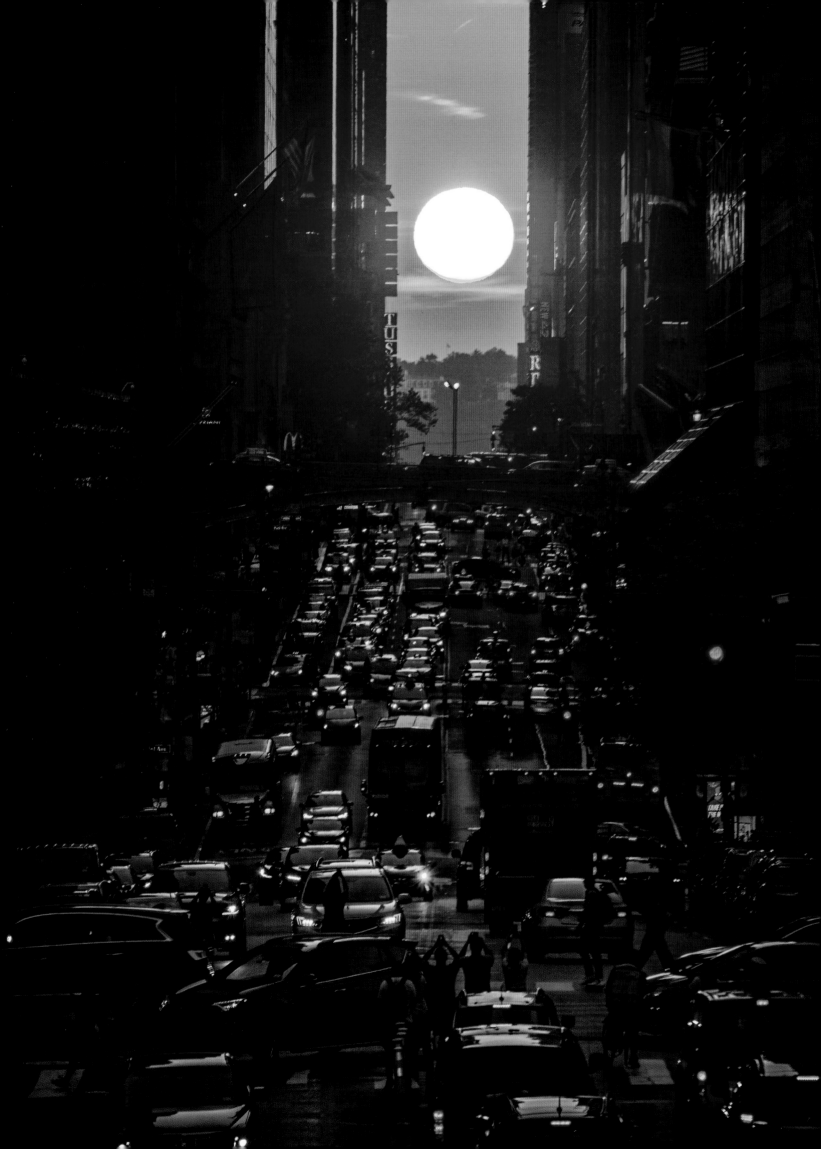

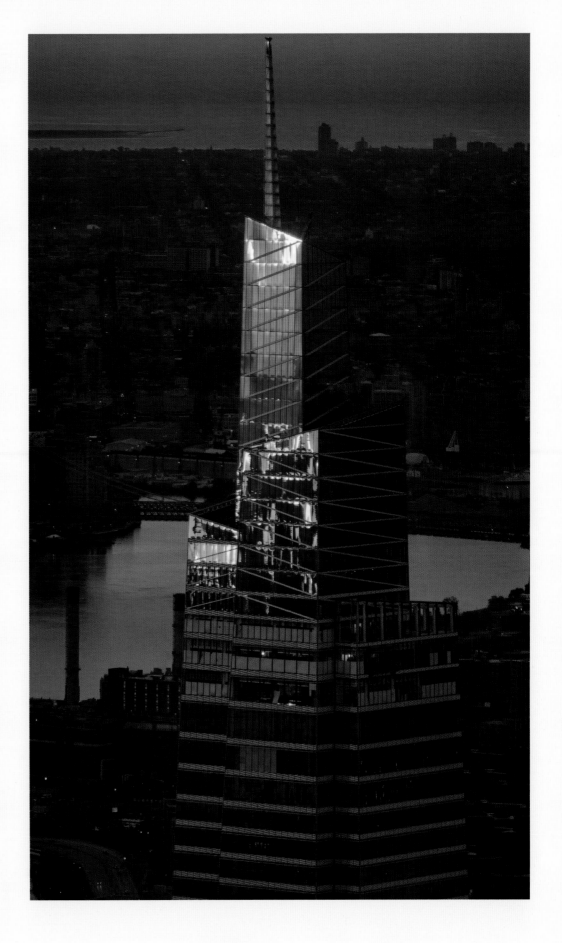

Page 126
Manhattanhenge
9 min. and 24 sec. before sunset
Altitude 38 feet

Above
One Vanderbilt, as seen from
Central Park Tower
11 min. and 59 sec. after sunrise
Altitude 1,550 feet

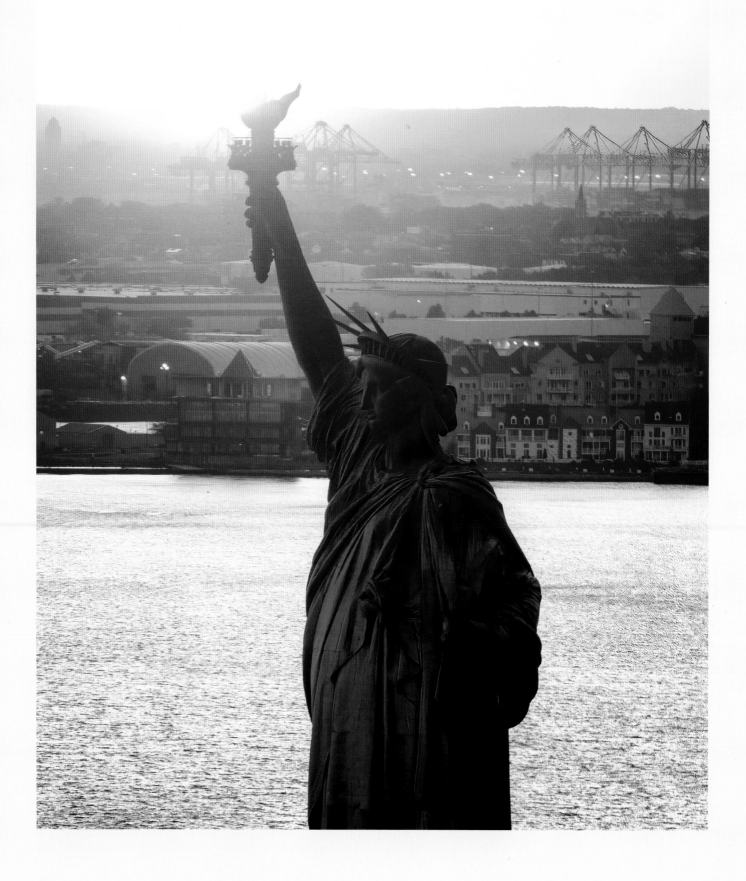

Above
Statue of Liberty
38 sec. before sunset
Altitude 400 feet

Page 129
Chrysler Building iron eagle
17 min. and 52 sec. after sunset
Altitude 780 feet

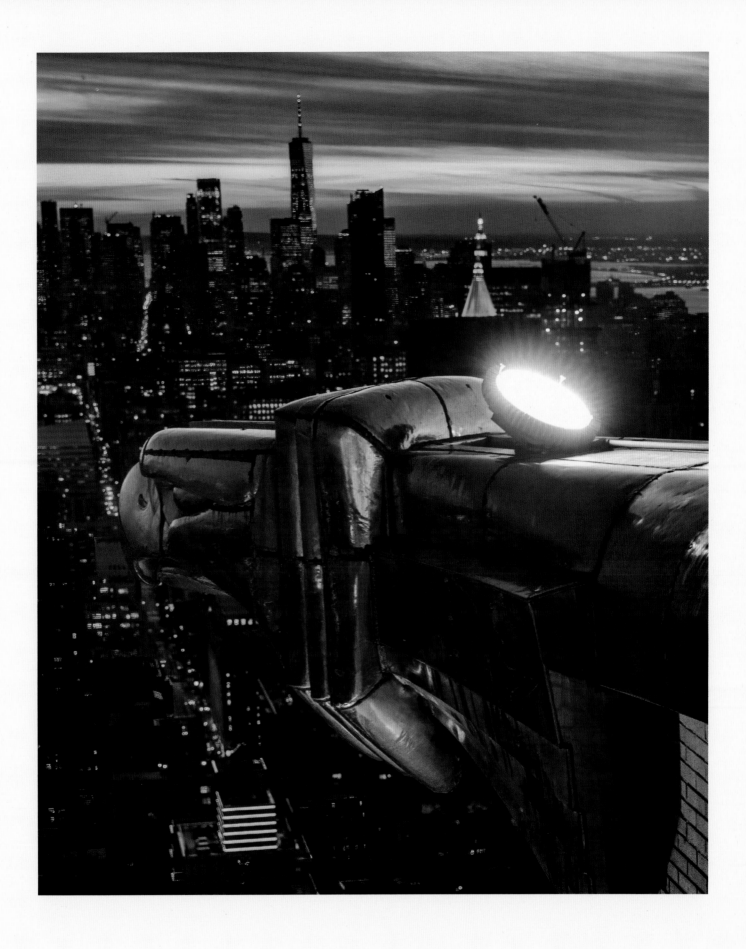

Page 130
The New Yorker Hotel
4 min. before sunset
Altitude 1,131 feet

Page 131
Pepsi-Cola sign, Long Island City, Queens
12 min. before sunset
Altitude 1,600 feet

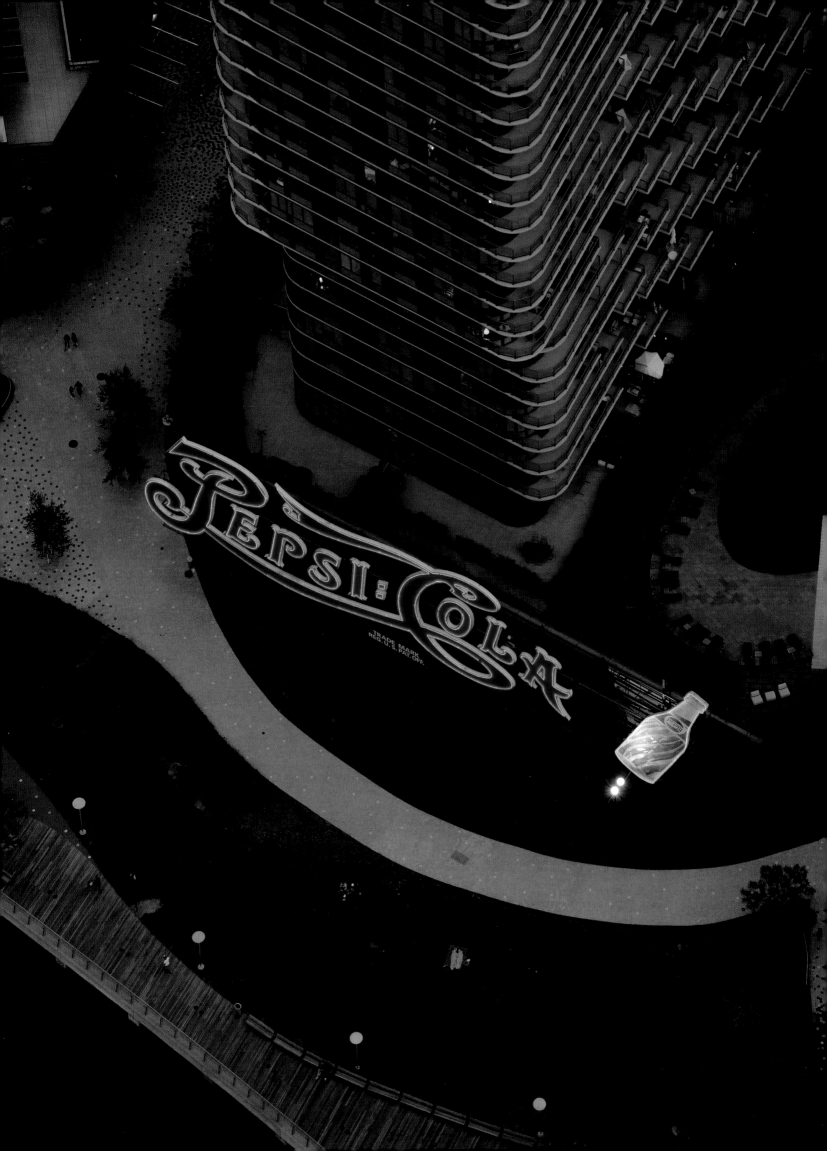

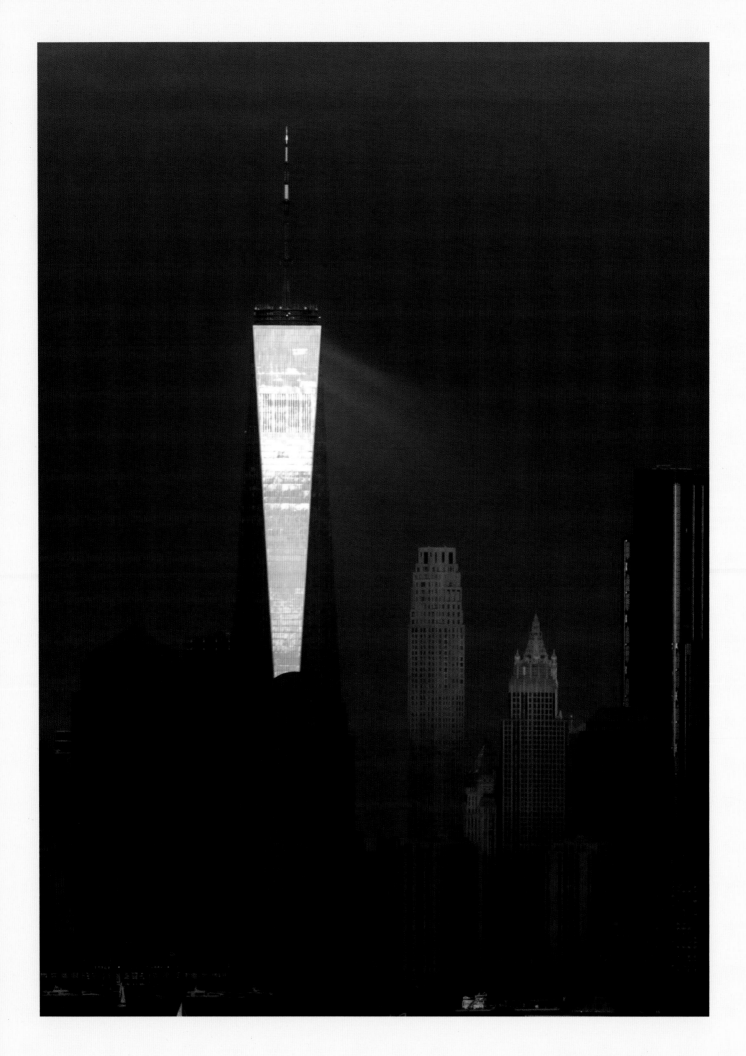

One World Trade Center
56 min. and 41 sec. before sunset
Altitude 1,100 feet

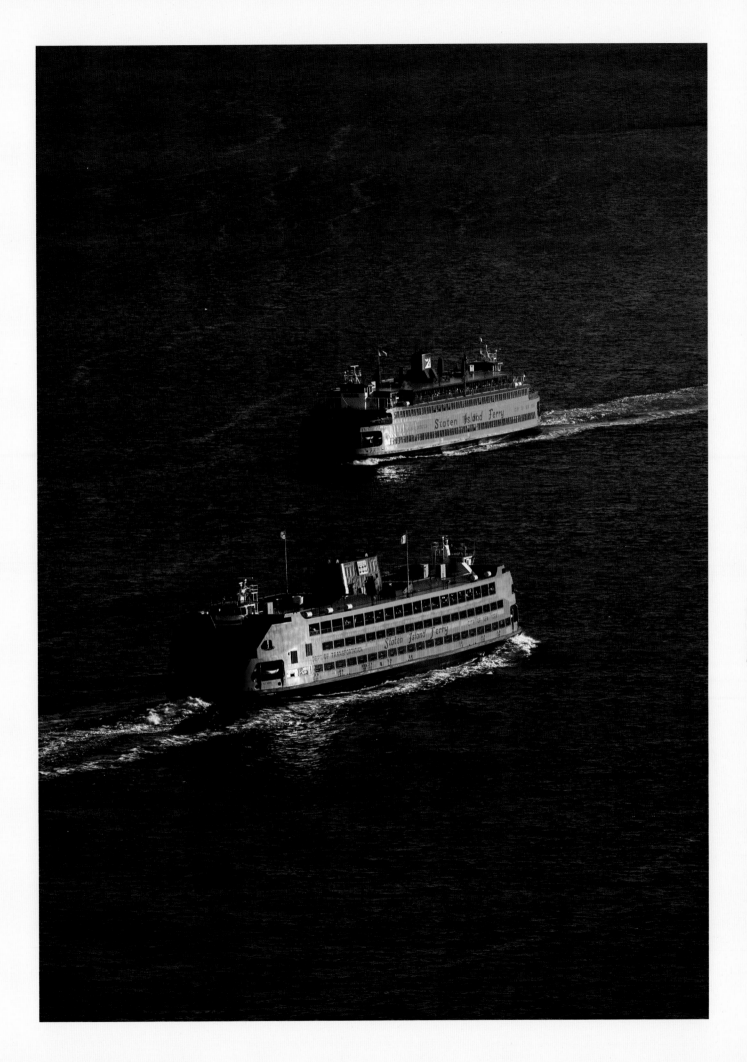

Staten Island Ferry, New York Harbor
1 hr. and 23 sec. before sunset
Altitude 1,300 feet

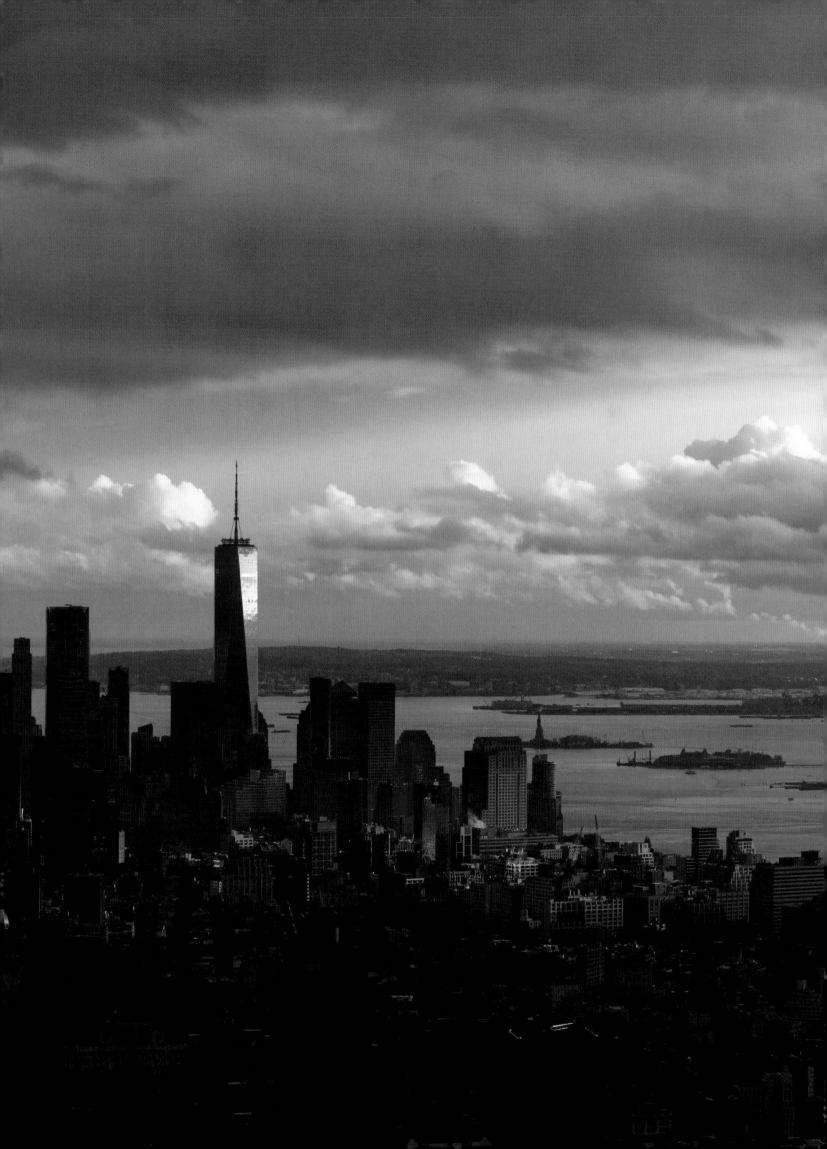

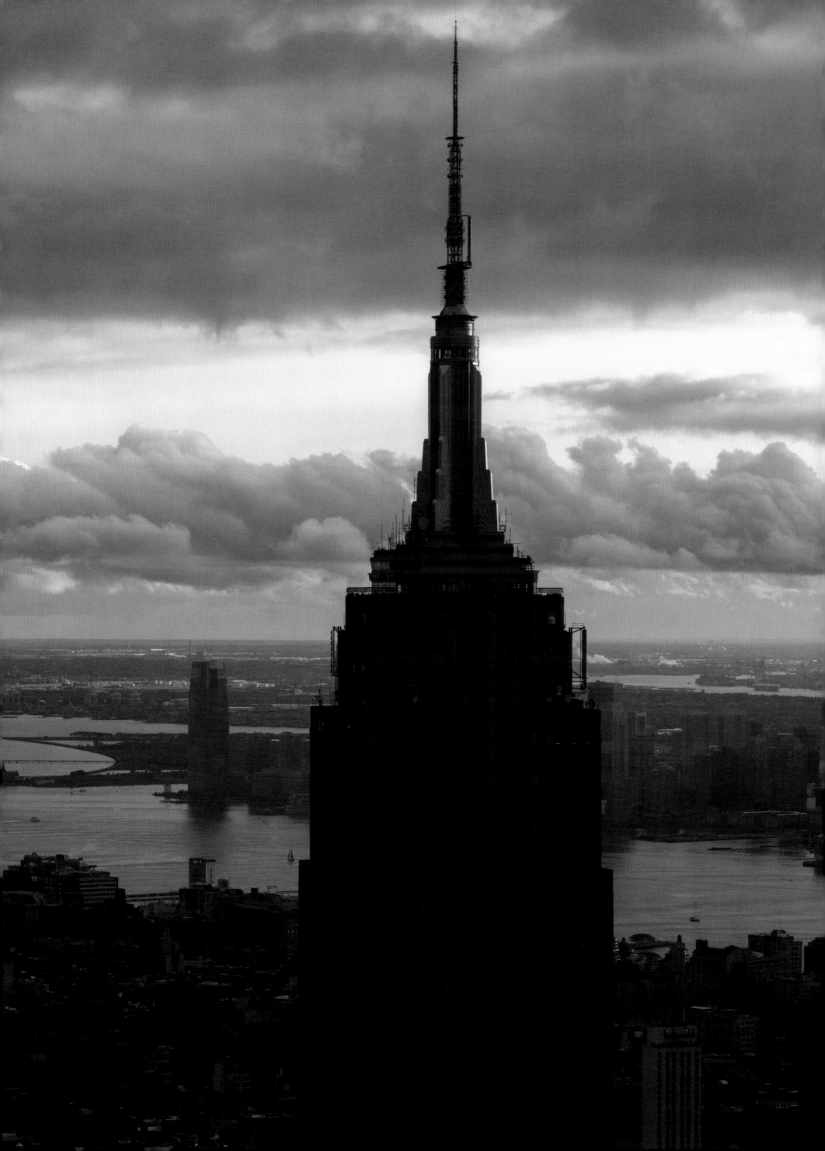

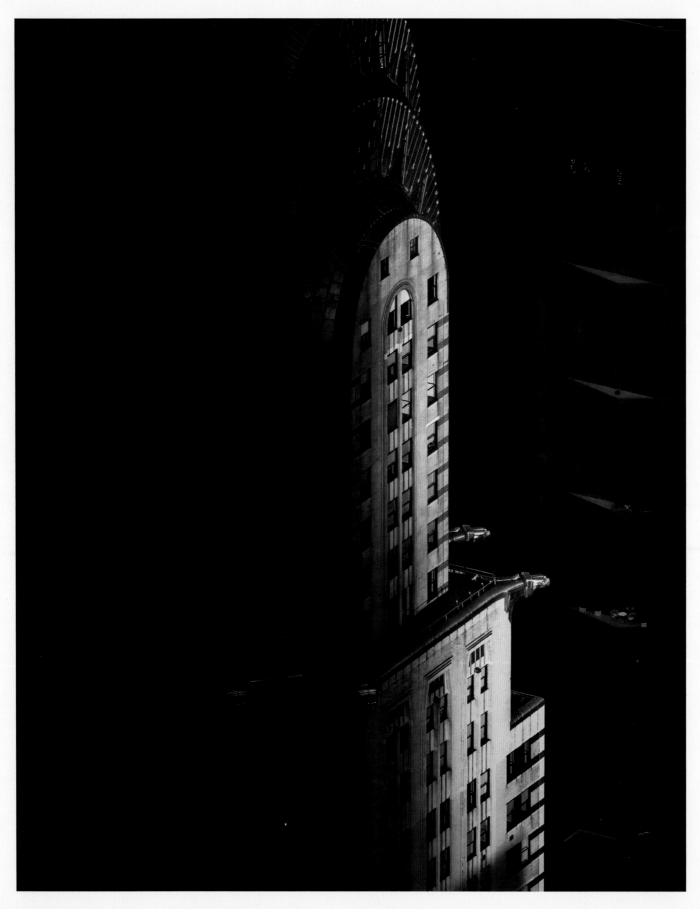

Pages 134-135

Empire State Building and Lower Manhattan, as seen from One Vanderbilt

42 min. and 58 sec. before sunset

Altitude 1,020 feet

Above

Chrysler Building

17 min. and 51 sec. before sunset

Altitude 1,250 feet

Page 137

Helmsley Building crown

18 min. and 24 sec. before sunset

Altitude 1,900 feet

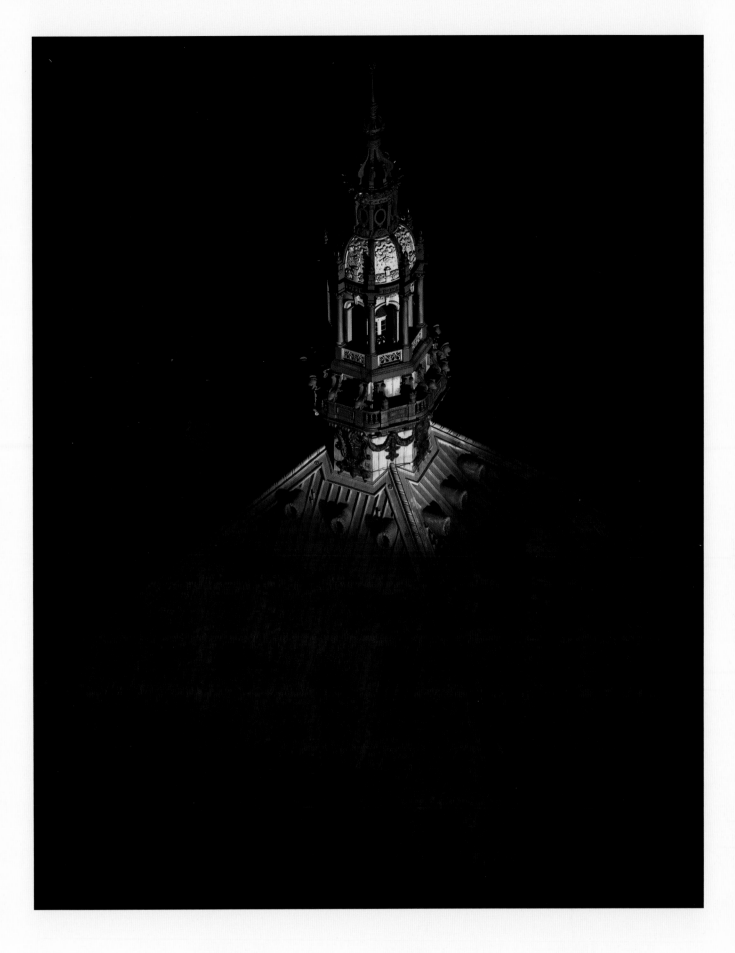

Page 138
Brooklyn Bridge
32 min. and 34 sec. before sunset
Altitude 1,475 feet

Page 139
South side of Flatiron Building
1 hr. and 29 min. before sunset
Altitude 1,650 feet

Page 140
Municipal Building
31 min. and 46 sec. before sunset
Altitude 1,575 feet

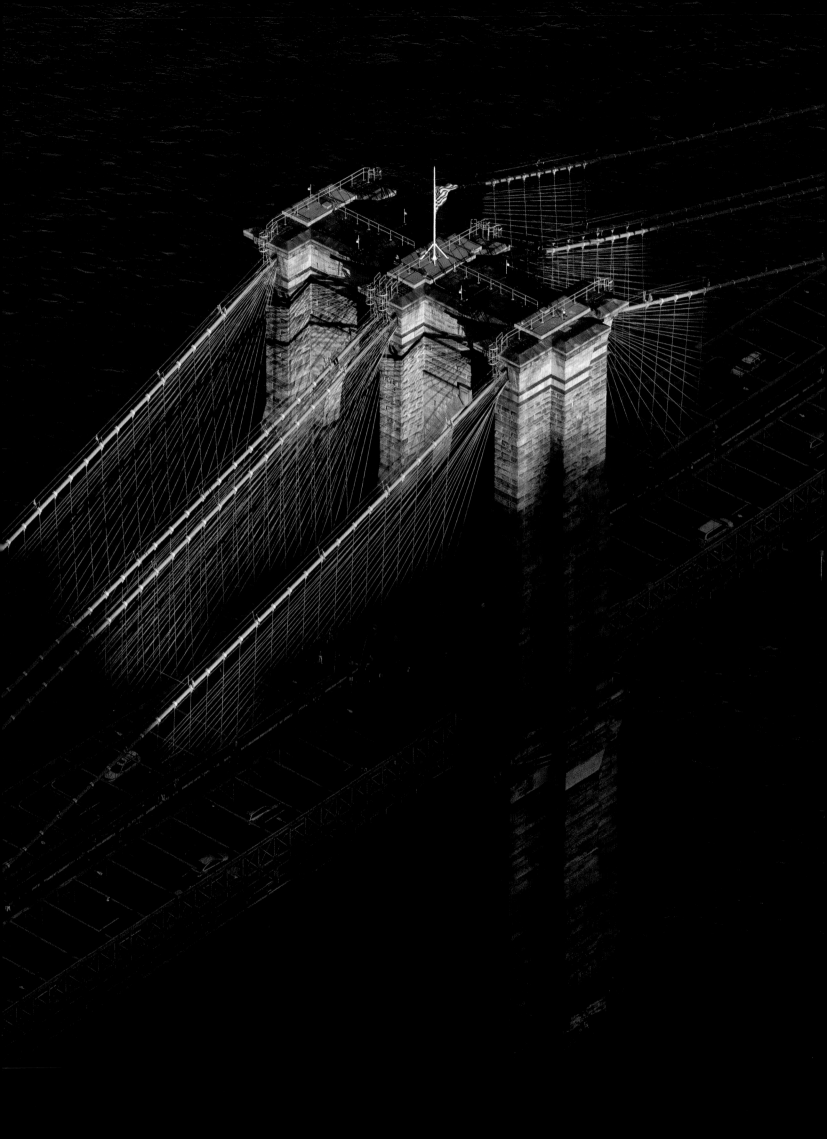

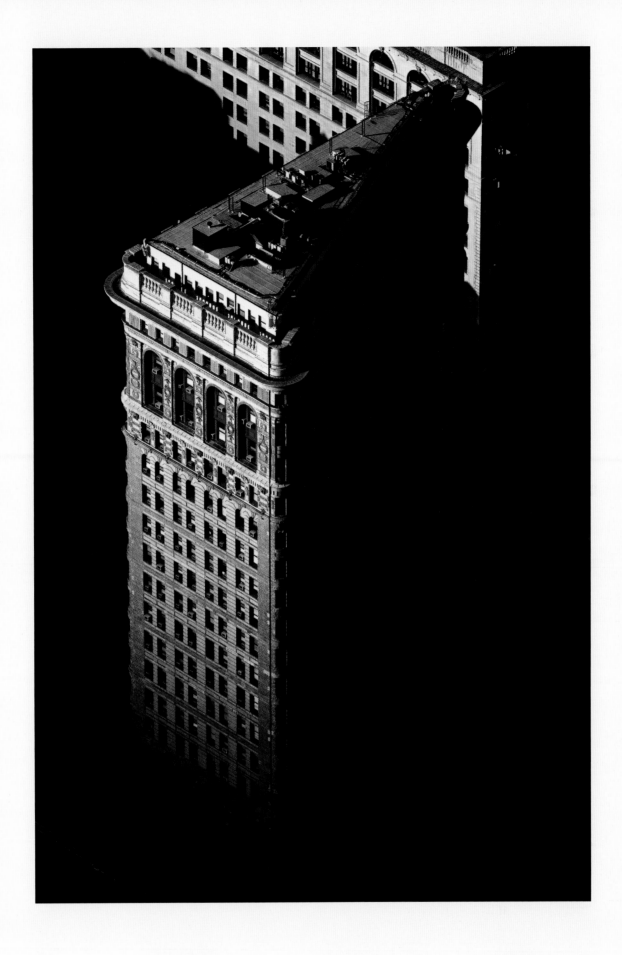

Page 141
Empire State Building
1 hr. and 18 min. before sunset
Altitude 15 feet

Pages 142-143
The Oculus, World Trade Center
PATH Station
5 min. and 22 sec. before sunset
Altitude 1,700 feet

Page 144
One World Trade Center
1 hr. and 1 min. after sunset
Altitude 1,776 feet

Page 145
Chrysler Building eagle
and MetLife Building
20 min. and 16 sec. after sunset
Altitude 780 feet

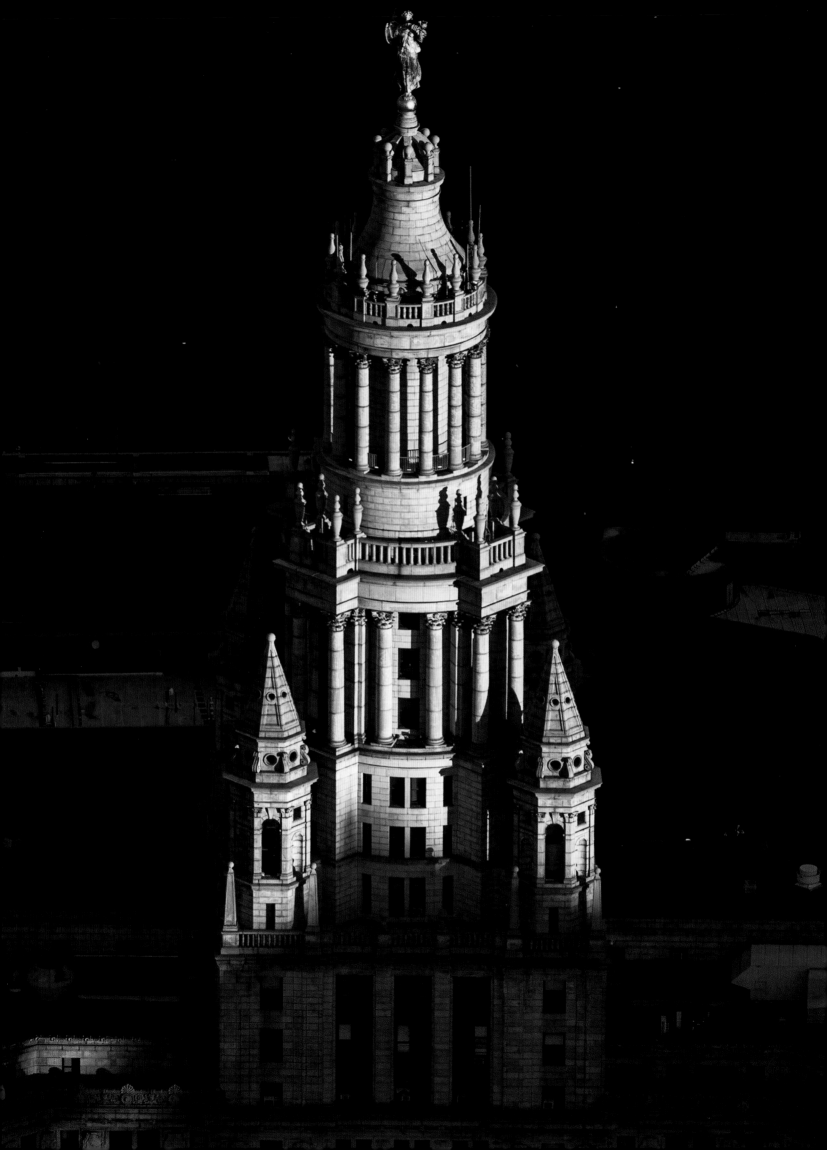

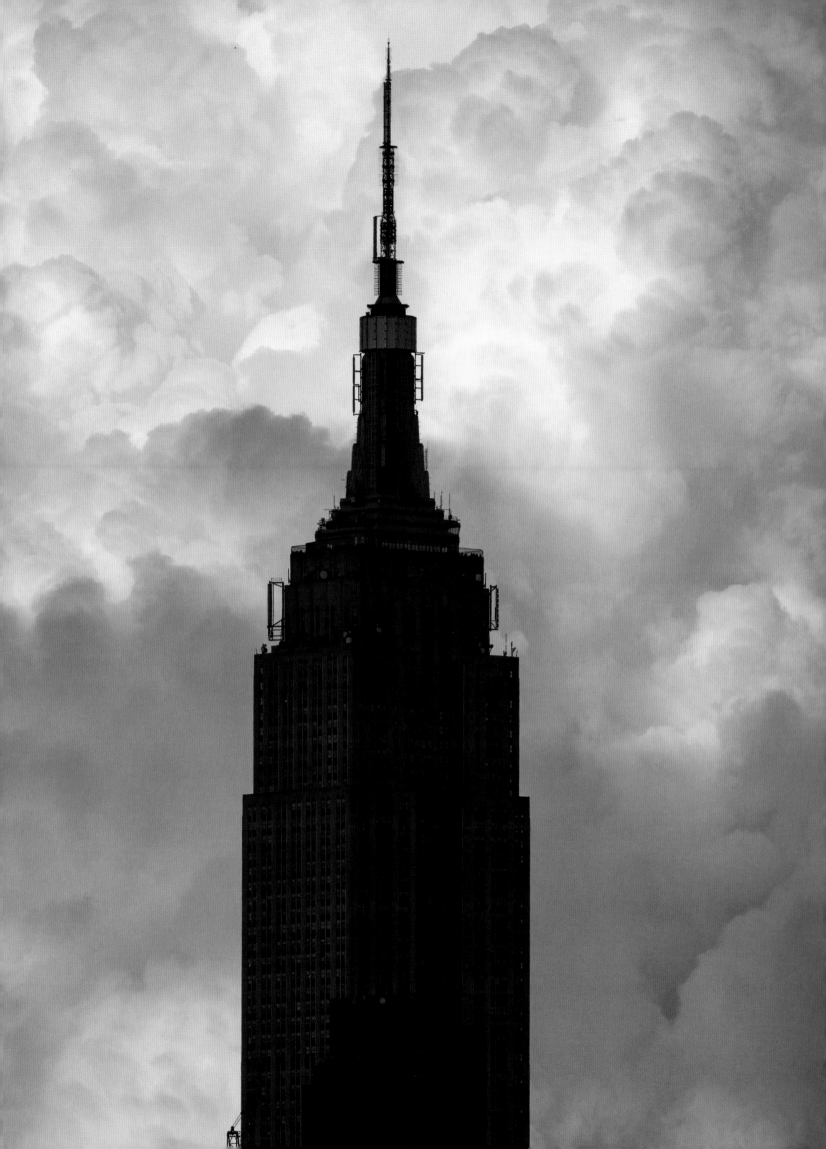

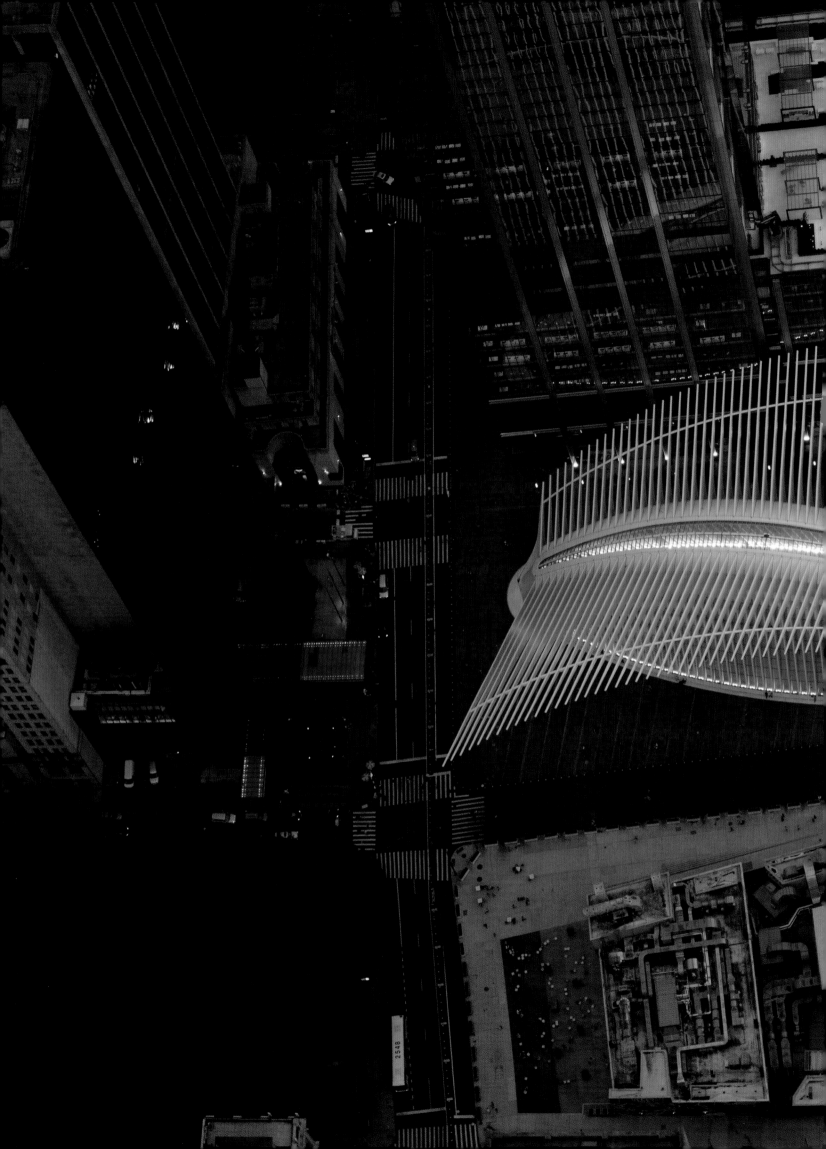

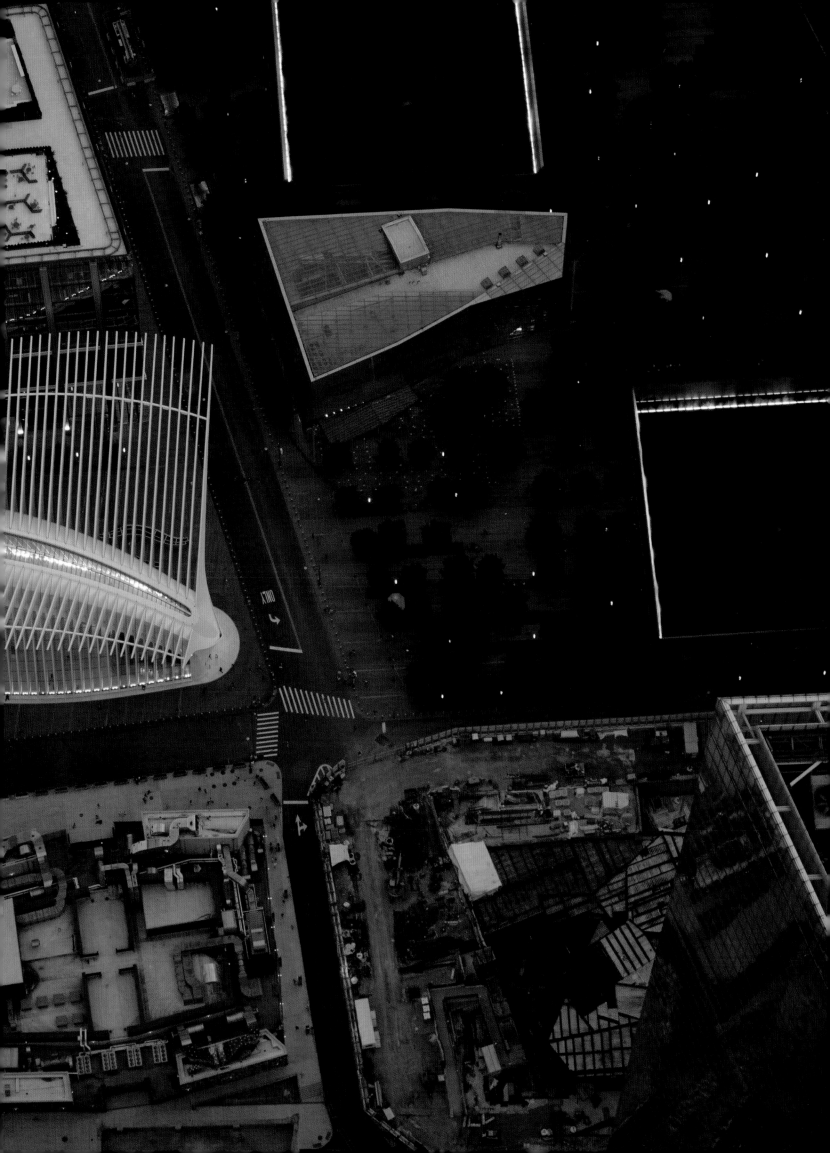

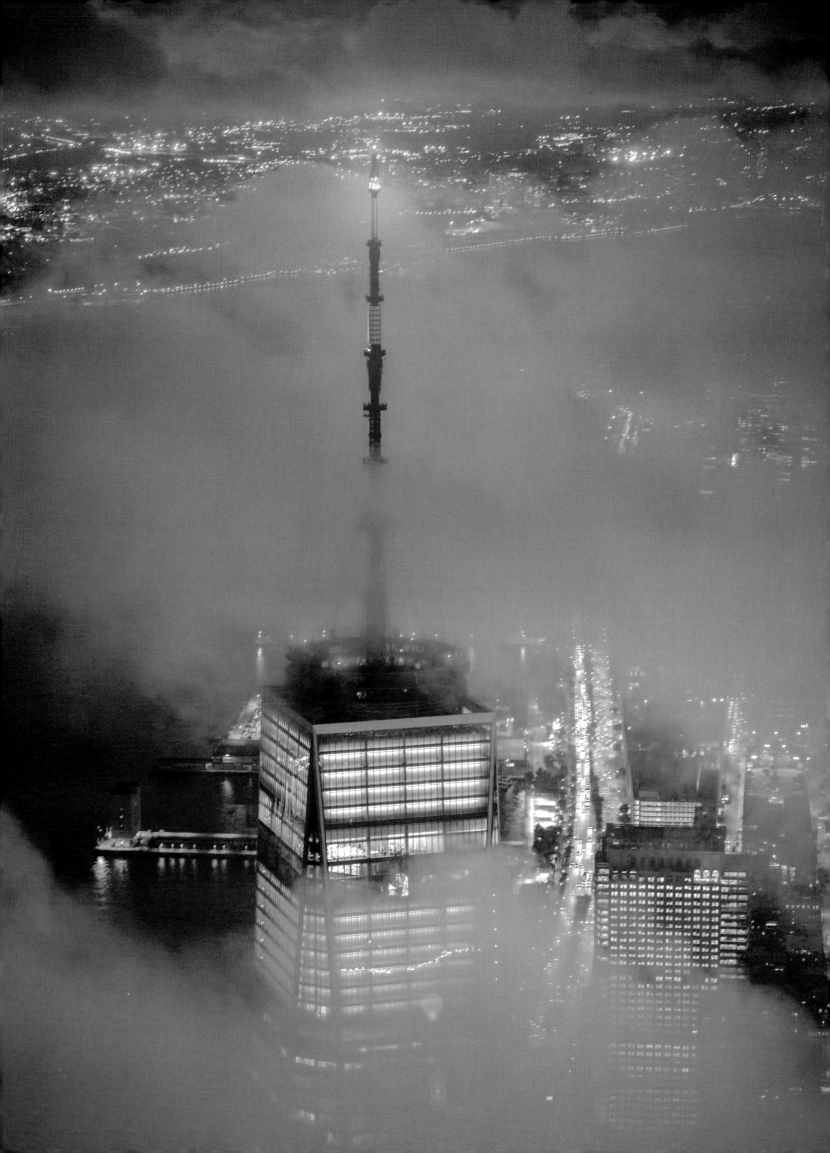

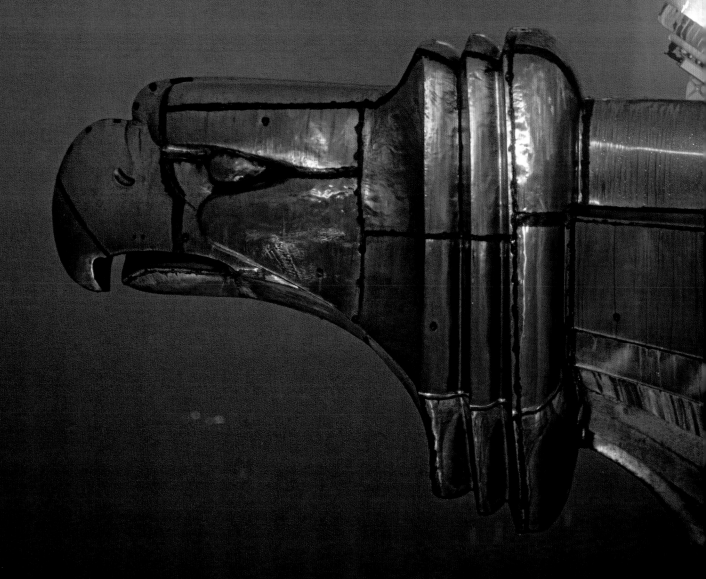

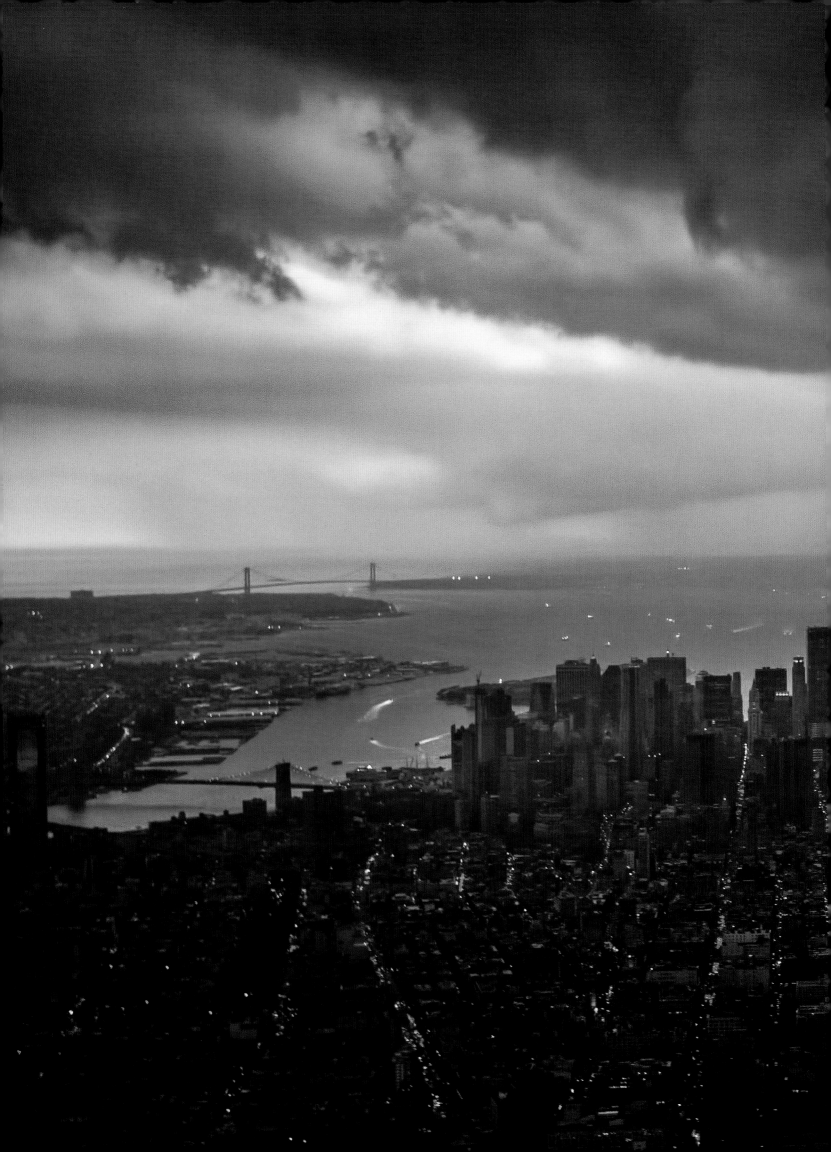

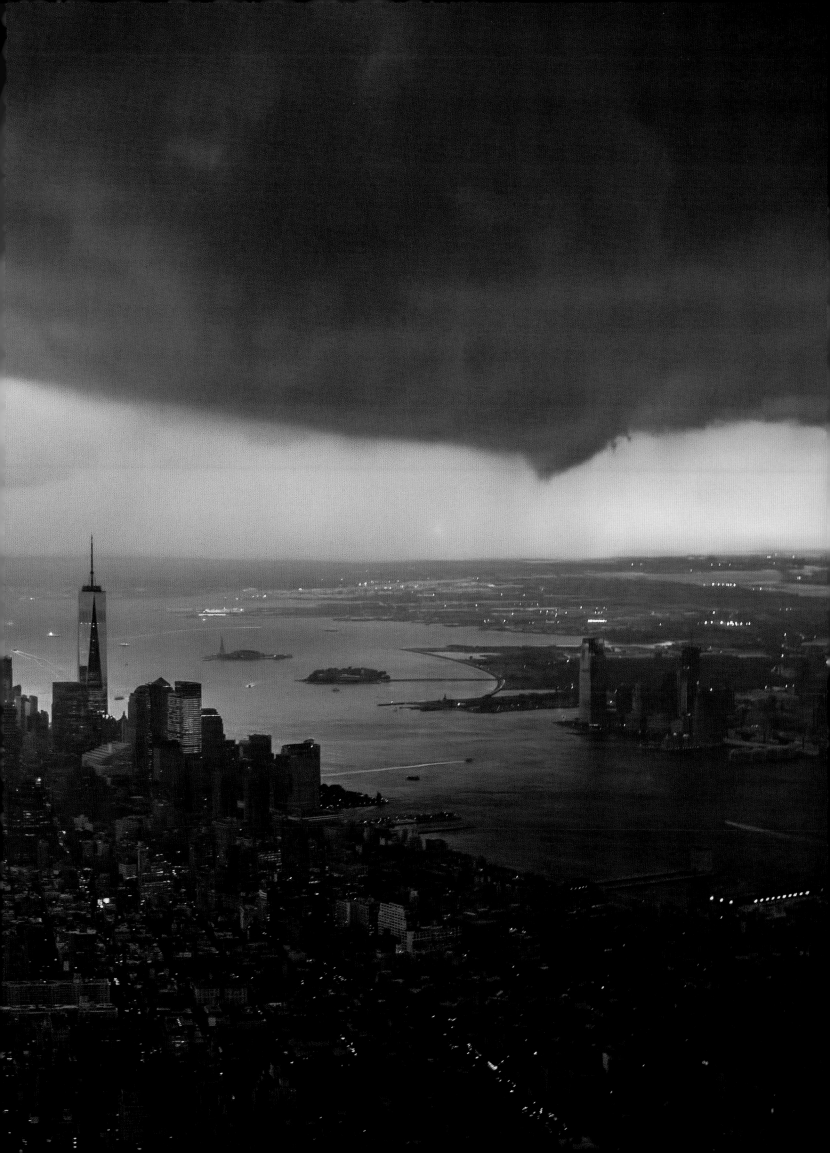

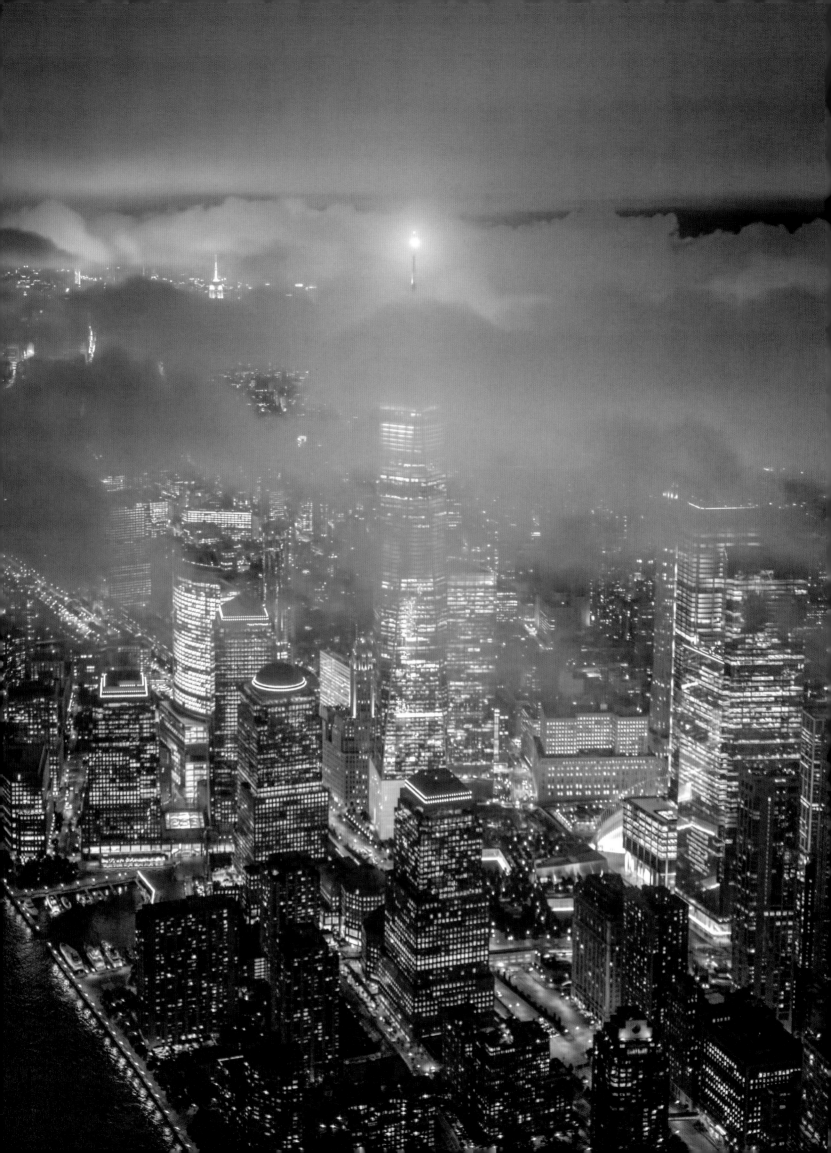

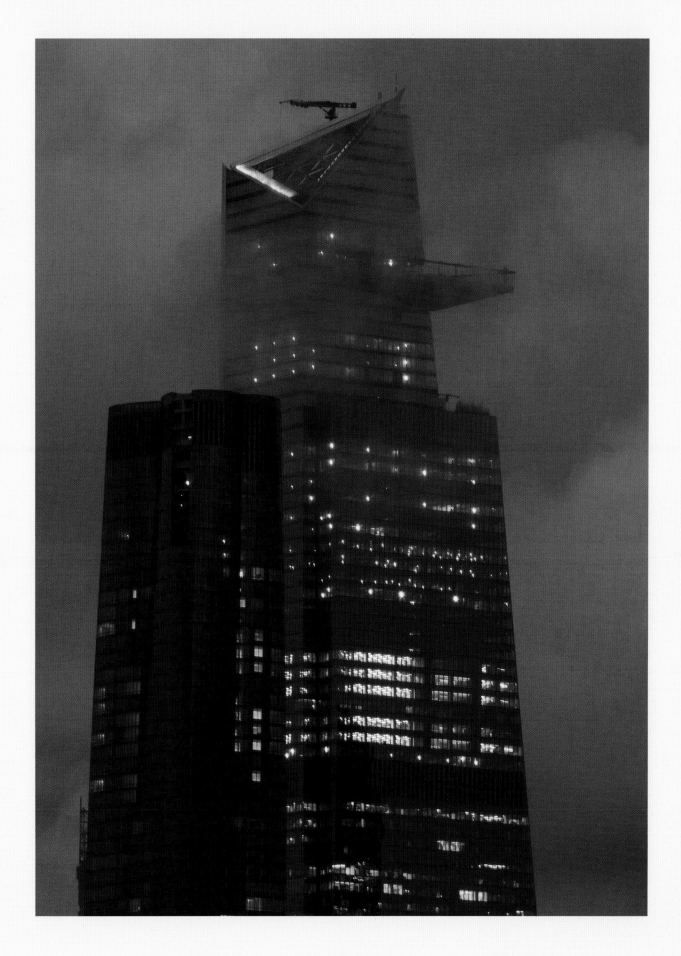

Pages 146-147
The Storm
1 hr. and 2 min. before sunset
Altitude 1,100 feet

Page 148
One World Trade Center
1 hr. and 6 min. after sunset
Altitude 1,900 feet

Above
Hudson Yards
1 hr. and 8 min. before sunset
Altitude 8 feet

NEW YORK TERMINAL AREA

HUDSON RIVER ROUTE:

 Northbound - East Side of Verrazano Bridge to Governors Island direct to southwest tip of Manhattan Island then via east bank to Spuyten Duyvil.

 Southbound - Harlem River direct west bank of Hudson River southbound via west bank to western Holland Tunnel Ventilation Tower to Hudson Checkpoint.

EAST RIVER ROUTE:

 Northbound - Governors Island direct Williamsburg Bridge via east bank to Bowery Bay.

 Southbound - Bowery Bay to west bank via west bank to Battery Park.

PARK ROUTE: JFK direct south side of Aqueduct Racetrack direct Prospect Park direct Hudson Checkpoint.

BRONX ROUTE: North tip Roosevelt Island direct Triborough Bridge toll plaza via west side I-278 to point ALPHA (I-895/I-278 intersection) direct to point BRAVO I-95 intersection SE of Bronx Zoo) northbound via elevated railway to Wakefield switchyard.

THROGS ROUTE : Udall's Millpond direct south Stanchion Throgs Neck Bridge direct LGA control tower direct Bowery Bay direct Triborough Bridge direct north tip Roosevelt Island.

CENTRAL PARK ROUTE: North tip Roosevelt Island across Central Park Lake at 72nd Street direct Hudson River.

** TRACK ROUTE: Intersection of Long Island Railroad and Meadowbrook State Parkway. West via Long Island Railroad to Ridgewood Reservoir direct to Lincoln Terrace Park. Note: Route may split at Ridgewood Reservoir.

WILLIAMSBURG ROUTE: East River direct Williamsburg Bridge, maintain 900' eastbound south of Twin White Tanks direct Ridgewood Reservoir as assigned, (see ** routes).

RESERVOIR ROUTE: East 34th Street Heliport direct Newtown Creek to Twin White Tanks direct Ridgewood Reservoir as assigned, (see * * routes) .

HARLEM RIVER ROUTE: Triborough Bridge via Harlem River northbound to Spuyten Duyvil.

CREEK ROUTE: Lincoln Terrace Park direct Spring Creek Park direct to a point immediately adjacent to northwest end of runway 13R parallel taxiway. Note: Simultaneous fixed wing arrivals on JFK ILS runway 13L.

TETERBORO TERMINAL AREA

SIERRA ROUTE:

 DEPARTURE - Direct to windsock at Coca Cola plant to stack at metal treatment plant direct to the Lombardi Service Area. REMAINING ON THE SOUTH SIDE OF EMPIRE BLVD. AT ALL TIMES, to the west entrance of the Lincoln Tunnel (via overhead N.J. Turnpike, I-95, - east extension and Route 3) or North Hudson Park.

 ARRIVAL - Via the west entrance to the Lincoln Tunnel or via North Hudson Park to the Lombardi Service Area direct to stack at metal treatment plant direct to windsock at Coca Cola plant. REMAINING ON THE SOUTH SIDE OF EMPIRE BLVD. AT All TIMES, then direct to the airport REMAINING EAST OF THE EXTENDED CENTERLINE OF RUNWAY 01/19 and CLEAR ALL RESIDENTIAL AREAS.

NOTE: PILOTS ANNOUNCE INTENDED ROUTE ON INITIAL CONTACT

CAUTION: ROUTES DEPICTED AND ALTITUDES ASSIGNED DO NOT PROVIDE OBSTACLE CLEARANCE PROTECTION. PILOTS ARE RESPONSIBLE FOR SEEING AND AVOIDING TERRAIN AND OBSTACLES. THIS CHART DOES NOT DEPICT COMPLETE OBSTACLE INFORMATION DUE TO THE HIGH CONCENTRATION OF OBJECTS IN THE AREA. OBSTACLES AND OTHER FEATURES SUCH AS POWER TRANSMISSION LINES AND PROMINENT STRUCTURES ARE DEPICTED FOR LANDMARK VALUE ONLY.

Page 151
FDR Drive, Stuyvesant Town,
and Midtown Manhattan
15 min. and 34 sec. after sunset
Altitude 1,250 feet

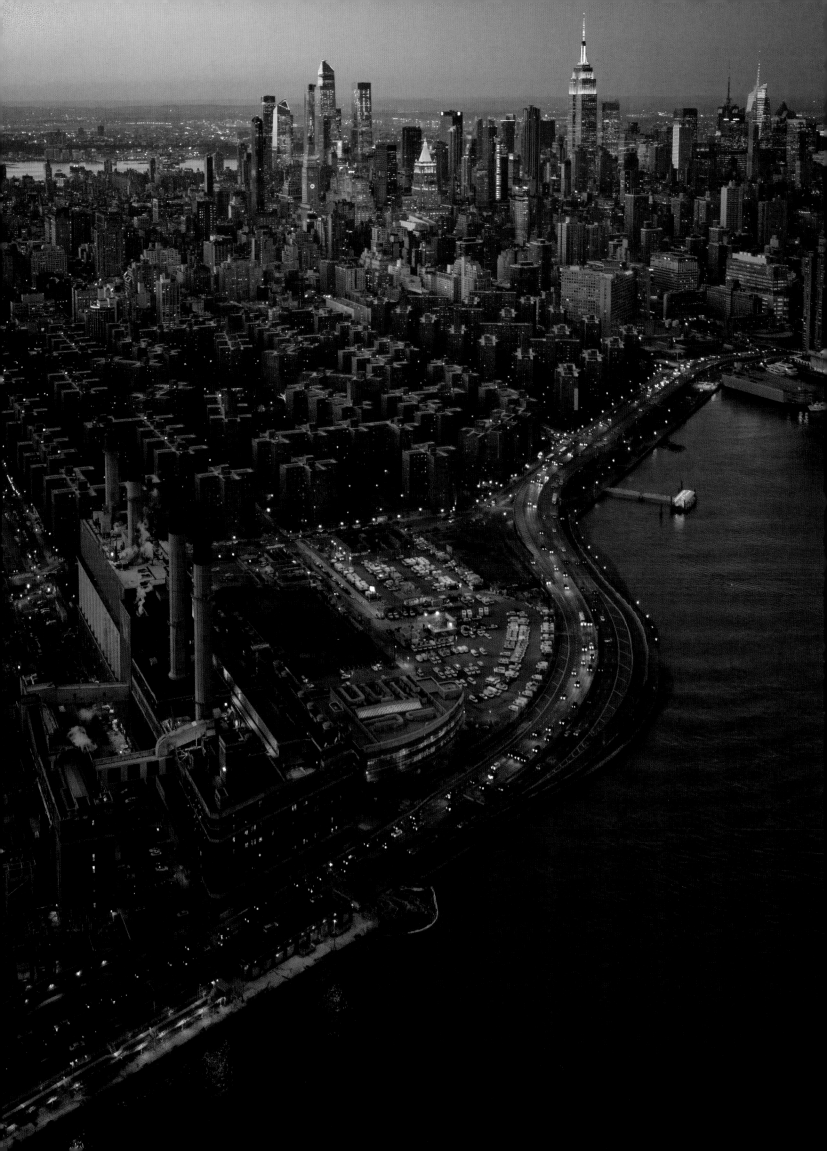

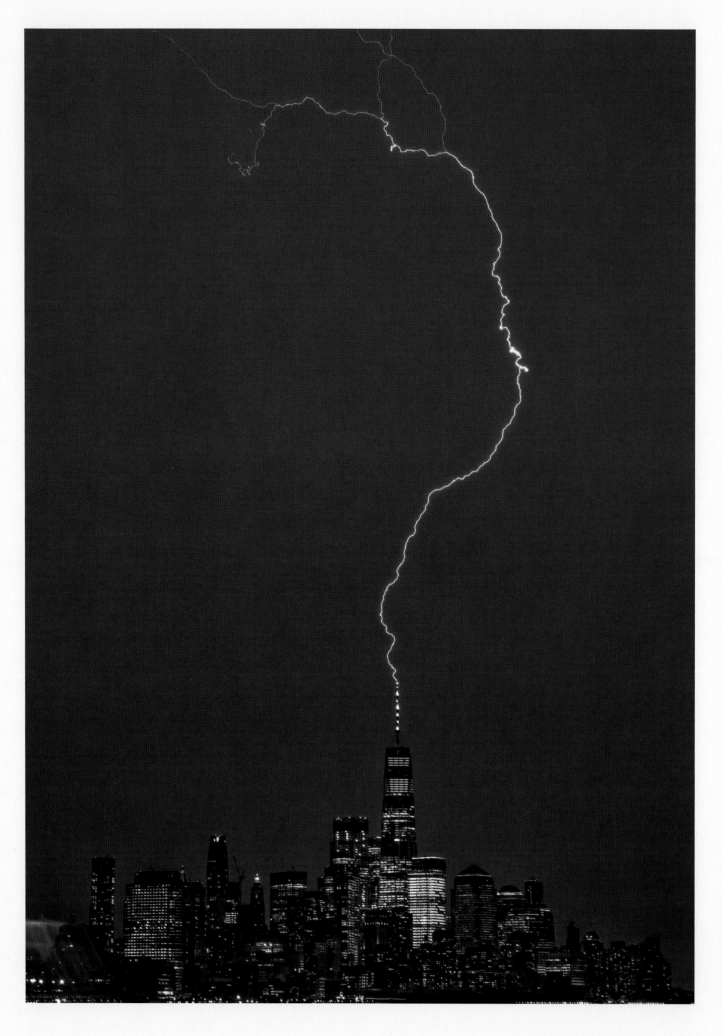

Lightning strike on
One World Trade Center

6 min. and 15 sec. after sunset

Altitude 8 feet

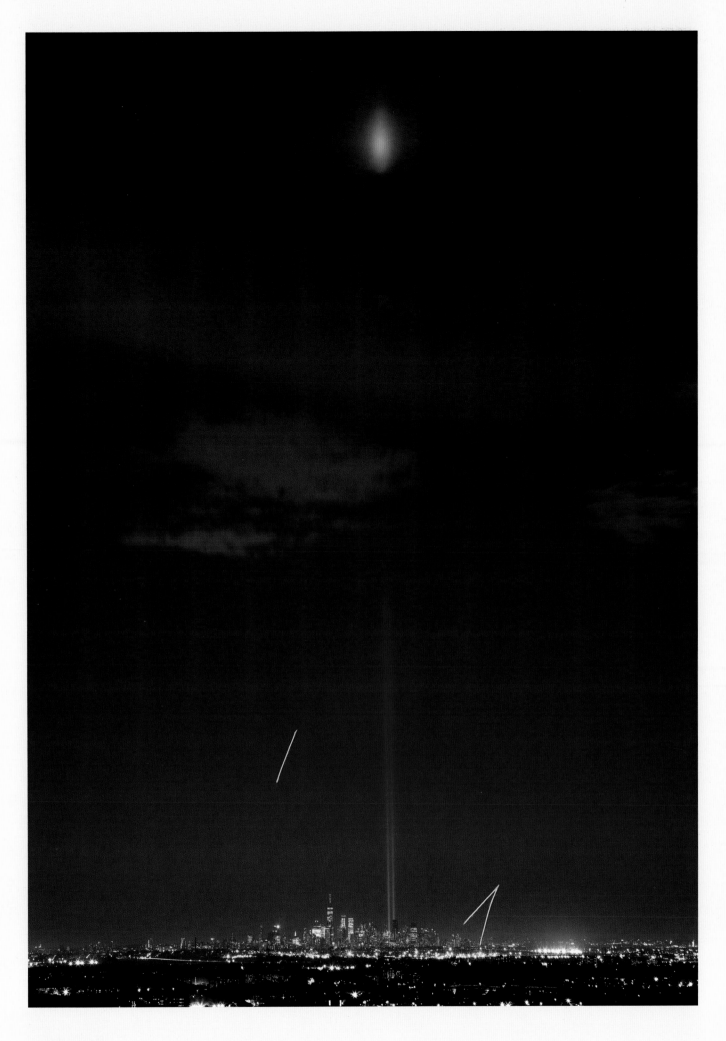

9/11 Tribute in Light,
from 20 miles away

1 hr. after sunset

Altitude 200 feet

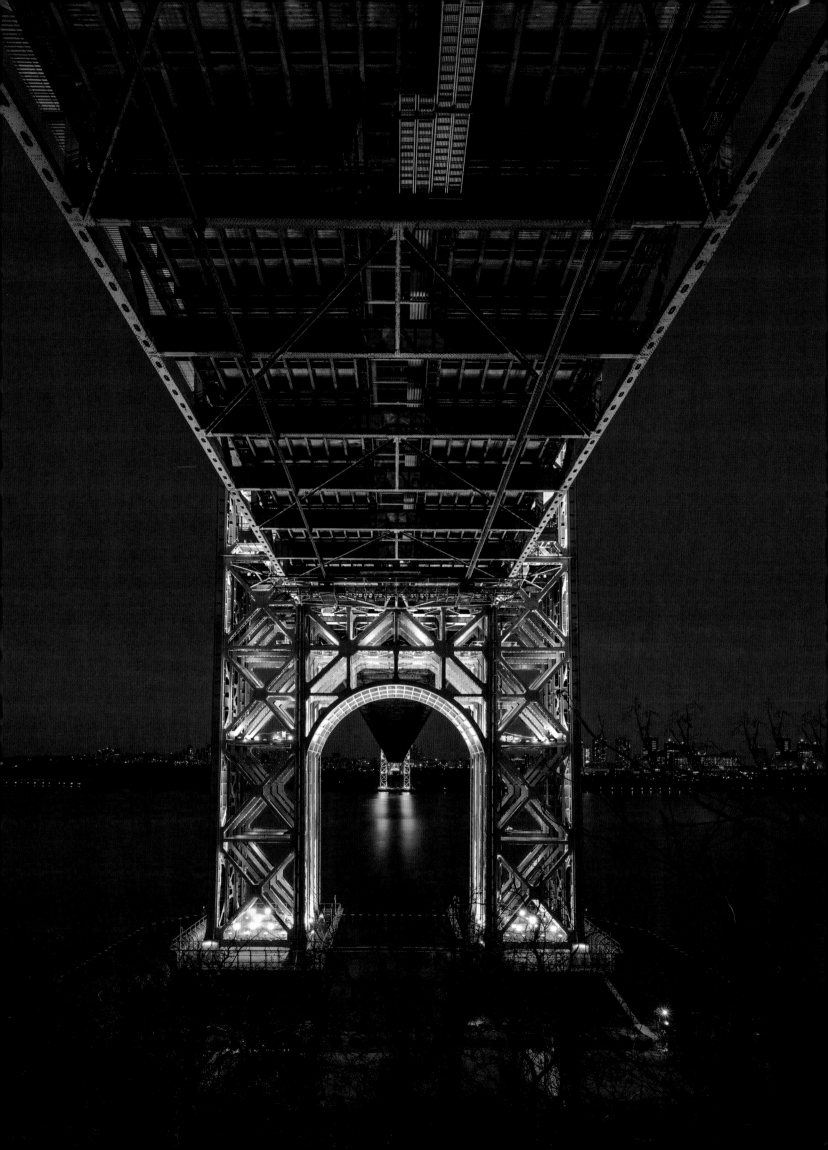

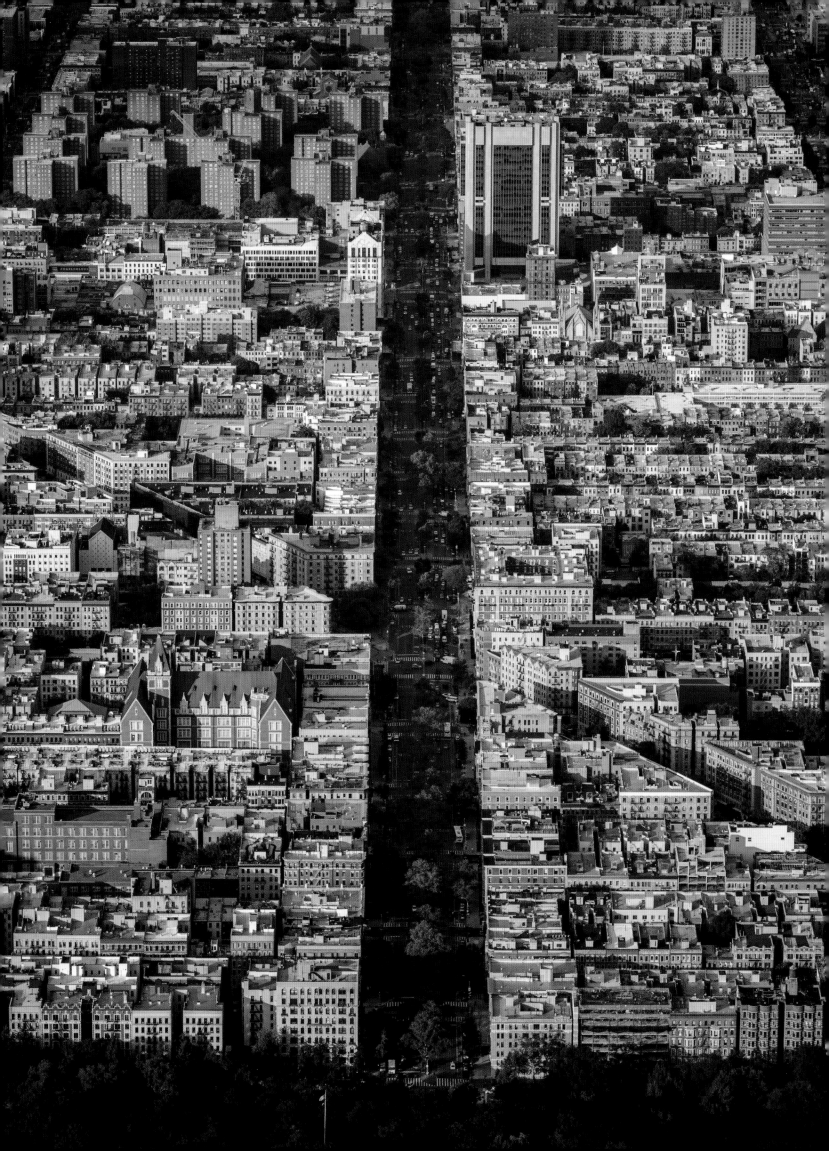

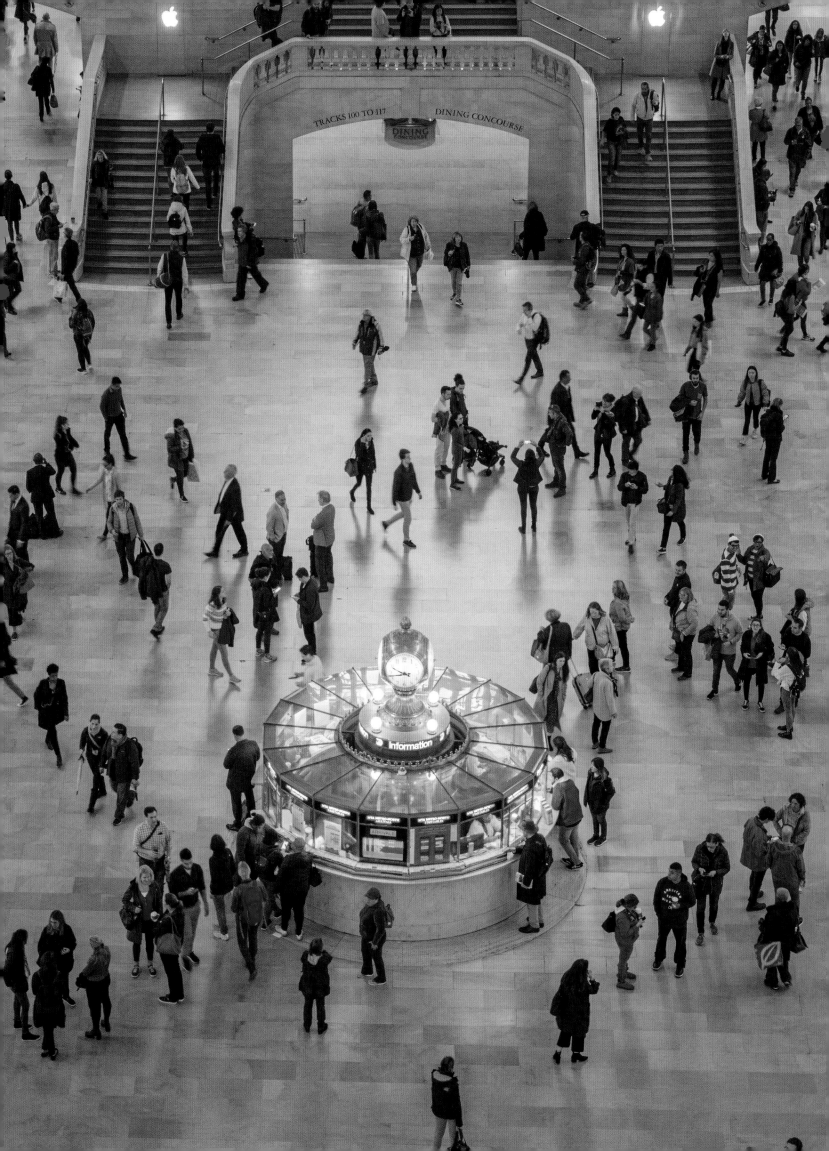

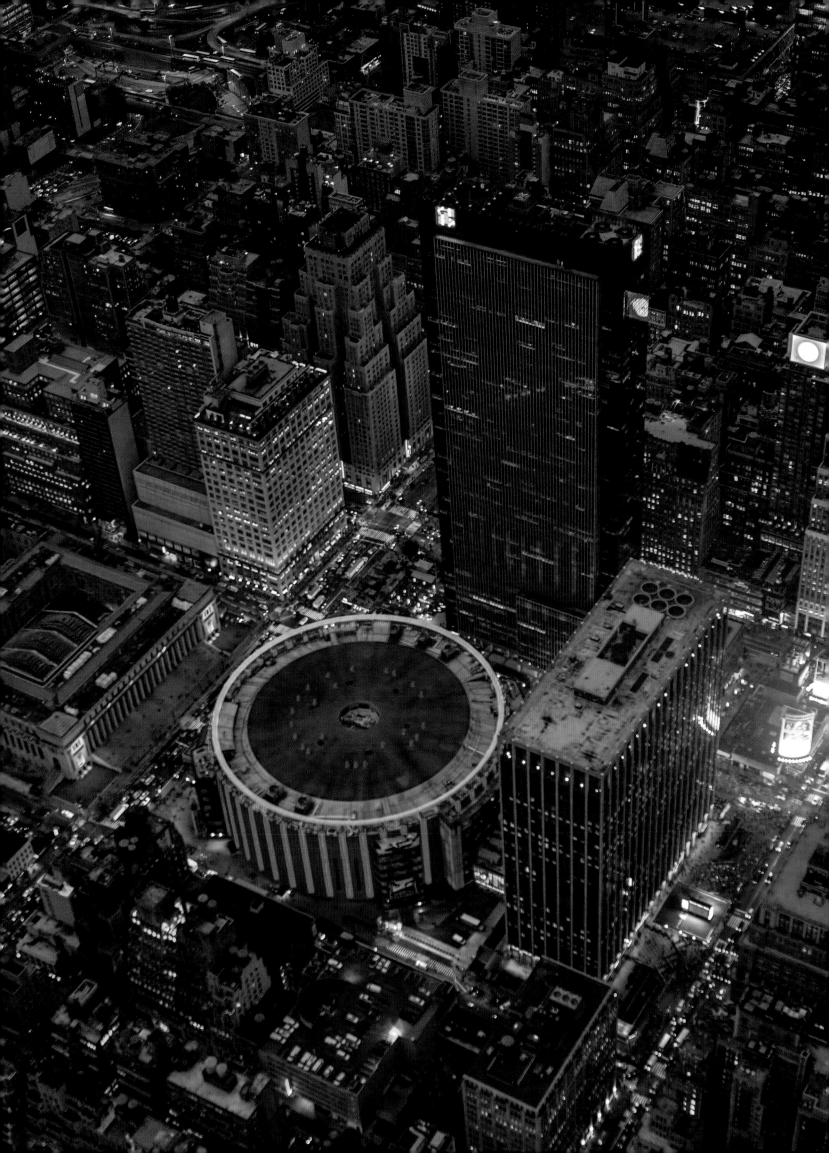

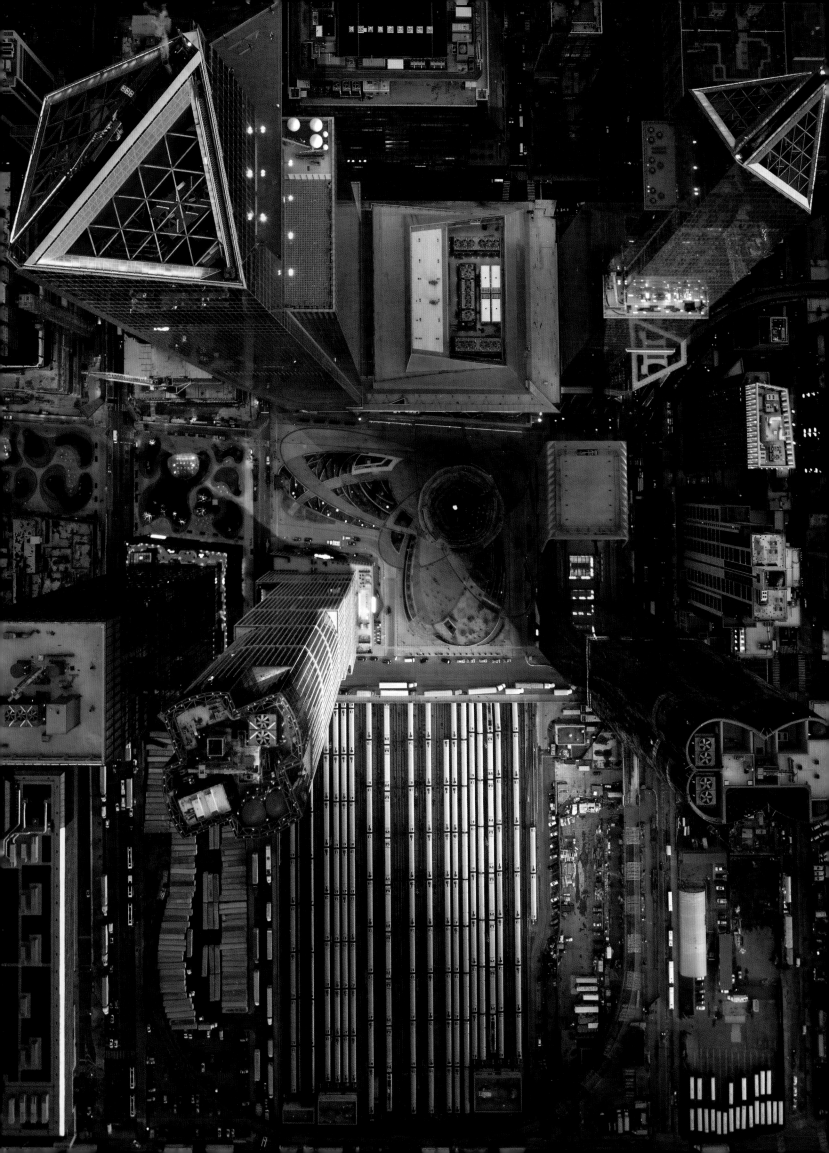

Page 154
Under the George
Washington Bridge
29 min. and 6 sec. after sunset
Altitude 75 feet

Page 155
Adam Clayton Powell Jr.
Boulevard, Harlem
1 hr. and 16 min. before sunset
Altitude 1,400 feet

Page 156
Grand Central Terminal,
Main Concourse Information Booth
1 hr. and 9 min. after sunrise
Altitude 155 feet

Page 157
Madison Square Garden
and One Penn Plaza
50 sec. after sunset
Altitude 1,550 feet

Page 158
Hudson Yards
1 min. and 39 sec. after sunset
Altitude 1,450 feet

Pages 160-161
Lower Manhattan
18 min. and 51 sec. after sunset
Altitude 1,900 feet

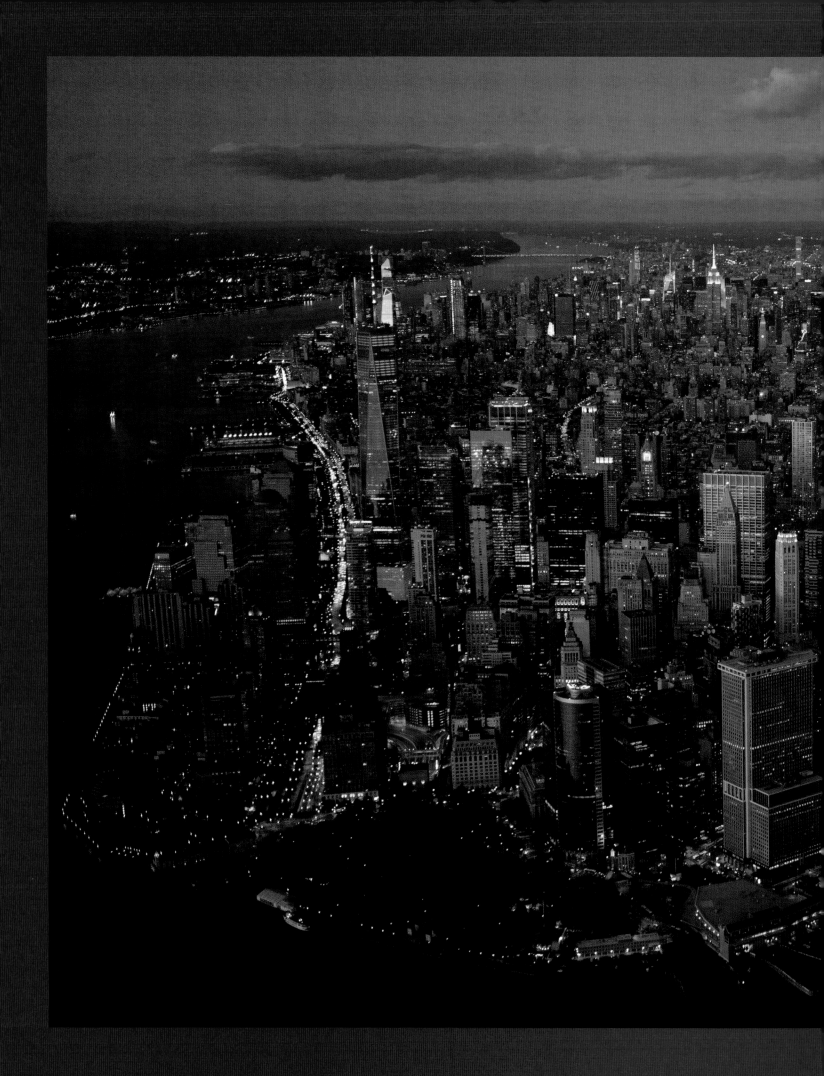

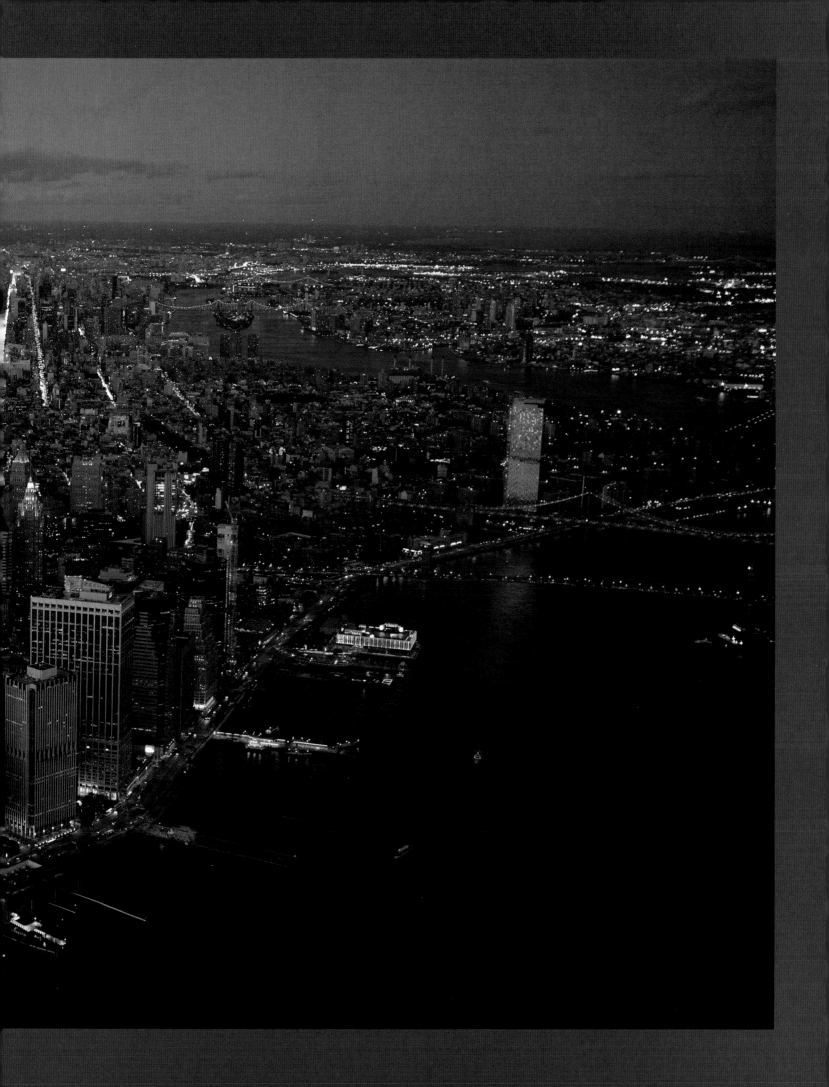

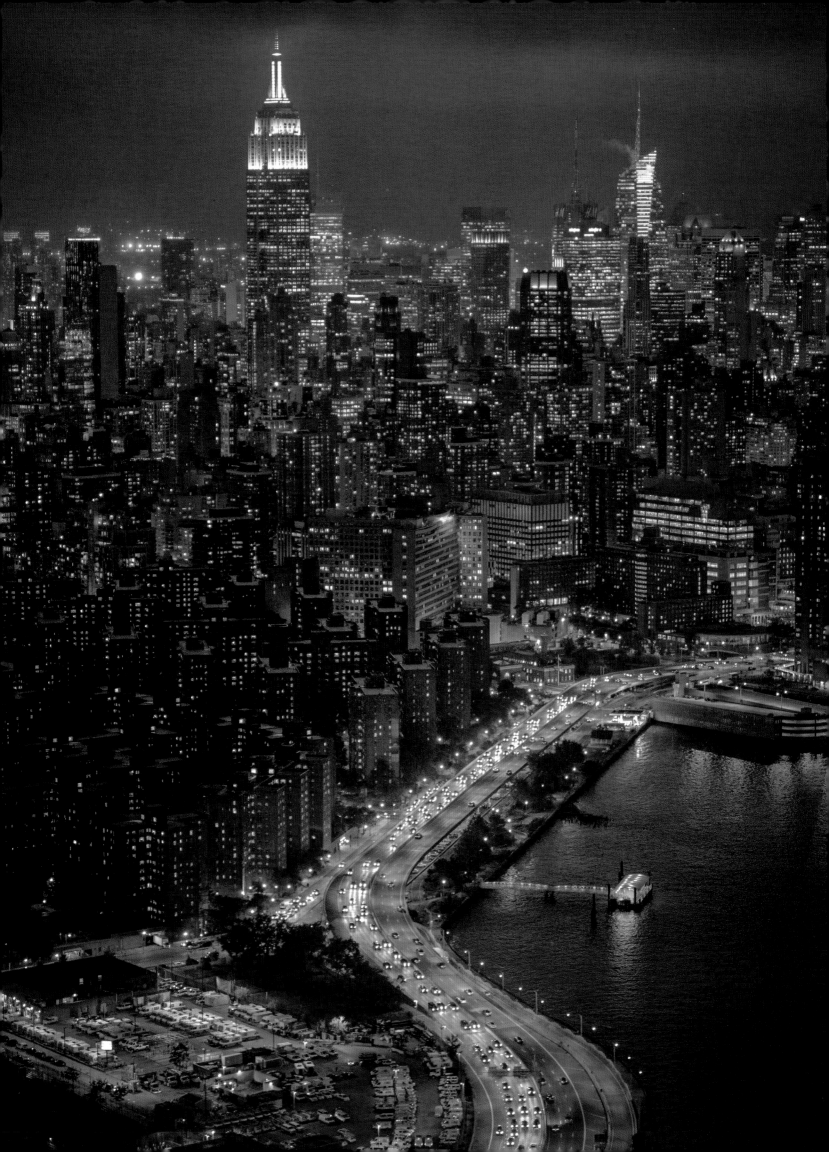

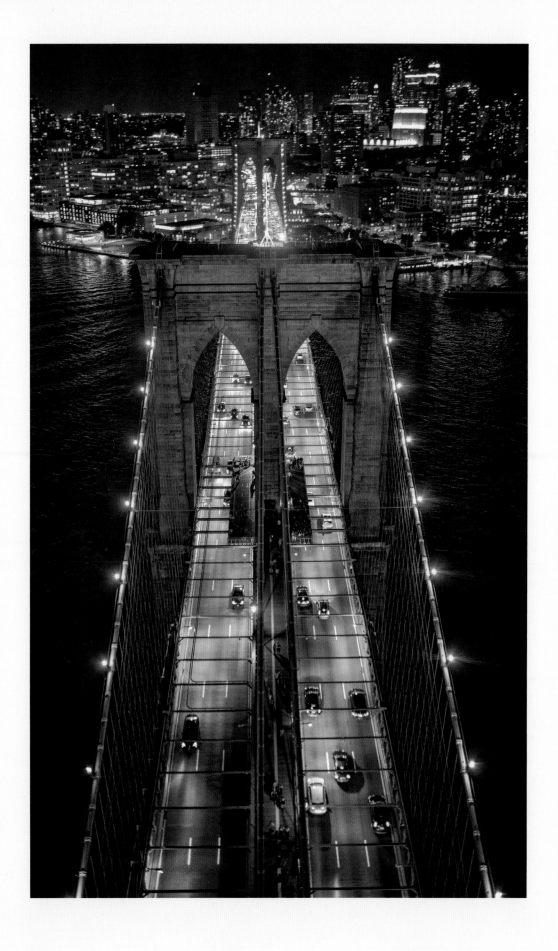

Page 162
Empire State Building, Midtown Manhattan, and FDR Drive
46 min. and 28 sec. after sunset
Altitude 1,100 feet

Above
Brooklyn Bridge
1 hr. and 19 min. after sunset
Altitude 450 feet

Page 164
Midtown Manhattan
38 min. and 18 sec. after sunset
Altitude 1,020 feet

Page 165
West Side Highway
and Financial District
14 min. and 47 sec. after sunset
Altitude 400 feet

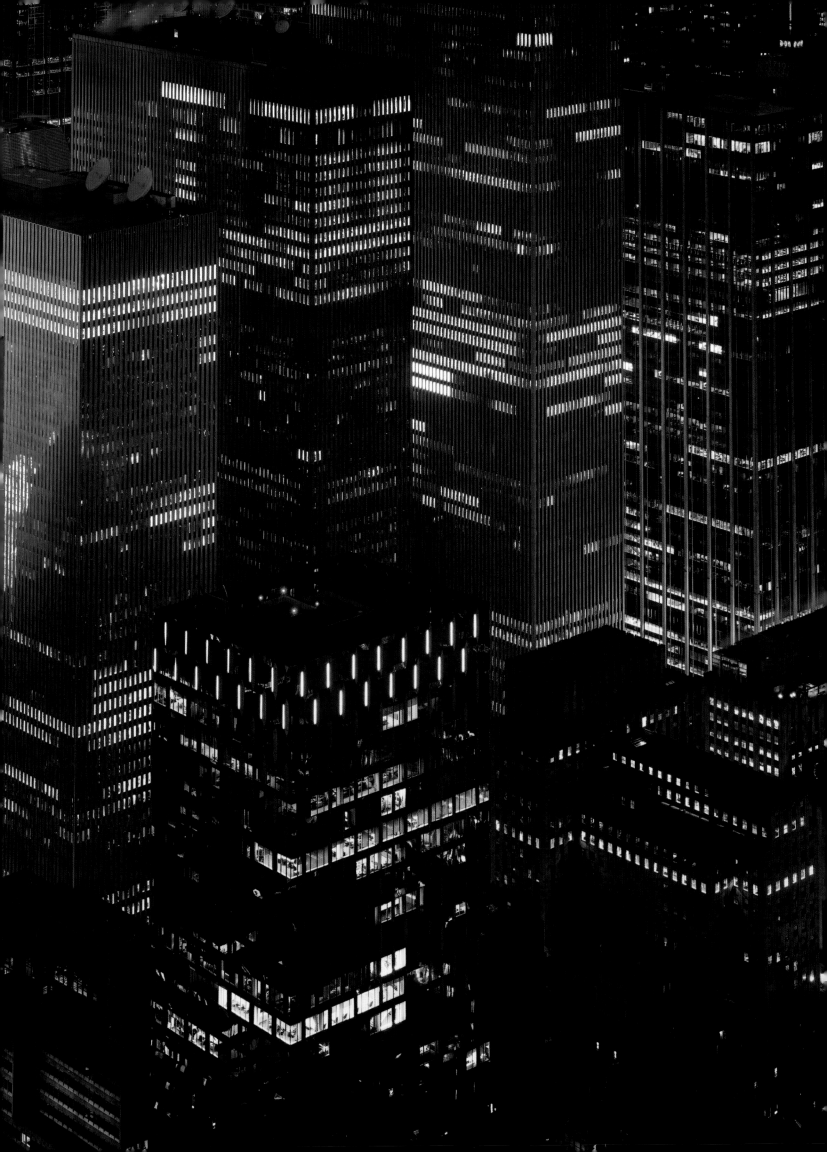

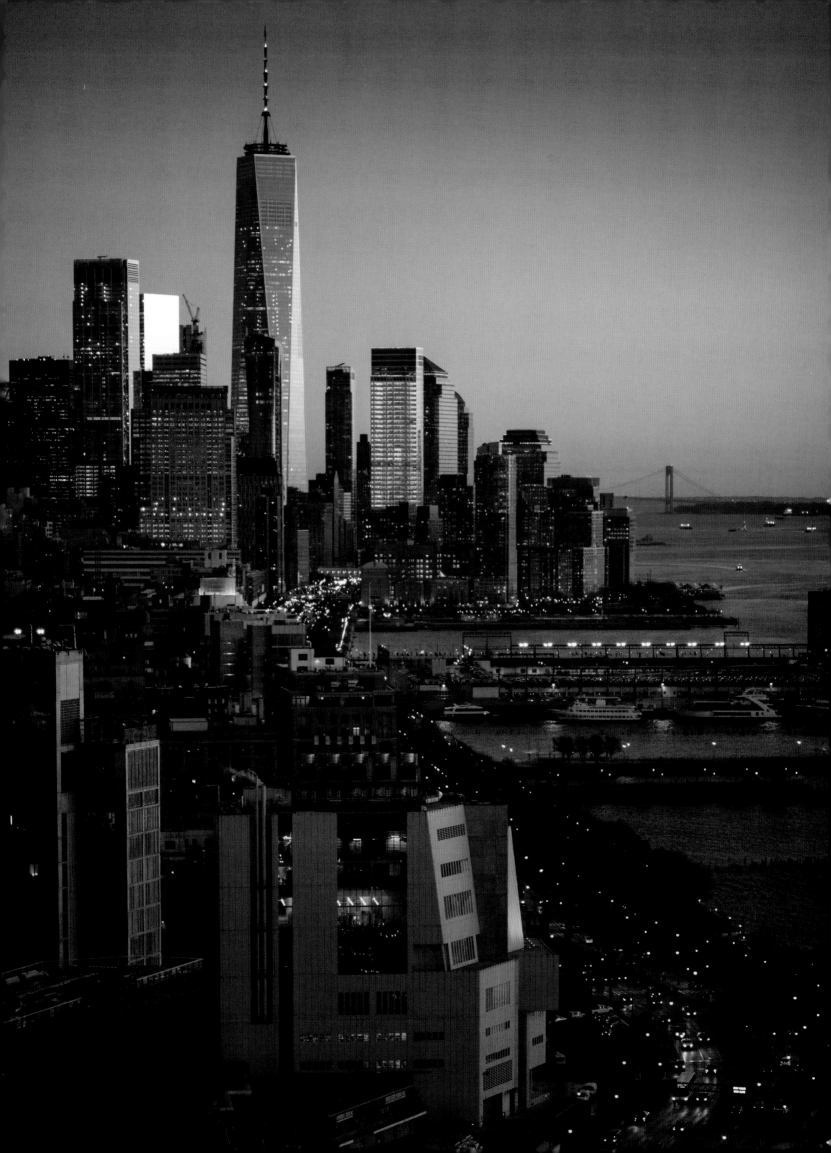

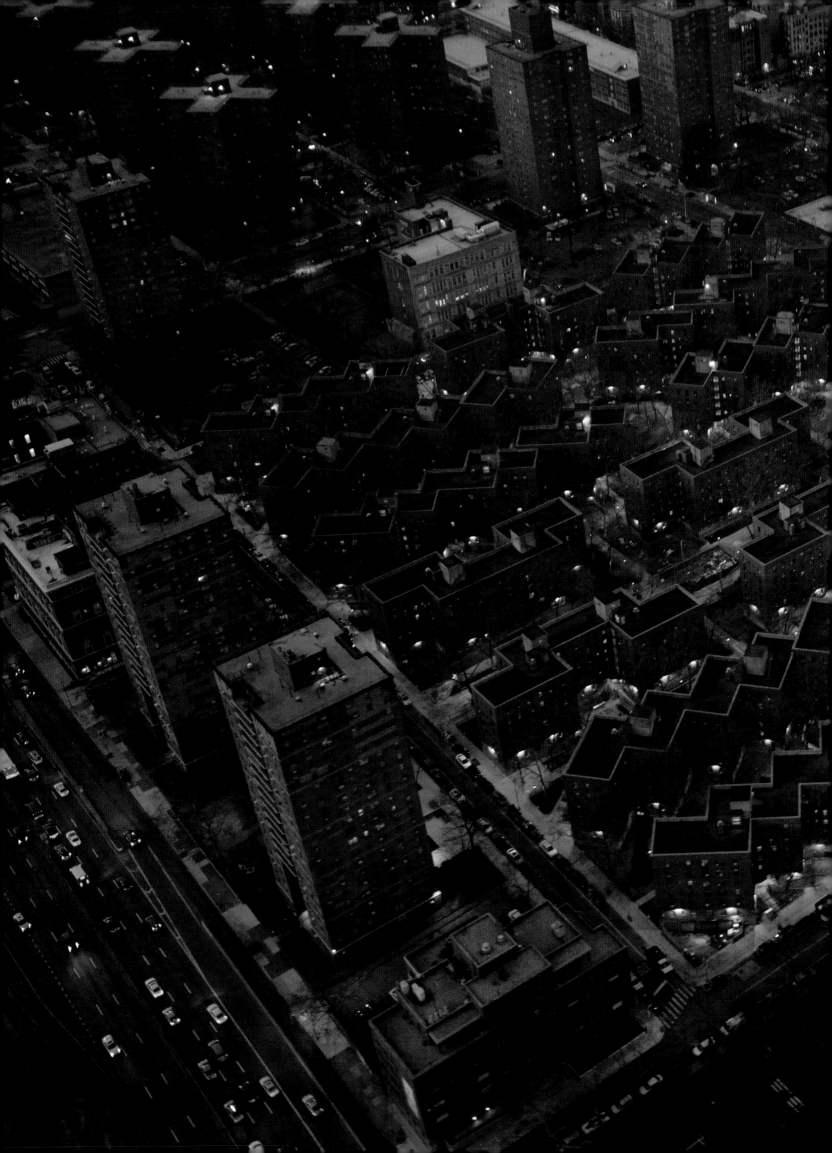

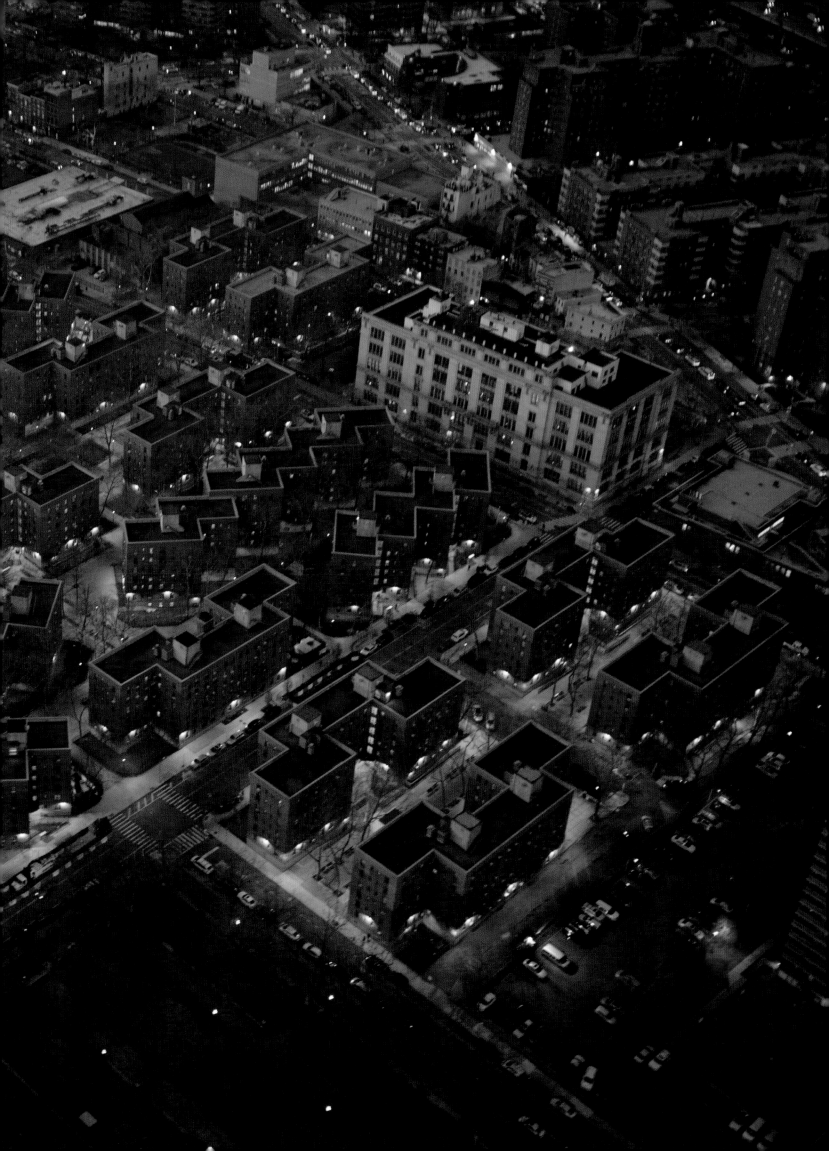

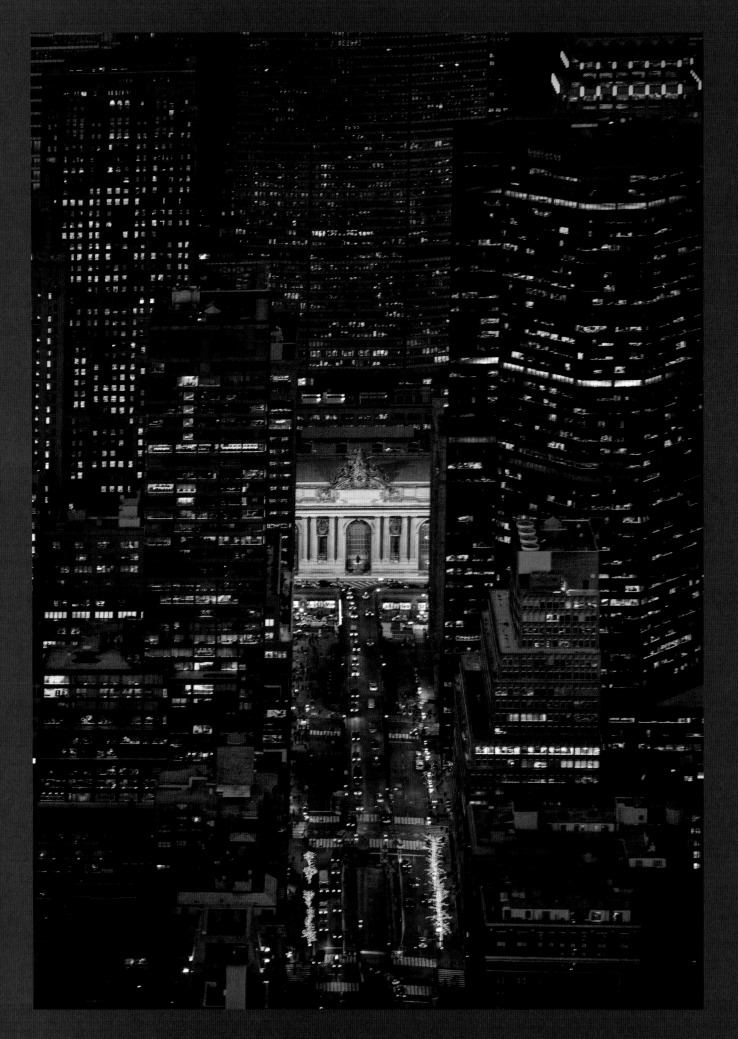

Pages 166-167
Vladeck Houses, Lower East Side
14 min. and 48 sec. after sunset
Altitude 950 feet

Above
Grand Central Terminal and Park Avenue
19 min. and 39 sec. after sunset
Altitude 1,250 feet

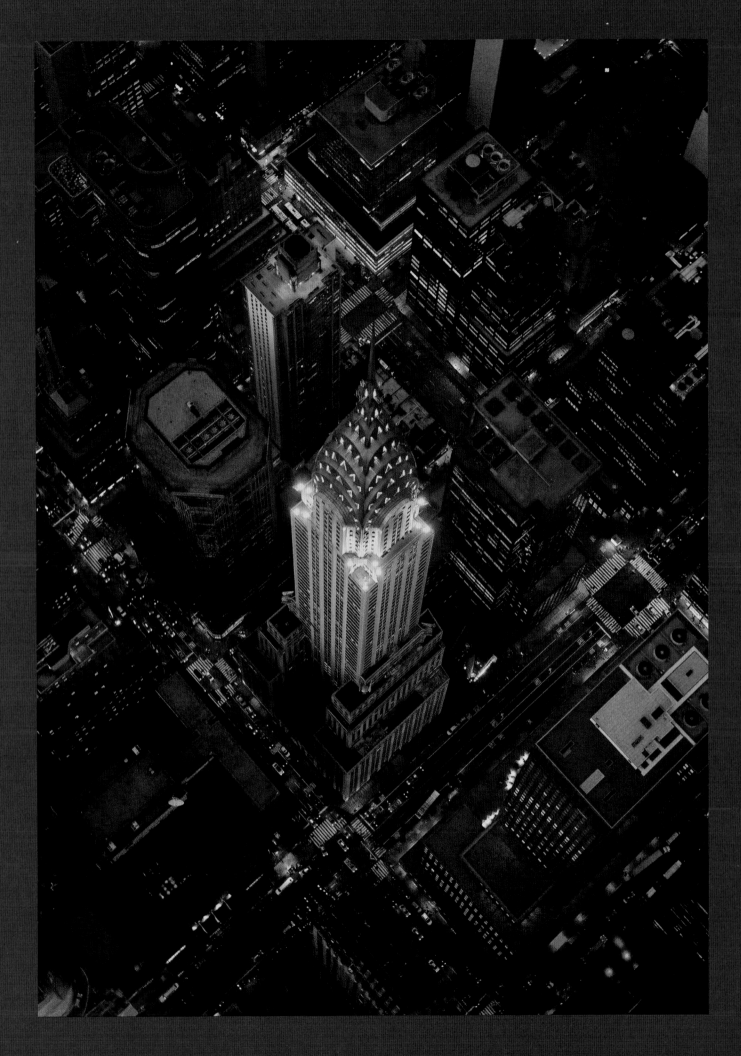

Chrysler Building
16 min. and 34 sec. after sunset
Altitude 1,700 feet

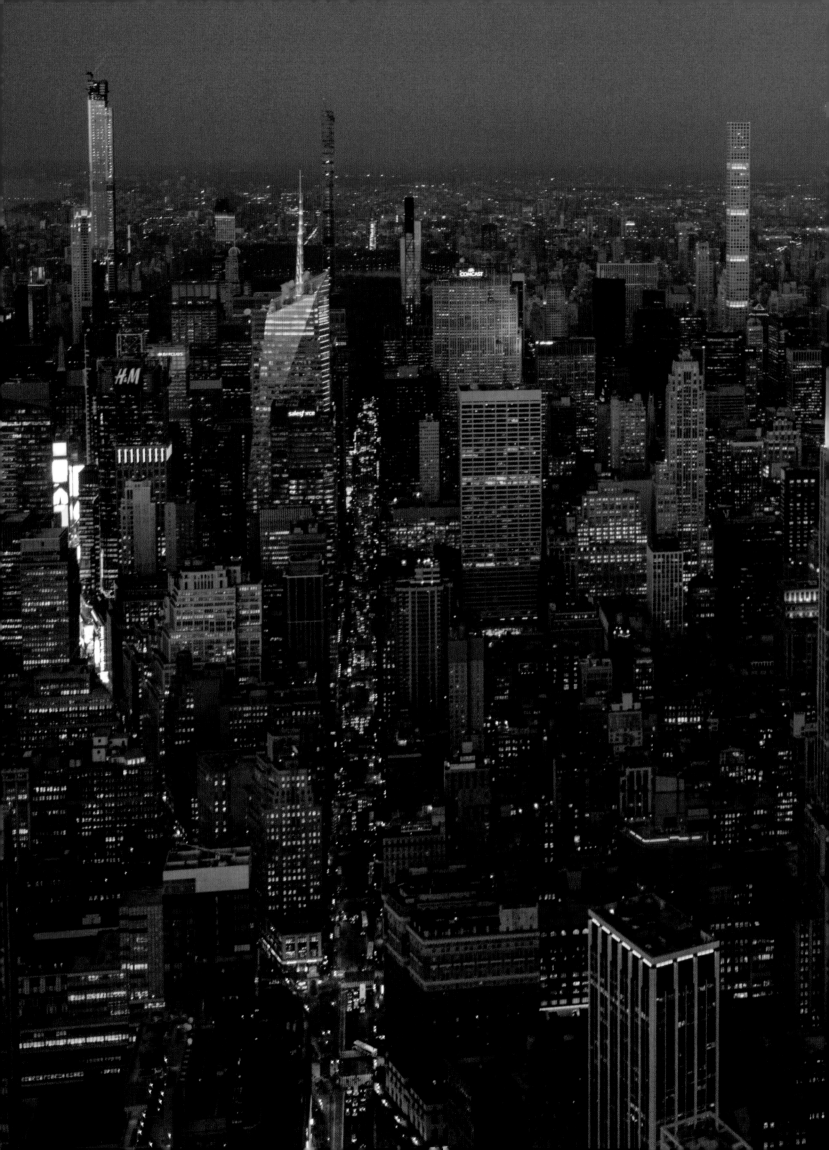

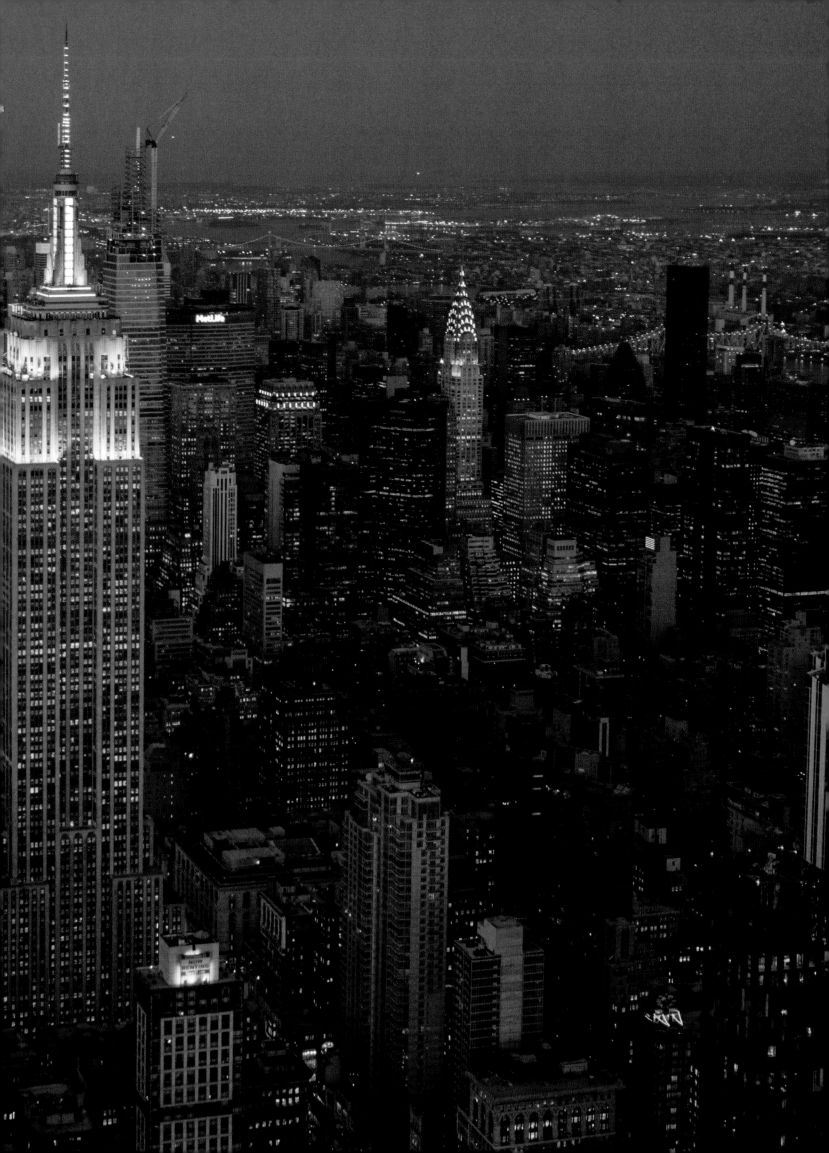

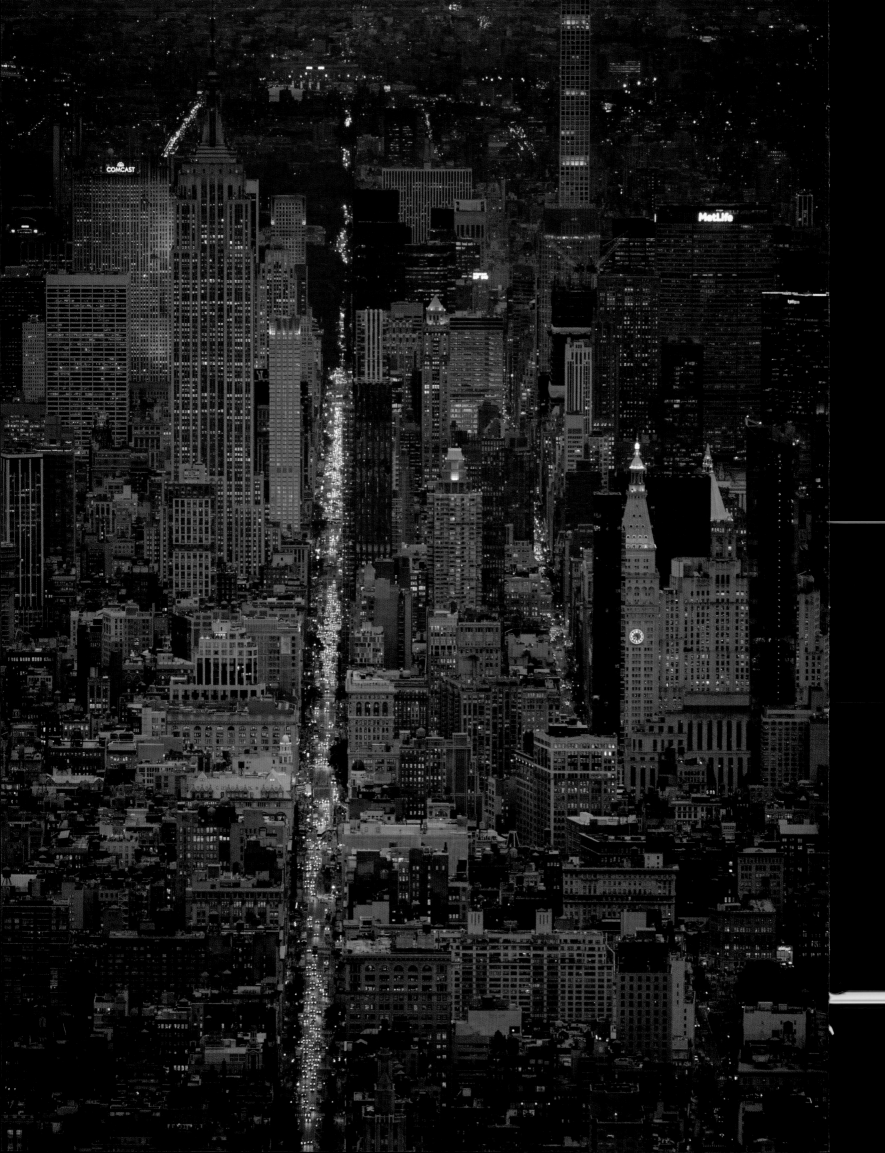

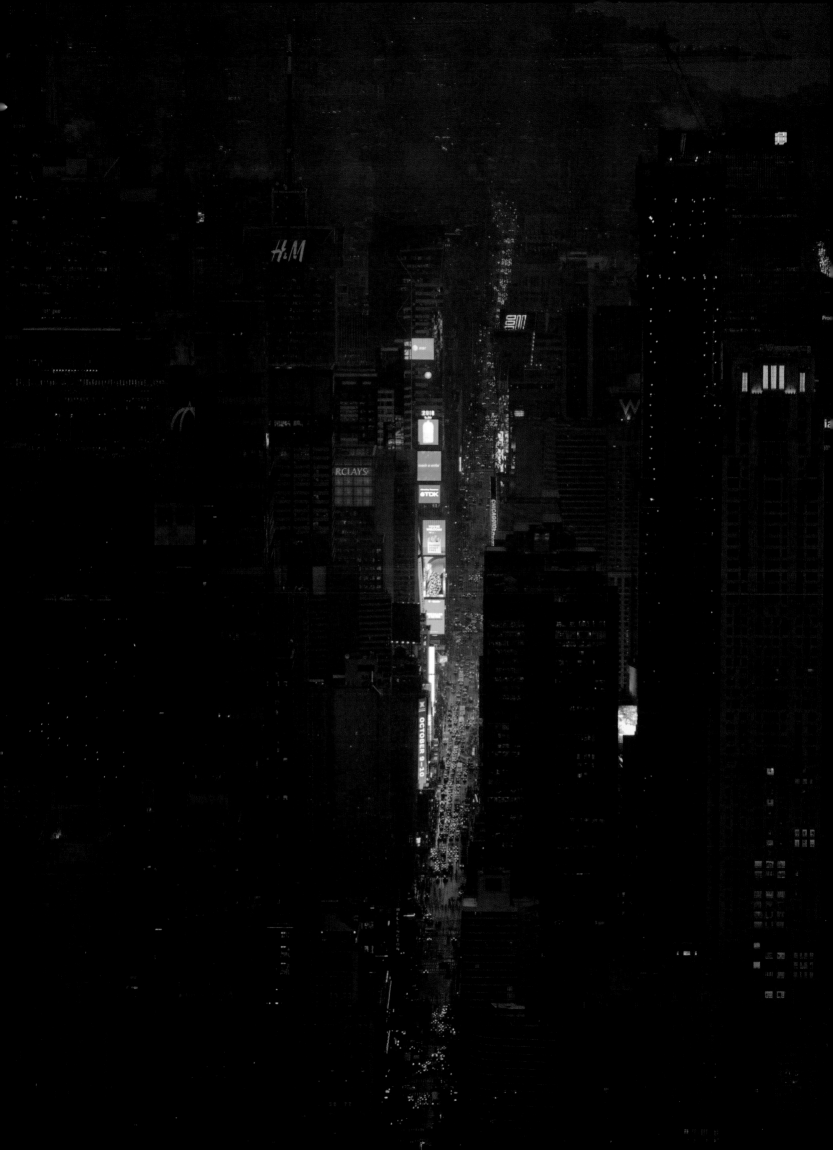

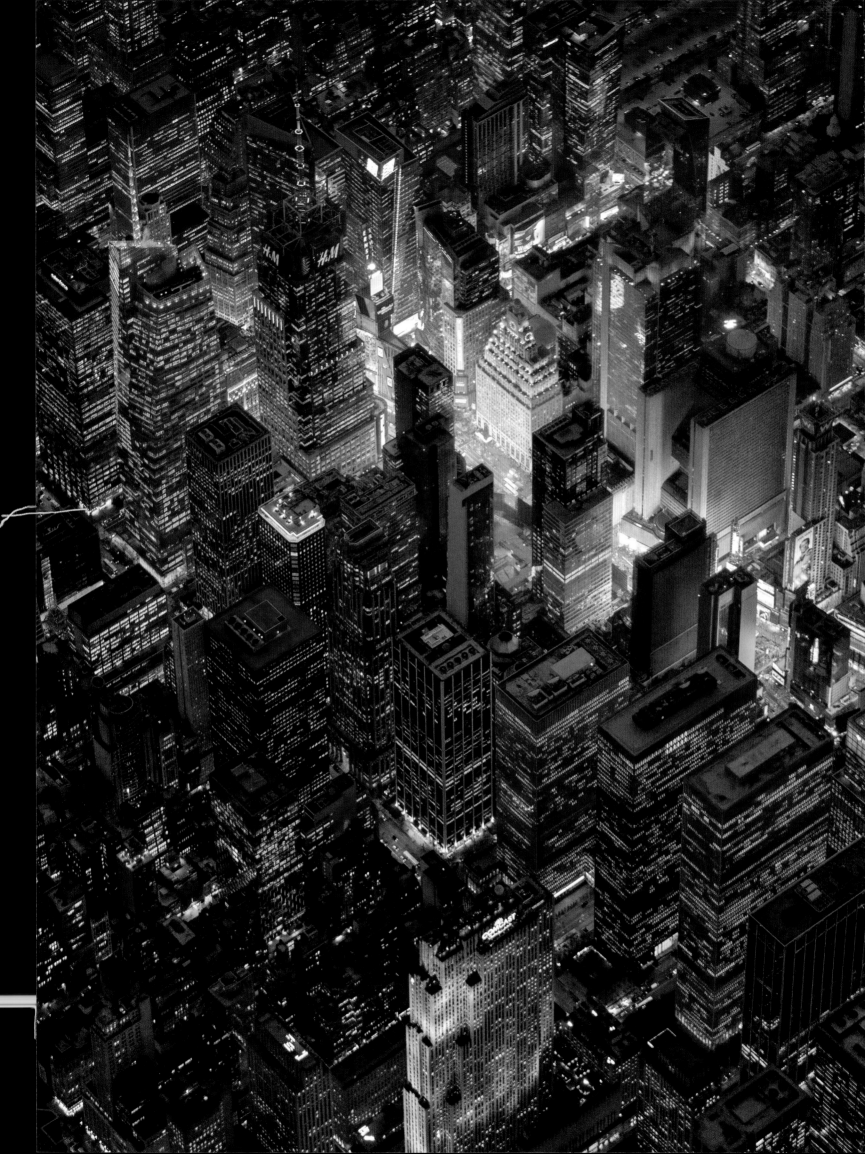

EXAMPLES OF CLASS B ALTITUDES

$$\frac{70}{30}$$ — — — Ceiling in hundreds of feet MSL

— — — Floor in hundreds of feet MSL

(Floors extending "upward from above" a certain altitude are preceded by
a (+). Operations at and below these altitudes are outside of Class B Airspace.)

VISUAL CHECKPOINTS
GEOGRAPHIC COORDINATES

NAME	LATITUDE	LONGITUDE
Alpha	40-49.36N	073-53.22W
Alpine Tower	40-57.64N	073-55.36W
Amusement Park	40-58.00N	073-40.42W
Aqueduct Racetrack	40-40.34N	073-49.77W
Baisley Pond	40-40.67N	073-47.14W
Belmont Racetrack	40-42.96N	073-42.54W
Berry's Creek Bridge	40-48.66N	074-05.49W
Boonton Reservoir	40-53.00N	074-24.50W
Bravo	40-50.19N	073-52.42W
Bronx Zoo	40-50.76N	073-52.72W
Cedar Grove Reservoir	40-51.57N	074-12.83W
Clock	40-42.72N	074-02.03W
Co-op City	40-52.64N	073-49.69W
Cunningham Park	40-44.22N	073-46.25W
Essex Co Golf Club	40-47.19N	074-15.79W
Freeport	40-39.52N	073-34.07W
Fresh Kills Landfill	40-34.57N	074-12.43W
Galloping Hills Golf Course	40-41.03N	074-17.00W
Governors Island	40-41.07N	074-01.56W
GWB	40-51.08N	073-57.15W
Holy Cross Cemetery	40-47.26N	074-07.66W
Hudson	40-40.34N	074-02.68W
Intrepid	40-45.88N	074-00.05W
Jamaica Station	40-41.96N	073-48.54W
Jones Beach Monument	40-35.79N	073-30.49W
Kew Gardens	40-42.59N	073-49.83W
Lake Success	40-45.84N	073-42.47W
Lincoln Terrace Park	40-40.01N	073-55.61W
Livingston Mall	40-46.11N	074-20.98W
Lombardi Service Area	40-49.57N	074-01.68W
Manhattan Beach	40-34.54N	073-56.64W
Marine Parkway Bridge	40-34.41N	073-53.09W
Meadowlands	40-48.87N	074-04.51W
Nassau Coliseum	40-43.38N	073-35.45W
North Hudson Park	40-48.14N	074-00.04W
Oceanside Incinerator Plant	40-37.04N	073-38.37W
Oradell Reservoir	40-57.52N	074-01.23W
Ridgewood Reservoir	40-41.34N	073-53.19W
Sandy Hook	40-27.12N	073-59.97W
Short Hills Mall	40-44.61N	074-21.98W
Spuyten Duyvil	40-52.69N	073-55.54W
Statue of Liberty	40-41.35N	074-02.67W
Tappan Zee Bridge	41-04.27N	073-53.68W
Turnpike Bridge	40-41.69N	074-07.03W
Udall's Millpond	40-47.99N	073-44.84W
Van Cortlandt Park	40-53.51N	073-53.72W
VZ	40-36.41N	074-02.63W
Wakefield Switchyard	40-54.06N	073-50.94W
Willowbrook Expwy	40-36.74N	074-09.23W

Pages 170-171

Empire State Building and
Midtown Manhattan

16 min. and 52 sec. after sunset

Altitude 1,200 feet

Page 172

Fifth Avenue

2 min. and 44 sec. after sunset

Altitude 1,400 feet

Page 173

Seventh Avenue and
Times Square

3 min. and 39 sec. after sunset

Altitude 1,600 feet

Page 174

Midtown Manhattan and lights
of Times Square

22 min. and 27 sec. after sunset

Altitude 8,000 feet

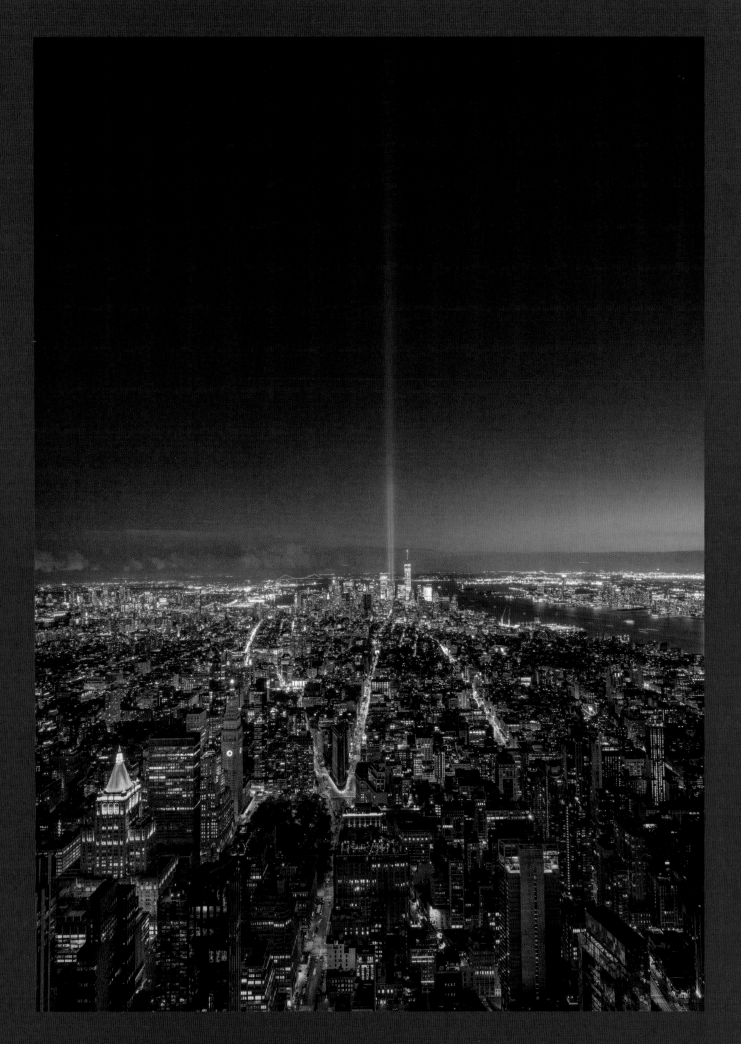

9/11 Tribute in Light, as seen from
Empire State Building 103rd floor
52 min. and 24 sec. after sunset
Altitude 1,250 feet

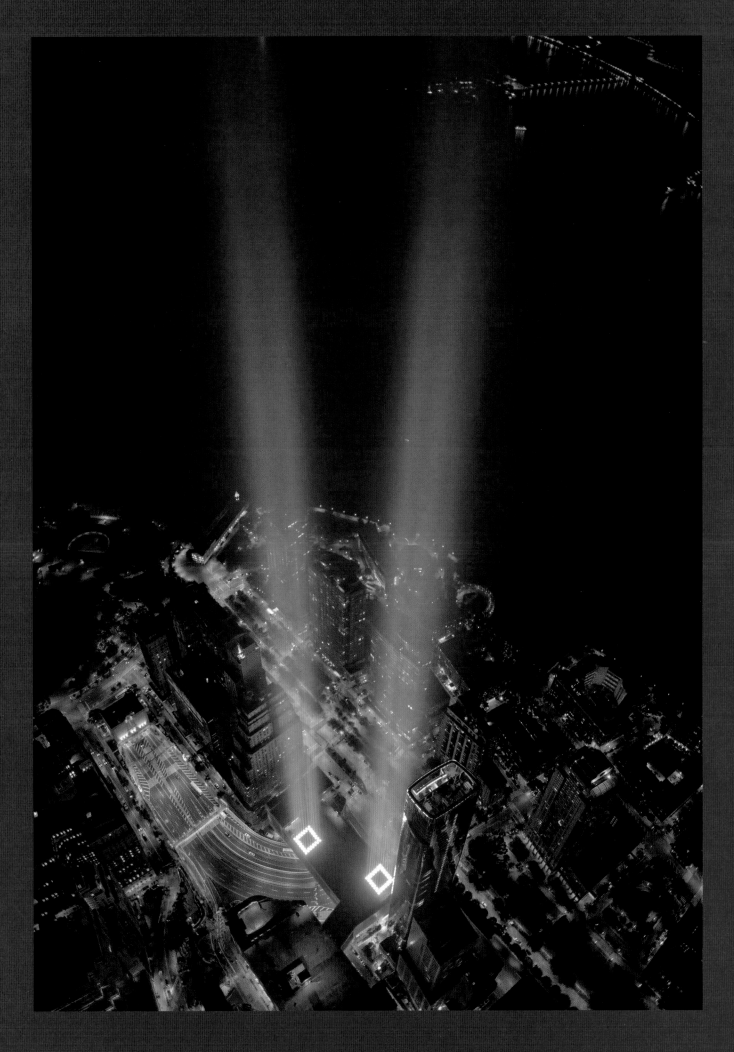

9/11 Tribute in Light
3 hr. and 52 min. after sunset
Altitude 1,776 feet

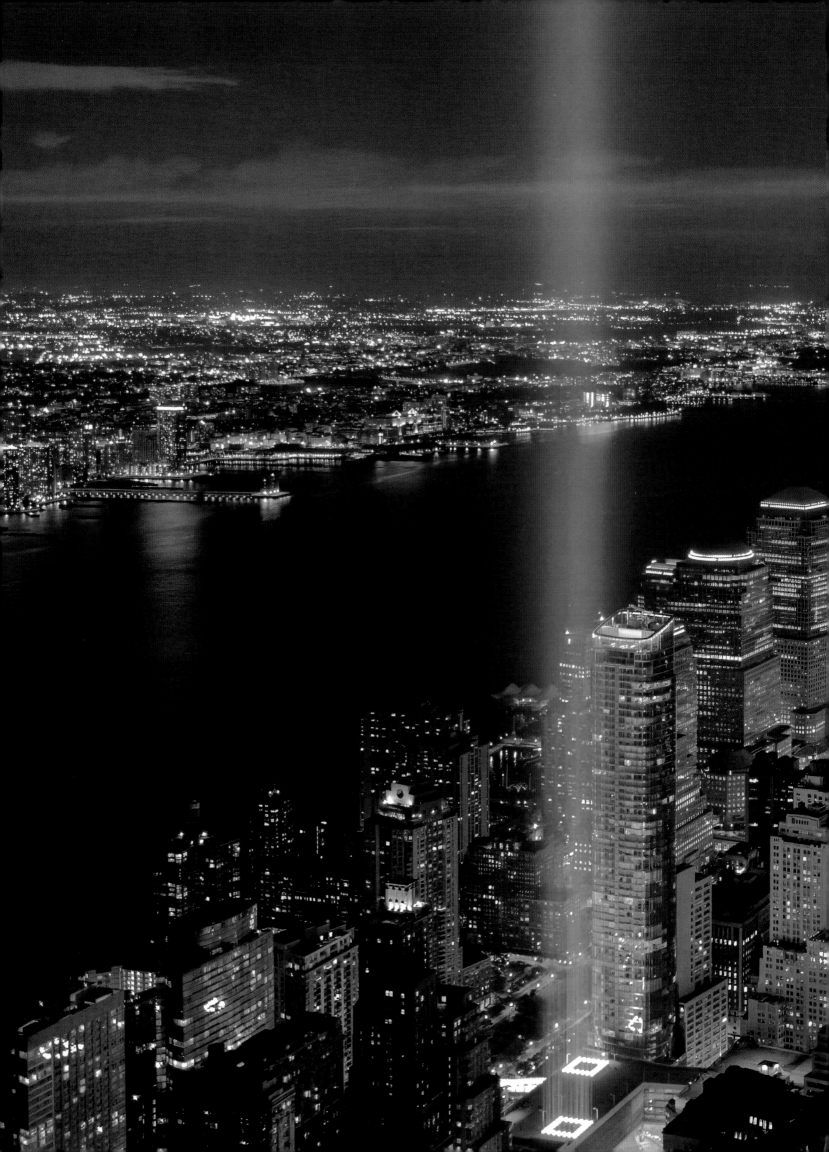

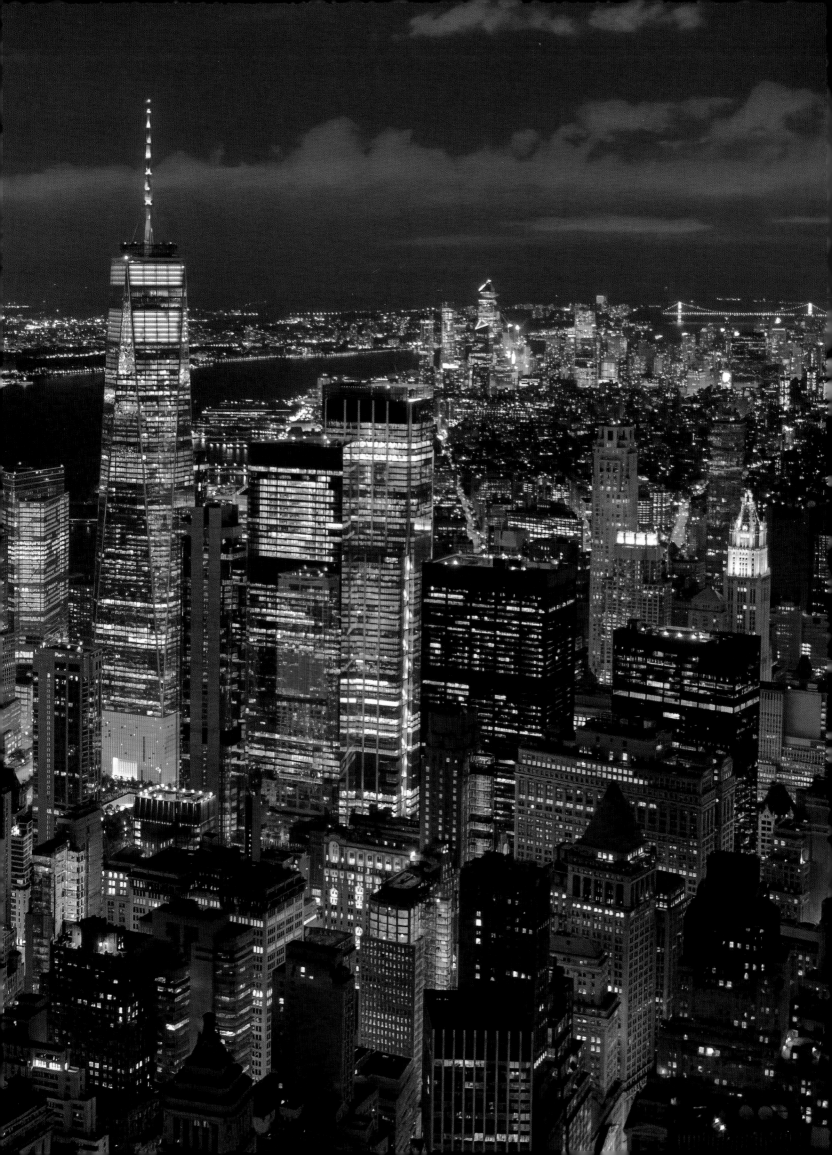

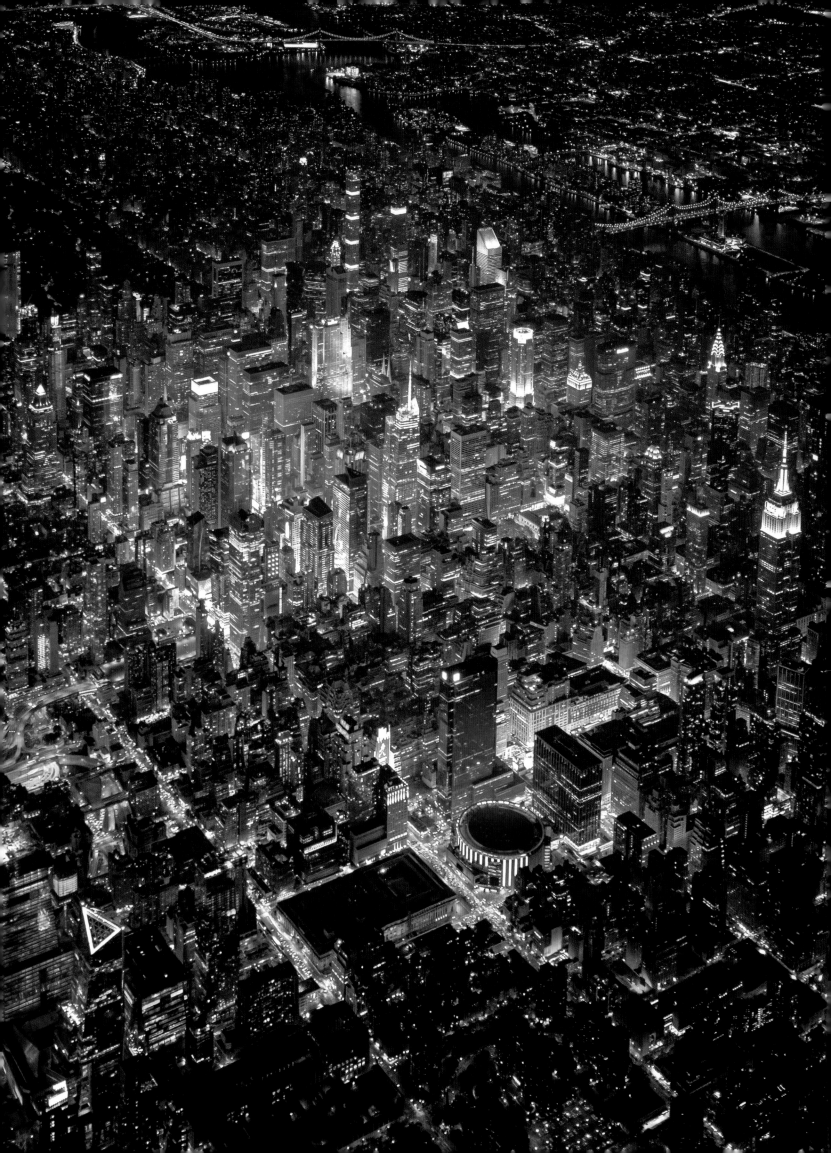

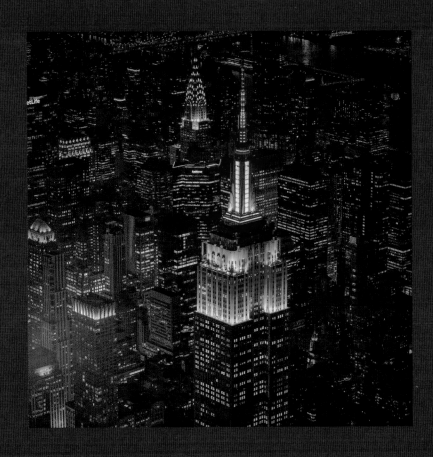

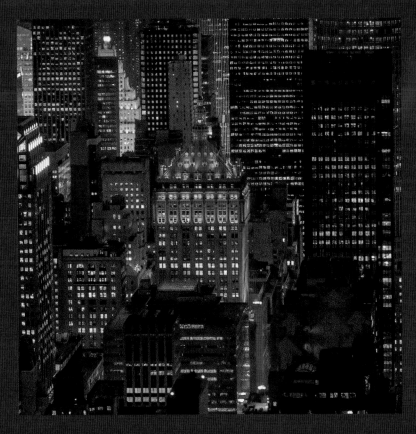

Pages 178-179
9/11 Tribute in Light
3 hr. and 59 min. after sunset
Altitude 1,650 feet

Page 180
Electric New York
59 min. and 2 sec. after sunset
Altitude 7,000 feet

Top
Blue Empire State Building
1 hr. and 17 min. after sunset
Altitude 1,350 feet

Bottom
Blue Helmsley Building
47 min. and 58 sec. after sunset
Altitude 1,100 feet

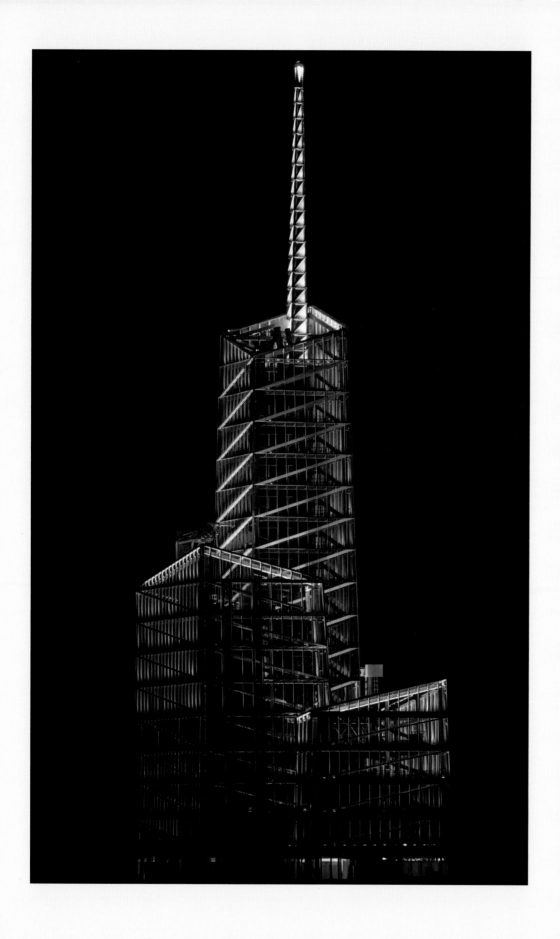

Above
One Vanderbilt crown
11 hr. and 55 min. after sunset
Altitude 1,050 feet

Page 183
Towers of George Washington Bridge
2 hr. and 21 min. after sunset
Altitude 285 feet

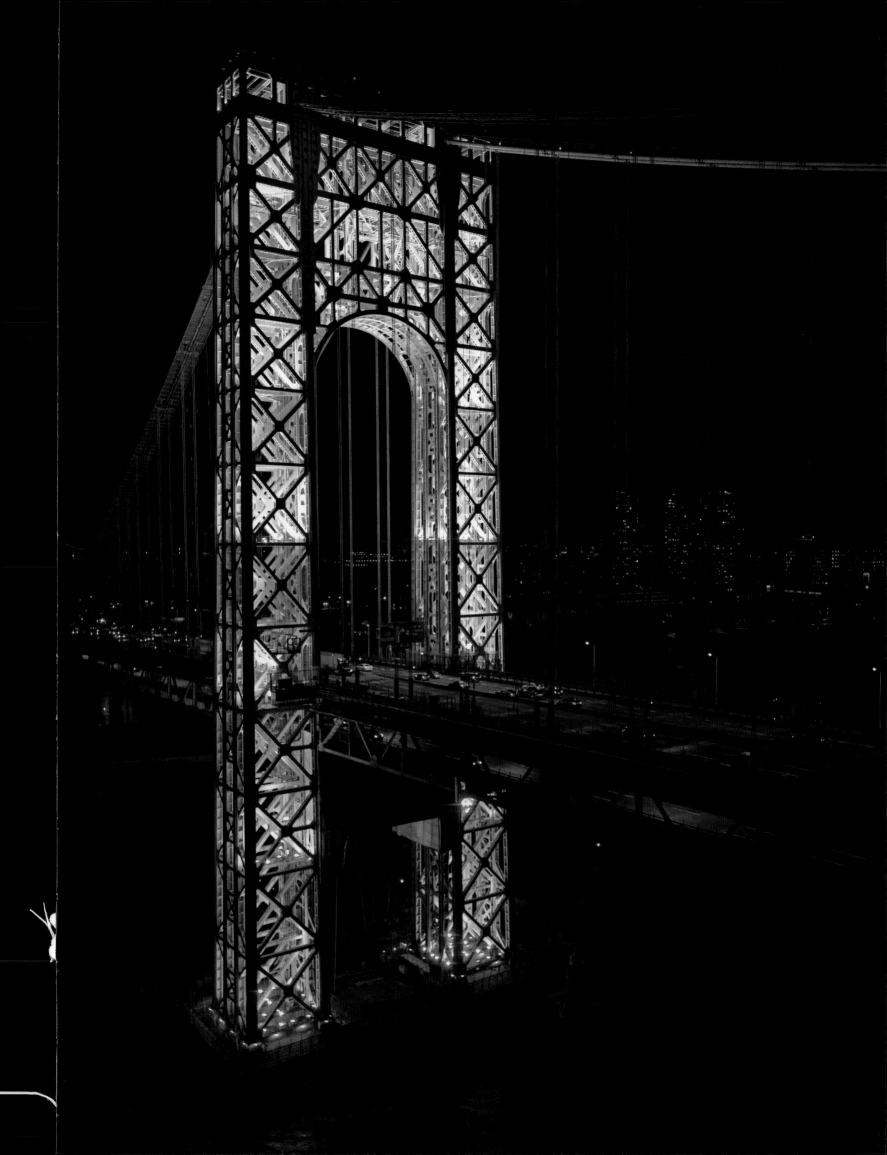

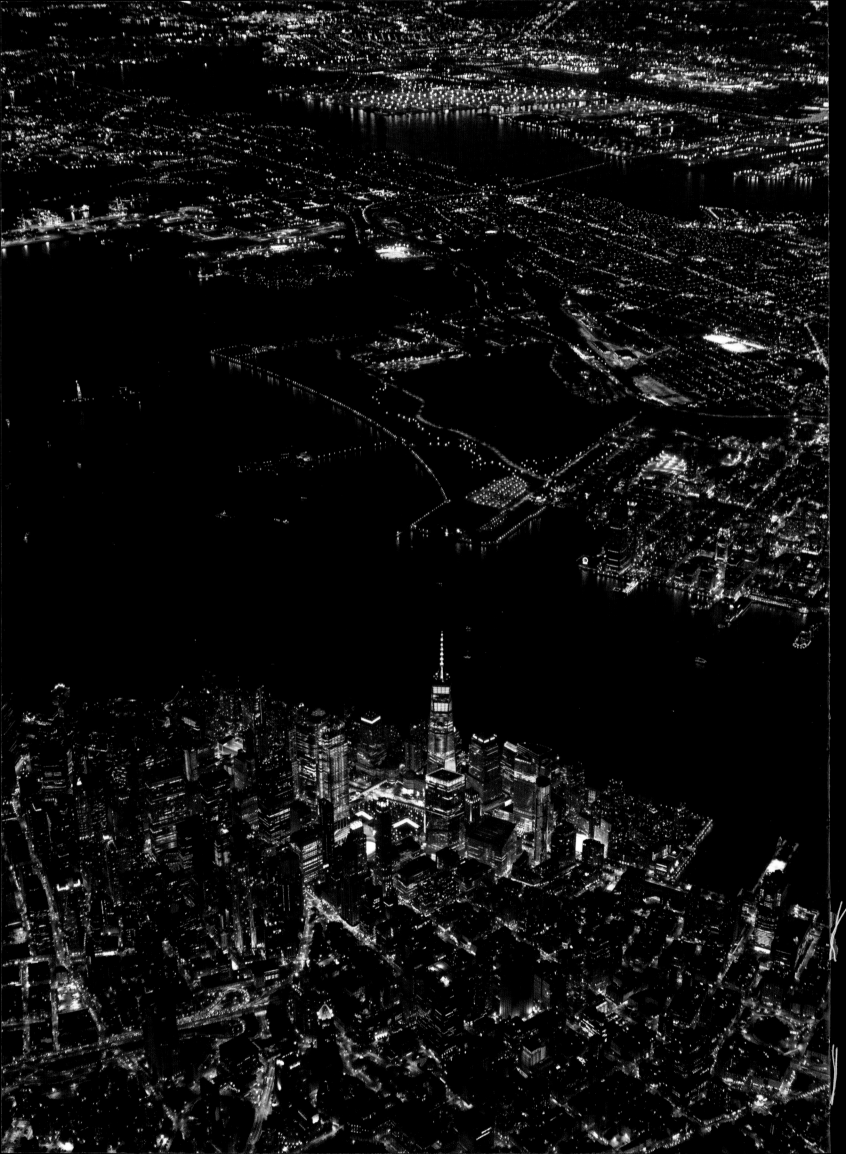

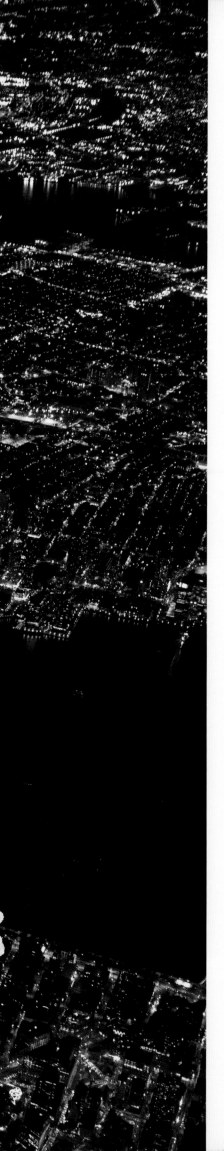
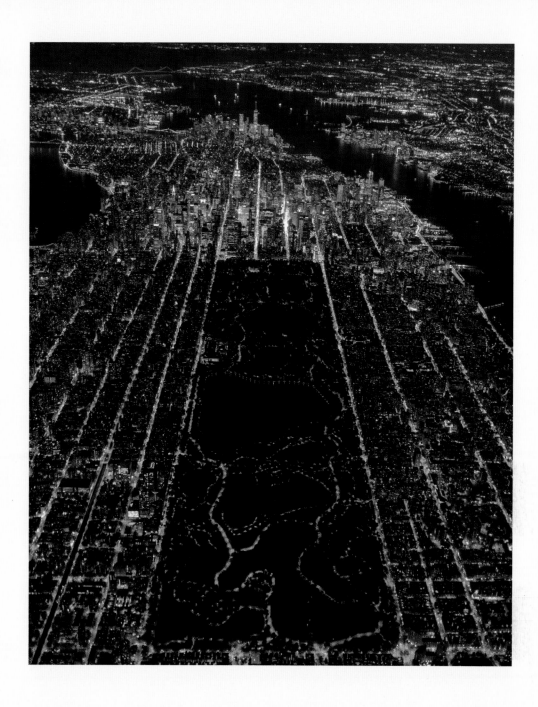

Page 184
Lower Manhattan, New Jersey,
and New York Harbor
1 hr. and 11 min. after sunset
Altitude 7,000 feet

Above
Island of Manhattan
1 hr. and 10 min. after sunset
Altitude 6,500 feet

185

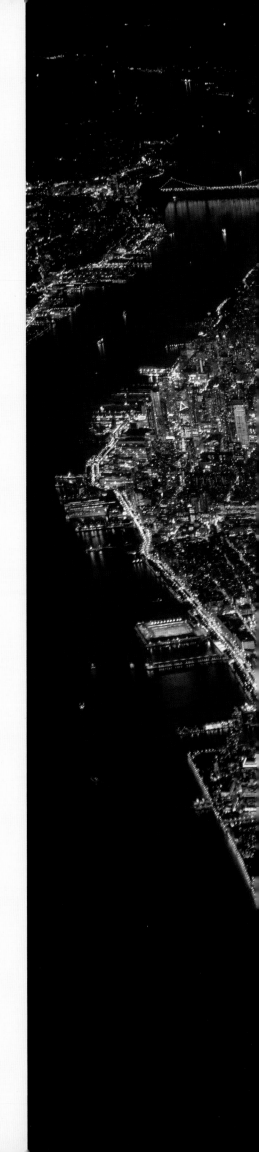

Lower Manhattan, Hudson
and East Rivers

1 hr. and 11 min. after sunset

Altitude 7,000 feet

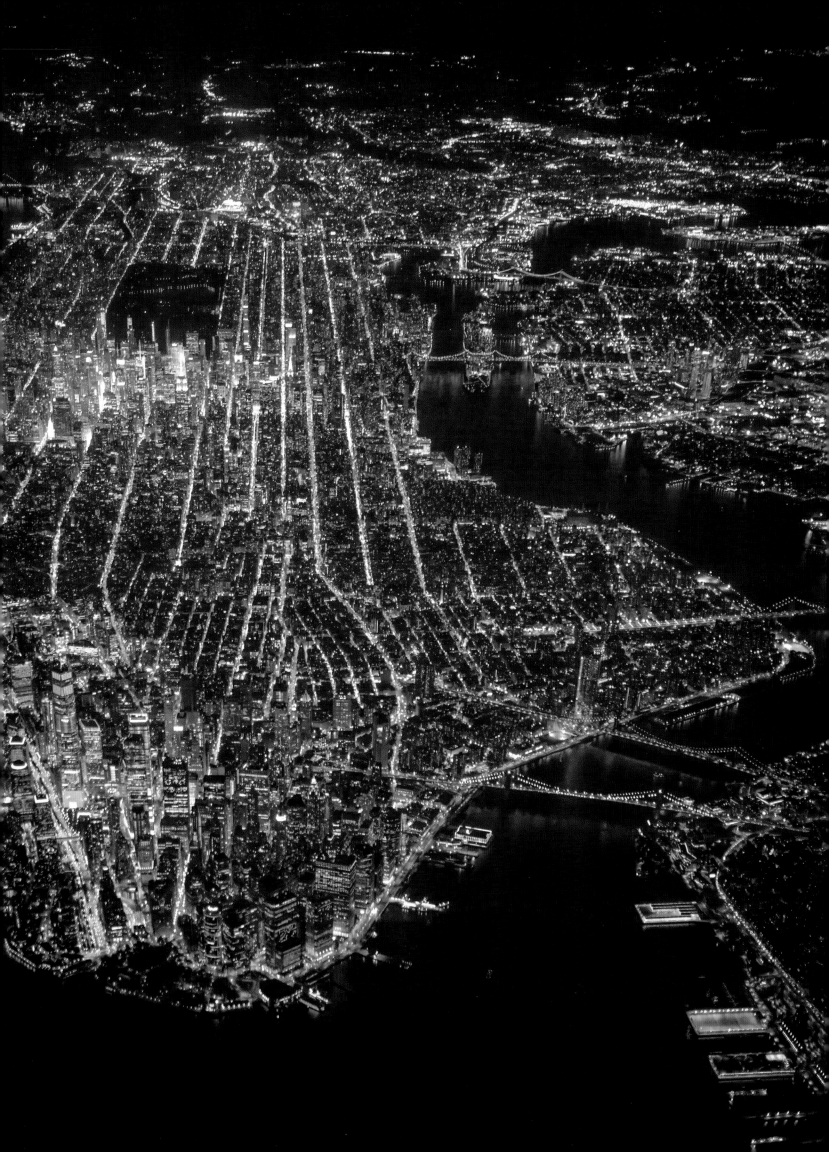

In late May 2020, I scheduled a flight to document New York City during the pandemic. This image of Columbus Circle is one of the more striking images from that flight. If you know anything about this area of Manhattan, you know that it is almost always busy, even in the very early morning. The combination of residential buildings, businesses, new construction, and a main entrance into Central Park normally makes this area a hotbed of activity. Because New Yorkers were following stay-at-home protocols at this time, there were only two moving objects in the frame, and zero people. In this vertigo-inducing image, my own legs add a missing human element and offer a little peek into my perspective as I'm shooting these images.

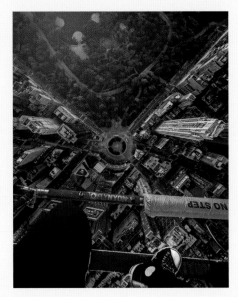

ABOVE THE NOISE

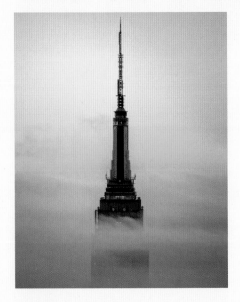

Page 24

Seeing the day begin from Edge NYC, the highest outdoor observation deck in the Western Hemisphere, is always special. But on one particular morning, the weather decided to provide me with a little something extra for my photographic experience. Watching the fog roll in, covering the streets 1,131 feet below me, can only be described as magical. On this morning, only the tallest buildings were given reprieve from the all-consuming fogbank. This gave an isolating effect to images that would normally be jam-packed with other buildings. It was one of the most unique weather moments I've experienced in New York City, and it created an image that, I believe, will stand the test of time.

Page 26

Few places in New York have produced more iconic images than Grand Central Terminal. This is one of the only images in the book that was taken as a long (two-minute) exposure. What happens when you leave the shutter open for that long is anything that is moving is virtually erased. Only the stationary objects remain. With some help of editing to clean up the "ghosts," I was left with one person who remained virtually still for the entire two-minute exposure.

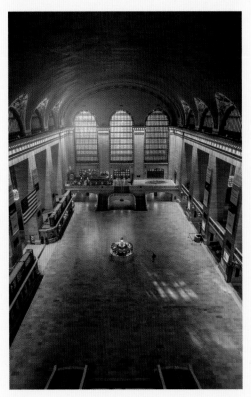

Page 33

Sometimes our oldest shots prove to be our favorites. During the COVID-19 pandemic of 2020, I had ample time to search my archives, and my mouth hit the floor when I saw this frame. Images of the crown of the Chrysler Building have always been favorites of mine. The seam of light cutting across the intersection of 42nd Street and Lexington Avenue already created an element of drama, but to be lucky enough (and I assure you, this time it was definitely luck) to also capture a single yellow taxi driving by added an element of motion to this still image. The detail of the crown, combined with the unique light and perfect timing, makes this one of my all-time favorite frames.

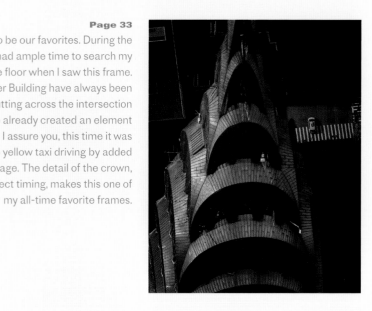

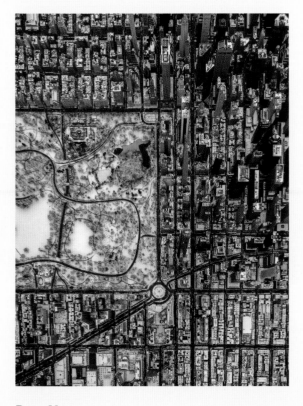

Page 41

One mile above New York City the day after a monster snowstorm is a great way to see the city.
The contrast between the clean white snow and the dark city streets really shows off the symmetry of the city blocks. What I really love about this particular frame is that as soon as nature is introduced as an element, all the lines change. While the city has rectangle after rectangle of streets and buildings, Central Park has this wonderfully random matrix of roads and footpaths meandering through the landscape.

Page 51

One of the newest additions to Manhattan is a previously underused area on the west side that was developed over rail yards. The development, named Hudson Yards, is a mixed-usage area with residential, retail, and a performing arts center. This particular image shows off an art installation called Vessel, which is composed of 154 interconnected flights of stairs and 2,500 individual steps. The most surprising elements that the snow accentuates in this image are all the designs and eclipses in the surrounding landscape. It is truly a unique detail that wouldn't be appreciated if not for the view from above.

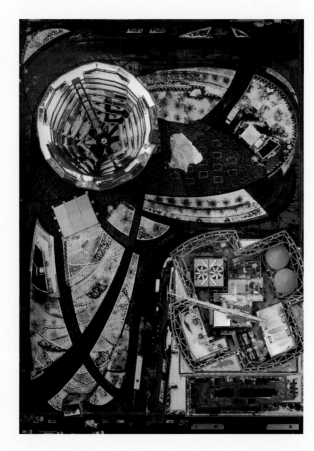

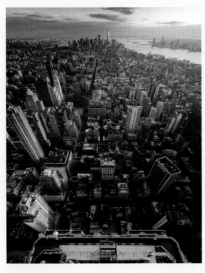

Page 108

The Empire State Building is unquestionably one of the most iconic buildings in New York, as well as the world. It has two public observatories. One is outdoors on the 86th floor, and the other is the newly renovated glass-enclosed 102nd floor observatory. A little-known fact is that there is a staircase that leads from the 102nd floor up to an outdoor catwalk on the 103rd floor. This intimate space has often been used to photograph persons of interest who visit the Empire State Building, and the building managers were kind enough to open it up to me. This image not only shows the vast downtown views afforded by this vantage point, but also is high enough on the structure that the lower decks of the building can be seen at the bottom of the frame.

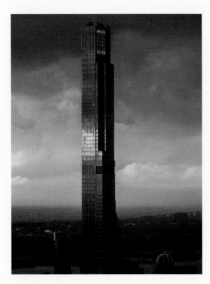

Page 120

Over the last 10 years, New York City has undergone a renaissance of new construction. Highlighted in this image is the newest addition to the skyline. Central Park Tower is the tallest residential building in the world and a sleek new addition to New York's famed Billionaires' Row.

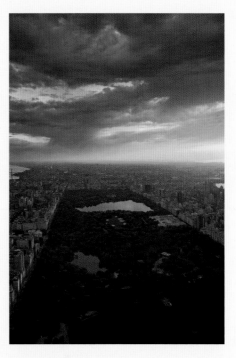

Page 121

Seeing the sun rise over Central Park from the roof of the tallest residential building in the world is an experience that everyone should be afforded. The fine folks at Extell invited me up to see the view for myself, and it did not disappoint. The view ranges all the way up the Hudson River to beyond the Verrazzano-Narrows Bridge. From the roof of Central Park Tower, you can see all five boroughs that make up New York City. Taking it all in as the day began and the city woke up below me was a precious moment.

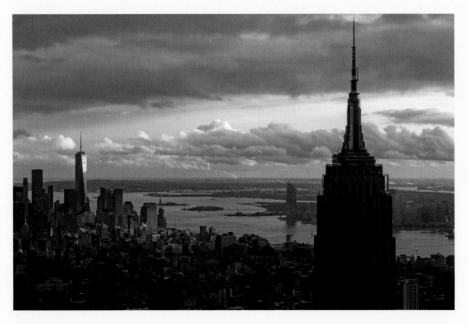

Pages 134–135

The kind people at SL Green Realty were gracious enough to allow me to access Summit One Vanderbilt, one of New York's newest outdoor observation decks. This view not only provided intimate views of the Empire State Building, but also showcased the length of the island and all of its world-famous landmarks. One Vanderbilt has also upped its game by building two additional features that will be sure to wow visitors. The Ascent is an all-glass enclosed elevator that travels up the side of the building to a height of 1,210 feet above the city. Truly adventurous guests can experience Levitation boxes, which are fully transparent sky boxes that jut out of the building and suspend guests 1,063 feet above Madison Avenue.

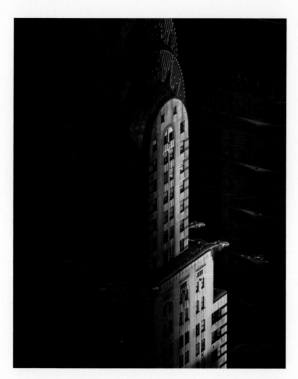

Page 136

Finding unique lighting while flying around New York City is one of my favorite things to do. I'm always looking for landmarks to present in ways I have never seen before. The handling of these images is extremely important to me. I always strive for there to be some detail in my shadows, but I also want to highlight the contrast of light and dark. This image was taken on an autumn afternoon, when the sun was lower in the sky and the shadows were deeper and longer. Golden hour in the fall is my favorite time of year to fly.

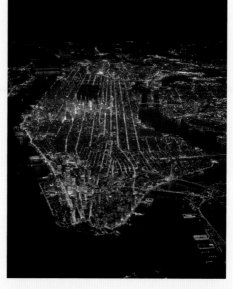

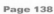

Page 138

This image was taken during a frantic realization that no one else in the helicopter saw what I saw. For a photographer, getting a shot that no one else has is something like capturing a unicorn. I have been flying around at the appropriate times of year to try to re-create this image, but have been skunked for the last three years. So this is one of my most precious images—my Brooklyn unicorn.

Pages 186-187

Shooting still images from a helicopter at night is probably the most challenging time to shoot. Photographers want the most amount of information to provide our viewers, with the most true-to-life visual experience. Now add to that the fact that I am more than a mile and a half above the city, and the contrast between the extremely bright areas and the pitch-black areas are really accentuated. Having an image taken from a moving aircraft, at night, without an immense amount of digital noise, is a treasure for me. This is how I see New York in my mind: electric, surrounded by water, teeming with light and life, and so incredibly vibrant with all its colors.

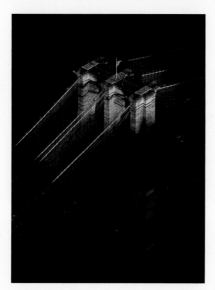

ACKNOWLEDGMENTS

To the Empire State Building and Empire State Realty Trust, thank you so much for your willingness to dream with me and allow me to use your building as a platform for my vision. The access you've given me over the years has planted a seed of confidence in my own creativity. This is a debt that can never be repaid. For allowing me to photograph New York from the 103rd floor, I am grateful.

To Related Companies and Oxford Properties Group, who allowed me to experience Edge NYC in so many beautiful and unique ways, thank you. Having the Western Hemisphere's highest outdoor sky deck to myself was a memory that I will cherish for a very long time.

To SL Green and Optimist at One Vanderbilt, it doesn't happen that often that I experience a view or angle of Manhattan that I've never seen before. That is, however, exactly what I experienced during my visit to Summit One Vanderbilt. Thank you for opening the doors to me early and showing me what New Yorkers and visitors from around the world would be in store for. There is an intimacy in your space, yet the sheer expanse and breadth of the views from Summit One Vanderbilt are remarkable. Thank you for the chance to capture it all!

To Extell and Noise at Central Park Tower, thank you so much for such a warm welcome and thorough tour of your most magnificent building. Being able to photograph the city as it comes to life from the roof of the tallest residential building in the world is something that will be quite hard to top. The ability to see every landmark and iconic structure in New York is a treat. To be able to fashion images using Central Park Tower as a reflective surface was some of the most fun I've had shooting in New York in a long while. Special thanks as well to Santiago Figueroa for the early wake-up call and tour.

To FlyNYON, your willingness to work with me has changed the trajectory of my career. The opportunity to explore New York City over and over again has shaped my creative process and molded the way I approach every shoot. As we have grown together over the years, the one comforting fact was that I could rely on you to see my vision not only for your company, but also for my own crazy projects. Thank you for allowing me to use some of my most favorite images that were captured over the years. The book wouldn't have been the same without them. Being NYON family has always been a point of pride for me, and something I will carry with me for years to come.

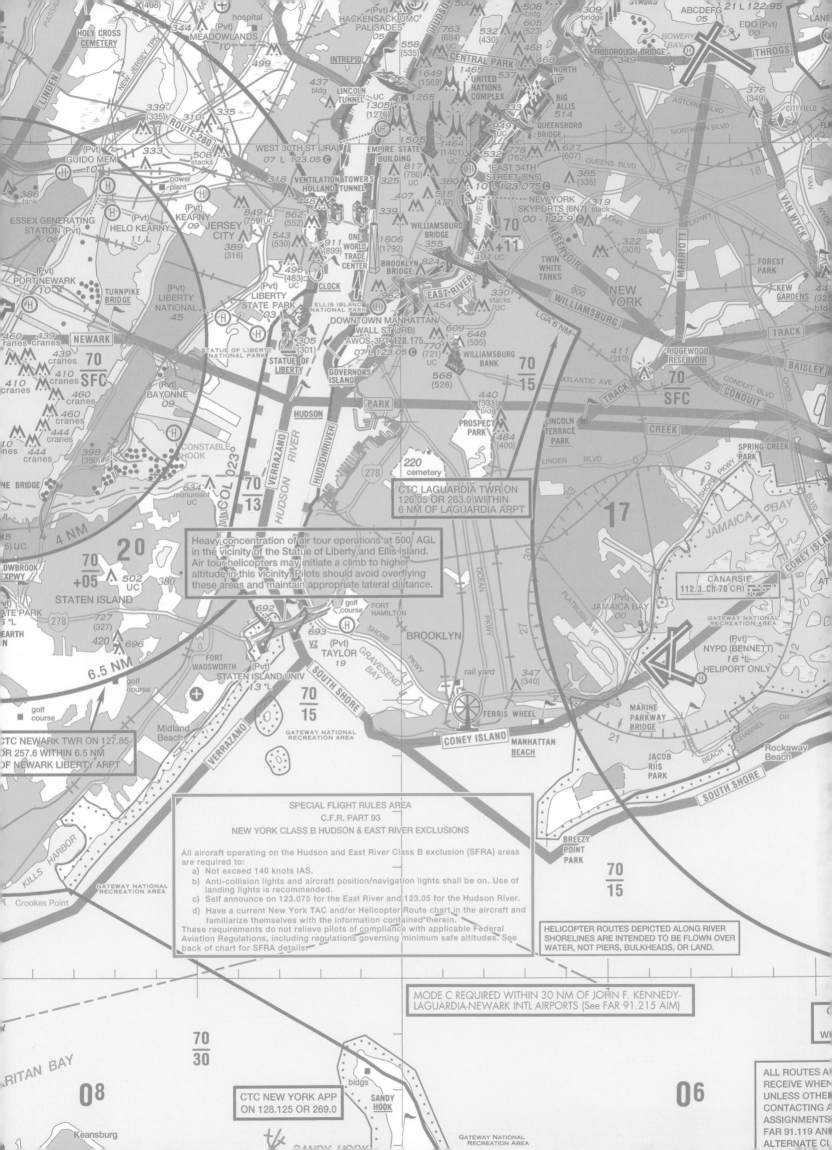